Editor:
Marcia Pointon, *University of Manchester*

Reviews Editor:
Gill Perry, *The Open University*

Associate Editor:
Paul Binski, *University of Cambridge*

Editorial Assistant:
Sarah Sears

Editorial Board:
Kathleen Adler, *The National Gallery*
Jeremy Aynsley, *Royal College of Art/Victoria & Albert Museum*
Craig Clunas, *University of Sussex*
Jaś Elsner, *Courtauld Institute of Art*
Sarah Hyde, *Courtauld Institute Galleries*
Ian Jenkins, *British Museum*
Patricia Rubin, *Courtauld Institute of Art*
Anthony Shelton, *Horniman Museum and Library*
Gilane Tawadros, *Institute of International Visual Arts, London*
Rachel Ward, *British Museum*

Anthea Callen, *Chair, Association of Art Historians*

International Advisory Board:
Cao Yiqiang, *Hangzhou*; Hubert Damisch, *Paris*;
Klaus Herding, *Hamburg*; Lynn Hunt, *Philadelphia*;
Natalie Kampen, *New York*; Joseph L. Koener, *Harvard*;
Serafin Moralejo, *Harvard*; Jessica Rawson, *Oxford*;
Sigrid Schade, *Bremen*; Pat Simons, *Ann Arbor*;
Nicholas Thomas, *Canberra*

Blackwell Publishers
Oxford, UK and Boston, USA

ART HISTORY

Journal of the Association of Art Historians

Volume 20 Number 1 March 1997

Art History is published quarterly in March, June, September and December for the **Association of Art Historians** by **Blackwell Publishers**, 108 Cowley Road, Oxford OX4 1JF, UK or 350 Main Street, Malden, MA 02148, USA. Registered charity no. 282579

Information for Subscribers: New orders and sample copy requests should be addressed to the Journals Marketing Manager at the publisher's address above (or by email to jnlsamples@BlackwellPublishers.co.uk, quoting the name of the journal). Renewals, claims and all other correspondence relating to subscriptions should be addressed to Blackwell Publishers Journals, PO Box 805, 108 Cowley Road, Oxford, OX4 1FH, UK (or by email to jnlinfo@blackwellpublishers.co.uk). Cheques should be made payable to Blackwell Publishers Ltd. All subscriptions are supplied on a calendar year basis (January to December).

SUBSCRIPTION PRICES 1997	UK/EUR	NA*	ROW
Institutions	£102.00	US$182.00	£115.00
Individuals	£ 58.00	US$112.00	£ 71.00

*Canadian customers/residents please add 7% for GST

US mailing: Second-class postage paid at Rahway, New Jersey. Postmaster: send address corrections to Art History, c/o Mercury Airfreight International Ltd Inc., 2323 E-F Randolph Avenue, Avenel, NJ 07001, USA. (US Mailing Agent)

Copyright: All rights reserved. Apart from fair dealing for the purposes of research or private study, or criticism or review, as permitted under the UK Copyright, Designs and Patents Act 1988, no part of this publication may be reproduced, stored or transmitted in any form or by any means without the prior permission in writing of the Publisher, or in accordance with the terms of photocopying licences issued by organisations authorised by the Publisher to administer reprographic reproduction rights. Authorisation to photocopy items for educational classroom use is granted by the Publisher provided the appropriate fee is paid directly to the Copyright Clearance Center, 222 Rosewood Drive, Danvers, MA 01923, USA (tel. 508-750-8400), from whom clearance should be obtained in advance. For further information see CCC Online at http://www.copyright.com/.

Advertising: For details please contact the Advertising Manager, Ludo Craddock, 15 Henry Road, Oxford OX2 0DG, UK. (tel 01865 722964, fax 01865 790740)

Articles for consideration to: Marcia Pointon, Editor, *Art History*, Department of History of Art, University of Manchester, Manchester M13 9PL, UK.

Books for review to: Gill Perry, Reviews Editor, *Art History*, The Open University, Walton Hall, Milton Keynes MK7 7AA, UK.

Membership of the Association of Art Historians is open to individuals who are art or design historians by profession or avocation and to those otherwise directly concerned in the advancement of the study of the history of art and design. The annual subscription, due on 1 January each year, is £34.00 (UK), £39.00 (Europe, including the Republic of Ireland); £45.00 or $80.00 (USA and Rest of the World), and includes four issues of both the journal *Art History* and the *Bulletin*. Student rates (UK) are available on application. Applications should be sent to Kate Woodhead, Dog and Partridge House, Byley, Cheshire CW10 9NJ, UK. (tel: 01606 835517)

Back Issues: Single issues from the current and previous three volumes are available from Marston Book Services at the current single issue price. Earlier issues may be obtained from Swets & Zeitlinger, Back Sets, Heereweg 347, PO Box 810, 2160 SZ Lisse, Holland.

Microform: The journal is available on microfilm (16 mm or 35 mm) or 105 mm microfiche from the Serials Acquisitions Department, University Microfilms Inc, 300 North Zeeb Road, Ann Arbor, MI 48106, USA.

Printed in Great Britain by Hobbs the Printers of Southampton.
This journal is printed on acid-free paper.

© Association of Art Historians 1997 ISBN 0-631-20477-6 ISSN 0141-6790

Art History Vol. 20 No. 1 March 1997 ISSN 0141-6790

CONTENTS

Shorter Reviews

NOTES FOR CONTRIBUTORS

Art History provides an international forum for original research relating to all aspects of the historical and theoretical study of painting, sculpture, design and other areas of visual imagery. The journal is committed to the publication of innovative, synthetic work which extends understanding of the visual within a well-developed interdisciplinary framework and raises significant issues of interest to those working both within the history of art and in related fields.

(1) *Two copies* of manuscripts should be submitted; the *overall* word length should not normally exceed 9,000 words. They should be clearly typewritten, *double spaced throughout* with generous margins. The title page of the script should indicate the author's name, institution, address and telephone number, together with accurate estimates of text and footnote wordlengths; subsequent pages should be numbered and should carry an identifying running head. The author should retain an up-to-date copy of the typescript. Photocopies of illustrations should be included with initial submissions and originals supplied only on the editor's request. Manuscripts submitted in languages other than English will be considered but may be subject to delay.

(2) English spelling conventions should be followed in the text (e.g. colour, centre); foreign-language citations should be given in translation in the main text, with the original appearing in full in an accompanying footnote. All quotations within the text should be enclosed within *single* inverted commas. More extensive citations should be indented without quotation marks. All new paragraphs should be clearly indicated by indentation.

(3) Footnotes should follow the text and be double spaced. References should be kept to a practical minimum and should avoid unnecessary digression or redundant displays of erudition. Bibliographical references should correspond to the following examples:

> M. Baxandall, *The Limewood Sculptors of Renaissance Germany*, New Haven and London, 1980, pp. 20–1.
> P.F. Brown, 'Painting and History in Renaissance Venice', *Art History*, vol. 7, no. 3, September 1984, pp. 263–95.

Titles in French should follow the capitalisation conventions adopted by the Bibliothèque nationale, Paris, as in the following example:

> J.-C. Chamboredon, 'Production symbolique et formes sociales. De la sociologie de l'art et de la littérature à la sociologie de la culture', *Revue française de sociologie*, vol. 27, no. 3, July–September 1986, pp. 505–30.

(4) Illustrations should be used discriminatingly and should be confined to objects whose discussion forms a substantive part of the text. Good-quality black-and-white plates should be provided upon acceptance of an article for publication. These must be clearly labelled and numbered, with accompanying typewritten captions on a separate sheet. Where indicated, measurements should be given in metric form; any details for reproduction from a larger image should be clearly indicated. Illustrations should be referred to as 'plate' in the text. All copyright clearance is the author's responsibility and full acknowledgement of sources should be included where appropriate.

(5) Corrections to accepted scripts should be kept to a strict minimum at proof stage. In view of the costs involved, the editor reserves the right to refuse any extensive alterations to authors' texts in proof. Prompt return of corrected proofs to the editor is essential.

(6) Manuscripts will not be returned to contributors.

The Art of History

After the End of Art
Contemporary Art and the Pale of History
Arthur C. Danto

Over a decade ago, Arthur Danto announced that art ended in the sixties. Ever since this declaration, he has been at the forefront of a radical critique of the nature of art in our time. *After the End of Art* presents Danto's first full-scale reformulation of his original insight, showing how, with the eclipse of abstract expressionism, art has deviated irrevocably from the narrative course that Vasari helped define for it in the Renaissance. Moreover, he leads the way to a new type of criticism that can help us understand art in a posthistorical age.

The A.W. Mellon Lectures in the Fine Arts: Bollingen Series
Cloth: £18.95 ISBN 0-691-01173-7

The Cultures of His Kingdom
Roger II and the Cappella Palatina in Palermo
William Tronzo

This analytical study takes seriously the proposition that the royal chapel of the Norman kings of Sicily, the Cappella Palatina in Palermo, preserves virtually intact—and uniquely so—an ensemble of architecture and the arts from the twelfth century. It sets out systematically to investigate every major component of the decoration and furnishing of the chapel, and in so doing propounds a new chronology for the edifice, in phases, which fixes a new frame of reference for understanding how the chapel functioned under the Norman kings.

"Professor Tronzo breaks new ground in interpreting the Cappella Palatina in Palermo as a far more original synthesis of royal and religious purposes than had been thought until now. . . . Chronology and meaning are shown to operate in a most unusual fashion in creating this unique masterpiece of medieval art."—Oleg Grabar

Cloth: £55.00 ISBN 0-691-02580-0

New in paperback
Marketing Modernism in Fin-de-Siècle Europe
Robert Jensen

"This is an impressive, highly original, and sophisticated work. It will fundamentally alter how art historians view the modern era in art."—Joan Weinstein

Paper : £14.95 ISBN 0-691-02926-1

PRINCETON UNIVERSITY PRESS

AVAILABLE FROM YOUR BOOKSELLER OR DIRECTLY FROM THE PUBLISHER: (609) 883-1759 U.S.
(1-243) 779777 U.K. • WORLD WIDE WEB SITE: HTTP://PUP.PRINCETON.EDU

Art History ISSN 0141-6790 Vol. 20 No. 1 March 1997 pp. 1–2

Introduction

Ever since the pioneering work of Nikolaus Pevsner, whose *Academies of Art Past and Present* (1940) brought to notice the diverse nature of art academies in European history, scholars have been aware of the importance of academies and their regulations and procedures for a full understanding of the development of art in certain centres and among certain individuals. More recently it has been the wider but nonetheless historically specific questions of the complex relationship between training, instruction and exhibition on the one hand and notions of originality and an avant garde on the other that have attracted attention. Historically dominant criteria of quality, the construction and policing of the canon, and concepts of statutory responsibility and national identity are all linked to the institutional histories of Europe's powerful academic organizations, and this is particularly true of the period from the mid-nineteenth to the early twentieth century.

Although there have been, since Pevsner, some very significant contributions to the scholarly literature on academies (one thinks, particularly, of Albert Boime's *The Academy and French Painting in the Nineteenth Century*, first published in 1971, and I. Bignamini and M. Postle, *The Artist's Model: its role in British Art from Lely to Etty*, the now rare but immensely useful catalogue of an exhibition at Nottingham and Kenwood in 1991), by and large the sense that institutional archives offer less rewarding documentation than, say, artists' journals or account books lingers, fostered perhaps by a generation of teachers who were themselves educated in the heady days of the 1960s, when academic art education, the traditions of formal competition, and the preeminence of the life class were so energetically challenged.

Art historians who focus on institutional records often do so primarily with the intention of clarifying the background to a particular artist or a particular art work. This is not entirely surprising as institutional archives, particularly those of the nineteenth century when bureaucracies expanded in all European capitals, are a daunting prospect for any researcher without a predilection for endless piles of minutes and records of internicine warfare of the sort all too familiar to those who work in universities today. Recognizing, however, the overwhelming importance of institutional history to our understanding of the structures within which art was produced, we are proud to present in this special issue of *Art History*, the results of the researches of five scholars who have, thankfully, possessed the will

© Association of Art Historians 1997. Published by Blackwell Publishers,
108 Cowley Road, Oxford OX4 1JF, UK and 350 Main Street, Malden, MA 02148, USA.

to conquer this document mountain. The results are both fascinating in themselves and, we believe, of immense significance in offering a picture – at times disparate, at times cohesive – of the dominant practices in the academies of several European cities during the important period 1860–1906.

The five contributions to this issue are forays into the history of art academies. There is no attempt here to offer any kind of survey; a comprehensive account of European academic history would, of course, require a major examination of the French academy in the seventeenth century, and this we do not provide. Our format, however, permits not only the presentation of a series of detailed cases, whether it be the Madrid Academy's exhibition of 1893, or the question of how anatomy was treated in the curriculum of the French academy, but also the publication for the first time of a collection of important data. Lasko's examination of the student records of the artists who would form Die Brücke is revealing not only in relation to the artistic development of the group and the individuals of which it comprised but also for what it indicates of the kinds of criteria used to award bursaries and of the financial circumstances of the artists' families. Jeanne Sheehy establishes definitively which British artists studied in Antwerp in a decade from the mid-1870s to the mid-1880s and, in so doing, shifts the focus of attention away from Paris, thus opening up new paths of inquiry. Similarly, Oscar Vázquez, by his close examination of events leading up to one exhibition in Madrid, illuminates academic practice in a city which has been in this respect almost entirely overlooked by scholars. Anecdotal evidence about how academies function has long been one of the problems of writing institutional histories; the *Trilby* genre of evidence invites the mythologization of the art school through reminiscence and fiction. Colin Trodd paradigmatically situates the Royal Academy in London in relation to the cultural politics of early Victorian England, thus offering a corrective to generations of biographical and celebratory writing, while Anthea Callen, similarly, in exposing the role of anatomy, provides a well-founded antidote to the heroicization of the French academy.

Marcia Pointon
Paul Binski

© Association of Art Historians 1997

Art History ISSN 0141-6790 Vol. 20 No. 1 March 1997 pp. 3–22

The Authority of Art: Cultural criticism and the idea of the Royal Academy in mid-Victorian Britain

Colin Trodd

English art ... is wide-embracing. Like English commerce it encircles the entire world ... It is a realm in which all latitudes meet ... In reviewing ... the Exhibitions of the present season, we ask ... Has enterprise opened up new regions of the earth ...? Have our artists ... caught the heroism of enterprise ...?[1]

I have heard the matter discussed in French studios until I was sick of hearing the inevitable concluding compliment – merited, I admit – to the keen business capacity of our painters – who, while they profess and laud free trade and liberality, take good care to keep their market as free from foreign competition as possible.[2]

Is it not a disgrace to this country that the leading historical painters should be obliged to exhibit their works like wild beasts, and advertise them like quack doctors![3]

In 1861, ten years after the *Builder* had distinguished the Royal Academy (henceforth RA) from its partner the National Gallery, by referring to the fact that the latter was open 'to every shirtless amateur', the British state acknowledged the professional status of painting by including it under this somewhat problematic category in the census report.[4] As we shall see in the course of this paper, articulations of the RA were often generated in the interplay between readings of its professional authority and business power, because contemporary commentary was often unsure about the identity of the institution within the increasingly commercial art world of a modern market economy.[5] The National Gallery, the RA's symbiotic twin, may have been associated with the derogatory appellation 'amateur', but, through its commitment to educational provision, it was seen to function within the general economy of cultural life, thus mediating between the state and civil society.[6] In contradistinction, the conflation of professional identity and educational efficacy, which was a marked feature of discussions concerning cultural institutions in this period, encouraged observers to see the RA as something like a cultural emporium. It was, claimed one journal, 'a show shop for exhibiting wares', rather than a National Academy of Art.[7]

© Association of Art Historians 1997. Published by Blackwell Publishers, 108 Cowley Road, Oxford OX4 1JF, UK and 350 Main Street, Malden, MA 02148, USA.

From this critical recognition commentators could reflect upon the status of a cultural order where the traditionally dominant 'binary' relationship between the artist and patron had been replaced by a veritable network linking consumers to the panoply of practices that comprised the 'business' of art. For a journal such as the *Builder*, itself very much a product of this new commercial art world, this process could be construed as part of the integration of art into the material fabric of business culture: 'Painters', it claimed in 1853, 'no longer despise social position', nor avoid the 'crowd' because 'fine art is becoming an essential, and pictures much safer investments than some railway shares.'[8] Seven years later *Fraser's Magazine* opined that the modern artist, in embracing the idea of competition, forms himself in the symbiosis of professional and business culture:

> Considered from this point of view, an exhibition of pictures is a kind of Art Exchange, where the painter lays out his imagination, his invention, his ideas of beauty, and his technical skill, and awaits the effect of his wares on the passer-by, which ... will depend upon the amount of merit in his merchandise ...[9]

Most commentators were less sanguine, however. For Edward Poynter, writing before he became President of the Royal Academy, the problem of contemporary art was its 'success', which seemed closer to the nature of advertising than it did to the artistic and educational cultures of the old RA. There was nothing progressive about the system of modern patronage: in transcending 'the circle of ... cultivated people' art had become part of a new economy of consumption. Indeed, this interest in art expressed the power of 'advertisement among so-called art companies and tradesmen'.[10] Elsewhere we find landscape painting identified as the perfect image of a system of production where, because of the sheer proliferation of art works, the idea of a profession organizing and defending qualities, standards and traditions, is surrendered to the 'clever mechanism and copyism of the hand'.[11] In such a system, we are informed, 'the stipple toil of industry stands in for the creative conception and composition of the mind.'[12]

Such commercialism was seen to be generated by changes in the operation of cultural institutions. Although widely acknowledged as a professional society, this reading of the RA occurred at an historical moment when a number of commentators came to realize that production for the market entailed the presentation and exhibition of works of art as commodities.[13] By the middle of the century even the *Art Union*, one of the RA's strongest supporters and for whom it formed the apex of national art, because of its teaching practice and exhibition policy, felt obliged to deal with the commercialism of the institution. In 1845, during the course of a review of the annual RA Exhibition, it stated that in 'treating the productions of Art as simple articles of commerce, we have left them like hay, straw, bricks and cotton to find a market where they could.'[14] As we shall see, mid-Victorian engagements with the RA, many of which were ostensibly concerned with mapping its identity as an exhibiting and educational space, tended to comment on its capacity to assert professional authority in a culture marked by the endless circulation of art works in diverse, often localized markets.

4

Thus the central subject of analysis in this paper is: what happens to the markers of professional life – the reproduction of normative standards through the provision of education, the mastery of specific techniques and knowledge, the control of the display of the artefacts associated with the public visibility of the profession – when commercial processes were often seen to strip the RA of its professional identity, reducing it to the level of trade? What happens to the morphology of the RA as a complex of ideas and practices when diversified markets rather than institutional regulations are identified as dominant cultural forces? And what happens to the image of the RA as a professional body when, as the *Douglas Jerrold's Weekly Newspaper* claimed in 1847, it put 'private interests' before 'public duties'.[15]

Since its inception in 1768 the RA had secured its authority by retaining a degree of freedom from the state, and, at the same time, establishing its material power through its position in the art market.[16] The most significant and authoritive 'national' institution concerned with the education of artists, the display of art works and the circulation of the visual arts, it was a key element in the performance of aristocratic culture and a fashionable site of assembly.[17] Identified as the locus of British art by conservative journals, it had, claimed the *Somerset House Gazette and Literary Museum*, given 'birth to the arts'.[18] Such symbolic power was augmented by the revenue raised from the one shilling charged to visitors to the Academy's annual exhibition.[19] After 1850 the exhibitions, which began in May, often generated something in the order of £10,000 in receipts, a third of which could be invested and added to the reserve income.[20] During the course of the 1860 Exhibition 152 of the 1,096 works on display were purchased for £7,435.[21] Ten years later nearly 300,000 visitors paid to attend an event which was soon to be called the 'Summer Exhibition' rather than the annual 'Exhibition of Works by Living Artists'.[22] Under the auspices in 1879 of the first exhibition under Leighton's presidency, the Academy attracted 391,197 paying visitors and sold 2,878 season tickets.[23]

However, the undoubted commercial success of the RA could be seen by artists as a denial of traditional patterns, customs and conventions of displaying art:

> The most curious thing to notice in this Exhibition is how *all* the works are for sale – some for large prices, like Herkomer's, some for modest ones, as are *Frith's*! – but all, whether R.A.'s or others, for sale, and prices, of course, pitilessly gibbeted in the catalogue. Alas the day![24]

This elision of the display of art with exhibiting the self emerges from Ford Madox Brown's realization that the process of commercialization meant that artistic authority was bound up with a new form of business culture. It is because works of art are 'made to be seen' that their exhibition is a 'commercial necessity' for artists.[25] According to P.G. Hamerton, writing in 1873, the modern artist, finding his identity in the culture of celebrity and fame, attends to business because a 'private connection is not so safe as a well-established position.'[26] The entanglement of art in 'publicity' – the term is Hamerton's – is part of a new exhibitionary system that signals the shift from a patronage-oriented to a market-

led art world.[27] In 1854 the *Art Journal*, which actively supported the business of contemporary art, claimed that:

> The commerce of our modern masters is in the hands of dealers ... many of the best works in all the late exhibitions were the property of dealers who owned them before they were hung on the walls, and whose profits upon them (they were for the most part sold again – sometimes twice or thrice – before the exhibition closed) were great, occasionally doubling the original costs.[28]

These developments provide evidence for the subordination of aristocratic authority to bourgeois power in the fine art realm.[29] However, I want to emphasize that this commercialization of the RA points to the dichotomous nature of its identity. On the one hand it was judged as a professional body; a 'National Academy' with duties and obligations to education; an autonomous institution organized around the idea of the purity of culture. On the other hand it was identified as the central market for the exhibition of art in an increasingly diversified art world. If articulations of the identity and value of the RA circulated around readings of the idea of professionalism *and* the workings of the market, the tension between these two positions came to the fore when the RA was examined as an institution, society or corporation. For many, its identification with business culture seemed to impare its capacity to act as a professional body. Thackeray, for example, writing under the pseudonym Michael Angelo Titmarsh in *Fraser's Magazine*, berates a cultural process which transforms artists into mere 'speculators':

> As one looks round the room of the Royal Academy, one cannot but deplore the fate of the poor fellows ... [They] can't sell their pieces; that is a pity. But why did the poor fellows paint such fiddle-faddle pictures? They catered for the *bourgeois*, the sly rogues! They know honest John Bull's taste, and simple admiration of namby-pamby, and so they supplied him with an article that was just likely to suit him. In like manner savages are supplied with glass beads; children are accommodated with toys and trash, by dexterious speculators who know their market.[30]

In a series of events – the identification of the annual banquet as a social occasion in which the nation could be addressed by public figures (particularly after the invitation accorded to *The Times* in 1851 to hear Prince Albert's address); the extension of closing time in 1862; the presentation of the Old Masters' Exhibition from 1870, which included works by such key contemporary academicians as Landseer, Leighton, Millais and Alma-Tadema; the introduction of a special day for the Press View in 1871; the publication of Blackburn's *Academy Notes* in 1875 and his *Academy Sketches* in 1883; the introduction of season tickets in 1876 and the production of *Royal Academy Pictures*, published by Cassell in 1888 – the RA becomes entangled with the techniques and technologies of publicity and advertising.[31] Through new marketing techniques and consumption patterns we can see radical changes in the management,

© Association of Art Historians 1997

organization and institutional economy of the RA. It should come as no surprise that looking back to the 1870s, G.D. Leslie saw the abolition of the rule prohibiting full-length and life-size half-length portraits from 'the line' in terms of the erosion of 'national art' by a form of advertising culture, in that the portrait was the meeting place between artistic fame and social celebrity.[32] It is clearly evident, then, that during the mid-Victorian period, the RA was identified as a business enterprise as well as, or, sometimes, in opposition to, a professional society; and, as a consequence of this, the relationship between the commercial systems and structures of the modern art world and the practices and conventions associated with the idea of professional life became the source of detailed critical examination.[33] Surveying a forty-year period, W.J. Laidlay, writing in 1898, claimed that the privileges of the academicians meant that a 'national art society' had become a 'commercial concern': where artists had once thrived, painter–businessmen contrived to emulate the fame and publicity of Millais, the ultimate 'business hero'.[34]

As we shall see when we come to examine the material produced in the 1863 Royal Commission, these matters swarmed around three aspects of RA culture: How is the business of professional life conducted? How does a professional society assert its autonomy and remain something more than a business? What is the authority of teaching and what values does it inculcate? It should be noted, however, that, in the face of continued critical examination, which had moved beyond the cultural to the political sphere, one of the ways that the Academy defended its right to resist the full power of scrutiny from the House of Commons was by affirming its authority as a self-regulating professional body. William Sandby, in his 1862 *History of the Royal Academy* wrote:

> Whether ... we look at the internal workings of the schools of the Academy, its laws and regulations in regard to the elections of its members, or the manner in which its funds are dispensed, we cannot think that any good could possibly result from parliamentary interference in its management. Those who know the wants and difficulties of a profession, are the most competent to direct the studies of its future members; and those who have attained eminence in the practice of art, are certainly the most competent judges on all matters relating to it; for Parliament cannot be expected to understand enough of such matters to be able to legislate for art.[35]

Seven years earlier the *Art Journal* had identified the RA with 'the requirements of the profession'.[36] What, we might ask, are the 'requirements' of a profession within a market economy? I shall deal with this question by arguing that the criticisms of the RA, many of which imitate some of the features of contemporary writings in political economy, tend to come to the paradoxical conclusion that it is free trade or economic individualism which sustains the identity of the professional artist by securing a system of circulation of art objects, such as to avoid the reduction of his status to that of an anonymous trader.[37] Rhetoric of this order appeared in a number of cultural spaces; but it should be noted that the tensions and conflicts in this model are best seen in the way in

which it adumbrates the content of professional activity as a generic form in relation to the workings of specific cultural bodies such as the RA. As we shall see, it was possible to identify the professional as the individual artist working in conjunction with a free market, thus resisting the monopolistic powers of corporate bodies. But such a division, pitting the market professional against the corporate professional, fails to acknowledge that 'individual autonomy' and 'institutional monopoly' are *stages* in the same economic cycle. This bifurcation is certainly evident in 'radical' critiques of the RA where the professional realm of art is associated with the workings of the individual artist, but the institutionalization of professionalism as a codified system, in which a particular body asserts its authority, is taken to be the outcome of reactionary social and economic powers.

The separation of professional ideal and institutional practice is featured in the writings of many Victorian cultural commentators. As early as 1840 Edward Edwards writes that the state is obliged to 'dissolve obstruction' and 'watch that artists and men of letters, no less than merchants, have a clear field for competition'; and that 'they suffer no interruptions either from oppressive fiscal laws or from monopolizing institutions'.[38] As we shall see, there is no difficulty in finding material where the market is at once coeval with the material reality of the artist as professional, and the ineluctable force which questions, probes and ultimately opposes those social relations of labour and power established by cultural institutions as agents of the *process* of professionalization. We find many examples of figures occupying spaces where inscriptions of the professional identity of art are made by a language which simultaneously resists and is absorbed by a model of economic life and where the relationship between cultural authority and artistic labour remains problematic. The idea of art as profession, I want to suggest, is caught up with the way in which cultural institutions produced and legitimized professional practices; and for the majority of mid-nineteenth century critics of the RA, this template of professionalism was approached through an examination of the exhibitionary cultures and educational processes of this body.

If it was customary to study the RA in terms of the idea of competition, analysis of its structural role within the art world connected this to the idea of the division of labour, as it could be deployed to describe the heterogeneous nature of contemporary art. As far back as 1836, in *The Select Committee Report on Arts and Manufactures*, we find stated in the introduction that 'it seems probable that the principle of free competition in art (as in commerce) will ultimately triumph over all artificial institutions.' Nine years later the *Art Union* declared 'the division of labour ... has worked miracles in nearly all the productive arts ... by following it out in painting as well as the inferior arts, an ascendancy can only be made.' In the 1863 Royal Commission the division of labour is identified as the 'principle' for accomplishing the restructuring of the forms and processes of education in the RA schools.[39] Yet, of course, as they circulated in cultural commentary, the ideas of economic competition and the division of labour existed somewhat uneasily with articulations of the RA as the disinterested arbiter of the values of fine art and the institutional bastion of the profession. Here, for instance, is a passage from a speech by Prince Albert:

© Association of Art Historians 1997

... the great principle of the division of labour, which may be called the moving power of civilisation, is being extended to all branches of science, industry, and art. Whilst formerly the greatest mental energies strove at universal knowledge, and that knowledge was confined to the few, now they are directed on the specialities, and, in these, again, even the minutest points; but the knowledge acquired becomes at once the property of the community at large; for, whilst formerly discovery was wrapped in secrecy, the publicity of the present day causes that no sooner is a discovery or invention made than it is already improved upon and surpassed by competing efforts. The products of all quarters of the globe are placed at our disposal, and we have only to choose which is the best and the cheapest for our purposes, and the powers of production are intrusted to the stimulus of competition and capital.[40]

This well-known panegyric to the power of capitalism as a process of endless human progress incorporating the political, cultural, social, economic and technological spheres was read by the Lord Mayor of London in 1850 before Ministers of the Crown, the Royal Commissioners of the 1851 Exhibition, Foreign Ambassadors and the mayors of 180 towns.[41] Its tone and content can be compared with the speech delivered by Prince Albert at the RA dinner the following year:

... our times are peculiarly unfavourable when compared with those when Madonnas were painted in the seclusion of convents; for we have now on the one hand the eager competition of a vast array of artists of every degree of talent and skill, and on the other as judge, a great public for the greater part wholly uneducated in art, and thus led by professional writers, who often strive to impress the public with a great idea of their own artistic knowledge by the merciless manner in which they treat works which cost those who produced them the highest efforts of mind or feeling.

The works of art, by being publicly exhibited and offered for sale are becoming articles of trade, following as such unreasoning laws of markets and fashion; and public and even private patronage is swayed by their tyrannical influence. It is, then, to an institution like this, gentlemen, that we must look for a counterpoise to these evils. Here young artists are educated and taught the mysteries of their profession; those who have distinguished themselves, and given proof of their talent and power, receive a badge of acknowledgement from their professional brethren by being elected Associates of the Academy; and are at last after long toil received into a select aristocracy of a limited number, and shielded in any further struggle by their well-established reputations, of which the letters RA attached to their names gives a pledge to the public.[42]

The first of these passages is similar to Gottfried Semper's observation that 'capitalism, will, if it recognizes its best interests, seek out and recruit the best workforces and for that reason will show more zeal as a protector and cultivator of art and artists than a Medici did.'[43] In the second passage, however, the division of

labour, 'the moving power of civilisation', comes up against a set of representations about professional life where the cultural institution is defined as the agency which must block the process of circulation in the name of a value that escapes and resists the forces of commodification. Value must remain marginal to those processes of exchange that characterize the commercial logic of contemporary social and economic practice; and if it does not, then art becomes detached from the domain of a professional culture which is identical to the workings of the RA. If it is a sign of progress that what he calls 'the complicated state of civilized society' should lead to the fragmentation or erosion of traditional forms of economic and institutional behaviour, it is difficult to know how the RA, in resisting market forces and economic competition, might generate a practice of value beyond the price mechanism established in the play between supply and demand.

The unease in describing society as a material structure organized by the division of labour, where all objects are treated as commodities, is apparent when Prince Albert is obliged to address the RA as both a public organization and as the vector by which the profession of art is held together in a set of stable images about education, artistic value, cultural tradition and historical custom. His first speech identifies trade with modernity and the professionalization of social relations, but its articulation in the second is redolent of Sir Martin Archer Shee's statement, written when he was President of the RA, that 'the moment you make art a trade you destroy it.'[44] That is, his address to the Academicians must find some way to assert that the knowledge they generate and communicate – in the form of the education they provide to their students and in the display of their works to the public at their annual exhibition – confirms that there is indeed some value which accrues from an expansive rather than 'detailed' knowledge; that the inculcation of the 'mysteries of the profession' registers the essential purity and value of education in art as something which resists the liquidation of value associated with the laws of the market.

Prince Albert's position, as it is articulated in the RA address, would have been recognized by earlier apologists of this institution; for his speech obliges us to ask how fine art, as an authentic profession, can contribute to civil society, confirm its civilizing processes and affirm the legitimacy of its own authority. Because if, as Barrell has written about Reynolds, the authority of the Royal Academy had been associated with the division it made between citizens and labourers – those who could survey society and those who were absorbed by its structural powers – then, what authority could accrue to this specialized cultural institution in a period which Albert characterizes through the benign operation of the market, a market whose universal powers expose and express the symbiosis of labour and capital? How can the RA affirm the civilizing powers of such 'productive forces' when its social relations are presented in terms of their *resistance* to the idea of the market?[45]

This presentation of the RA as an institutional site where knowledge resists the specialization associated with the market, a presentation which articulates the traditional values of art through its replication in the structures and patterns of art education, and affirms the professional integrity of the artist by the management and organization of the annual Exhibition, was made against a body of criticism that charted institutional identity in terms of the circulation of a rather different set of characteristics. Indeed, throughout its history, the Royal Academy had been

10

subject to critical inspection from a variety of sources.[46] In the 1820s and 1830s the *Examiner*, adopting a modified Painite position, preaching liberty and the limitation of the powers of an oligarchical aristocratic state, had attacked the RA as vulgar monopoly.[47] Such criticism was often conducted in a highly dramatic and acerbic style, at once dexterous and filigree, as if rhetoric could be both a surface where the experience of the exhibition was enacted, and the point at which its meaning could be blocked or erased. Early nineteenth-century reviews consistently wrote out the paintings that they were meant to describe in order to draw attention to the nature of the audience. 'Our eyes were dazzled', wrote one commentator in the *Mirror of Literature and Amusement* in 1838, 'with the newly-painted canvases and gilt frames which cover the walls of the RA; but they are flat and still when compared with the happy smiling faces that float through the room.'[48]

The comic mode could be adopted in order to suggest the absorption of painting into a sort of theatre in which the audience had become an object of display. A panoply of textures, surfaces and signs, the audience became a concatenation of clichés in a language which insisted on the ineluctable artifice of all that it surveyed. Thus, the *Spectator* in 1837:

> Flaring uniforms of blue, red and yellow, interspersed with plain suits and superfine broadcloth, varied with satin and velvet gowns, stuck into attitudes and surmounted with heads, fixed as into a vice, the characteristic expressions of their faces being smoothed down into a simper of self-complacency, or represented by an unmeaning stare.[49]

Because writing became the space where individuality was affirmed at the moment when judgements were made, language blocked the subject's contact with those forms which engaged him, for it had to confirm that, by digging deep into the surface of painting and its assembled audience, he discovered their absolute unity. Such writing aimed to reproduce the perpetual oscillation between the ranks of crowded portraits and the exhibition crowd; to grasp this as a moment in the endless circulation of signs and things; to see here the absolute purity of the idea of exhibition in a space where art had become a set of traces held together by 'mere mechanical dexterity'.[50]

In a domain defined as 'an exhibition of corporate limners', portraiture came to be identified as the dominant image of an institutional body where art was a 'profitable trade'.[51] Writing was the place where the space of the RA could be understood and explained because language transported the reader into a realm that dabbled in the currency of fashion and style; and by dealing with the trade between people and paintings, we are allowed to glimpse such objects over the shoulders of the parade from which the critic recoils in the process of recalling. This critical mode, at once quotidian and patrician, at once in the crowd and surveying it, affirmed an imaginary union between the critic–beholder and a lost continent of value. Writing transcribed the paintings in the exhibition by its inscription of the figures who attended such events. Writing was the act whereby the union of value and experience could be maintained in a social space where such a relationship was taken to be marginal or almost impossible to perform.

© Association of Art Historians 1997

11

In contrast, later criticism is marked by the appearance of a mode of address which is not only concerned with dramatizing the lineaments which hold the drama of the exhibition together, but with examining how the institution *qua* institution is held together as a material force or body. Although some of the early rhetorical techniques continue into the period after 1850, what tends to happen is that the association of the RA with the realms of luxury and leisure is augmented or supplanted by a form of writing which does four things: it examines the corporate character and management of the institution; it questions its relationship with the art market; it investigates the nature of education which is provided in the schools; and it assesses its values in relation to what are perceived to be the universal needs of professional life.

This agenda is articulated in a number of different sites in the period. Two of the most important examples were produced in cultural and governmental spaces: in 1851 the *Westminster Review* published a long essay on the RA; twelve years later came the Royal Commission on the RA, accompanied by a report containing evidence from such academicians as Sir Charles Eastlake, President; William Dyce; Sir Francis Grant; David Roberts; Daniel Maclise; Sir Edwin Landseer; C.W. Cope; John Everett Millais; as well as from William Holman Hunt, G.F. Watts, Tom Taylor and John Ruskin. As both documents are crucial to any informed understanding of the place of the RA within the cultural politics of mid-Victorian Britain, I shall examine these texts in detail.[52]

The central questions posed by the *Westminster Review* are: From whence does the RA derive its authority? What are the effects of this authority? What is the nature of its institutional identity?[53] Prince Albert had approached the RA by posing the question: If the production of art for the market affirms its commodity status, how can it be possible to apply the laws of competition to art, such that its authority is not ruined? In opposition, the *Westminster Review* presents the conflation of art practice and free trade in terms of the development of individual authority, economic independence and rationalized self-interest. Thus, by associating the RA with the control of the national art world, the *Westminster Review* could present the authority of the RA as a form of 'patronage' which structured, organized and controlled the flow, display and appearance of contemporary art.[54] Because it identified the RA with the monopolization of cultural power, it developed a type of exegesis where the government of art – the practices, processes and mechanisms which form the instruments of institutional life – are seen to be as fundamental in the formation of the profession of art as the specific acts of individual Academicians. Like earlier critics, the *Westminster Review* attacks the RA as a self-elected corporation, but this is augmented by a liberal idea of a civil society producing and encouraging diverse forms of cultural work. The market, associated with openness, Protean energy, freedom and choice, is compared to what is seen as the monolithic culture of an institution which establishes a fatal symbiosis between itself and Art.

We have to be very clear about the nature of the claim made by the *Westminster Review*. In effect, we are informed that it is in the endless equivocation between two registers – that of the public body and the private organization – that the professional status of the RA was formed. So, by occupying an ambiguous space between the state and civil society, and by

© Association of Art Historians 1997

conflating legislative and economic power, its birth is defined in the following terms:

> The ... pervading error is implied in the fact of the establishment being at once a trading society and a privileged one. Analogous close corporations have existed in trades and professions. Of such questionable models the Academy was an imitation. The trust should, as a matter of course, be distinct from the trading interest, for its adequate fulfilment. Two heterogeneous principles are conjoined; the one not allowing room even for the other, however good we may assume the intent to be.[55]

Defined as a body which marginalizes artists by absorbing their art into its system of display, we are presented with an image of an institution where the productive forces of art have been subordinated to the specific needs of a cluster of traders. The criticism is not that the RA reduces art to trade, but that it practises a system that makes the market aberrant and inelastic. Of the annual Exhibition we are informed that it is a site of 'private prerogative and monopoly'; a place where the 'interests of art, of the profession, the public, are postponed.'[56]

As we noted earlier, the problems with this mode of address is the way in which the term 'professional' is approached and defined. It may acknowledge the idea of professional activity, but its embodiment – in terms of the legitimization of professional authority through institutional processes – is denied. The market professional, formed in and by the continual workings of an endlessly mobile and elastic market, is authentic; but the corporate professional, through his affiliation to the RA, is identified as chimeric.

This conflict between the market professional and the corporate professional is in turn grounded on the way in which the relationship between the authority and the property of the artist is established. The conflation of property and authority occurs through the generation of human capital: the accumulation of skill, experience and knowledge through the study of art, and its institutional forms, so that work oscillates between artistic practice and the development of a career path.[57] In opposition to Hamerton, for whom artists 'have no stake in society' because their 'capital is all invested in themselves and their two hands', we can see that a subject has property when it is possible to sustain an identity within the matrix of forces connecting the subject to institutional networks.[58] And yet, of course, this brings us back to what can be called the *Westminster Review*'s ur-relationship: that of art and business. Business, the article affirms, aids the professional ideal when it expresses the interests of the individual artist, but not when it organizes the profession of art through the 'mediating' agency of a cultural institution, such as the RA.

Claiming that a national market based on free competition enables art to realize its true identity, because this system erodes the influence of sectional groups, the *Westminster Review* affirms that 'the coherent or just system must be wholly free, expansive; the institution open to all.'[59] Thus:

> The stray rays of glory really emitted by a congress of Ineffables to which sundry of the profession's most honourable members, and the majority of

the distinguished in all departments of art, save one, are even ineligible, are of uncertain, not to say meretricious illuminating value. The only sufficient 'stimulus to exertion' the man of genius knows, is that nature herself has provided: the love of his calling, of excellence, and of the highest.[60]

The RA, then, provides its membership with the *image* of a profession: instead of generating artistic value, it is caught up in advertising status. But this provision of public status deprives the artist of any real private identity. Affirming its powers in the name of art and its values, the RA is defined as the process by which the authenticity of art is perpetually deferred. The authority of the RA cancels the authority of art because the formation of the institution is taken to produce the conditions in which art is fragmented into a series of marginal practices. Firstly, we are presented with a producer who absorbs and internalizes the customs of the Academy. Secondly, we have a vision of a limited class of consumers, whose powers enforce and control the circulation of art by managing its appearance, identity and character.

Claiming that the business of the RA is to advertise the idea of the corporate professional, the *Westminster Review* asserts that it generates a matrix of 'embellishments' which are 'rude, uncertain approximations to the direct and certain indication of nature's hand'. Therefore, 'the system of artificial labels of honours is a levelling one' in which the 'small men triumph, raised to a quasi-equality with their superiors.' All that 'an Academy of the illustrious can do, is to extend the cloak of honour, borrowed from the true nobles, over the bare and ragged, that their poverty be not seen.'[61] The circulation of authority, we are informed, generates an institutional culture where property and power, the power to make property and the properties of power, have become the means whereby those who have no intrinsic individuality as artists establish a corporate existence:

> The individual man – above all, the individual man of genius, rises to his full value only when standing singly. In a mob his native dignity and power are dissipated. The ablest man, so long as he is of the mob, is lost in it, degenerates into a mere unit, of as little importance there, as another.[62]

From the perspective of the *Westminster Review*, being a market professional enables the artist to make himself in and through the processes of labour. The market authenticates art in the process of realizing the professional ideal because, in a sense, it is internal to the artist. It replaces, therefore, the image of the public as the conduit through which the idea of value passes. Moreover, this internalization of the market, in the form of the psychological impulse of competition, is contrasted to the self-absorption of an academic regime where:

> a mere Academician's large sense of things, of the arts, of the world in general; his succinct summary view of all, comprehended or advantageously dispensed with by that great phenomenon of human polity to which he

© Association of Art Historians 1997

mentally refers the whole; nay, the Academician himself, taken as Academician, rather than as painter or man, are curious and pregnant topics for consideration. How vast his mind's image of the petty figment – to him a cosmos – this 'Academy of the Arts'; how small and slighting his notion of those other arts and matters undreamed in its philosophy.[63]

The Academician is mistaken, then, because he assumes that the RA is the cultural space from which he can survey the art realm in order that he might make of his work a unified whole. But the desire for a comprehensive vision, which, as we have seen, Prince Albert believed the RA could satisfy, and the identification of the institution as the source of artistic authenticity, are compensatory fantasies for the loss of self which obtains when the artist enters into the legitimation practices of an academic culture that 'cannot stand for that whole; far less take the place of the more living parts of it'.[64] Knowledge cannot be gained through the authority that accrues from an institutional fragment: to be absorbed into the institutional locus of the RA is to lose the capacity to make oneself an authentic individual because the authority of professionalism – its allegiance to independence in practice, action and belief – is eradicated. The 'error' of the RA is that it sees identity through status, so that artistic personality becomes the pursuit of the emblems which confirm the authority of business and trade as a form of advertising for the Academy itself. Here authority is conflated with the achievement of these 'authentic' signs of professional status.

For the *Westminster Review* it is the authority of the market which establishes professional identity *because* it generates a set of relations that do not circulate around the idea of status. Professional identity is defined as the outcome of the interplay between the individual and the market: this is the only whole or unity to which the artist can aspire and it is not one which is consequent upon the activity of the cultural institution but the reality of competition and private enterprise. The RA is taken to consume the idea of individuality at the moment it produces its own professional identity, and consequently the Academicians

with headlong bigotry ... identify the vicious system as their own, and are driven to blind upholding of it, to the letter. Such thick-and-thin defenders of an established fact, with ground or without, nature and universal fact accordant or defiant, form ever a humiliating spectacle. One such, taken at his best of stinted endowment, half-man, half-conventional hearsay of a man, becomes, at such moments, mere windy unveracity throughout, and idle noise: his allegiance, such as it is, sworn to the incoherent and absurd. The poor slave knows not of his serfdom and emptiness, nor the battle he is fighting. Saddest pass of all, he believes, in the depths of such shrunken soul ... he is uttering strict law and reason.[65]

Many of these views reappear in the less exuberant language of the 1863 Royal Commission, where the workings of the RA are examined in great detail. Established 'to inquire into the present position of the Royal Academy in relation

to the Fine Arts, and into the conditions under which it occupies a portion of the National Gallery', it also set out to 'suggest such measures as may be required to render it more useful in promoting Art and in improving and developing public taste'.[66] In fact, most of the information and evidence arose from matters relating to the efficacy of the RA as a professional institution. In his evidence, the art critic Tom Taylor suggested that, due to the educational and intellectual marginality of even the most learned and intelligent of contemporary artists, the threshold of professional life and the components of national culture were beyond them all. Reynolds, he claimed, was the last artist who could survey the cultural and social realm; and he therefore concluded that the next presidential appointment should be of a figure from beyond fine art itself.[67]

The origin of the Commission and its subsequent Report can be seen as part of a process in which the administration of government was itself professionalized through the development of systems of observation and inquiry.[68] Indeed, if the history of government in this period can be read as a chronic oscillation between, on the one hand, centralization, legislation and the development of administrative systems to support these 'reforms', and, on the other hand, articulations of the autonomy of the economy within commercial society through the adoption of *laissez-faire* principles, then the history of the state in this period can be registered in terms of the production of techniques and technologies which test, probe and examine corporations, institutions and associations within the social, cultural and industrial spheres. It is within this governmental complex − the replacement of local amateur systems by national professional norms − that we should place the Royal Commission's investigation of the RA.[69] Yet we should not see this process of observation, management, or what Foucault calls 'governmentality', as the formation of an homogeneous state culture.[70] The 1863 Royal Commission − with its elision of the rhetorics of the market and professionalism, and its inability to break down the public–private identity of the RA − supports the contention that the state is 'the condensation of a relationship of forces'.[71]

Dealing with the testimonies of forty-six witnesses, the Commission took five months to produce a Report some 557 pages long, in which the authority of the RA was examined by investigating the professional administration of teaching students and exhibiting works of art.[72] Advocating reform, the Report recommended that the RA should become a National Academy of Art, mediating between the profession as a whole and the state. Indeed, the pages of the Report are full of questions concerning the teaching at the RA schools, a subject that was to remain important until the end of the century, as the writings of Laidlay and Leslie indicate.[73] Even the Academicians brought before the Commissioners indicated that the general level of teaching in the RA schools was less than satisfactory. When asked if he was happy with the quality of education given to the students, William Dyce replied:

> No, I am not satisfied with it, and I have frequently objected to the
> system of teaching by visitors. In my opinion it is more advisable to have
> a permanent teacher than visitors who give possibly conflicting advice.
> Even if the permanent teaching were of an inferior order, I think it would
> be more beneficial than the occasional advice of successive visitors.[74]

© Association of Art Historians 1997

If the classes were badly attended, and the teaching spasmodic and inconsistent, Sir Charles Eastlake, President, countered by asserting that the value of study at the schools transcended the idea of practical instruction. The institution was above prescribing 'the precise order of study, or the precise taste which should influence the artists of the country'. It might be the case that science 'is a legitimate object of instruction, and also mechanical art', but this is not the case with fine art. He goes on to claim:

> I believe that the principles of what we understand by fine art are much
> too refined and vague to admit of definite instruction. I will go so far as to
> say that in proportion as instruction in fine art becomes definite, so the art
> is lowered and becomes mechanical.[75]

For Eastlake, education must be the registration of artistic autonomy rather than a professional system in itself. Or, rather, education is so devoid of the materiality of mere training that the process of learning escapes the vulgarity of prescriptive norms. From this perspective, most forms of education are, in fact, no more than forms of training; they provide a series of inductions into the routines of a labour culture distanced from aesthetic substance. Such a move ensures that the physicality of artistic work – and its relation to educational practice – is rendered invisible by a rhetoric proclaiming that the authority of the profession of art escapes any immediate codification.

Part of Eastlake's anxiety about securing the status of the RA as something other than a teaching establishment can be put down to the desire to distinguish the institution from the idea of a guild. The Commission concerned itself with this type of cultural formation, and Eastlake, in his presidential capacity, seems to have identified the idea of formal art education with the social relations of cultural production associated with guild culture. Unlike the Commissioners themselves, Eastlake did not envisage a category of Art-Worker Academicians, and his evidence, marked by a desire to distance the RA from the idea that it inculcates practical skill, does not concern itself with the techniques and forms of specific educational programmes.[76]

Behind Eastlake's patrician rhetoric is the fear that a National Academy, based on the idea of a guild and developing a fragmented economy of craft practices, could not embody a homogeneous, professional or national culture. However, the substantial body of criticism directed against the RA, claiming that it was not a professional institution, tended to focus on its capacity to play its public–private identity in such a way that any national obligations were obscured. It was assumed that a National Academy should determine the way in which art was taught through the production of a universal system of certification, and that it should acknowledge the identity of the English school by including watercolour painters in its membership. This failure to allow such artists to show their work at the annual Exhibition can be seen as further evidence to support the claim that the RA was as much a business organization as it was a professional society; and that the annual Exhibition was more of an attempt to display the components of what was identified as the English School. Directed to the subject of exhibition policy, David Roberts acknowledged that the RA failed to express the national character

of art. By ignoring the charms and qualities of watercolour painting, it avoided something 'purely English' which had been 'carried to a very great degree of perfection'.[77]

This desire to read professional authority in terms of the identification and support of the national character of art can be seen in the testimony of Sir Francis Grant, portrait painter and President of the RA between 1866 and 1878. Grant claimed that far from affirming any residual 'amateurism', the eclecticism of the RA was, in itself, a concrete representation of Englishness.[78] Such a claim makes the RA a key element in the expression of a national cultural identity, and presents pluralism as a sign of a relaxed, informal and persuasive liberalism. In this scenario it is in the multiplicity of picturesque localisms that the source of national character is discovered; and this finds cultural expression in the idea of a national school comprising endless variations in form, technique and style. It should come as no shock that Grant could attack Pre-Raphaelitism because of its apparent devotion to a theory-based practice. In contradistinction to a sensational style that broadcasts and advertises itself by negating true form, the RA must, according to Grant's account, express the diversity of art created by genuine artists seeking the expansiveness of beauty rather than the minuteness of labour.[79]

Although the idea of national identity invoked by the Commissioners was expressed in many different ways, its association with education was particularly strong, where it took the form of measuring the efficacy of teaching systems, defining artistic expertise and establishing professional norms. The relationship between the RA and debates about national culture, debates in which the issue of education was central, circulated in critical discourse throughout this period. Writing in 1914, Leslie identified the 1860s and 1870s as the beginning of the erosion of a national style at the RA and its schools.[80] In the same year in which the Commission sat, the *Art Journal*, the most aggressive supporter of the institution, declared that it was 'antagonistic' to the 'social and civil life of England'. The RA, it continued, was not truly national because, in putting its own publicity before the honour of art, it rejected 'competition' and could not be 'entrusted with Art education'.[81]

If the debates about national education were shaped by ideas about what national art might mean, they were also bound up with articulations of the content of professional life. As in other areas of professional life dealt with by the Commission, one of the questions put to witnesses concerned itself with the need to establish proper entry requirements to the fine-art realm. These questions tended to focus on the relationship between the development of a professional fine-art culture and the formation of the examination as a technology for judging artistic achievement.[82] Here the professional ideal is associated with the delivery of educational systems which could be tested and probed by investigators rather than a generalized form of training. Education becomes the accumulation of skills commensurate with the idea of the expert: the ability to maximize specialized human capital is the generation of a self-defining professional identity.

Some defenders of the RA, in acknowledging the importance of education to the professional standing of the institution, sought to make it a marker of artistic autonomy. In his evidence before the Commissioners, Daniel Maclise proclaimed that none but professional men could be judges of painting and works of art.

© Association of Art Historians 1997

'Enlightened non-professional lovers of art' would be obliged not only to pass 'judgement upon the works of artists sent in for the exhibition, but also upon the drawings of students'; and it is in the area of student work 'that technical and professional knowledge is most needed'.[83] Yet professional knowledge is not necessary for judging 'finished works ... for exhibition on the walls'. To understand finished paintings, it is not 'professional knowledge' but the 'power of judging ... the poetic inspiration' which is needed to appreciate the 'higher qualities' of the work. Asked whether this identification of technical competence with professional status tends to detach the artist from a more 'refined' approach to the study of art, Maclise responded by stating:

> I think that there is, to a large extent, an estimate of the mental qualities of works of art in the present day, quite independently of their technical qualities. I think that the mental qualities are fairly estimated, and sometimes too highly, as when a meaning is attributed that only exists in the mind of the spectator. It is, indeed, a more subtle thing to discover the technical merits of a work ...[84]

This desire to turn away from dealing with interpretation, this retreat into 'technique' in the face of questions about the composition of 'professional' regulating bodies, is particularly revealing. This is, after all, hardly an example of the understanding of the 'mysteries of art' which Prince Albert had identified as one of the values of the RA. Far from it. The presentation of technique as the special province of the artist left this definition of the profession of art open to an obvious retort. Responding to C.W. Cope's identification of technique as a marker of professional understanding, Lord Elcho, the Chairman of the Commission, asserted that the 'cultivated taste and love of art' of non-professional gentlemen should provide them with 'large views of art'. Moreover, their taste, being expansive and catholic, would avoid the 'small details' and the 'specialities of art'.[85] Thus, if the painter believes that he becomes a real artist by giving himself to the technical matters of painting, it is the connoisseur, in surveying the realm of art, and avoiding the logic of a specialization which seems to be a form of the division of labour, who secures the public and professional standards of art.

Whilst Cope and Maclise saw the subject of technique as a way of confirming the status of the artist as a professional, many, including Ruskin, saw this 'symbiosis' as evidence of the close relationship between the nature of modern art and contemporary business practices.[86] Indeed, there is a great deal of information which documents another way of reading this uneasy relationship, where the artist, establishing the autonomy of his studio as a realm of professional culture from which the image of the workshop as commercial enterprise has been erased, loses direct contact with the experience of practical chemistry, and thus becomes detached from any immediate control over the materials and pigments of his work.[87] If the professional ideal assumes knowledge of the materials, techniques and technologies of a specific discipline or subject, with the increasing proliferation of the painters' materials by a veritable army of artists' colourmen, the processes of the division of labour worked in such a way as to separate the

painter from this realm of experience and preparation. Here again we see, as we have throughout this paper, the ineluctable war between the processes of professionalization and the image of the professional, between the values of cultural association and the forces of economic individualism.

Colin Trodd
University of Sunderland

Notes

I would like to thank Stephanie Brown for her valuable help in the preparation of this article.

1 J.B. Atkinson, 'London Exhibitions and London Critics', *Blackwood's Edinburgh Magazine*, no. 84, August 1858, p. 193; and J.B. Atkinson, 'The Royal Academy and other Exhibitions', *Blackwood's Edinburgh Magazine*, no. 88, July 1860, p. 65.

2 W.J. Laidlay, *The Royal Academy, its Uses and Abuses*, London, 1898, p. 142.

3 B.R. Haydon, *Correspondence and Table-Talk*, London, 1876, vol. 2, p. 293.

4 *The Builder*, vol. 2, no. 343, p. 413, 1 September, 1849. The RA shared the Trafalgar Square building with the National Gallery between 1837 and 1868. Since 1868 it has been located at Burlington House, which it occupies on a 999 year lease at £1 per annum. S.C. Hutchison, *The History of the Royal Academy, 1768–1986*, London, 1986, pp. 87–9; pp. 107–111.

5 Even its most consistent supporter, the *Art Journal*, claimed that the commercial authority of the RA, arising from its monopolistic tendencies, resulted in its failure to recognize the flexibility of institutions within modern culture and its consumer networks (*The Art Journal*, 1 June 1849, p. 165). Although the fine arts are not analysed in his massive tome, H. Perkins's *The Rise of Professional Society*, London, 1989, is the key source on the processes, practices and institutions which generate professional capital.

6 For an account of the cultural politics of the National Gallery in this period see C. Trodd, 'Culture, Class, City: The National Gallery and the Spaces of Education 1820–1863', in M. Pointon (ed.), *Art Apart*, Manchester, 1994, pp. 33–49. The term civil society – referring, as it does, to the totality of autonomous institutions and associations beyond the specific control of the state – includes material relationships formed in cultural and social life. See J. Keane, *Democracy and Civil Society*, London, 1988. A more detailed and advanced politico-philosophical reading of the concept is provided by N. Bobbio's 'Gramsci and the Conception of Civil Society', in his *Which Socialism*, Oxford, 1988, pp. 139–61. In 1836 the *Spectator* demanded that the RA, in becoming linked to the National Gallery, should develop its profile as a public institution and resist the seductions of Royal authority. See *The Spectator*, vol. 9, no. 440, 3 December 1836, p. 1165.

7 *The Spectator*, vol. 10, no. 465, 27 May 1837, p. 498.

8 *The Builder*, vol. 11, no. 535, 7 May 1853, p. 289.

9 *Fraser's Magazine*, 11 June 1860, p. 874.

10 E.J. Poynter and P.R. Head, *Classic and Italian Painting*, London, 1885, p. x.

11 J.B. Atkinson, op. cit. (note 1), 1860, p. 75.

12 J.B. Atkinson, op. cit. (note 1), 1858, p. 185.

13 The following examples give some sense of the critical spaces occupied by those critics for whom the RA was central to this process: 'The [Royal] Academy is a manufactory where forty persons have obtained the privilege of preparing a certain quantity of coloured canvas and hewn stone, for market' (*The Athenaeum*, no. 291, 25 May 1833, p. 329); 'The Year 1847 will be remembered for a long period, as a remarkable epoch of the commencement of a continuous series of struggles between the artist and the capitalist or broker, who has, for so long a period assumed to be the medium through which the public reward should be indirectly conferred upon those who are, as they ought to be, the direct recipients of public approbation' (*The Fine Art Journal*, no. 25, 24 April 1847, p. 377); 'We consider that the circumstances which regulate the production of the Fine Arts are precisely similar to those of any branch of manufactures – that unless the supply tendered fulfill the demand, it will be profitless to the producer. We feel assured, too, that like all manufactured productions, a constant, extensive, and discriminating demand will urge the producer to advance steadily towards excellence, and will find him, if not slightly in advance of public taste, generally keeping pace with it ...'. (*The Builder*, vol. 6, no. 294, 23 September 1848, pp. 459–60.)

14 *Art Union*, no. 7, January 1845, p. 5.

15 *Douglas Jerrold's Weekly Newspaper*, no. 38, 3 April 1847, p. 413.

16 For the standard account of the institutional

© Association of Art Historians 1997

history of the RA, see Hutchison, op. cit. (note 4). A reading of the nature of cultural institutions in nineteenth-century Britain is provided by C. Trodd, 'Formations of Cultural Identity: Art Criticism, the National Gallery and the Royal Academy, 1820–1863', DPhil, University of Sussex, 1992.

17 The relationship between the RA and aristocratic culture is traced in G.J. Fyfe's 'Art Exhibitions and Power during the Nineteenth Century', in J. Law (ed.), *Power, Action and Belief*, London, 1986, pp. 20–45.

18 *The Somerset House Gazette and Literary Museum*, vol. 1, no. 17, 31 January 1824, p. 257. In the mid-Victorian period the *Gentleman's Magazine* defended the 'aristocratic' traditions of the RA and claimed that its critics, particularly the *Athenaeum*, were 'ultra radical'. See *The Gentleman's Magazine*, new series, vol. 7, July–Dec 1859, p. 3.

19 Hutchison, op. cit. (note 4), pp. 98–9.

20 ibid., p. 99.

21 ibid., p. 99.

22 ibid., p. 115.

23 ibid., p. 122.

24 Quoted in Ford Madox Hueffer, *Ford Madox Brown: A Record of His Life and Work*, London, 1896, p. 368.

25 William Michael Rossetti, *Fraser's Magazine*, June 1865, p. 738; P.G. Hamerton, *Thoughts About Art*, London, 1873, p. 147.

26 P.G. Hamerton, ibid., p. 149.

27 Fyfe, op. cit. (note 17), pp. 20–5.

28 *The Art Journal*, 1 August 1854, p. 312.

29 See Fyfe, op. cit. (note 17), pp. 20–5; and his 'The Chantrey Episode: Art, Classification, Museums and the State', in S. Pearce (ed.), *Art in Museums*, London, 1995 pp. 5–41.

30 *Fraser's Magazine*, June 1844, p. 701. In its shifting cultural and political identity, this journal is a microcosm of the history of the literary and artistic press during the Victorian period. Established in 1830, and with contributions from Carlyle, Hogg and Thackery, its tone was deliberately acerbic and iconoclastic. However, by the late 1840s this combative style had been replaced by a tone at once sober and serious. See note 9 above for an example of this later approach to cultural journalism.

31 For details concerning these developments see Hutchison, op. cit. (note 4), pp. 97–132.

32 G.D. Leslie, *The Inner Life of The Royal Academy*, London, 1914, pp. 129–37.

33 In 1851 *The Builder* claimed that by extending the period of the annual Exhibition, the RA had tried to assert an unfair advantage over the Art Union of London, a 'rival' in the business of art. *The Builder*, vol. 9, no. 446, August 23 1851, p. 529.

34 Laidlay, op. cit. (note 2), p. 131.

35 W. Sandby, *The History of the Royal Academy of Arts*, London, 1862, p. 384.

36 *The Art Journal*, 16 June 1854, p. 158.

37 For an account of the relationship between political economy, cultural institutions and art, see E. Edwards, *The Fine Arts in England*, London, 1840, pp. 20–43.

38 ibid, p. 33.

39 *Report from Select Committee on Arts and Manufactures*, 1836, p. viii; *Art Union*, no. 6, September 1844, p. 285; *Report of the Commissioners Appointed to Inquire into the Present Position of the Royal Academy in Relation to the Fine Arts*, 1863, para. 2811.

40 *The Principal Speeches and Addresses of his Royal Highness The Prince Consort*, London, 1862, pp. 110–112.

41 Of course, such ideas found expression in popular literature, where the division of labour could be associated with the opening up of culture to the 'general public'. In 1847 *Douglas Jerrold's Shilling Magazine* dealt with the division of labour in the following manner: 'Division of labour ... is undoubtedly a great means of carrying forward the human race ... [It] is as completely a natural phenomenon as the diversity of sex ... Rival governments and statesmen only interrupt the peace and friendship that terrestrial division of labour is continually promoting ... It establishes a relation of mutual service ... between all the industrial classes ... Division of labour establishes friendly and just relations, for jealousy, envy, and fear, and contributes to check crime and promote virtue.' *Douglas Jerrold's Shilling Magazine*, no. 6, 31 July, 1847, pp. 73–4.

42 Prince Albert, op. cit. (note 40) pp. 128–9.

43 G. Semper, 'Science, Industry and Art' (1852), in E.G. Holt (ed.), *The Art of All Nations*, New Jersey, 1982, p. 67.

44 *Report from Select Committee*, 1836, op. cit., paras 1972–3.

45 J. Barrell, *The Political Theory of Painting From Reynolds to Hazlitt*, New Haven and London, 1986, pp. 1–68.

46 A. Hemingway, *Landscape Imagery and Urban Culture in Early Nineteenth-Century Britain*, London, 1992, pp. 1–7 and pp. 111–39; and his 'Genius, Gender and Progress: Benthamism and the Arts in the 1820s', *Art History*, vol. 16, no. 4, December 1992, pp. 619–46.

47 See the following sources in *The Examiner*: no. 687, 13 May 1821, pp. 300–301; no. 709, 6 August 1821, pp. 483–4; no. 728, 6 January 1822, p. 10; no. 736, 3 March 1822, p. 138.

48 *The Mirror of Literature and Amusement*, vol. 2, no. 315, 31 May 1838, pp. 382–3.

49 *The Spectator*, vol. 10, no. 462, 6 May 1837, p. 427.

50 ibid, p. 427.

51 ibid, n. 463, 13 May 1837, pp. 451–2.

52 *The Westminster Review*, no. 55, July 1851, pp. 394–429. Long associated with middle-class liberal politics, the journal was influenced by the

work of Bentham. For an account of the cultural importance of *The Westminster Review*, see W.E.S. Thomas, *The Philosophic Radicals*, Oxford, 1979, pp. 158–68. The 1863 Royal Commission was conducted and organized by the following commissioners: Earl Stanhope, Viscount Hardinge, Lord Elcho, Sir Edward Walker Head, William Stirling, Henry Danby Seymour and Henry Reeve.

53 Edwards, op. cit. (note 37), pp. 20–42.
54 *The Westminster Review*, op. cit. (note 52), pp. 396–8.
55 ibid, p. 399.
56 ibid.
57 *The Art Journal*, 23 May 1861, p. 147.
58 P.G. Hamerton, op. cit. (note 25), p. 109.
59 *The Westminster Review*, op. cit. (note 52), pp. 405–406.
60 ibid, p. 415.
61 ibid, p. 416.
62 ibid, p. 417.
63 ibid, p. 421.
64 ibid, p. 421.
65 ibid, p. 421.
66 *Report of the Commissioners*, 1863, op. cit. (note 39), p. iii.
67 ibid., paras 3025 and 4384.
68 See N. Pearson, *The State and the Visual Arts*, Milton Keynes, 1982; P. Corrigan and D. Sayer, *The Great Arch: English State Formation as Cultural Revolution*, Oxford, 1985.
69 See G. Sutherland (ed.), *Studies in the Growth of Nineteenth-Century Government*, London 1972; V. Cromwell (ed.), *Revolution or Evolution? British Government in the Nineteenth Century*, London, 1977; R. Johnson, 'Educating the Educators: Experts and the State, 1833–1839', in A.P. Donajgrodski (ed.), *Social Control in Nineteenth-Century Britain*, London, 1977.
70 As used by Foucault, this term is allied to the study of practices rather than the analysis of institutions. He writes: 'the finality of government resides in the things it manages and in the pursuit of the perfection and intensification of the processes which it directs ...' G. Burchell, C. Gordon and P. Miller (eds), *The Foucault Effect*, London, 1991, p. 95.
71 N. Poulantzas, *State, Power, Socialism*, London, 1980, p. 136.
72 Approximately half the report was devoted to these matters.
73 Laidlay, op. cit. (note 2), pp. 73–80; Leslie, op. cit. (note 32), pp. 65–7 and pp. 129–38. As early as 1836 the *Spectator* claimed that the RA offered little to students because it produced 'no real instruction', 'examination or report of progress'. *The Spectator*, vol. 9, no. 440, 3 December 1836, p. 1166.
74 *Report of the Commissioners*, op. cit. (note 39), para. 4097.
75 ibid, para. 640.
76 ibid, paras 180–901.
77 ibid, para. 1151.
78 ibid, paras 2480–1.
79 Asked his opinion about the 'pre-Raffaellites', he stated that such art has 'sent men in the wrong direction. Instead of aiming at large and broad effects, it has descended to a needlework style of art, which is anything but art; it is labour without art.' ibid, para. 2493.
80 Leslie, op. cit. (note 32), pp. 129–37.
81 *The Art Journal*, 23 June 1861, p. 162.
82 *Report of the Commissioners*, op. cit. (note 39), paras 2818–2960 and paras 3310–79.
83 ibid, para. 1423.
84 ibid, para. 1426.
85 ibid, para. 1802.
86 ibid, paras 1424–9; paras 1791–1807; paras 5092–5. W. Holman Hunt, 'The Present System of Obtaining Materials in Use by Artist Painters', in *Journal of the Society of Arts*, 23 April 1880, pp. 487–93.
87 ibid, pp. 488–92.

© Association of Art Historians 1997

Art History ISSN 0141-6790 Vol. 20 No. 1 March 1997 pp. 23–60

The Body and Difference: Anatomy training at the Ecole des Beaux-Arts in Paris in the later nineteenth century[1]

Anthea Callen

> The anatomy course, the programme of which is repeated every year, embraces the study of man and of the rudiments of comparative anatomy. The professor [Duval] is intending to go further and to confront for the purpose of debate the study of the human races ... [1875][2]

Positioned at the intersection between art and medicine, anatomy provides a vital field for the study of the human body as culturally constituted. From the Italian Renaissance on, artists and physicians alike commonly studied human anatomy, including dissection and, as the art academies' programmes crystallized, it became an integral component of training in both fields. The European aesthetic emphasis on the human form as the highest, noblest subject for the representation of man's moral and spiritual values ensured that the intimate scrutiny of his physical appearance became paramount. Drawing from the Antique and from the live male figure were central disciplines within academic art training from its inception, and practice at the Académie Royale de Peinture[3] was no exception. Likewise, anatomy was considered imperative. In Paris the same doctors professed at the medical school as at the Ecole des Beaux-Arts; many, too, were artists of sorts in their own right, some providing their own illustrations for the anatomy treatises they published.

This overlap of expertise meant that the ways the body was figured were significantly linked across the two disciplines: art and its pictorial traditions served to help medicine visualize its normal and its pathological bodies, while the knowledges of human anatomy and physiology pursued by the medical profession were embodied in artists' representations of the figure – representations which were disseminated via the popular medical and artistic presses as well as through art exhibitions. Artistic exceptions to this rule throw into high relief the normative nature of dominant views of the human body.[4] These two emergent professions, art and medicine, thus worked hand in hand in the process of formulation and transformation of ideas about the body, through that most direct and potent medium of communication: the visual image.

From 1839 a prize in the Special *Concours* in Perspective at the Ecole des Beaux-Arts[5] was made compulsory for all Prix de Rome candidates.[6] In Anatomy that was not the case. Paradoxically, then, in a training system the main emphasis

© Association of Art Historians 1997. Published by Blackwell Publishers, 108 Cowley Road, Oxford OX4 1JF, UK and 350 Main Street, Malden, MA 02148, USA.

of which lay in drawing the human figure, it seems the science of anatomy was not deemed of an importance equivalent to the science of perspective. Perspective offered an essentially mathematical system designed to enable painting students to articulate space on a flat surface and, in particular, to depict the human form in space. However, it appears that perspective was, for Ecole students, a focus for rebellion and artistic dissent; their dislike of the subject (commonly attributed to its mathematical content), and particularly the difficulty in persuading them to attend classes and submit to the *Concours*, provoked regular comment in Ecole reports throughout the century.[7] But what of anatomy? In spite of the scientific knowledge the Ecole Academicians considered that this subject demanded of their students, it appears – with one notable exception – to have been popular among students in the nineteenth century, and perhaps for this reason did not require the degree of official coercion implied by a compulsory contest. What, then, is the history of anatomy's institutional relations to art, as evidenced in the formation of the painter at the Ecole des Beaux-Arts? What is the function of anatomical science in the construction of pictorial meaning?

This paper has two aims. Firstly, to augment the published information currently available on the teaching and learning of anatomy at the Ecole des Beaux-Arts in Paris,[8] principally in the later nineteenth century, and secondly, to analyse some of artistic anatomy's roles and meanings in pictorial representations of the human body. For this, I shall take as foci for analysis an oil painting by François Sallé (1839–99), *The Anatomy Class at the Ecole des Beaux-Arts* of 1888 (223 × 302 cm), awarded a third-class medal at the Salon of 1888, where it was entitled *Un cours d'anatomie*,[9] and the photographs of human morphology by Paul Richer (1849–1933, plate 1), anatomy professor at the Ecole from 1903 to 1933.[10]

The Professors

Anatomy training was introduced early into the curriculum of the Ecole des Beaux-Arts. In Mathias-Marie Duval's history of anatomy in the plastic arts, produced in collaboration with Edouard-Pierre-Jacques Cuyer, he lists the professors of anatomy from 1648.[11] The second half of the eighteenth century and the first half of the nineteenth were dominated by two anatomists from a single family. Jean-Joseph Sue (1710–92 [plate 2], Sue *père*, or 'de la Charité', as he was known after the Parisian hospital to which he was attached), was assistant to Professor Sarrau at the Ecole des Beaux-Arts from 1746 to 1772 (Sarrau was in post from 1728), and then professor of anatomy until his death in 1792; his son, also Jean-Joseph (Sue *fils*, 1760–1830),[12] assistant to his father at the Ecole des Beaux-Arts from 8 March 1789, took over from him as professor on 6 October 1792; Sue *fils* died on 21 April 1830. In addition to dominating the teaching of anatomy to art students, the Sues' publications on the subject were influential within both the art and medical worlds, and beyond. It was under the name and protection of Sue *père* (as surgeon to the King, professor of anatomy at the royal college of surgery and royal censor for books on surgery as well), that the work of Alexander Monro, translated by the aristocrat Marie Thiroux

© Association of Art Historians 1997

d'Arconville – a rare woman anatomist – was published in 1759. Scottish anatomist Monro's *The Anatomy of the Humane Bones* (Edinburgh, 1726) was published in two volumes in France as *Traité d'ostéologie*, with additional comments by d'Arconville, and engravings after drawings apparently directed by her from nature; on the title page the draftsman is named as J. Tharsis, and the engraver as M. Aubert.[13] D'Arconville-Sue's volume was notably influential in that it offered for the first time a detailed study of a female skeleton, with annotations taken from Monro on the 'différences entre le squelette de l'homme et celui de la femme'.[14]

Although the text in the d'Arconville-Sue translation of Monro was aimed principally at students and professionals of medicine, the inclusion of a female skeleton also provided art students and artists, for the first time, with explicit visual evidence that science had come to consider the male and female body as fundamentally different, right down to the bones. Particularly given the authority of publication in the name of the chair of anatomy at the Ecole des Beaux-Arts himself, the engravings in *Traité d'ostéologie* were, for his students, visual prototypes of the 'ideal' female and male skeletal structure.[15] Whereas the male skeleton, represented from three different angles, followed earlier precedents like that of Albinus (1747) in depicting a universal male skeletal type, d'Arconville's female skeleton – with its narrow ribcage, small skull and refined extremities – embodied a quasi-Houdonesque, rococo conception of the ideal female form (compare plates 3 and 4): apart, that is, from the inelegantly broad pelvis.[16] The longstanding medical view that anatomy could only be taught from a synthesized universal body, a normative 'type', and not from any individual body with all its particular idiosyncracies,[17] reveals an unspoken agenda behind d'Arconville's female skeleton: by choosing a refined, apparently aristocratic anatomy for her skeleton, she loaded the female bodily ideal with culturally specific notions of the feminine, while at the same time, by emphasizing the subject's very individuality, designating the female anatomy as inherently pathological. Paradoxically, the bodies available for dissection were, in fact, from the lowest working and criminal classes, generally the condemned, and the female bodies thus used were most commonly those of prostitutes. Since only nude male models were permitted at the Ecole, whether in life drawing or anatomy classes, and these were inevitably working-class bodies, the students' anatomical knowledge of bodily gender difference was premised on cultural distinctions of class. The bases within art training at the Ecole for the construction of an ideal masculine and a beautiful feminine anatomy were thus both highly gendered and class-specific.

This view was reinforced and further popularized in a later volume: *Elemens d'anatomie à l'usage des peintres, des sculpteurs et des amateurs*, published in 1788 by Sue *fils*. In a much more discursive and less medically specialist text, the male–female skeletal differences were again spelled out;[18] Sue *fils* also re-used the four plates, including that of the female skeleton, from the earlier d'Arconville-Sue *père* treatise.[19] After the fashion of the time, Sue *fils* also published a treatise on physiognomy, which – like the biologically determinist visions of the Italian anthropologist Lombroso almost a century later – imposed anthropomorphic tendencies even on the vegetable kingdom. Sue's *Essai sur la physiognomie des corps vivants* (Paris, 1797) found human emotions expressed in the physiognomies

© Association of Art Historians 1997

25

1 Paul Richer in his studio, (n.d. 1920s?) Photo: courtesy of the Départment de morphologie, Ecole nationale supérieure des Beaux-Arts, Paris.

of plants and trees.[20] Anatomists and physiognomists were retrospectively identified as the forefathers of anthropology[21] and, as we shall see, the anatomy professors at the Ecole towards the end of the nineteenth century were themselves also deeply involved in the early formation of anthropology as a professional discipline in France.

 Although Sue *père* had introduced teaching from the live model as well as from the dissected cadaver at the Ecole des Beaux-Arts,[22] the emphasis in artistic anatomy remained the 'deep' structure, which is visible by way of dissection and not immediately to the naked eye, except where the bones rise close to the epidermis. The norm in anatomy teaching at the Ecole until the later nineteenth century was to work outwards from the inner structure, the bones, rather than beginning with what is superficially visible in the living body and informing that with a knowledge of the inner machinery supplied by dissection, by the inanimate body with all its limitations. Given that before the painter Edouard Cuyer joined the anatomy staff at the Ecole in 1881, the professors were all medical anatomists first and foremost, this is not surprising; however, it does indicate the degree to which art students' approach to the body was determined by the medical preoccupation with the cadaver.[23]

© Association of Art Historians 1997

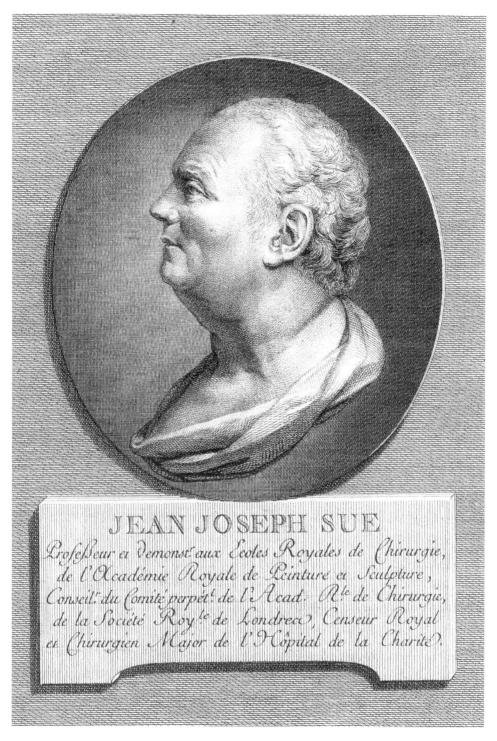

JEAN JOSEPH SUE

Profeſſeur et demonst.ᵗ aux Ecoles Royales de Chirurgie,
de l'Académie Royale de Peinture et Sculpture,
Conseil.ᵗ du Comité perpét.ᵗ de l'Acad. R.ᵗᵉ de Chirurgie,
de la Société Roy.ᵗᵉ de Londres, Censeur Royal
et Chirurgien Major de l'Hôpital de la Charité.

2 Jean-Joseph Sue (*père*), line engraving by N. Pruneau, 1775, after A. Pujos. Photo: courtesy
the Wellcome Institute Library, London. Classicising, medallion-style profile portrait of the
anatomist.

© Association of Art Historians 1997

3 J. Tharsis, draughtsman, M. Aubert, engraver: *A female skeleton*, in Alexander Monro, *Primus (1697–1767), Traité d'ostéologie*. vol. II, translated J.-J. Sue/Marie Thiroux d'Arconville, Paris, G. Cavalier, 1759, Plate IV. There are two plate IVs in this volume: the first is an outline engraving of the same skeleton, numbered to refer to a list of the relevant bones; this, the second Plate IV is a tonal variant with a landscape setting, and no numbers. Photo: courtesy the Wellcome Institute Library, London.

© Association of Art Historians 1997

4 Jean-Antoine Houdon (1741–1828), *Diana*, 'the eighteenth-century ideal of feminine beauty', from Dr E. Galtier-Boissière, *La Femme: conformation, fonctions, maladies & hygiène spéciales*, Paris, n.d. [1905]. Photo: A Callen. Houdon's vision shows a far more athletic, slimmer-hipped female body than does d'Arconville's skeleton.

© Association of Art Historians 1997

The work of the young anatomist Pierre-Nicolas Gerdy (1797–1856) was vitally influential, both among art students in the 1820s, and again notably towards the end of the century, when his approach was revived by both Duval and Richer. From the age of twenty-four Gerdy taught anatomy in the Académie de médecine in Paris, where he 'won the sympathy of the young' creating for the first time an 'anatomy of forms', an *anatomie des beaux-arts*'; his classes were open to art students. Gerdy's approach was admired for its novelty and its sensitivity to the visible, outer structure of the human body; for him, 'the artist sees much better, and more quickly.' Dissection took a back seat in his teaching of anatomy, only 'coming to the help of the eyes, making the skin transparent and displaying to the artist's understanding the forms on the surface of the body through the reminder of the hidden parts'.[24]

In contrast to the dominant preoccupation with the inanimate body, then, Gerdy – a close contemporary of Géricault – stressed the importance of the live figure; he described its exterior forms in rich detail and repeatedly advised students to study anatomy from Antique sculpture and the paintings of the great masters in the Louvre rather than simply from dissected corpses. His ideas were published in 1829 in his *Anatomie des formes extérieures du corps humain appliquée à la peinture, à la sculpture et à la chirurgie*. Gerdy failed to succeed Sue *fils* in the chair of anatomy at the Ecole des Beaux-Arts in 1830, perhaps because of his popularity and youth,[25] but certainly because his questioning of dissection alone as an adequate teaching tool for anatomy, whether medical or artistic, must have been threatening to established medical anatomists. This failure meant that his immediate impact was curtailed. Discouraged, he abandoned his research in anatomy and ceased publishing in this field.

Sue *fils* was in fact replaced by Edouard-Félix-Etienne Emery (1788–1856), who held the post from 1830 until his death. He was unpopular with the students, who wanted Gerdy, and their refusal to accept Emery ended in rioting, which coincided with the revolutionary upheavals of 1830; student dissent over the appointment prevented Emery from conducting anatomy classes, which therefore commenced only in 1832. Probably as a direct result of this incident, revised regulations for the Ecole in 1831 included a proposal to make the chair of anatomy, along with those of history and literature, open to competition; a committee would be selected from among Ecole professors or *agrégés* in painting and sculpture, professors or *agrégés* from the Ecole de Médecine, plus literary figures and scholars from the Académie de France; the appointment committee would be required to record its proceedings.[26] Emery's appointment marked the beginning of a period of stasis in anatomical studies, for neither he nor his successor from 1856 to 1862, César-Alphonse Robert (1801–62),[27] offered new vision or publications in the field of artistic anatomy. Both concentrated heavily on dissection to the degree that, at least under Emery, local residents complained of cadavers dragged unceremonially in front of people's houses, and of the detritus of human remains thrown over the garden wall following his classes instead of being properly interred.[28] Towards the close of Emery's term as professor, the need to rekindle students' enthusiasm for the subject was recognized by the *conseil d'administration* of the Ecole which, during the academic year 1853–4, introduced a *Concours spéciale* in anatomy, which was first awarded in

© Association of Art Historians 1997

1855.[29] After only six years Robert was succeeded in the chair of anatomy by Pierre-Charles Huguier (1804–72). Huguier was a far more actively influential figure; under him new accommodation at the Ecole was constructed for anatomy teaching, and at his instigation a special anatomy prize was inaugurated. He was in post until his death in January 1872.[30]

The emphasis on medical aspects of artistic anatomy, namely dissection, was reduced during Duval's time as professor of anatomy at the Ecole des Beaux-Arts, from 1873 to 1903. Mathias-Marie Duval (1844–1907, plate 5) was renowned for providing the students solely with what was required for their work as artists, and no more; he excelled at the Ecole as a popularizer of what was a complex medical specialism.[31] While, from the 1830s on, the appearance of cadavers and students undertaking dissections were a commonplace in the department, Duval, like Gerdy before him and Richer after him, valued the evidence supplied by the live figure over that of the dead. Both Duval and Richer cited the absence of dissection in Antique Greece in support of their approach. Nevertheless, a permanent demonstratorship in anatomy was created soon after Duval took up his post. Henry-Paul Boyer (1852–94?), who had been demonstrating anatomy at the Ecole since 1871, was formally appointed to this post in August 1876, and the appointment was confirmed the following January; he became *professeur supplémentaire* to Duval in 1881.[32] Duval's ex-student and collaborator, the painter Edouard Cuyer, who joined the Ecole staff in 1881 to replace Boyer as anatomy demonstrator, was himself promoted to *professeur supplémentaire* in 1894.[33] In 1877 Cuyer had won the *Prix supérieur d'anatomie, Huguier*, newly founded in 1874.[34] He did not attain the professorship on Duval's death, when he left to teach anatomy in the provinces. His abrupt departure was apparently the result of a further change of direction with the succession to the chair of anatomy in 1903 of Paul Richer, who was in sympathy with the morphological approach of Gerdy. It has been suggested that, in 1908, Richer broke with tradition by not renewing the post of demonstrator; however, the register of personnel indicates the presence of an anatomy demonstrator on a rolling annual contract at least until 1914.[35] Richer may not have completely abandoned instruction by way of dissection, but did concentrate on what he called the 'Science of the Nude'.[36]

The Curriculum and the *concours*

During the nineteenth century admission to the Ecole was open to all unmarried male students aged between fifteen and thirty years (the upper age limit was waived for foreign students), on provision of a birth certificate, a certificate establishing their level of university education, and a letter of recommendation from 'a recognized professor attesting to [their] good conduct and [their] aptitude for passing the admissions test'.[37] Enrolment was a formality which entitled aspirants to attend drawing classes and to compete in the *Concours d'admission* or *Concours des places*. Students were only registered at the Ecole once their names appeared on the judgement lists for these competitions, which were held twice a year, normally in May and September; these *concours* served to allocate priority of place in the drawing classes, and permitted students to compete in the

5 Mathias-Marie Duval in his laboratory at the Ecole de Médecine, Paris, (n.d., 1900?). Photo: courtesy of the Départment de morphologie, Ecole nationale supérieure des Beaux-Arts, Paris.

© Association of Art Historians 1997

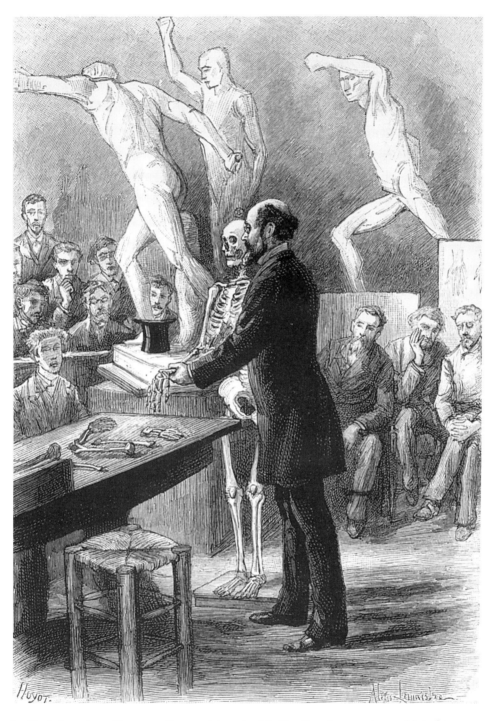

6 Alexis Lemaistre, 'Le cours d'anatomie', under Mathias Duval, engraving, published in
Lemaistre, *L'Ecole des Beaux Arts...*, Paris, 1889. Photo: courtesy of Paris, Ecole nationale
supérieure des Beaux-Arts.

© Association of Art Historians 1997

internal *Concours d'emulation*. By the 1870s the *Concours d'admission* for painters included a two-hour anatomical drawing test, on human (actually male) osteology, which had to be executed under rigorous examination conditions *en loge*.[38]

It was under Sue *père* that anatomy teaching at the Ecole became more regular and formalized, but there was no formal *concours* in the subject.[39] Sue evidently attempted to institute a competition, but this was never made part of the official programme. He records placing a skeleton in the pose of the *Gladiator* for his students to copy, and the Academicians were invited to judge these drawings and award a prize for the best. He chose the *Gladiator* in preference to the Vatican *Apollo* solely on the grounds of the greater anatomical challenge it presented:

> I have favoured this figure because the stretching and opposing movements also present foreshortenings, and that point of knowledge which cannot be subjected to the rules of perspective, is not the easiest to execute. Besides, the action of this figure is so beautiful and so developed ...[40]

Drawing from skeletons posed after famous, especially Antique, sculptures and from casts of artistic flayed figures were common components of anatomical study at the Ecole in the nineteenth century, inculcating the knowledge of a classically inspired ideal of human morphology. Common, too, was the practice of 'transposition' during the process of drawing, of classical sculptures into flayed musclemen as a further means of penetrating the structural mysteries behind these ideal forms.[41] A cast of the *Gladiator* can be seen in Lemaistre's print of Duval's anatomy class (plate 6); it was one of several anatomical exemplars kept permanently in the Ecole anatomy theatre during the nineteenth century.

A review of the workings of the pre-Revolutionary Académie suggests an official *Concours* in anatomy had still not been instituted by the time of the Revolution of 1789. There was, however, a designated room for the anatomy courses, in the Cour du Louvre.[42] This same source confirms that, under the Sues, anatomy was taught 'as much from the cadaver as from the live model'.[43] In 1779 Sue *fils* introduced an exercise for anatomy students which continued during the nineteenth century:

> ... Sue, Professor of Anatomy, has proposed that the students ... be invited to come to draw for two hours before the lesson the parts which were subject to demonstration the previous day. The Professors, having long recognized the indispensable need to extend the study of artistic anatomy [*anatomie pittoresque*] beyond its present limits, are so much in agreement with this provisional demand, that they propose that they themselves present in due course to the Minister the means to attain this desirable end.[44]

The practice was again affirmed towards mid-century, when it was reported that the 'students are authorized to draw from the portions dissected, in the Salle of the anatomy course, for two hours before the lesson.'[45] Extant drawings, like the

34

© Association of Art Historians 1997

remarkable coloured chalk drawings by Louise Roudenay, show that work from fragments of the dissected corpse were still common in the late 1890s.[46]

It appears that *Concours spéciaux* linked to the *Cours spécial* in anatomy were introduced only in the post-Revolutionary period. The report by the Commission set up to re-organize the Ecole recommended an annual competition for all the special courses, including anatomy. A 'first class' of professors was attached to the teaching of drawing for the three categories: the life model, the Antique and architectural drawing. Professors in charge of the *Cours spéciaux* were 'second class', each teaching a single course per year, the duration of which depended upon the demands of the particular subject. These were identified as: Stereometry; Geometry and perspective applicable to the arts; history of antiquities; anatomy.[47] Revisions to the Ecole regulations in 1839 indicate that, independent of the main *Concours d'émulation*, each semester there were six *Concours spéciaux* in: perspective; anatomy; composition; historic landscape; painted *esquisse*; history: painted *esquisse*; and history: modelled *esquisse* (for sculptors).[48] In 1853 a new Special Medal in anatomy was instituted, the *Concours* for which was scheduled immediately upon the close of the anatomy course; it was first awarded in 1855, when the *Concours spéciaux* were listed as expressive head; torso; tree; anatomy.[49] The Ecole *procès-verbaux* for the period outlines the competition regulations:

> ... students wishing to take part will be [required] ... to make, within a given time, and after the life model, a line drawing [*dessin au trait*]. Once this drawing is completed, the students, isolated from each other, must first and in red ink ascertain on this same drawing the osteology, that human frame. That done, they are required to represent in crayon, either in the whole figure or in certain parts only which will be designated in advance by *Mr Le Professeur Spécial*, all the muscles, tendons and other anatomical parts which might appear under the skin.[50]

One, or indeed two, drawings of the whole figure was not a consistent requirement in the anatomy *Concours spécial*; the earliest examples are of whole figures, but these soon gave way to partial anatomies. By Duval's time the exercise involved a single anatomical study of a set part of the body, drawn life-size; in the *concours* records, numerous examples of the tests set and signed by Duval are conserved. Based on an initial line drawing from the live model, these required the student, for example,

> To represent the *skeleton of the right leg*, viewed directly from its *outer face* (fibula and tibia), from the upper part of the knee (condyles of femur), to the heel (the rest of the foot indicated only as contours)
> [or]
> To represent the *left humerus*, viewed directly from its frontal face (make life size).[51]

The judgement itself was to follow the pattern already established for the *Concours* in perspective, which required a meeting of the professors in the painting and sculpture sections to be called 'on a given day':

> In this meeting, *Mr Le Professeur d'Anatomie*, who will previously have placed the students' anatomical drawings into the order of relative merit which he has identified, after having made known to MM. his colleagues the principles decreed by him and in respect of which the *Concours* has taken place, will bring out the special merit of the various drawings and the assembly will proceed to judgement in the customary manner.[52]

Further details of the competition were resolved in February 1855. The annual medal competition in Anatomy was to be held in March (the anatomy course itself ran from November to March). The *Concours* was to take place over two days. The first began at 8 am, when the model was posed by the professor on duty, aided by the professor of anatomy, five hours were allowed, from 8 am till 2 pm, including rests (for the model), for the completion of a whole figure. Afterwards, the drawings had to be handed in to the invigilator for deposition with the Secretariat. The following day from 8 am until evening the students gathered in the *Salle des Concours* and, on the drawings made the previous day, they had to indicate the osteology of the whole figure in black crayon, and the myology in red crayon in those parts designated by the professor of anatomy. Neither medals in anatomy, nor in any of the *Concours spéciaux*, were automatically awarded; when standards were not deemed sufficiently high, no prize-winners were identified – hence the gaps which appear in the annual register of prizes.[53] A report in 1874 shows that by then there were two levels of *concours*: the first, held in October, aimed 'to admit students to the semester competitions', the second took place 'after the course and is its complement'.[54]

At the close of Huguier's term as Professor of Anatomy, a new prize was inaugurated for the anatomy students: the *Prix supérieure d'anatomie Huguier*:

> M. Le Docteur Huguier, late Professor of Anatomy at the Ecole, having expressed a wish to found a prize, his widow, Mme Huguier, has taken it upon herself to respond to the generous intentions of her husband. The value of the prize founded is a sum of 600F, to be given to the student at the Ecole who has furnished proof of the best propensities for the study of anatomy.[55]

The competition, which opened on 26 June 1874 under Duval's direction, produced 'remarkable results, as much in the drawings exhibited by the students as in the manner with which they responded, before the Jury, to the oral examination'. In addition to the winner (M. Desporte, student of MM. Pils and Robert Fleury), five '*mentions*' were awarded that first year.

Noting the growing emphasis placed at the Ecole since the 1863 reforms both on technical instruction, and on the oral teaching which by this date comprised anatomy, perspective, history and archeology, the Director's Report for 1874–5 provided further information on the popularity of the anatomy programme:

> Today I am able to state that anatomy is in high repute among our students. The prize founded by Mme *veuve* Huguier ... has aroused a remarkable rivalry ... the oral examination which closed this *concours*

© Association of Art Historians 1997

made us recognize in [the winning] candidates a knowledge the extent of which we were far from surmising.[56]

It is clear both from the nature of this *concours*, with its close oral questioning on human anatomy, and from surviving contest drawings and, in particular, examples of course-work which were highly complex, and often richly annotated with anatomical nomenclature, that the Huguier prize demanded a commitment to and an expertise in the subject well beyond that of the normal *Concours spécial*.[57] An equivalent incentive to the *Prix Huguier* would, it was felt, be necessary before perspective would achieve a comparable popularity with the students.

The official agreement, hotly contested, to the registration of women as students on the 'oral courses' at the Ecole at the end of the century, prompted the Director to speculate that they would dominate the *Concours spéciaux* in both: 'I should not be surprised if, in the *Concours spéciaux* open to all ... [the women] carry off the first prizes for anatomy and perspective.'[58] His comment is interesting in view of contemporary conceptions of appropriately feminine skills or knowledge – especially given the gory nature of anatomical dissection (in which the women were involved as much as the men[59]), and given the Ecole's concern over the inadequate formation even of its male students faced with the scientific and the mathematical content of these courses respectively. Lucienne Antoinette Heuvelmans, a pupil of Mme Thoret, did indeed win a medal in the anatomy *Concours* in 1901, and went on to become the first female *Prix de Rome* winner, for sculpture, in 1911.[60] All the oral courses had been opened to students of both sexes in 1895–6, apart from anatomy, in which a special course for women was created that year; whether in deference to the sensibilities of the male or the female students, or of Duval or the life model, clearly propriety did not permit a subject involving such intimate scrutiny of the male body to be tackled before a mixed class.

Alexis Lemaistre, in his illustrated book on the Ecole, gave an ex-student's overview of the life and work of the school, including the anatomy department. He attested to the popularity enjoyed by anatomy in general, and Mathias Duval in particular. The most assiduously attended of all classes, it was, under Duval, held on Mondays and Fridays from 1 to 2 pm; throughout the century lunchtime sessions were always used, to maximize the winter daylight. Lemaistre described the students arriving at the anatomy theatre half an hour early to ensure the best seats: it was always packed. The amphitheatre was lit by excellent daylight from a 'vast bay window' positioned above and behind the stepped rows of seats; 'below, the space reserved for the professor is occupied by a heavy table' and a turntable – beneath the *Gladiator* cast in the Lemaistre print (see plate 6) – 'to carry various anatomical specimens or a partially dissected cadaver'.[61] To minimize the problems of rapid putrefaction and stench, the anatomy course was scheduled exclusively for the winter months; anatomies were traditionally performed in deepest winter and often, in Italy at least, during Mardi-Gras. Lemaistre continued:

> On either side of the table, two large plaster casts, one the reproduction of the Gladiator, the Antique statue the most admired for its anatomical

exactitude, and the other, the flayed figure represented from this same statue. In a corner, a skeleton, along the walls, large plaster flayed figures in different positions ... the group of Castor and Pollux and a Medici Venus. In the background, and on easels, blackboards are anatomical drawings. Finally, in the right-hand corner ... a large red *écorché*, a fixed bar and some dumb-bells, which serve for the lesson on the live model.

In Lemaistre's print of Duval's class both *Gladiator* casts can be seen and, in between, a cast of Houdon's second *Ecorché* of 1792. The red *écorché* described by Lemaistre was a painted copy of his first life-size flayed figure, executed in Rome in 1766–7, casts of which found their way into art academies throughout Europe. The original cast, still in the Ecole des Beaux-Arts (Département de morphologie), was presented to the School by the sculptor himself in 1769, but the painted version has not survived.[62] Houdon's 1767 *Ecorché* was customarily painted: the most prominent colour, red, represented the muscles, the veins were picked out in blue, and the tendons in white. Such coloured flayed figures were common in art schools, notably during the eighteenth and nineteenth centuries. Houdon's later *Ecorché* of 1792, the bronze cast of which is now in the Département de morphologie, is described by Debord as having 'the allure of a thorough-bred'; perhaps unwittingly, this reading aptly equates selective breeding with artistic selection of an anatomical ideal – as found in Houdon's own opinion voiced to the Académie in 1800: the 'most perfect [anatomical] truth in nature' was insufficient for the purposes of art, which required 'the purest selection of proportions within the whole [*ensemble*], in the same way as of the forms within all the parts'.[63] This view of Houdon was no longer dominant at the Ecole by the time of Duval when, in the tradition of renowned Scottish anatomist William Hunter,[64] casts for anatomical study were made directly from dissected or partially dissected corpses.[65] In contrast to the ennobling hygienic abstraction of artistic *écorchés*, the corporeal irregularity and authentic flesh texture of these casts (albeit transposed into plaster) imbue them with a poignant reminder of individual human frailty.

Lemaistre described Duval's anatomy course, the syllabus for which is included here as an Appendix (see pages 52–5). First and foremost came the study of the skeleton, the bones, their joints and articulation. Study of the muscles was simultaneously described on the cadaver and on the live figure: 'the cadaver gives the anatomy – the places where the muscles are attached, the relationships between muscles; the live model gives the physiology – the action of the muscles, the movements which provoke their contraction, and the resulting forms.'[66] The cadavers were prepared for demonstration in classes by Duval's assistant, firstly Boyer, later Cuyer. In Lemaistre's print Cuyer can be seen in the anatomy laboratory demonstrating the mechanics of a skull (the remains of a body are draped), observed by three students (plate 7). An atmosphere of informal masculine *camaraderie* is created by showing two men smoking during this procedure: Cuyer has a cigar in his mouth, while another is held by the top-hatted student behind him. Smoking during dissection was common, however, as it helped to mask the appalling smells. A similar sense of rakish iconclasm appears in Lemaistre's print of Duval's anatomy lesson, where a boldly black top hat is

© Association of Art Historians 1997

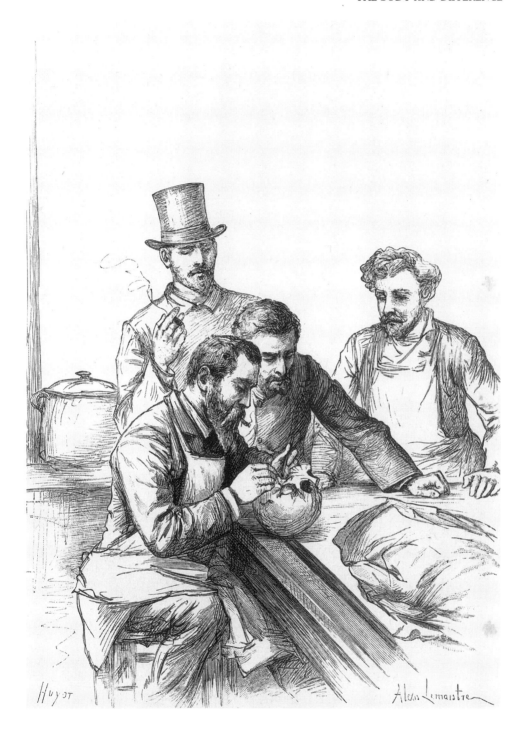

7 Alexis Lemaistre, 'Le prosecuteur', engraving published in Lemaistre, *L'Ecole des Beaux-Arts...*, Paris, 1889. Photo: courtesy Paris, Ecole nationale supérieure des Beaux-Arts.

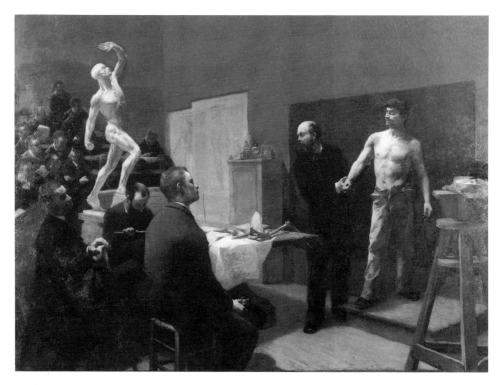

8 François Sallé, *The Anatomy Class at the Ecole des Beaux-Arts*, 1888, oil on canvas, 223 × 302 cm. Sydney, The Art Gallery of New South Wales. Photo: courtesy the Art Gallery of New South Wales.

placed at the feet of the *Gladiator*; Cuyer appears again in this image, seated immediately beyond the standing figure of Duval. Star pupils generally sat with the demonstrator, and the figure with his chin in his hand looks markedly similar to the man on the right in Lemaistre's *Le prosecuteur*; the top-hatted student here may be the same one appearing bare-headed on the far right in plate 6. Lemaistre pointedly emphasized that students were not permitted to wear hats in Duval's class.

Four of the final anatomy lessons in the syllabus, of which there were thirty-eight in total (two per week over the nineteen weeks of the course), focused on physiognomy – the anatomical mechanisms of human expression: 'Inspired by the theories of Darwin and the studies of Duchenne de Boulogne, M. Mathias Duval demonstrates the physiognomic changes effected by the emotions, as much illuminated by ecstasy as convulsed by terror.'[67] Lessons XVIII, XIX and XXXVII dealt with anatomical questions of gender and race; the first two examined skull types. Lesson XXXVII, under Duval's rubric of 'anthropological characteristics', examined: skin colour, hair types, skeletal variations and 'facial angle' – the measuring technique devised in the 1790s by Dutch anatomist Petrus Camper to distinguish advanced European skull structures from atavistic racial or degenerate low-class skull types, the Greek classical profile being the ideal. In his *Anatomie des maîtres*, Duval published Camper's method, popularizing it for the

40 © Association of Art Historians 1997

contemporary artistic audience and identifying it as a fundamental tool of the modern anthropologist.[68]

Sallé's *The Anatomy Class*: Charcot, Duval, Richer and anthropology

François Sallé's *Un Cours d'anatomie*[69] (plate 8) is a large-scale 'modern' history painting celebrating the work at the Ecole of Mathias-Marie Duval, anatomy professor from 1873 to 1903 (see plates 5 and 6). Again included is his *prosecuteur* Edouard Cuyer (see plate 7), the bearded figure seated drawing in the foreground beneath the *écorché*[70] – a celebrated modern flayed figure by Jacques-Eugène Caudron (1818–65), a pupil of David d'Anger. In contrast to traditional medical 'anatomy lessons' portraying dissection of the cadaver by a famous physician, Sallé's painting shifts attention to the art school and, symptomatic of the period, to the anatomy of the living body.

Duval trained at the Faculty of Medicine at Strasbourg between 1866 and 1870, where he became doctor of medicine in 1869. In 1872 he was appointed head of anatomical proceedings at the Faculty of Medicine at Nancy (where the Strasbourg Medical Faculty transferred after the Franco-Prussian War[71]), and *agrégé* in anatomy and physiology at the Faculty of Medicine in Paris on 3 January 1878.[72] He was elected a member of the Académie de Médecine in 1882.[73] In Sallé's *The Anatomy Class* we have in a single image a representation both of anatomy teaching in progress at the Ecole, and of bodies viewed anatomically: a male model stripped to the waist, a cast of a sculpted, flayed figure, various bones, and two two-dimensional anatomical models – a skeleton and a muscle man – pinned to the wall; and, of course, clothed male figures, probably all portraits. The figures of Duval and his model stand out against a huge blackboard positioned immediately behind them and used for drawing demonstration anatomies. The setting for the painting (as for Lemaistre's print, plate 6) is the *Théâtre d'anatomie* in the Ecole des Beaux-Arts.[74] The anatomy theatre was one of three spaces specially constructed at the Ecole and dedicated to anatomy teaching; they were custom-built during the time of Duval's predecessor, Huguier, and inaugurated in 1869. The other two rooms were a practical laboratory for dissection and a gallery to house the Huguier anatomical collection and what little remained of Sue *père's* collection.[75]

Where, in the Lemaistre book illustration, Duval demonstrates to his class the anatomy of the arm on a skeleton, in Sallé's oil painting he uses the live model:[76] these two images display Lemaistre's differentiation between what can be taught from the live body as opposed to the cadaver. In the painting, on a table before Duval lie the relevant skeletal fragments, from the scapula, erect like a yacht sail, down to the (hidden) bones of the hand. The articulation in question here is that of the bones of the forearm, the ulna and the radius. One of the most difficult for the artist to grasp, and crucial for the expressivity of the human body, the relationship of these two bones in movement is invariably made explicit in anatomical prints (cf. plate 3[77]) by displaying the two arms differently positioned; this can be seen, too, in the opposed arms of the *écorché*. With the arm hanging at rest, palm facing towards the body or slightly forwards, the radius (the smaller,

anterior bone) lies parallel to the longer, posterior bone, the ulna; the forearm in this position is flat (as in the *écorché*'s right arm, plate 8, and Duval's own left arm in plate 6). However, when the hand rotates inwards on the wrist turning the palm out and away from the body, the radius moves over the ulna, producing in the forearm a complex, twisted form in which the anterior plane of the wrist moves through nearly 180° in relation to the plane of the inner elbow (see the *écorché*'s left arm and, in plate 6, the forearm bones of the skeleton; the live model's right arm is halfway through such a turn). Duval's demonstration, then, concerns a great interest of his: anatomical movement in the live body – a concern complemented by the evident physical vitality of the model. This vitality is expressed not only in the model's body, but in the relation of the two men and their contrasting body movements – Duval leaning forward, his whole body actively engaged in communication; the model, weight on his rear leg, leaning passively back and away from the master, his body alone recognized, and that only in terms of morphological fragments. Interestingly, from this point of view, the model's figure does not work as a whole; it is not on a coherent plumb-line, so his body is split at the waist, the top and bottom halves not joining correctly. The errors in the *contrapposto* are disguised by shadows on his left side.

The architectural positioning of the window, high off to the left, means the depicted light falls fully on anatomist and model. It catches Duval's exposed cranium to suggest genius, his dark beard ensuring that the light picks out only his forehead. On the model, however, it is the torso which is stressed, the light and shade emphasizing his muscular form. Body versus mind are posited in Sallé's two contrasting protagonists (Cuyer and the students, too, all with highlit foreheads, partake in Duval's status). Duval's physicality is subsumed in his role as professional, the light falling on his body absorbed by the black costume and emphasizing only that exposed flesh which connotes the luminary: Duval's skills reside in head and hands. So he, too, is visually fragmented. The model's skills are differently embodied to configure the labouring body: undone at the waist, his casually hoisted, ill-fitting trousers are coarse and crumpled; they speak of a careless, rapid toilet and a poverty stark in contrast to the neat bourgeois attire of the remaining company. His black hair is also unkempt as opposed to the close-cropped students, his moustache swaggering and gypsy-like; his thick hair, low forehead and narrow facial angle are all Lombrosian characteristics of human degeneration identified with the man's class.[78]

The model towers over Duval, his size expanded by the light on his torso, his pose open and displaying a diffident physical confidence, an ease in his body which contrasts with the closed chest produced by Duval's fervent gestures; but it is Duval – his thumb pincer-like on the model's wrist – who dictates the balance of power within their relationship, controlling the model's body and defining its meaning. Compositionally, this is reinforced by placing Duval on the Golden Mean line; his body makes the fourth side of a square which encloses professor and pupils in a shared, rationally harmonious unit of meaning, an echo of the square which contains Vitruvian Man. The model's compositional isolation reminds us of his otherness; he cannot participate in the production, dissemination and consumption of knowledge, but is, rather, its raw material, simply an anatomical specimen. His closed eyes and hence absorption in his bodily

© Association of Art Historians 1997

materiality affirm this. So, too, does the physical relationship inscribed between the two men; Duval's authority sanctions his public invasion of the (paid) model's bodily privacy with an intimacy unthinkable under circumstances outside the institutions of art or medicine.[79] The play of light and shade reveals the fingers of Duval's left hand depressing the model's flesh as he draws the upper arm forwards, while his right hand grasps the wrist to adjust his display of the articulation of the forearm. He does not look at the model while he touches him, but turns away towards his audience. Because Duval's demonstration focuses here on the anatomy of the arm, Sallé's painting shows the model naked only from the waist up, as if he were a temporarily displaced building labourer; but as anatomy demonstrations were commonly conducted on the fully naked figure, this forms an unspoken subtext to the painting.

The spatial organization of the actual amphitheatre and of the teaching situation structure the social relations embedded in it: master, pupils and (anonymous) object of study. This is echoed in the pictorial space, which pivots around Duval as its key figure, his students fanned out around him; their connection is amplified not only colouristically, but by the mutuality of concentrated attention and focused eyelines. But a secondary key figure is that of the *écorché*. Like the hub of a wheel, the flayed figure stands at the centre of a circle formed by the black figures around it. The light, which is even more brilliant on the *écorché* than on the live model, links these two figures – twin subjects in a discourse of scientific inquiry made sober by the *habits noirs* of the remainder – in a diagonal axis across the pictorial space which also takes in the skeletal samples on their white cloth and the prints behind on the wall. However, reinforced by the customary left-to-right reading of paintings, Sallé uses the direction of the fall of light to draw the spectator's gaze inexorably towards his unidealized male model; hence, the climatic pictorial focus is on the brute strength and physical prowess of the man's body.[80] Contrasts between the warm, sensual materiality of his classed body and the cold, hard perfection of the white plaster *écorché*, all taut muscle and heroics, reinforce the reading of the model's social position – as does his undress in the face of his besuited audience.

Duval's approach to teaching artistic anatomy then, like that of Paul Richer (plate 1) involved a scientific understanding informed more by study of the living body than by dissection of the dead. This was the basis of Richer's 'science du nu' – study of the live 'nude' rather than the naked cadaver. The approach of both men was influenced by the work of Jean-Martin Charcot (1825–93, plate 9) in his clinics at La Salpêtrière. Charcot's *Leçons de mardi* were frequented by both Duval and Richer – who was Charcot's assistant and the artist who recorded his patient's hysterical symptoms. Charcot and Richer collaborated on a number of medico/art-critical publications on the anatomical body. The painting by Brouillet of Charcot lecturing on hysteria at La Salpêtrière, which is almost contemporaneous with Sallé's painting and markedly similar in composition (but with a female rather than a male object of inquiry), includes both Duval and Richer, and the medical photographer Albert Londe (plate 10).[81]

The key to Charcot's approach was close scrutiny of the live human body. Where, traditionally, medics had been preoccupied with what happened internally – often only discernible once the patient was dead – Charcot believed that there

9 Jean-Martin Charcot, wood engraving by Lorillon, after Paul Richer, 1891. Richer conceived this portrait of his chief in the tradition of the medallion profile portrait of Sue (plate 2). Photo: courtesy the Wellcome Institute Library, London.

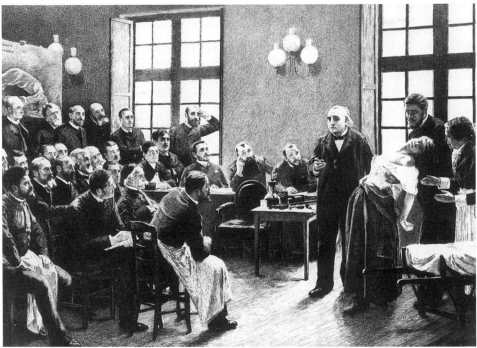

10 Pierre-André Brouillet, *Charcot lecturing on Hysteria at La Salpêtrière*, anonymous etching after the oil painting, 1887, Musée de Nice. Photo: courtesy the Wellcome Institute Library, London.

44

© Association of Art Historians 1997

was everything to learn from studying the external symptoms: 'Look, look again, always look: it is only by this means that one comes "to see" [à voir]. This minute observation, visual above all, is the source of all Charcot's discoveries.' In his daily clinics at La Salpêtrière Charcot, accompanied by his interns, externs and 'stagaires', had his patients undress and parade naked in order to observe their bodies, with the aim of assisting diagnosis; several naked patients were often seen together, to compare their bodies.[82] This preoccupation with observing and assessing the naked body was a common feature at this period across the sciences, particularly in the medical and in the emergent social sciences, notably anthropology; the naked body in question was, almost invariably, that of the lower classes or of other races. Duval, as already noted, had extended the anatomy course at the Ecole to embrace 'for the purpose of debate the study of the human races...'.[83] For him, anthropology was the science of '... the human races, which it classifies, defines and describes on the basis of their *anatomical characteristics*'.[84] Richer was to take artistic anatomy at the Ecole further down the route towards an anthropological comparative anatomy.

The new science of anthropology, in which Duval and Richer were both professionally engaged, at this date involved the comparative analysis of the anatomies of different races. However, the comparative anthropological measurement of skulls and skeletons, characteristic of the approach of Paul Broca (1824–80), gave way under Duval and Richer to the study of the live subject.[85] In particular, Richer shared the contemporary obsession with understanding the mechanics of physical movement. Around 1890 Richer, while still working under Charcot and with his full support, and firstly in collaboration with Albert Londe, began to take photographs studying naked European men in movement, using the techniques of the chronophotographer Etienne-Jules Marey. These photographs formed the basis for Richer's book on *Anatomie artistique. Description des formes extérieures du corps humain au repos et dans les principaux mouvements* (Paris, 1890), a study of the male body, and his later *Physiologie. Attitudes et mouvements*; the original photographs, gathered into a three-volume, unpublished *Atlas de physiologie artistique*, are conserved in the Ecole collections. In these chronophotographs, the men displayed the effects on the anatomy of athletic movements, including running and weightlifting; another series demonstrated the movement of naked men 'at work', complete with props: the blacksmith, the woodcutter etc. The choice of tasks enacted in this series specifically designates a classed, labouring body. The strength, agility and physical development of the male bodies photographed, and the poses adopted, identifies them not only as workmen; some of the models were evidently athletes or circus performers. Certainly they were not from the sedentary middle classes. Thus, extending the classed relations inscribed in Sallé's image of Duval's anatomy lesson, Richer's photographs provided a visual taxonomy of the male working-class body as viewed by a member of the medical professional classes.

In a second series of photographs of male bodies, this time not chronophotographs, Richer undertook a study of the morphology of the male body. For each model, in a total of up to thirty photographs, a series of programmatic poses captured the male body first in positions akin to those found in anatomies, then showed the body at rest and in various movements which

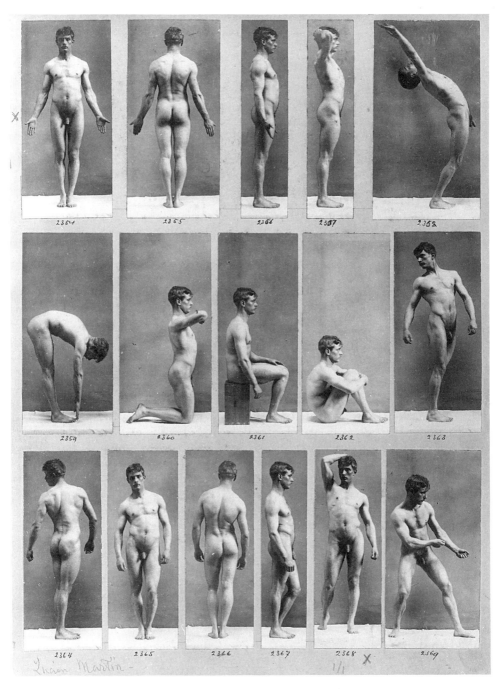

11 Paul Richer, Male morphology; plate nos. 2354–2369, *c.* 1890. Photo: courtesy Paris, Ecole nationale supérieure des Beaux-Arts.

 © Association of Art Historians 1997

displayed the forms extended and in torsion; these were often augmented by poses in imitation of classical sculpture – Gladiators, Davids after Michelangelo, *contrappostos* (plate 11).

After 1900 Richer also began photographing female subjects in a setting identifiable as his anatomy theatre at the Ecole. Where the faces of all his male subjects were exposed, some of the female subjects chose to mask or hide their faces behind hands or hair (plate 12); this was clearly inadequate to mask their identity, and suggests the concern was to break eye contact with Richer/the viewer, with the idea of preserving (the model's?) modesty;[86] the effect, however, is to transform the photographs in question into studies in erotic coquetry. In one set, an increasingly erotic dialogue unfolds between model and photographer from the moment the subject lets down her enormously long hair (plate 13). For each woman, ritualized poses displaying the female morphology were followed by more personal poses, some after Venuses, and including one where the model has put on stockings and *bottines*, and been photographed from the side to demonstrate the 'ogee' curvature of the spine which results from wearing high-heeled shoes (plate 14). The *bottines* tip her body forward and, compensating in terms of balance to remain upright, her buttocks, stomach and chest are thrust up and out. The contrast between this photograph and the adjacent one where her feet are flat on the floor, shows the eroticization effected by women's fashion on the female anatomy through exaggeration of the erogenous zones. Richer was equally preoccupied, like many of this contemporaries throughout Europe, with the damaging effects on the female anatomy of the corset, which phenomenon is further analysed in his photographs of female subjects (plate 15).

On both the female and male models Richer collected complex anatomical statistics, ostensibly to provide data for comparative anthropological study; they were each subjected to a standardized list of a couple of dozen key body measurements, which were taken to establish varying morphological types. Richer made hundreds of drawings from his photographs of women; these, and his statistical data, then served as the basis for his *Morphologie: la femme* (Paris, 1915).[87] Departing from prior conceptions of an ideal (if changeable) female body type, Richer's book celebrated the rich variety of female morphological types, which he scrutinized and analysed in turn. He not only provided extensive material for the use of art students, but looked beyond the Ecole to a categorization of European female body types which could form the basis for comparative anthropological study of non-European races. In preparing this volume he came to conclude that photography was less useful as a medium for scientific study than drawing: drawings could be modified to emphasize those anatomical characteristics to which the anatomist wished to direct his viewer's attention. Hence the apparent objectivity of the camera was, for Richer, a problem; it lacked discrimination. The artifice of art proved the better medium to construct the meanings he sought. Paradoxically, Richer found fault with art as a scientific tool. He argued that, because artistic canons were not universal, scientific rules of human proportion were needed, based – like his data – on the study of nature. Artists and scientists took opposing views, he thought: 'artists seek to express what should be, following the ideals of beauty they construct, and scientists (*savants*) simply *what is*.'[88] He saw art as offering only constructed

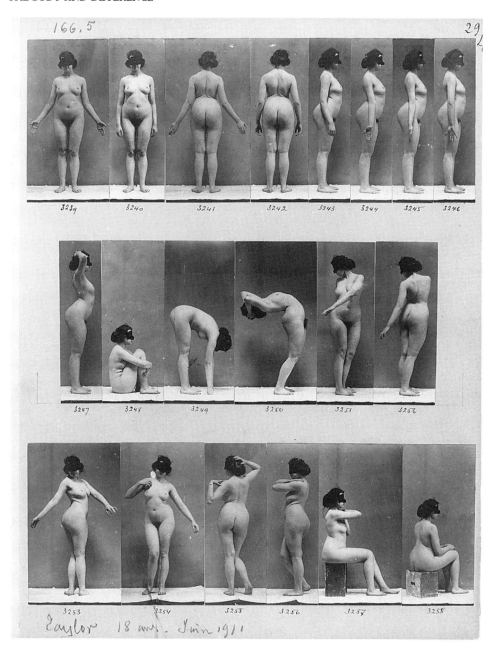

12 Paul Richer, Female morphology; Mme Taylor (eighteen years), plate nos. 3239–3258, 1911.
Photo: courtesy Paris, Ecole nationale supérieure des Beaux-Arts.

© Association of Art Historians 1997

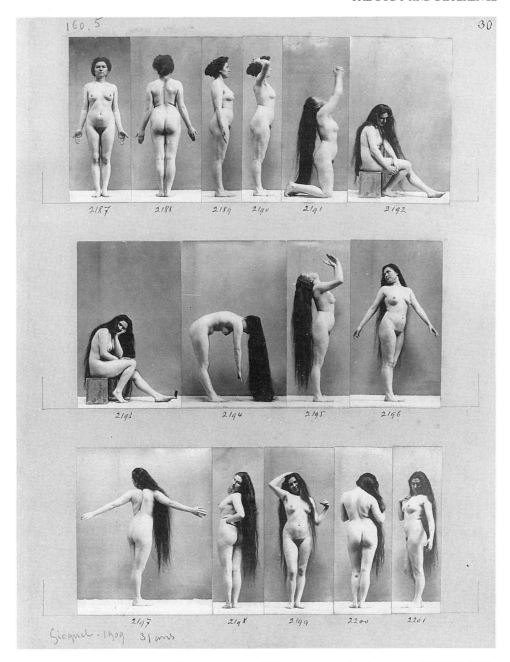

13 Paul Richer, Female morphology: Sou Gicquel (thirty-one years), plate nos. 2187–2201, 1909.
Photo: courtesy Paris, Ecole nationale supérieure des Beaux-Arts.

© Association of Art Historians 1997

49

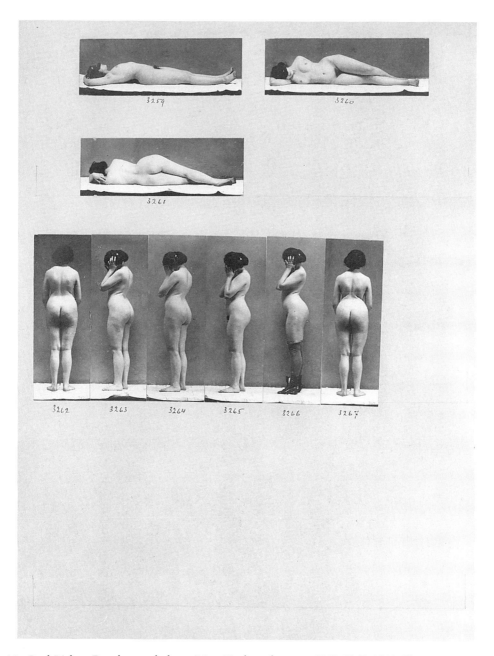

14 Paul Richer, Female morphology: Mme Taylor, plate nos. 3259–3267, 1911. Photo: courtesy
Paris, Ecole nationale supérieure des Beaux-Arts.

 © Association of Art Historians 1997

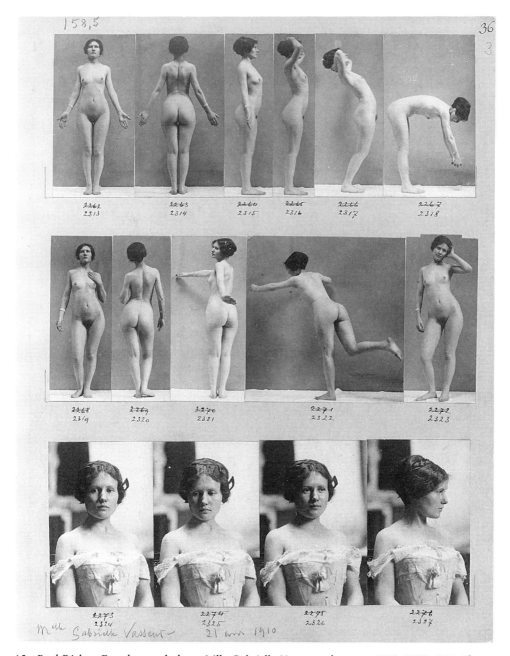

15 Paul Richer, Female morphology: Mlle Gabrielle Vasseur, plate nos. 2313–2327, 1910. Photo: courtesy Paris, Ecole nationale supérieure des Beaux-Arts.

© Association of Art Historians 1997

truths, but failed to recognize that science was equally implicated in culturally driven perceptions of the human body.

Anthea Callen
University of Warwick

APPENDIX – CARAN AJ/52/41 – Syllabus (1880s) Dr Mathias Duval.

ECOLE NATIONALE ET SPECIALE DES BEAUX-ARTS

COURS D'ANATOMIE

I.
De l'anatomie plastique: son histoire; son importance; son objet; sa méthode. – Division du cours; questions de nomenclature. – Questions d'anatomie pure et de physiologie (mécanismes des articulations; saillies des muscles en action).

II.
De l'ostéologie au point de vue des formes: des saillies osseuses dans le modèle extérieur. – Des axes des membres et des angles articulaires.
De la colonne vertébrale: vertèbres. – Régions du cou, du thorax, des lombes. – Saillies des apophyses épineuses; courbures de la colonne chez l'homme et les animaux; ses proportions.

III.
Squelette du tronc. – Sternum: formes, proportions, directions suivant les âges et les sexes. – Côtes et cartilages costaux. – Ensemble du thorax: ses formes dans l'effort. – Etude du creux épigastrique.

IV.
Clavicule: son importance comme forme selon les sexes et les constitutions athlétiques; ses mouvements; son articulation avec le sternum; ses proportions comparées au sternum et à l'omoplate. – Anatomie comparée.

V.
De l'omoplate: formes; direction. – Articulation de l'épaule; ses mouvements: rôle essentiel de la clavicule dans ces mouvements. – Déplacements de l'omoplate dans l'élévation du bras. – Proportions et anatomie comparée.

VI.
De l'humérus; son obliquité; ses saillies au niveau du coude; sa position chez le cheval; ses surfaces articulaires; ses mouvements.

VII.
De l'articulation du coude: formes (angle du coude); de l'épitrochlée comme saillie à choisir pour toutes mensurations du bras. – Mouvements (charnière sans mouvements de latéralité); limites de l'extension.

© Association of Art Historians 1997

VIII.
Os de l'avant-bras: déductions au point de vue des formes. – Radius et cubitus. – Mouvements de pronation et de supination; modifications essentielles quant à la direction des axes, quant aux formes, quant à l'angle du coude, etc.

IX.
Squelette de la main: carpe et métacarpe; formes du poignet; de la main dans les mouvements de pronation et de supination. – Des mouvements de flexion de la main en totalité; formes du poignet fléchi.

X.
Des doigts: mouvements d'opposition du pouce. Mécanisme comparé des articulations métacarpo-phalangiennes et des articulations interphalangiennes. Proportions du membre supérieur en totalité (comparé à la taille et comparé au membre inférieur.)

XI.
Proportions relatives des divers segments du membre supérieur: indice brachial. – La main comme commune mesure. – Le canon égyptien.
De la constitution du membre antérieur chez les plantigrades, les digitigrades. – Chez le cheval. – Proportions de ce membre chez le cheval.

XII.
Du squelette de la hanche. – Du bassin (os iliaque et sacrum). Du bassin selon les sexes et les âges; formes et proportions. – Saillies des hanches selon les sexes. – Anatomie comparée.

XIII.
Du fémur et de l'articulation de la hanche: direction du fémur; direction de son col; saillie de son grande trochanter; modelé de la région; considérations générales et récapitulatives sur la manière dont se révèlent les saillies osseuses dans les modelés extérieures. – Courbure du fémur.

XIV.
Articulation du genou: condyles et trochlée fémorale; rotule, tibia, tête du péroné. – Mouvements du genou: limites du mouvement d'extension; mécanique de la station, – Mouvements de rotation. – Formes du genou dans la flexion et dans l'extension; modelés osseux et tendineux en avant, en dedans et en dehors; modelés musculaires en arrière.

XV.
Squelette de la jambe: tibia et péroné; crête du tibia; fixité des deux os. – Malléoles: leurs différences de forme, de niveau et de rapports avec le plan antérieur; formes extérieures des chevilles; enroulement des muscles; disposition du péroné.

XVI.
Squelette du pied: il est tout pour les formes extérieures (cambrure, voûte et dos du pied). – Tarse et métatarse; mécanisme des articulations du pied avec la jambe, et de l'astragale avec le reste du pied (mouvements sus et sous-astragaliens). – Formes du dos du pied et du talon.

© Association of Art Historians 1997

XVII.

Métatarse, phalanges et ensemble du pied. – Proportions du membre inférieur; indices; *pied* comme commune mesure; divers systèmes de proportions. – Anatomie comparée du membre postérieur. – Proportions chez le cheval.

XVIII.

Squelette de la tête. – Du crâne proprement dit; os qui le composent; formes du crâne selon les âges, les sexes, les races. – Indices céphaliques (dolichocéphalie, brachycéphalie, mésaticéphalie); caractères ethniques. – Anatomie comparée.

XIX.

Squelette de la face: orbites; os nasaux; maxillaires; arcades zygomatiques. – Dents et mâchoires et articulation temporo-maxillaire. – Angle facial de Camper. – Anatomie comparée.

XX.

De la hauteur de la tête comme commune mesure; récapitulation et histoire des divers systèmes de proportions.

XXI.

Des muscles en général. – La part qu'ils prennent au modelé selon qu'ils sont en repos ou gonflés par la contraction. – Principes de nomenclature des muscles. – Des corps charnus et des tendons. – Part qui revient à chacun dans le modelé extérieur.

XXII.

Muscles du tronc: pectoraux. – Obliques et droits de l'abdomen. – Récapitulation des formes osseuses et musculaires de la face antérieure du tronc.

XXIII.

Muscles du dos: trapèze, grand dorsal et grand rond. – Anatomie comparée.

XXIV.

Muscles de l'épaule: deltoïde, grand dentelé. – Creux de l'aisselle.

XXV.

Muscles du bras: biceps, etc. – Triceps. – Formes du bras: action et modelé de chaque muscle dans chaque mouvement.

XXVI.

Muscles de l'avant-bras: muscles antérieurs, externes et postérieurs superficiels. – Formes et actions; dispositions relatives à la supination et à la pronation. – Saillies tendineuses du poignet.

XXVII.

Muscles postérieurs profonds de l'avant-bras: modelé spécial du poignet (tabatière anatomique). – Muscles de la main.

XXVIII.

Muscles du bassin: fessiers et fascia lata; mouvements du grand trochanter. – Muscles de la station verticale; anatomie comparée.

54

XXIX.

Muscles de la cuisse. – Couturier, triceps, adducteurs, etc. – Mécanismes et modelés.

XXX.

Muscles de la jambe. – Jambier: saillies tendineuses obliques; péroniers; jumeaux et tendon d'Achille; mécanismes et modelés.

XXXI.

Muscles du pied. – Pédieux et plantaires; tendons et corps charnus. – Récapitulation des formes osseuses et charnues du pied.

XXXII.

Muscles du cou. – Sterno-mastoïdien; muscles de l'os hyoïde; formes du cou; surfaces de section des muscles du cou. – Peaucier.

XXXIII.

Muscles de la face: 1° muscles masticateurs (masséter et temporal); 2° muscles de l'expression: leurs dispositions spéciales (muscles peauciers); leur mécanisme général.

XXXIV.

Muscles de l'expression. – Historique: Léonard de Vinci, H. de Superville, Duchenne, Darwin. – Classification des muscles et des expressions. – Muscles du front et des sourcils.

XXXV.

Muscles des paupières. – Muscles des lèvres, des joues, du nez, du menton. – Expressions étudiées d'après les grandes photographies de Duchenne, et d'après les schémas du professeur.

XXXVI.

Des combinaisons des actions des muscles de l'expression; combinaisons classiques; combinaisons déduites du mécanisme anatomique. – Associations de certaines expressions. – Rapports de l'expression par geste, et de l'expression par le jeu de la physionomie.

XXXVII.

Des races humaines. – Caractères anthropologiques: peau, poils, squelette, angle facial, etc.

XXXVIII.

De la station et de la locomotion. – De la locomotion des quadrupèdes; des allures du cheval; analyse et synthèse.

Notes

1 I would like firstly to express my gratitude to The Leverhulme Trust for funding the Senior Research Fellowship 1995–6 which has enabled me to pursue this research in Paris and the writing of my book *Intimate Relations in the Studio: Art and Anatomy from Albinus to Charcot* c 1740–1920. I should also like to thank the University of Warwick for research funding in 1994–5 towards this project and for granting me leave of absence during 1995–6. I am grateful to the conservators of the Collections in the Ecole nationale supérieure des Beaux-Arts, Paris,

© Association of Art Historians 1997

particularly Mme Annie Jacques, Conservateur
en chef, Mme Mathon, Conservateur des
collections photographiques, Mme E. Brugerolles
and M Schultz, and the staff of the Service
photographique. I am especially grateful to the
Professor of Morphology, M Jean-François
Debord, for the enthusiasm and generosity with
which he shared with me his knowledge of the
subject and of his departmental collections. My
thanks also to Professor Nick Spencer for
verifying my anatomical details, and for helpful
comments on parts of the text.

2 *Rapport au Conseil Supérieur par le Directeur de
l'Ecole au commencement de l'année scolaire
1874–75*, Paris, Imprim. Nat., 1875, p. 9,
Archives de l'Ecole nationale supérieure des
Beaux-Arts, Archives Nationales (referred to
hereafter as CARAN), AJ/52/440.
3 The name of the institution was changed a
number of times, firstly during the aftermath of
the Revolution of 1789 and then several times
during the nineteenth century with changes of
political regime. For the purposes of clarity, I
shall refer to it throughout this article as the
Ecole des Beaux-Arts.
4 Although obviously very important in any study
of the history of art and anatomy, the work of
artists which disrupted the academic anatomical
canons of masculine and feminine form (Courbet,
Manet and Degas provide obvious examples),
will not be examined within the limits of the
present article, but are discussed elsewhere
(Callen, op. cit. [in preparation]).
5 '... aucun élève quels que soient le nombre et la
nature de ses succès dans l'école, ne peut être
admis dans le concours de composition, de la tête
d'expression et de la figure peinte s'il n'a obtenu
l'une des récompenses attachées aux concours de
perspective', Article 28 of the regulations of 1839,
quoted in P. Grunchec, *Le Grand Prix de
Peinture: Les concours des prix de Rome de 1797
à 1863*, Paris, Ecole nationale supérieure des
Beaux-Arts, 1983, p. 96. The annual report of the
Ecole for 1854–5 (CARAN, AJ/52/53), *Ecole
Impériale et Supérieure des Beaux-Arts.
Distribution des prix et médailles de l'année
scolaire 1854–55*, Paris, 1855, p. 10, notes that
this regulation was only put into effect from
1841: '... cette obligation, imposée depuis 1841
...'; this source makes it clear that students
without a prior award in perspective were not
only denied access to the Grand Prix contest, but
were also excluded from the Painted Torso
contest. CARAN AJ/52/1, however, under
réglements – 25 Août 1827 – records that
perspective instruction was made obligatory for
students who wished to enter the *concours
d'esquisse* and composition, and hence Grand
Prix de Rome.
6 On the Prix de Rome see P. Grunchec, *The
Grand Prix de Rome: Paintings from the Ecole
des Beaux-Arts 1797–1863*, Washington DC,

1984, and Grunchec, op. cit. (1983).
7 See references in notes 5 & 6, and also, for
example, CARAN AJ/52/53, *Rapport annuelle de
l'Ecole impériale et supérieure des Beaux-Arts.
Distribution des prix et médailles de l'année
scolaire 1854–55*, Paris, 1855, p. 10, which notes
painting students still neglecting perspective;
requirement imposed in 1841, but 'rebels still
...', and AJ/52/440, *Rapport au conseil supérieur
par le Directeur de l'Ecole au commencement de
l'année scolaire 1874–75*, Paris, Imprim. Nat.
1875, pp. 10–11, again refers to the students as
'rebellious', commenting on the large numbers of
students who attend the perspective classes, but
how few present themselves for the *Concours*;
their almost complete lack of scientific formation
is seen here as the cause.
8 The most comprehensive study to date is J.-F.
Debord's 'De l'anatomie artistique à la
morphologie', in J. Clair (ed.), *L'Ame au corps:
arts et sciences 1793–1993*, Paris, 1993, pp. 102–
117. P. Grunchec, op. cit. (1984), has very limited
information on the *Concours* in anatomy and its
teaching (p. 24), but in his 1983 volume (op. cit.,
p. 89) the anatomy professors are listed, and
general information is given on methods of
appointment and payment of staff; he notes that
succession was not automatic. However, under
Concours spéciaux (op. cit., 1983, pp. 96ff)
anatomy is again left out, the detailed
information focusing instead on perspective,
historical landscape and historical composition,
the expressive head and the painted torso
contests. See also Alexis Lemaistre, *L'Ecole des
Beaux-Arts dessinée et racontée par un élève*,
Paris, 1889, on anatomy, pp. 119–31; Henri
Delaborde, *L'Académie des Beaux-Arts*, Paris,
1891; Gabriel Rouchès, *L'Ecole des Beaux-Arts*,
Paris, 1924.
9 I am very grateful to Alan Krell for bringing the
Sallé to my attention when I was in Sydney in
1994, and for the fruitful conversations we had
about it; he is studying it in the context of
Manet and Caillebotte's work, with particular
reference to masculinity, sexuality and the homo-
erotic, for the catalogue of an exhibition on the
art of the body (nineteenth and twentieth-
century), Sydney, The Art Gallery of New South
Wales, 1997. See also notes 69 and 70 below.
10 CARAN AJ/52/53, chronological register of
personnel 1793–1956, no. 205; Richer became an
Honorary Professor of Anatomy 26 October
1922.
11 M.-M. Duval and E.-P.-J. Cuyer, *Histoire de
l'anatomie plastique ...'*, Paris, 1898, pp. 245–6.
12 Most sources list him as Jean-Joseph, which is
logical in view of the distinction always made
between *père* and *fils*; however, CARAN, AJ/52/
53, in the chronological register of personnel
1793–1956, no. 16, lists him as Jean-Jacques Sue.
The son of this Sue *fils*, Marie-Joseph-Eugéne
Sue (1804–57), also began in medicine,

© Association of Art Historians 1997

specializing in anatomy, and was offered the chair of anatomy at the Ecole des Beaux-Arts on his father's death, but chose instead to devote himself to writing, becoming the well-known novelist.

13 On Thiroux d'Arconville, whose class and gender status did not permit her to publish in her own name, see L. Schiebinger, *The Mind has No Sex? Women and the Origins of Science*, Harvard, 1989, esp. Chaps 7 and 9. As with the identity of the author–translator, there is confusion regarding the execution of the drawings for *Traité d'ostéologie*; the 1759 edition gives J. Tharsis, but Schiebinger, pp. 195–6, suggests both that d'Arconville herself made the drawings, and that she directed their drawing by others.

14 J.-J. Sue, *Traité d'ostéologie*, Paris, 1759, vol. 1, p. 210. Cf. Schiebinger, op. cit., p. 193, 'The bones of Women are frequently incomplete, and always of a Make in some Parts of the Body different from those of the robust Male, which agree to the Description already delivered, unless where the proper Specialities of the Female were particularly remarked, which could not be done in all Places where they occur, without perplexing the Order of this Treatise ...' (Monro, 1726, Appendix, p. 341): Monro deemed the differences so numerous as to disrupt the orderly male narrative of the Treatise if examined in the body of the text rather than as a separate appendix. The role and importance of anatomies, notably concerning theories of social and racial distinction, including gender difference between male and female skeletons, are developed in Callen, op. cit. (under preparation).

15 See Schiebinger, op. cit., pp. 194–200.

16 The d'Arconville rib cage does not display the conical and crushingly narrow lower-rib form, often with a twisted spine, resulting from long-term corsetting; its narrowness appears the greater because the pelvis is so wide. Sue *père*'s anatomical ideas of gender difference were more in sympathy with the Antique; the feminine ideal which emerged in his anatomy teaching was the plumper, unconstricted *Venus de Medici*, as described in the *discours* he presented to his fellow Academicians: *De l'ostéologie*, MS 1, p.3, n.d. [eighteenth-century], côte Sue 223, Département des collections, Ecole nationale supérieure des Beaux-Arts, (referred to hereafter as ENSBA).

17 See Charles Singer, 'Historical Introduction', in Ludwig Choulant, *History and Bibliography of Anatomical Illustration*, New York and London, 1961, pp. 22–5.

18 Jean-Joseph Sue (*fils*), *Elémens d'anatomie à l'usage des peintres, des sculpteurs et des amateurs*, Paris, 1788, p.20.

19 Plates 1–3, three views of the male skeleton; plate 4, the female skeleton; the pictures are again attributed on the title page to Aubert, after Tharsis.

20 Jean-Joseph Sue *fils*, *Essai sur la physiognomie des corps vivants, considerée depuis l'homme jusqu'à la plante: ouvrage où l'on traite principalement de la nécessité de cette étude dans les arts d'imitation, des véritables règles de la beauté et des grâces, des proportions du corps humain, de l'expression des passions, etc.*, Paris, chez l'auteur, 1797.

21 See M.-M. Duval and A. Bical, *L'anatomie des maîtres*, Paris, 1890, p.22.

22 See CARAN AJ/52/439, MS, 'Etat de l'Académie de Peinture et de Sculpture avant la Révolution', an 8, (n.p.), [p.5].

23 This approach circumscribed medical knowledge of the body, too; it was only with Charcot in the 1870s that a new emphasis on medical study of the live body emerged; see A. Souques and H. Miege, 'Jean-Martin Charcot (1825–1893), Les Biographies Médicales: Notes pour servir à l'histoire de la médecine et des grands médecins', *Revue médicale illustrée*, 13e année, 1939, part I; I shall return to this issue below.

24 *Revue des beaux-arts*, 1856, t. VII, p.123, quoted in Debord, 'De l'anatomie artistique à la morphologie', in Clair (ed.), op. cit., p. 106.

25 According to Ecole regulations put in place in the post-Revolutionary period, professors were expected to be at least thirty years of age before election to office.

26 CARAN AJ/52/439, Dossier of revised regulations for the Ecole des Beaux-Arts, 28 January 1831, Article 12.

27 CARAN AJ/52/35, chronological register of personnel 1793–1956, no. 90.

28 CARAN AJ/52/433, cited in Debord, 'De l'anatomie artistique à la morphologie', in Clair (ed.), op. cit. pp. 107–108.

29 CARAN AJ/52/53, *Rapport annuelle de l'Ecole impériale et supérieure des Beaux-Arts. Distribution des prix et médailles de l'année scolaire 1853–54*, Paris, 1854, p.8, 'Le Concours d'Anatomie, de nouvelle institution, et qui aura lieu pour la première fois à l'issue des Cours de l'année prochaine, nous permet d'espérer des resultats satisfaisants.'

30 CARAN AJ/52/35, chronological register of personnel 1793–1956, no. 96; the standard salary for the anatomy professors almost throughout the century was 2,400F per annum.

31 See Lemaistre, op. cit., p. 124, and note 11, below.

32 CARAN AJ/52/35, chronological register of personnel 1793–1956, no. 134. Here it is noted that Boyer had been a student of the Ecole des hautes études, and had hospital training and experience; he became a hospital *externe* in 1873 and was a *Laurier* of the Faculty de médecine in 1874. He was a hospital intern from 1875 to 1878, and a hospital *Laurier* in 1875, 1876 and 1878. The information on his death in this source is contradictory; it states that he was on permanent leave from the Ecole des Beaux-Arts

after April 1905, suggesting ill health; it also states that he died in 1883. The entry under Cuyer (no. 140) states that Boyer was *Professeur supplémentaire* to Duval when Cuyer took over that position from Boyer in 1894; hence Boyer was *Professeur supplémentaire* from 1881 to 1893 or 1894, and so he cannot have died in 1883.

33 ibid., no. 140, and see Lemaistre, op. cit., p. 127. Cuyer was appointed *Prosecuteur d'anatomie* on 1 August 1881 at an annual salary of 800F, and promoted to *Professeur supplémentaire* to M. Duval on 1 October 1894 at an annual salary of 2,000F.

34 ENSBA MS register of anatomy prizewinners 1855–1965, Département des collections; his prizewinning drawings, which are of surprisingly poor quality, are conserved in the Département de morphologie. Prix Huguier discussed below.

35 Suggested in Debord, 'De l'anatomie artistique à la morphologie', in Clair (ed.), op. cit., p. 109, citing CARAN AJ/52/460, *dossier Chicotot; Anatomie artistique d'Arnould Moreaux*, Paris, n.d., p.xx, but cf. CARAN AJ/52/35, chronological register of personnel 1793–1956, no. 231 – Charles Vincent, *prosecuteur d'anatomie*, annual contract from 1 Jan. 1909 –1 Jan. 1914, replacing Dr Chicotot.

36 Richer's 'Science du Nu' will be outlined later in this article, and see Debord, 'De l'anatomie artistique à la morphologie', in Clair (ed.), op. cit., pp. 108–11.

37 Grunchec, op. cit. (1984), p. 23; see also the regulations published in 1879, AJ/52/2, pp.4ff.

38 CARAN AJ/52/2, published Ecole regulations, 1879, Article 24, p. 10.

39 In 1785 he presented to the Académie his 'Précis d'un cours d'anatomie pittoresque à l'usage des élèves'; see Debord, 'De l'anatomie artistique à la morphologie', in Clair (ed.), op. cit., p. 104. Debord notes that the comte de Caylus proposed opening a 'concours pour l'étude du squelette', but later Ecole records suggest that this was never formally instituted; see notes 42 and 47 below.

40. ENSBA, Département des collections, MS Sue, *De l'ostéologie*, (n.d. [18th c.]) pp. 2–3.

41 ENSBA, Département de morphologie, drawings collection.

42 CARAN AJ/52/439, MS *Etat de l'Académie de Peinture et de Sculpture avant la Révolution*, an 8, (n.p. [pp.5,7]).

43 ibid. [p.5].

44 CARAN AJ/52/1, MS, 5 January 1797, (n.p.).

45 ibid, MS, 21 January 1843.

46 Drawings conserved in the Département de morphologie, ENSBA. Mlle Roudenay was, in 1897, the 115th woman to register at the Ecole; see the second page of the 'Ordre d'inscription des femmes (à partir d'Avril 1897) pour suivre les Cours oraux et étudier dans les Galeries', reproduced in Marina Sauer, *L'Entrée des femmes à l'Ecole des Beaux-Arts 1880–1923*,

Paris, ENSBA, 1990, Annexe 7, p.71 (CARAN AJ/52/971). And cf. Lemaistre's book illustration *Avant le cours d'anatomie* (1889). Lemaistre's print of a student drawing a skeletal fragment *Avant la cours d'anatomie* also affirms this practice.

47 CARAN AJ/52/439, *Projet d'organisation définitive de l'Ecole spéciale des Beaux-Arts à Paris*, Commission under Vien, Vincent, Moitte, Raymond and Regnault, an 10, n.p. [p.14]. Perspective was originally listed as separate from geometry, but revisions in red ink brought the two subjects under a single professor and into a single *concours*. The salary of emeritus professors (after the age of seventy) was given [p.15] as 19,200F per annum, History painters and sculptors (first-class professors) 14,400F, architects, 7,200F, and all second-class professors 1,800F; in practice 2,400F for the latter was the norm. The principal concern of this document is with professors, their numbers, rights, power and remuneration, rather than with artistic or aesthetic issues.

48 CARAN AJ/52/439, 'Projet de reglements', 1839, Article 22, and cf. AJ/52/2, a published report of regulations, (n.d., 1840?), pp. 17–19, which emphasized, p.19, Article 26, that competitors were forbidden to communicate with each other outside the *Salle des Concours*. Absolute silence had to be maintained during the competition itself.

49 CARAN AJ/52/39, notes on the teaching programmes, *concours spéciaux* for the school year 1854–5; anatomy medal noted as new for this year. The earliest anatomy prize drawings conserved in the Ecole collections are from 1855.

50 CARAN AJ/52/1, MS *procès-verbaux* of concours regulations, 27 August 1853, n.p.

51 CARAN AJ/52/59, 8 Juillet 1885; n.d.

52 CARAN AJ/52/1, MS *procès-verbaux* of concours regulations, 27 August 1853.

53 ENSBA, Département des collections, MS, Register of prizewinners in anatomy, 1855–1965. Sometimes, however, winners were simply not entered in the Register; for example, the first Prix Huguier winner listed is Cuyer, in 1877, but the prize was first awarded in 1874.

54 CARAN AJ/52/440, MS, *Rapport au conseil supérieur de l'Ecole nationale des Beaux-Arts, année scolaire 1873–4*, par M. Guillaume, Directeur, [p.11].

55 ibid., [p.15].

56 CARAN AJ/52/440, *Rapport au conseil supérieur par le Directeur de l'Ecole au commencement de l'année scolaire 1874–75*, Paris, Imprim. Nat. 1875, pp. 9–10.

57 Drawings for the *prix Huguier* are conserved in the Département de morphologie, those for the *concours spécial* in anatomy are in the Département des collections, ENSBA.

58 CARAN AJ/52/440, *Rapport sur l'exercice 1897–1898 presenté au Conseil par le Directeur de*

© Association of Art Historians 1997

l'Ecole au commencement de l'année scolaire 1898–1899, p. 7; the Director was disparaging of the women's efforts in general, but excepted their performance in the anatomy and perspective courses; in 1896–97, the Ecole 'proprement dit' was opened to women. The Report for 1896–97, p. 5, notes that in 1895–96 women had been authorized to follow the oral courses, and that a special anatomy course had been created for them. On the struggle for women to enrol at the Ecole, see Sauer, op. cit.; and T. Garb, *Sisters of the Brush*, London, 1993.

59 For example, Mlle Roudenay; see note 46 above.

60 CARAN AJ/52/56, *Concours Publics Spéciaux. Anatomie. Professeur M. Mathias Duval*. The name *prix Huguier* had been dropped after 1894–95. See also Sauer, op. cit., p. 36 and annex 9, and plates 11–12, photographs of Heuvelmans and one of her reliefs.

61 Lemaistre, op. cit., p. 120. A smaller turntable is visible, far right, in Sallé's painting.

62 Debord, 'De l'anatomie artistique à la morphologie', in Clair (ed.), op. cit., pp. 104–106.

63 ibid, p. 105; Houdon's remarks formed part of a critical debate among Academicians on an artificial anatomical piece offered to the Ecole by M. Susini of Florence. Houdon's bronze *Ecorché* is now in the collection of Département de morphologie, ENSBA.

64 See M. Kemp, *Dr William Hunter at the Royal Academy of Arts*, Glasgow, 1975, pp. 16–17.

65 Several of these casts survive in the collection of the Département de morphologie, ENSBA; they must date from the time of Duval (who was an admirer of Hunter) since extant coloured drawings datable to the late 1890s after one particular cadaver match an extant cast made after it. The drawings in question are by Louise Roudenay, see note 46 above.

66 Lemaistre, op. cit., p. 127.

67 ibid., Lemaistre states that comparative anatomy, involving the horse, dog, sheep etc., was also taught, although the syllabus (see Appendix), Lesson XXXVIII, mentions only horses. The Darwin material taught by Duval came from Darwin's *The Expression of the Emotions in Men and Animals*, London, 1872; Duchenne's relevant work was *Mécanisme de la physionomie humaine ou analyse électro-physiologique de l'expression des passions applicable à la pratique des arts plastiques*, Paris, 1862. Very much in sympathy with Duval, who was one of the few medics to take his work seriously, Duchenne gave his entire collection of photographs to Duval for the Ecole Département de morphologie.

68 Duval and Bical, op. cit., p. 22, and n. 1, and p. 27. In Duval's syllabus, Camper's 'facial angle' was also taught in relation to the anatomy of the cranium, Lesson XIX. On Camper's 'facial angle', and other issues of art, anatomy and difference,
see A. Callen, *The Spectacular Body: Science, Method and Meaning in the Work of Degas*, New Haven and London, 1995, Chap. 1.

69 The painting was purchased from the Salon by E. Montefiore and the London Selection Committee for shipment to Australia, and entered the collection of the Art Gallery of New South Wales in Sydney. Information from the archive of the Art Gallery of New South Wales, kindly supplied by Sherrie Joseph; unfortunately, no more detailed information on its acquisition has been uncovered. It is clear from the Ecole archives (CARAN AJ/52/234–437) that Sallé never registered there as a student, and I have so far been unable to locate where he studied, or what was the connection with Duval that prompted him to undertake this painting. Given the issues of class the painting raises, it is interesting to speculate upon its didactic role in Australia *qua* colony; it is beyond the limits of the present article to pursue this question (which is addressed in Callen, op. cit. [in preparation]) but, especially given Duval's Darwinism and his role as an anthropologist, the painting's articulation of differences of class and status would constellate in radically different ways within a culture formed upon such distinctions as aboriginal/white criminal/white military ruling-class, and with its own emerging national identity, education system and professional and working classes.

70 P. Grunchec in 1981 suggested to the Art Gallery of New South Wales that Cuyer was the figure far left; however, when compared with Lemaistre's portrait of Cuyer (plate 7), the identity in the Sallé now proposed seems beyond dispute. According to the gallery, H. Toussaint suggests that the youthful student left of centre could be Léon Bonnat. Grunchec erroneously locates the Sallé as in the National Gallery of Victoria, Melbourne (in op. cit. [1983], p. 88).

71 Etienne Roc, 'Professeur Mathias Duval', *Les Hommes d'Aujourd'hui*, vol. 6, no. 273, Paris, n.d. [1886], n.p.

72 CARAN AJ/52/35, chronological register of personnel 1793–1956, no. 124.

73 Noted in N. Schiller, 'Une collaboration artistico-scientifique: Mathias Duval et Edouard Cuyer', *Comptes Rendus du 92nd Congrès national des sociétés savantes*, Strasbourg et Colmar, 1967, Section des sciences, tome I, Paris, Bibliothèque nationale, 1969, p. 159, n. 14.

74 The door from this theatre giving access to the landing is, in fact, situated where Sallé has placed the anatomical wall charts in his painting; he thus represents the space as enclosed and self-reflexive, and avoids the distracting narrative latency of an avenue to the outer world. I have not yet been able to identify definitively the two anatomical wall charts shown here; there are at present several possible candidates for the skeleton.

75 The anatomical collection of Jean-Joseph Sue *père*, inaugurated by Sue *fils* at the Ecole des Beaux-Arts in 1829, was afterwards almost entirely destroyed by damp and rats due to inappropriate storage; information kindly supplied by Jean-François Debord, and see his 'De l'anatomie artistique à la morphologie', in Clair (ed.), op. cit., p. 106–107. For further information on the Sue's 'musée philosophique', see MS Sue, 3, 'Inventaire de la collection Sue', Département des Collections, ENSBA; and 'Extrait du discours prononcé par M. le Professeur Sue le jour de l'installation de son musée dans la nouvelle salle destinée au cours d'anatomie pittoresque de l'Ecole Royale des Beaux-Arts', Paris, 1829, 4pp, Département des Collections, ENSBA; and CARAN AJ/52/443. Huguier's anatomical collection, most of which survives, remains housed in the gallery of the Département de Morphologie, ENSBA.

76 Although contrasting medium (including photography), scale and means of dissemination are vital to a thorough understanding of the functions of the various anatomical studies under discussion, this aspect can only be touched upon in passing here.

77 In the skeleton's left arm in the d'Arconville, the movement of the radius over the ulna is poorly represented; the Albinus male skeleton shows it far better.

78 Identified by contemporary anthropologists with atavism and a low position on the evolutionary scale, these particular physiognomic signs, in class terms, defined low social status and potential deviance and criminality; see C. Lombroso, *The Criminal, in Relation to Anthropology, Jurisprudence, and Psychiatry*, London, 1876, and also A. Callen, 'Anatomy and Physiognomy: Degas's *Little Dancer of Fourteen Years*', in R. Kendall, *Degas: Images of Women*, London, 1989, p. 12.

79 While the important issues of desire and the erotic in this context (whether homo- or hetero-) fall outside the limits of the present article, they are addressed in Callen, op. cit. (under preparation).

80 French seventeenth- and eighteenth-century theories of pictorial unity to which Sallé's treatment of light and shade principally conforms are discussed in T. Puttfarken, *Roger de Piles's Theory of Art*, London, 1985, esp. chap. 4 and pp. 131–3.

81 A copy of the print after this painting is housed in the Musée de l'Assistance Publique de Paris, and it is annotated with the names of all those present, which also include Jules Clarétie,

Théodule Ribot and Philippe Burty. See the analysis of this image and a discussion of female hysteria, and of the Charcot/Richer collaboration in Callen, op. cit. (1995), pp. 50ff. An exhibition on the subject was held at the Musée de l'Assistance Publique de Paris in 1986, *La Leçon de Charcot: voyage dans une toile*, Paris, 1986. See also S. Schade,' *Art History*, vol. 18, no. 4, pp. 499–517.

82 Souques et Meige, 'Les Biographies Médicales: Jean-Martin Charcot', op. cit., p. 333, and see Debord, 'De l'anatomie artistique à la morphologie', in Clair (ed.), op. cit., p. 108–109.

83 note 2.

84 Duval and Bical, op. cit., p. 3, my emphasis.

85 In 1873, Duval was elected a member of the Société d'Anthropologie. Broca was also a follower of Darwin and founder of the French school of anthropology in 1861; in 1876 he founded the Ecole Publique d'Anthropologie in Paris. On Broca's death, Duval succeeded him, in 1880, as Director of the Laboratoire d'Anthropologie in Paris, where he led research in comparative embryology, the laws of development and of heredity. See E. Roc, 'Professeur Mathias Duval', op. cit., p. 1. Richer, another Darwinist, was also associated with the Société d'Anthropologie; see P. Richer, *L'Anatomie dans l'Art, Proportions du corps humain, canons artistiques et canons scientifiques*, Paris, 1893, esp. pp. 32–6, and his *Leçon d'Ouverture*, 25 November 1903, Ecole Nationale et Spéciale des Beaux-Arts, Paris, 1903.

86 The issue of a female gaze is too complex to address here, but a desiring, and potentially castrating, female gaze with regard to these photographs, and in photographic anatomies more generally, forms part of another study (Callen, op. cit. [in preparation]). Cf. T. Garb, 'The Forbidden Gaze: women artists and the male nude in late nineteenth-century France', in K. Adler and M. Pointon (eds.), *The Body Imaged*, Cambridge, 1993, pp. 33–42.

87 These drawings are conserved in the Département de morphologie, ENSBA. As Debord has pointed out, the female morphology produced by the era of the corset and included in Richer's book was in this respect already an anachronism by the time it was published. See Debord, 'De l'anatomie artistique à la morphologie', in Clair (ed.), op. cit., p. 112.

88 P. Richer, *L'Anatomie dans l'Art, Proportions du corps humain, canons artistiques et canons scientifiques*, Paris, 1893, pp. 31–2, 33, my emphasis.

© Association of Art Historians 1997

Art History ISSN 0141-6790 Vol. 20 No. 1 March 1997 pp. 61–99

The Student Years of the *Brücke* and their Teachers[1]

Peter Lasko

The *Studienbücher* – the study files – of the four students of the *Königliche Sächsische Technische Hochschule zu Dresden* who formed the *Brücke* association of artists in June 1905[2] still survive in the archives of what is now the Technical University of Dresden.[3] They are very nearly complete and give much information about courses taken, their teachers, and marks achieved by the four founding members: Fritz Bleyl, Ernst Ludwig Kirchner, Erich Heckel and Karl Schmidt, who added his birthplace Rottluff (near Chemnitz) to his name in his last year as a student. The survival of such documents after the devastating damage suffered by the city of Dresden in the war and after the change of the *Technische Hochschule* into a university, is a surprise.

Bleyl and Kirchner, both born in 1880, on 8 October and 6 May, joined the Highschool on the same day: 15 April 1901 (plates 16 and 18). Heckel, born on 31 July 1893, was admitted three years later on 21 April 1904 (plate 20), while Schmidt, the youngest, born 1 December 1884, enrolled only on 27 April 1905 (plate 22), in the year when both Kirchner and Bleyl completed their studies. In April 1906 Heckel requested leave of absence for the summer semester 1906 (granted on 10 May 1906) and later in that year, on 17 October, he asked to be finally released from the Highschool. Schmidt also sought leave of absence for the same semester of 1906, adding that he intended to 'devote himself for that period to the study of painting' (plate 23). In a letter granting the leave, dated 1 May 1906, the Rector lays down the conditions under which the leave was granted: on his return he is to register and to provide official proof of his activities during his absence. If, at the end of the leave, he does not return without having requested an extension of leave, he will be dismissed from the school and will forfeit his signing-on fee. In October of that year, now signing himself Schmidt-Rottluff, he asked for an extension of leave for the winter semester 1906–7 (granted 18 October 1906), and on 20 April 1907 he requested to be released finally from the Highschool (see Appendix A).

The department of the Technical High School all four students joined was that of architecture (*Hochbau*) which, despite a title which suggests that it was only concerned with structural engineering, obviously offered a wide education in architectural and interior design, freehand drawing and sketching, perspective drawing, the History of Art and Architecture, as well as both historical and practical aspects of the Applied Arts. The evidence of the seminars attended and

© Association of Art Historians 1997. Published by Blackwell Publishers, 108 Cowley Road, Oxford OX4 1JF, UK and 350 Main Street, Malden, MA 02148, USA.

the exercises (*Übungen*) that were required of the students is given by both the Enrolment Forms (*Einschreibebogen*) and the final examination submissions and results listed (plates 19 and 21, and Appendix B). What these documents make quite clear is that the often-stated claim that the *Brücke* artists were entirely self-taught (*Autodiktaten*) can hardly be sustained and is, at best, much exaggerated. A fuller examination of their years of study in Dresden and the influences to which they were exposed by their teachers, seems very worthwhile.[4] Both Bleyl and Kirchner achieved better than average marks throughout their careers and both comfortably passed their final *Diplom-Ingenieur* examinations on 1 July in 1905 (plate 17).[5]

Before analysing the enrolment forms common to all the files, the documents that are found in only one or another of the folders need to be mentioned. Evidence of school results, the *Reifezeugnis* (*Abitur* certificate), survives only in E.L. Kirchner's file.[6] He sat for his final examinations (*Maturitätszeugnis*) at his Grammar School (*Realgymnasium*) in Chemnitz between 18 and 25 February and took his oral exam on 18 March 1901. The *Reifezeugnis* of his school was handed to him on 29 May 1901, some three weeks after his twenty-first birthday on 6 May. He was an average pupil. His results in all but one of the fifteen subjects examined were an unrelieved 'satisfactory' (*genügend*), with marks of IIIa or III. They were:

Religious studies, German language, Latin, French, English, Geography, History, Natural History, Physics, Chemistry, elementary Mathematics, analytical Geometry, Perspective studies [*Projectionslehre*] and Gymnastics (*Turnen*).

He achieved an 'Excellent' (*vorzüglich*) with the mark of I, only in what was obviously his favourite subject: Freehand Drawing (*Freihandzeichnen*). His overall mark was a III, the lowest pass mark. No doubt the fact that he achieved only one high mark – in drawing – underlines his early desire to take up the study of the arts. But it was architecture at the Technical High School rather than drawing and painting at the Academy, which he would probably have preferred, that his father permitted him to study.[7] If today's normal standards are at all comparable, the fact that he achieved a satisfactory standard in both French and English language no doubt meant that he was able to read the periodical literature in both languages, such as The *Studio* which was specifically mentioned by Fritz Bleyl as of special interest to them in their early years.[8]

Fritz Bleyl entered the Technical High School on the same day. The poor financial situation of the Bleyl family stood in marked contrast to Kirchner's, whose father was a chemical engineer who bore the title 'Professor' on the Entry Registration. This is clear from the applications for a stipendium Bleyl made in every year from 1901 to 1904. He even requested help with the cost of a student excursion in July 1902.[9] The first application for a stipend, dated 7 May 1901, was accompanied by a document issued by the Town Council of Zwickau, the family's place of residence, on 3 May 1901. It gives full details of the family's circumstances in a series of columns. His father, Hilmar Heinrich Bleyl's profession is listed as Businessman or Trader (*Kaufmann*), but he was employed

© Association of Art Historians 1997

16 Hilmar Friedrich Bleyl,
Registration, 15 April 1901.
Technische Universität
Dresden.

at the time as book-keeper by Hugo Frey, Builder. His mother Alma's maiden name was Falck. The form asks how many brothers or sisters the applicant has, and whether they are able to assist the applicant financially. Three are listed: Käthchen Louise, nineteen years of age, who is said to assist in her parent's home; Gustav Adolf, fifteen, who attends the *Realgymnasium* in Zwickau; and Herbert, aged four. The income of the family is given as 2,496 M. per annum, and it is stated that the family has no property 'at this time'. The debts of the family are given as 2,400 M., consisting of loans of 1,800 M. from Frau Falck, and 600 M. from Frau Bleyl, widow, Hilmar Heinrich's mother-in-law and mother respectively. In the column asking whether anyone else, or any other relative can assist his studies, it is declared that he will receive 40 M. per month each, from his widowed Grandmother Friederieke Falck in Zwickau and from his uncle Arthur Bleyl, *Kassendirektor* (cashier) residing in Oelsnitz im Erzgebirge.

© Association of Art Historians 1997

Diplom u. Schlußprüfung.
(Neue Prüf. Vota.)

Hochbaufach.

Studienzeichnungen
des Studierenden Friedrich Bleyl.

Zeichnungen.	Zu beurteilen von Herrn	zuteile Note.	Unterschrift.
Perspektivische, mit Schatten versehene Darstellung eines beaufsichtigt	Professor Weichardt.	1ᵉ	C. Weichardt
Darstellungen aus dem Gebiete der Stein-, Holz- und Schreinerei, Konstruktionen.	Professor Köhm.	2ᵃ	Köhm
Darstellungen ganzer Gebäude oder einzelner Bauteile aus der antiken, mittelalterlichen und Renaissance-Baukunst.	Prof. Hartung.	2ᵃ	Hugo Hartung
	Prof. Weißbach.	2ᵉ	K. Weißbach.
Einfache und reichere Kylindrische vorstehnegartiger Gebäudegattungen.	Professor Köhm. " Hartung. " Weißbach	2ᵃ	Hugo Hartung
		2ᵃ	K. Weißbach.
Darstellungen von Ornamenten und fartigen dekorationen, Denkmäler und Naturstudien.	Professor Weichardt.	1ᵉ	C. Weichardt
Darstellung eines ganzen Gebäudes oder erheblicher Teile eines umfangreichen Bauwerkes nach eigener Aufnahme.	Professor Weichardt.	2ᵃ	C. Weichardt
		1·87	

17 Hilmar Friedrich Bleyl, Final Examination, marks given to drawings submitted (1 July 1905). Technische Universität Dresden.

On his application form Fritz Bleyl states that it was only because the fees were reduced by a half that he was able to attend the *Realgymnasium* in Zwickau, and that the help he was to receive from his grandmother and his uncle were to be loans, without interest. The *Technische Hochschule* refused financial help in 1901, but, perhaps because of the good marks achieved in his first year, it must have been granted by 1902, because it was renewed in both 1903 and 1904. The request for the renewal of the stipend, dated 6 November 1903, survives. The sums granted are entered in the margin of the application for help. It is noted that Bleyl has served his sixth semester and that at Easter 1903, he passed his preliminary Diploma examination, and that he was granted 300 M. for the year 1903–04. On 14

64

© Association of Art Historians 1997

18 Ernst Ludwig Kirchner, Registration, 15 April 1901. Technische Universität Dresden.

December 1903 in the winter semester of 1903–04, the sum of 180 M. seems to have been 'paid in arrears', which might mean that it was a grant for the year 1902–03. On the request for renewal dated 7 May 1904, the stipend of 300 M. for 1903 is noted again, and the sum of 460 M. is granted for the year 1904–05, dated 4 July 1904.[10] As the request in 1904 makes clear, the total Bleyl received in 1903–04 was 300 M. After having paid his tuition fees of 198 M. for the two semesters, it only added 102 M. or 8.50 M. per month to the allowance of 80 M. per month he received from his grandmother and his uncle. But his total annual income, amounting to 1,096 M. after fees had been paid, is hardly evidence of real hardship when seen against the total income of 2,496 M. declared by his father for a family with three children. In 1904–05, when his fees were 193 M. and he was awarded a stipend of 460 M., his monthly income may have risen to 102.25 M.

© Association of Art Historians 1997

19 Ernst Ludwig Kirschner, Enrolment Form, Summer Semester 1901. Technische Universität Dresden.

In 1902 he was granted an additional 30 M. for the student excursion, probably that led by Professor Cornelius Gurlitt to Bautzen, Altzella and Nossen, the only one recorded for that year in the *Hochbau* department.[11] In Bautzen, the district capital, some 60 kilometres east of Dresden, no doubt the mainly sixteenth-century Schloss Ortenburg and the thirteenth-century cathedral were visited. Nossen also had a *Schloss* and in Altzella the thirteenth-century ruined Cistercian Abbey, which was later published by Gurlitt, must have been studied.[12]

The difference between Bleyl's financial situation and that of Kirchner is underlined by the fact that Bleyl always paid his semester fees some two, or even on occasion, three months later than his friend. It may be that Bleyl's student years were financially more constrained than might appear from the given facts, especially if the sums promised by his relatives were not always received, or were

© Association of Art Historians 1997

20 Reinhold Erich
Heckel, Registration, 21
April 1903. Technische
Universität Dresden.

sent to him late. Also, if the help of his grandmother and his uncle really were loans, he was left with considerable debts at the end of his studies.[13]

Details of school performance or financial status do not survive in the files of Erich Heckel and Karl Schmidt. Of course, both their files are much thinner, covering only the years from the summer of 1904 to October 1906 in the case of Heckel, and from the summer of 1905 until April 1907 for Karl Schmidt. There appears to be no record of Schmidt having even paid his fees in either of the two semesters he attended, the Summer of 1905 and the Winter of 1905–06 and obviously Heckel having studied for only four and Schmidt for only two semesters, neither completed their diploma studies.

© Association of Art Historians 1997

21 Reinhold Erich Heckel, Enrolment Form, Summer Semester 1904. Technische Universität Dresden.

The enrolment forms and courses of study

The Enrolment forms in Appendix B (page 87) list the lectures and practical seminars attended, but it should be remembered that students were, of course, free to attend any of the lectures given in the Technical Highschool, although the time taken up by the courses attended would leave little opportunity to do so. Enrolment meant that students were committed to fulfil the requirements of written work and or examinations attached to them. No mark given, indicated by a K.Z. (*Keine Ziffer*), means either that it was a course of lectures only and

© Association of Art Historians 1997

22 Karl Friedrich
Schmidt,
Enrolment Form,
27 April 1905.
Technische
Universität
Dresden.

attracted no mark, or that having enrolled on the course, the student did not fulfil
the written work requirements. The *Abgangs-Zeugnis* (Leaving Report) of the
Highschool, given to Kirchner on his departure for Munich for the Winter
semester, makes that clear. For example, in the course taught by Professor Helm
in the Summer Semester 1901 called *Analytische Geometrie I*, which consisted of
both *Vortrag* and *Übungen*, a K.Z. is given, suggesting that the student did not
fulfil the requirements of the practicals, while *Darstellende Geometrie I*, taught by
Professor Rohn, also had both lectures and exercises and the mark 2a is noted for
the latter. Professor Fuhrmann in the same semester gave lectures only and a K.Z.
is of course entered.

The *Verzeichnisse der Vorlesungen* (Lecture List) published for each semester
gives further details of the courses offered, which seem to vary considerably in
duration. Thus, for example, the list for 1905–06 shows that Professor Böhm's

© Association of Art Historians 1997

23 Karl Friedrich Schmidt, Application for leave of absence, 23 April 1906. Technische Universität Dresden.

Baukonsgruktionslehre (taken that year by Heckel and Schmidt, and by Bleyl and Kirchner in 1901–02) did not consist of just one or two lectures a week, but expected attendance on Monday and Thursday 2–5 pm, Tuesday 10–12 am, Friday 10–11 am – a heavy load indeed; while those taken by Bleyl and Kirchner with Professor Schumacher, *Bauformen der Antike* on Wednesday 4–7 pm, Friday 5–7 pm and Saturday 2–5 pm and *Freihandzeichnen* on Wednesday 2–4 pm, Thursday 11 am–1 pm and Friday 10–12 am, added another fifteen hours. Bearing in mind that Bleyl and Kirchner took another five seminars in 1901–02 in other departments, their total class work in the week must have amounted to well over thirty-five hours. Other seminars were less demanding. For example Professor Oehme's *Aquarellmalen* only occupied the two hours between 10 am and 12 am on Saturdays, and Professor Sponsel's *Die Kunst des 18. Jahrhunderts in Dresden*, only Wednesday 5–6 pm. Clearly, students received a surprising amount of tuition for six days a week, some classes beginning at 8 am and others ending as late as 7 pm. The withdrawal from some courses on their lists may have been caused by timetable clashes, or simply because the load was too heavy.

© Association of Art Historians 1997

Obviously, there was little time left to attend other lectures that might have interested them.[14]

The majority of seminars taken by Bleyl and Kirchner were those of a technical and mathematical nature strictly necessary for their architectural studies, like those taught by Professors Böhm, Fuhrmann, Helm, or Weissbach (see Appendix C, page 91). But they were not by any means the only subjects studied. Of the eleven seminars Bleyl and Kirchner signed up for in their first semester, six were strictly 'architectural', two were 'neutral', two were 'Drawing' courses. One strictly 'art-historical' course was taken by Kirchner, while Bleyl took a 'Photographic' course instead. The proportion of purely 'technical' seminars to more 'historical' or 'artistic' options does not seem to alter much throughout the five years of study, but perhaps a somewhat greater emphasis on historical/philosophical studies may be noted on the part of Bleyl during the Winter Semester of 1903–04, when he signed up for two seminars with Professor Gurlitt (the History of Architecture from the Baroque to the present, and Wood Architecture), two with Professor Lücke (Art of the Italian Renaissance and Principles of Aesthetics), and one with Professor Treu (Greek sculpture). Perhaps it was a reaction to the absence of Kirchner, who, in the Winter Semester 1903–04 was enjoying his studies at the Technical College in Munich, and the Debschitz/Obrist school.

In the freehand drawing classes of Schumacher both Bleyl and Kirchner achieved better than average marks, Bleyl normally achieving the better marks, quite frequently a 1a, while Kirchner usually got marks of 2a or b, although once, in his second seminar, he did manage to get a 1b. Indeed, throughout their careers, Bleyl, perhaps because he was conscious of the financial sacrifices his family had to make, always worked hard to achieve slightly higher marks than Kirchner. The immediate need to earn his living and perhaps to repay his debts to his grandmother and his uncle were very likely major factors in his decision to accept a teaching post at the *Bauschule* in Freiberg in October 1906, shortly after leaving his studies in July 1905.[15]

Kirchner's experience in Munich in the Winter Semester of 1903–04, was certainly of considerable importance. It may well have been instrumental in finally confirming his decision to turn towards a far wider view of the visual arts, spanning not only architectural interior design and the applied arts, but also sculpture, graphic art, drawing and painting. Besides the teaching of Professor Anton Hess in modelling and of Professor P. Pfannin in landscape and figure drawing at the Technical College, the far more important influence was the intellectual stimulus he must have received during his attendance in the evenings, at the progressive art school of Wilhelm von Debschitz and Hermann Obrist, only recently opened in January 1902. He may well have been encouraged to spend a semester in Munich because of the fame of Hermann Obrist and the appreciation of his work found in *Dekorative Kunst*, the 'leading periodical of the Moderns', as Fritz Schumacher later called it. It is also possible that Schumacher met Obrist personally, because Obrist was one of only three artists who contributed to the discussions at the *Kunsterziehungstages* (Art Education Day-Conference) held in Dresden on 28–9 September 1901. It is perhaps surprising that none of the teachers at the Technical High School attended this conference, or if they did, that they did

not contribute papers or take part in the discussions. Only W. von Seidlitz, the Director of the Dresden Royal collections, who was a member of the organizing committee, and Georg Treu, who was the Director of the Royal Sculpture Collection, which was the venue of the conference, can be shown to have taken part. The great majority of participants were civil servants and school teachers, including a number from Dresden, and the main emphasis of the discussions was on the teaching of art in primary and secondary schools, and the encouragement of art appreciation among the general public. Local contributors to discussions were Professor Thieme, the first editor of the Thieme-Becker Dictionary of Artists, Ferdinand Avenarius, founder and owner of the influential *Kunstwart* periodical, and Dr Paul Schumann, writer and critic and frequent contributor to *Kunst für Alle*.[16]

In Munich, Kirchner would not only have received a thorough grounding in Art Nouveau, but would also have enjoyed the encouragement to develop his own talents rather than depend on traditional values and historicism. Debschitz's (b. 1871) background was formed in the *Wiener Werkstätte*, but his energy went mainly into the administration of the school. Hermann Obrist (1863–1972), designer and sculptor, eight years older than Debschitz, was the more experienced artist, having studied in Weimar and Karlsruhe as well as in Paris and Florence. He was no doubt the more important intellectual influence on the students. Through his Scottish mother and an extended visit to Britain in 1887 he knew a great deal about William Morris, and the British Arts and Crafts Movement,[17] which fed the roots of his belief in the importance of the 'Applied Arts' – *Kunstgewerbe* – as fundamental to the training of artists, and indeed to the fine arts themselves. His attitude to the development of artistic talent is well documented, as well as his work with students in the studio. He held seminars every Thursday evening,[18] when he lectured and freely discussed his theoretical position, which is clearly expressed in his writings:[19]

> Art presents heightened, intensive sensations, art is condensed sensation, factually condensed and intensively felt life. Or more exactly expressed: for the productive artist art is Feeling, Hearing or Seeing and the presentation of the Heard, the Seen or the Felt, which, either in reality or in the imagination he feels, hears or sees more vibrantly and less affected by the trivial, than ordinary human beings, and he presents by heightened, energetically intensified means appropriate to his art. And for the consuming layman, art is the reception, the taking, the sympathizing, the experiencing of the given, heightened life of the artist. And only then is a work artistic, when such effects are released.[20]

Obrist's view of the artist's creativity and the artist's place in society would undoubtedly have had immense appeal for the young Kirchner, and seems to have influenced him deeply. In 'An artistic art education', published in 1900, Obrist writes:

> God protect you, young man, from that famous Professor, who for years exhibits only yellow-grey-brown canvases ...

© Association of Art Historians 1997

... so now numerous young painters have for some time worked on their own as half or totally self-taught artists.[21]

Indeed, the whole tone of Obrist's essay, cast in the mould of a direct address to the reader, strongly reminds one of the 'Manifesto' – or as they called it *Unser Programm* – written by Kirchner and his friends in 1905. It reads:

With a belief in progress, in a new generation of creators and connoisseurs, we call all youth together and as youth, who carry the future, we want to achieve freedom of life and action against the well established older forces. All are with us, who directly and without falsification present what drives them to create.[22]

Not only in the underlying sense Obrist's essay seems to foreshadow it, but even in some of the phrases in which it is expressed:

... Yearning in all youth, which wants to create art ... And many fight and work long and hard, to remain that which they wanted to become: artists. Those then, who always strive to improve themselves, those we can liberate ...
... he shall now, with enthusiasm, deepen, strengthen, heighten to something more than mere nature, to an artistic creation, by presenting that, which stirred him intensively, so that the spectator receives the same strong feelings the artist himself had experienced.[23]

The attitude to creativity of the young *Brücke* artists, and a little later, their appreciation of 'Primitive' art, is also clearly foreshadowed in another of Obrist's essays, entitled 'The Future of our Architecture':

Much rather we could ponder on such peoples, who created relatively original works, as for example, the early Greeks and the 'Gothics', or still further back, for instance the old Vikings, or even the savages of the South Sea Islands ... No, we should only create, as they created; unselfconsciously, truthfully, simply, as it came to them naturally ...
 We must again become what human beings were earlier: Creative. If you do not become like children, so you will not enter the realm of creative art.[24]

In addition to the attendance at the Debschitz school, Kirchner almost certainly also came into contact with at least two of the avant-Garde movements in Munich: the 'Phalanx' led by Wassily Kandinsky and the Dachau group of Adolf Hölzel.[25] He is very likely to have visited the two Phalanx exhibitions, held simultaneously in the spring of 1904, one dealing with Munich Graphics in the Galerie Helbing, the other going under the title of 'Impressionism', where he would have seen several coloured woodcuts and drawings by Kandinsky.[26] There were also many other exhibitions he would have seen in his time in Munich from October 1903 until late in May 1904.[27] In the Munich Secession, for example,

over 300 works of art were shown in the spring of 1904, including works by progressive artists like Lovis Corinth, Adolf Hölzel, Hermann Pleuer and Hanns Purrmann. But it must not be overlooked that the works of the same artists and many more, amounting to well over 2,000 works including a retrospective as well as a foreign section, were shown in the *Grosse Kunstaustellung* held in Dresden in the same year, from May to October 1904, which Bleyl and Heckel would have visited, and which Kirchner could, and surely would have seen after his return to Dresden.

Heckel, who only took up his studies in the Summer of 1904, after Kirchner's return, took Schumacher's freehand drawing course twice, in his second and third semesters, and Karl Schmidt took it once only in his first and last semester, Summer 1905. Neither achieved any marks for their participation. Kirchner and Bleyl took several seminars in Geometry and Perspective, both in lectures and practical study. Professor Karl Rohn offered 'Pictorial Geometry' (*Darstellende Geometrie*), and the same course was taken by Karl Schmidt in the summer of 1905, but taught by Professor Disteli. In a course offered by Professor Karl Weichardt, design of ornament and practical perspective was taught as well as drawing in life classes, all of which must have been of particular interest to the students. Both Kirchner and Bleyl regularly achieved marks varying from 1b to 2b. How significant Weichardt's tuition in figure drawing was, of course, is not easy to determine. That his talents may have been somewhat limited is suggested by the fact that his contribution to a book edited by O. Mothes was restricted to the architectural drawings of a 'modern' Music Room, a 'Pompeian' Vestibule, a 'Roccoco' Living Room and a 'Gothic' Hunting Hall, while the figures were added to the scenes Weichardt had created, by another artist – J. Schmid.[28] As a watercolourist he achieved some critical acclaim for his Italian landscapes: they are called 'splendid watercolours true to nature' by Bruno Petzold.[29]

With his interest in creative art, it is surprising that Kirchner never signed up for a semester's study under Professor Erwin Oehme, a well-known Dresden landscape and genre painter, even though he took the course in freehand drawing offered by Fritz Schumacher no less than six times in his nine semesters and twice took courses which included drawing, taught by Karl Weichardt and by Paul Wallot. Erwin Oehme was born in 1831, the son of E.F. Oehme (1797–1855). He studied under his father and Ludwig Richter, and became a member of the Dresden Academy in 1864. He took a prominent part in two of the major decorative schemes commissioned in Dresden in the second half of the nineteenth century: at the Court Opera House and in the new Theatre in Dresden-Neustadt. He is known to have travelled widely in Germany as well as in France and England.[30] He was appointed Professor for aquarelle painting in the Technical High School in 1887, a post he held in parallel with his appointment at the Dresden Academy, until his death in 1907. Perhaps it may be possible to conclude that Kirchner decided that Oehme, who was already in his seventies at the time, worked in a style that was really too dated and perhaps too dull for his tastes. Fritz Bleyl, on the other hand, whose earliest known work was more traditional, even if it was influenced somewhat by the progressive 'Jugendstil',[31] intended to take a seminar taught by Oehme. He signed up for his *Aquarellmalen* in the winter of 1903–04, while Kirchner was in Munich, and again in the Summer

© Association of Art Historians 1997

semester of 1904, but apparently he changed his mind on both occasions, and the entries are crossed out on his enrolment form.

In the art-historical field, a fairly wide range was offered by Professor Gurlitt whose lectures on the history of Architecture in Antiquity, the Renaissance, and selected chapters of Aesthetics were attended by both Kirchner and Bleyl; those on the artistic problems of town planning were also attended by Heckel. The 'History of Architecture from the Baroque to the Present' was taken by Bleyl while Kirchner was in Munich; 'Wooden Architecture, Ceramics in Architecture and History of Architecture' (without definition) were taken by Bleyl only, and 'Brick Architecture' was taken by Kirchner. Professor Hermann Lücke offered 'Art of the Italian Renaissance', which, together with Professor Georg Treu's 'Greek Sculpture II', was taken by Bleyl when Kirchner was away. It may be noted that there was a rather more traditional trend in the courses taken by Bleyl during Kirchner's absence. He also attended the perhaps more theoretical lectures given by Lücke on 'Aesthetic Principles' in modern developments in Art, which perhaps did not attract Kirchner. But against that, it might be noted that both attended Gurlitt's 'Selected Chapters of Aesthetics'. Treu's lectures on the 'Sculpture of Antiquity' were attended by both Kirchner and Bleyl, but Kirchner alone signed up for Treu's 'Sculpture of the nineteenth century', and that, surprisingly, twice, in both his first and second semester. One suspects that the programme of his first semester was too full and strenuous for the young, inexperienced student, and the subject interested him enough to retake it in the following semester, although it should be noted that he received no mark in either semester, which suggests that he attended only lectures.

The content of the seminars on *Stillehre des Kunstgewerbes* (Style of the Applied Arts) and *Kunstgewerbliche Übungen* (Applied Arts Practicals) taught by Professor Schumacher, attended by Kirchner, Bleyl and Heckel, may have been historical as well as practical, while Professor Bruck's seminar taken by both Kirchner and Bleyl, on 'Medieval Applied Arts', was clearly historical. Bruck also taught a seminar on 'Art and Applied Art with reference to Industry', attended by Bleyl in 1905, and the interesting seminar on Dresden Museums, taken by Kirchner in the Winter of 1904–05. Unfortunately, it is not known which museums were visited. Although it is perhaps unlikely that Bruck would have included it, one is bound to wonder whether the Ethnographical Museum was visited, which Kirchner in later years claimed to have become aware of by 1904.[32] Professor Hartung also taught a medieval seminar with a practical component and probably, judging by his other courses, he taught with an architectural content, called *Formenlehre des Mittelalters* (Study of Form and Structure in the Middle Ages), taken by Kirchner and Bleyl in 1902, by Heckel in 1904, and Schmidt in 1905.

Bearing in mind the role played by Erich Heckel certainly in the early years, and probably throughout the existence of the *Brücke*, it is interesting to note that only he took a 'practical' course in economics (*Volkswirtschaftliche Übungen*), taught by Professor Wuttke in the Winter semester 1905–06, after the *Brücke* had been founded on 7 June of that year. In 1906 the business activity of enrolling passive members of the *Brücke* began with the first of the annual folders of prints, with three woodcuts, all cut in 1905: Fritz Bleyl's *Haus mit Freitreppe*, Erich Heckel's *Die Schwestern*, and Ernst Ludwig Kirchner's *Kauernder Akt*.[33]

Preliminary and final examinations

Preliminary examinations for the Final Diploma were held in April 1903 and the *Protokoll* of them for both Bleyl and Kirchner survive. In their submitted *Studienzeichnungen* (Study drawings), both were awarded a 2a – 'average'.[34] The details of these drawings are given in separate *Protokoll* which survive in both Bleyl's file (plate 17) and Kirchner's. They were awarded a 2a-b and 2a by Professor Rohn for perspective drawing respectively and a 2a and 2b by Professor Böhm for representations of stone and wood constructions and design. Professor Schumacher gave them 1b and 1b in freehand drawing and 1b and 2a in studies of forms in Antique architecture. Professor Fuhrmann marked his 'technical' drawings of elevation and plan 1b and 2b. For the design of a small building with special consideration of its construction, Professor Böhm awarded them 2a and 2b. These marks are added up to make 10.75 and 13.0 and give a numerical average of 1.8; 2.1 which is expressed as a 2a result for both students.

The marks in the oral examinations recorded on 30 April 1903, for both Bleyl and Kirchner respectively were: 'Physics, (Hallwachs) 2b and 3a; Chemistry, (Hempel) 2a and 2a; Pictorial Geometry, (Rohn) 2b and 2a; Structural studies, (Böhm) 2b and 2b; Building Materials studies, (Förster) 2b and 2a; Architectural studies, (Böhm) 2a and 2a; and, under examination condition (*Klausur*), Freehand drawing (Schumacher) 1a and 2b. Bleyl's overall mark is given as 17 = 2.1, and Kirchner's as 18.8 = 2.25. Both passed in all subjects and were awarded a final 'Good' grade.

The final examination in 1905 consisted of the submission of study drawings, an oral examination and a 'Diploma work'. For both Bleyl and Kirchner the same study drawings are listed, and the marks awarded by the relevant Professors were, as follows. For 'Perspective representation of a building, with shadows', Weichardt awarded a 1b to Bleyl and a 2a to Kirchner. For 'Representations from the area of stone, wood and iron constructions', both achieved a 2a from Böhm. For 'Representation of whole buildings or parts of them, from the Antique, Middle Ages and Renaissance', marked by both Hartung and Weißach, both were awarded two 2a marks each. For 'Simple and more complicated designs of various types of buildings', the same Professors gave each student a 2a. For 'Representations of ornaments and coloured decorations, designs of ornaments and nature studies', Weichardt gave a 1a to Bleyl and a 2a to Kirchner. Finally, for 'A personally drawn representation of a whole building, or substantial parts of a large one' a 2a was awarded to both students by Weichardt. The average mark for this part of the examination, entered on the final examination *Protokoll* was a 2a for both candidates.

The Oral subjects taken on 1 July 1905, Bleyl and Kirchner achieved the following marks: Town and Country building, Public Buildings (Weißach) 2a and 2a; Private dwellings (Hartung) 2a and 2a; Study of Building construction, with application of engineering (Böhm) 2b and 2b; Heating and ventilation plant, with consideration of Hygiene (Frühling) 2b and 2b; Study of style and history of Antique, Early Christian, Medieval and Renaissance architecture (Gurlitt) 2a and 2b; and Style study of the applied arts (Gurlitt) 2a and 2b.[35] The result for both was: Good pass (*Gut bestanden*)

© Association of Art Historians 1997

As Diploma work, Bleyl submitted a *Wandelhalle für ein feines Bad* (Foyer for Fine Baths), and Kirchner a *Friedhofsanlage* (Graveyard layout). Professor Weichardt awarded them a 1b and a 2a respectively.

Finally, Professor Schumacher's report that soon after finals Kirchner expressed a desire to obtain a doctorate with the submission of some drawings, which the Professor considered to be totally inadequate, tends to underline his serious interest in academic qualifications.

The Professors

Only members of the faculty whose seminars the *Brücke* students attended are included in this section. In many cases their lives and their work are not well documented. Although frequently something is known of their careers, less is known of the content their of courses, or what their teaching was like. Only Fritz Schumacher, one of the more important teachers of the *Brücke* artists, has given us some insight into his teaching methods,[37] but Cornelius Gurlitt's published work does give us a great deal of interesting evidence of the cast of his mind, and therefore an idea of what his teaching must have been like.

Professor Theodore Böhm's *Baukonstruktionslehre I – IV, Statik und Festigkeitslehre*, and *Architektonisches und technisches Zeichnen* were taken by Kirchner and Bleyl in four semesters and by Heckel in three. These courses were fundamental to their architectural studies, so it is not surprising that they were the seminars most frequently attended. Böhm studied in Berlin from 1868 to 1871, and took his final architect's exams in Rome in 1876. For the next three years he was active in the Potsdam Garrison, and in Berlin thereafter. In 1901 he was called to Dresden to fill the post vacated by Rudolf Heyn and from 1906 to 1908 he led the *Hochbau* faculty. The faculty was then split, in order to give structural engineering greater importance. His professional activity included work on the German Embassy in Rome, the Anhalter Railway Station in Berlin, as well as army barracks in Potsdam and Berlin. In 1900 he was largely responsible for the transformation of the interior of the oldest medieval church in Dresden, the *Kreuzkirche*, first restored in 1491 and again in 1741–5. In 1910 he was given sick leave and in the following year had to retire. His main interests seem to have been in structural and engineering problems rather than architectural design.[38]

Lectures and seminars taught by other professors are listed in Appendix C (see page 91). Most of them, like 'Technical Drawing' by Professor Buhle, 'Building Materials' by Professor Foerster, or 'Heating and Ventilation' by Professor Frühling were, of course, purely part of the architectural training of the students. Others, like 'Pictorial Geometry' (*Darstellende Geometrie*) by Professor Rohn, 'Sketching in the area of architecture', taught by Professor Wallot, along with Professor Schumacher's 'Freehand drawing' and Professor Weichardt's classes that included life drawing, were of deeper interest to their painterly ambitions.[39] It might be noted that the rejection of the conventional rules of perspective in the later work of the '*Brücke*' is therefore based on conscious intention rather than on ignorance.

The two best-known, and possibly the most influential Dresden Professors were Cornelius Gurlitt and Fritz Schumacher. According to Schumacher's evidence, Professor Gurlitt, who was nearly twenty years his senior, was a kind of *Stammvater* (father/progenitor) to the department. He not only disliked all things antiquated, indolent and bureaucratic, but it gave him particular pleasure to display such dislikes, both wittily and forcefully. But he was not merely negative; he had the rare gift of constructive criticism. His natural instinct, his agile-minded and adaptable intellect, enabled him to sense the lines of future developments, and he took pride in playing an active part in defining them.[40]

Cornelius Gurlitt was the son of the painter Louis Gurlitt (1812–97), and his younger brother Fritz, who died in 1896 aged only forty-two, was an art dealer of considerable importance, both of older and contemporary art.[41] Cornelius was 'Professor of the History of Architecture and Style of the technical and tectonic Arts' from 1893 until 1920. His literary output was extensive. In 1886 to 1888 he published his three-volume *Geschichte des Barockstils, Rokoko und Klassizismus*; in 1899 there was *Die Deutsche Kunst des 19. Jahrhundert*, followed by *Die Baukunst Frankreichs*, in 1899–1901, and he had just completed his two-volume *Geschichte der Kunst* in 1902, when the students attended his lectures. His lectures on *Die künstlerischen Aufgaben im Städtebau*, attended by Kirchner, Bleyl and Heckel in the summer of 1904, no doubt led eventually to the publication of his *Handbuch des Städtebau* in 1920. A fairly accurate picture of the content of his lectures may be inferred from Gurlitt's published work. The importance he attached to visual material in his teaching is shown by the fact that he formed a collection of plans, drawings and reproductions of architecture, which he made publicly accessible in the Technical High School in 1896, to further the teaching and research of the history of art.[42]

For our purposes, it is worthwhile to try to form an idea of his opinions on the arts and especially his judgements of the contemporary arts, both 'applied' and 'fine'. Among his publications, nothing does that better than the consideration of his voluminous book on the nineteenth century, where he deals with the history of German art, and with many a sideways glance at French and English art as well. He examines work right up to 1900 in the second edition, the first edition of 3,000 copies published in 1899 having sold out within the year.

In his seventh chapter, entitled *Des Streben nach Wahrheit* (The Striving for Truth), he deals mainly with Realism, Naturalism and Impressionism. Unlike most contemporary critics, Gurlitt attempts to differentiate between these movements. His appreciation of French Impressionism is surprisingly wholehearted at such an early date:

> We want the sun, the light, the open air, a straightforward, bold painting, which represents the object, as it appears in the light; we want to paint what our eyes see and comprehend. To see everything, to paint everything! Life, as it is lived on the street, the life of the poor as well as of the rich, in the markets, at the races, on the Boulevards and in the alleys ...[43]

and again, a little later:

© Association of Art Historians 1997

The new view sees beauties in all light ... that on a sunny midday a bluish white, in the morning a deep violet, in the evening a reddish brown, and finally a deep blue lies over all colours, such a strong tone, that outline and local colour disappear under them ...[44]

Gurlitt, of course, relates French Impressionism to *Hellmalerei* (light/bright painting) and Naturalism in Germany, but like most contemporary critics, he sees German art, probably correctly, as mainly influenced by the Netherlands and not France. The eventual background of the freedom of handling in Naturalism was seen to be Velasquez and Manet in the case of France, but Rembrandt and Hals in Germany. His knowledge of Impressionism in France seems to be restricted to the work of Manet, with just a mention of the younger Monet. He writes:

So in 1886 Zola made his painter say, what twenty years earlier buzzed in young heads in Paris. It is Manet, whom he describes, it is the Impressionists. They first came to the fore in 1863, derided, ridiculed. Today no painter is uninfluenced by them. They have conquered the world, as thirty years earlier had the Romantics.[45]

He also supports the 'Realists' and especially the work of Max Liebermann, whom he ranks among them. He defends him against the implied attack by the eminent thinker Konrad Fiedler, in his undifferentiated censures of 'Realism', 'Naturalism' and 'Impressionism'. Fiedler saw in all these contemporary movements an unfortunate attempt on the part of artists to vie with the natural sciences, which were engaged in an entirely laudable search for the 'Truth' in the second half of the nineteenth century.[46] According to him, this tendency in the spiritual life, as distinct from the scientific, is bound to result in the loss of all individuality and idealism in the arts. 'Artistic activity ... must inevitably make itself the slave of Reality – its Reality is then fundamentally its only value,' as he puts it.[47] Fiedler ends with; '[One day] ... there will again be great Artists, and one will then speak of this latest Naturalism that has arisen so ambitiously and has prided itself as epoch-making, as only one of the aberrations which arise and die, as long as there are human beings.'[48]

Cornelius Gurlitt, on the other hand, develops a positive view of Impressionism and Naturalism, very like the one so passionately argued by Julius Meier-Graefe some five years later.[49] He sees it as a fresh, new and above all, a valid vision of life, both in style and content. Nothing makes his contrasting view of art with that of Konrad Fiedler more telling than the statement that 'The entire Art of the past is a glossing over, a distortion of Reality',[50] and he continues: 'Already Zola calls the turnip a subject of art of equal value with all the intellectual subjects of the ancients.'[51]

The same thought is even more vividly expressed, when he discusses the work of Liebermann:

It is not a matter of content only, content has not necessarily anything to do with art; a well-painted turnip is a greater work of art than a badly painted Ascension.[52]

© Association of Art Historians 1997

Later in the chapter Gurlitt mentions important foreigners who had exhibited in Germany: the Scots in Munich in 1891, the Norwegians and Swedes, including Thaulow, Zorn and even Munch, who 'each brought new discoveries', the American Whistler's 'poetic colour', the Italian Segantini's divisionism, with 'colours placed next to each other to effect fusion only at a distance'. He is also aware of the 'Belgians', who 'were first to dissolve the surface in coloured dots.'[53] A number of the avant-garde groups in Germany are mentioned, including Dachau, although Hölzel at its centre is not mentioned by name, while surprisingly, in the case of Worpswede, all the early members of the group are named, and their exhibition in Munich in 1895 is treated very sympathetically.[54]

In the last chapter of the book, entitled '*Die Kunst aus Eigenem*' (literally: Art 'out of oneself' – perhaps better: 'The Art of Individualists'), he deals mainly with those German painters, like Hans von Marées, Feuerbach and Böcklin, whose creative work he sees as driven by an 'inner necessity',[55] as well as Thoma and Klinger, whose work he found difficult to classify. After paying what was perhaps diplomatic lipservice to the quality of the 'nineteenth-century baroque' architecture of his colleague in Dresden, Paul Wallot, who designed the '*Reichstag*' building in Berlin,[56] he quotes the Viennese architect Otto Wagner's dictum with approval: 'The starting point of artistic creation must be modern life.'[57] He puts on record his appreciation of a building designed by Joseph Olbrich, one of Wagner's students, the exhibition hall for the Vienna Secession completed 1899 – a work that reflects a sensitive response to Art Nouveau elements:

> How small stood the Secession in its glorious white and its modest gold, in the midst of massive buildings ... the effect of the interior, in regard to its mood, belongs to the finest creations I have ever experienced ...[58]

In painting too, he is aware of only some of the latest movements. Cézanne, Van Gogh or Gauguin, for example, who were to play such an important part in Meier-Graefe's '*Entwicklungsgeschichte der modernen Kunst*' only four years later, are not mentioned. However, he is appreciative of some avant-garde artists born around 1860 – particularly those of Belgium – like Jan Thoroop, who exhibited in Munich in 1893, Khnopff, Rysselbergh and, even more surprisingly, James Ensor, the strange recluse, who were all members of the 'Société des Vingt'.[59]

Perhaps the most significant part of this chapter for our purposes is Gurlitt's discussion of the 'Decorative and Applied Arts':

> There is a strong revolutionary trait in the 'Applied Arts', similar to that of the painters' Realism. One of the most often mentioned representatives of this tendency, Van der Velde, is of the opinion that unless one destroys the contemporary, Art cannot rise in a new form: cannot blossom in the fertile soil of work. To completely forget the old styles is its foundation.[60]

Gurlitt sees in the Applied Arts a future development of individuality and originality of style, breaking away from traditional characteristics, much in line

80

with the thinking of Van der Velde and others.[61] It seems to him that the developments of art in trade and industry would soon lead to a new individuality of style.[62] Here also, he recognizes a new attitude to colour, especially to pure and even violent colour, stating: 'The young Applied Art found an ally in colour', followed by an attempt to define some of its source in the work of painters, and perhaps, somewhat surprisingly, by reference to the nowadays rarely mentioned Ludwig von Hofmann (1861–1945):

> With astonishment one saw the picture of Ludwig von Hofmann. What a screaming red, what a blazing yellow, what a poisonous green, and what carelessness in drawing! And yet, when one adjusted ones eyes to it: a Bliss, a peace, a mild sheen is laid across all those radiant colours.[63]

and again, a little later:

> Decorative art, which now arose, took some of its stimulus from the mystics [i.e., Böcklin]: Particularly the exaggeration of colour, which practically dispenses with all modelling, and retains the picture only in its main outline. It is a kind of de-materialization of the object, as the concept of drawing in the past brought with it a de-colouration. The colour alone speaks in loud or delicate words, in it the whole of the charm of expression resides. But this colour is no longer the old, mixed-in brown, but has achieved a power and a freshness, which has not survived from earlier times, and which perhaps it never had.[64]

In discussing the sources of this new attitude to both drawing and colour, he considers the increasing knowledge of Japanese art, perhaps to some extent popularized by the writings of the 'best connoisseur' of their art, Woldemar von Seidlitz (1850–1922),[65] of the greatest importance:

> Everywhere began the attempts, to handle surfaces in the Japanese manner; the liberating influence of the Far East extended deep into the nature of illustration. The trade in genuine Japanese works grew ever greater in range, draughtsmen like Hokusai became known to German artists and they learned to love them, as if they were one of their own. Japan's influence on all the graphic Arts is unique. One imitated the curious manner of saying much with a few strokes: thus the etchers.[66]

Subsequently he develops the point:

> Japan is undoubtedly the most important among these others [stimuli]. But, at any rate, it is close to the art of the poster, the art, for a picture to be effective over a distance, to arouse attention from afar ... Because the poster must shout loudly to the crowds; it must therefore exaggerate both form and colour; must reckon with the taste of the masses. Today artists accept the accusation that they set out to achieve this with equanimity.

Because the design of posters has become a branch of art, through which one can achieve fame. They know that art is not subject to one law, but that it should strive to become rich and many-sided like nature.[67]

He continues by discussing the influence of the English Arts and Crafts Movement, bearing in mind the importance of the 'Applied Arts':

Alongside the Japanese, the English who came from the school of William Morris, Walter Crane and others, were instrumental in bringing about this change. In the year 1893 the leaders in the Applied Arts in Berlin, with Peter Jessen at their head, began to point to English art ... A strong revolutionary streak is apparent in the Applied Arts, similar to that of 'Realism' in painting.[68]

Finally, he points to the growing numbers of periodicals as an important influence on the contemporary scene in Germany. He speaks approvingly of the English *Studio*,[69] and especially the German *Jugend, Simplizissimus* and *Pan*, where he sees forces freed that 'occasionally show a force of expression, registering a power, in which rage turbulently finds words'.[70]

Clearly, Gurlitt is aware of the important developments in the field of the Applied Arts and Graphics, and, quite correctly, sees important currents of influence from them to the Fine Arts. Moreover, his sympathetic reaction to experimental attitudes in the Fine Arts, in the Applied Arts and even in recent developments in poster art is certainly unusual at his time, both among critics and even more among art historians. The opinions he expresses suggest a capacity to predict future developments in the use of violent colour, less controlled drawing and, above all, a rejection of long-accepted historical or academic standards. How far his students may have benefited from his perceptive awareness and extensive knowledge of contemporary art, is difficult to assess, but it would be surprising if, on excursions, for example, there was not quite a free interchange of ideas. Contact with his mind, either through lectures, seminars or more informal discussions, might well have encouraged the young men to develop the rebellious attitude that characterizes their art if not at once, certainly in later years. As well as matters of art, there is here and there a hint of progressive political awareness, although it is expressed in moderate language and always modified by a personal conservatism and even patriotism. Thus, he writes:

Social democracy is modern; the various conservative parties with social aims are; Anarchy is modern and the endeavours of inner Missions are, right down to the Salvation Army; then again, a series of other intellectual trends are, like Individualism.

However, he modifies this at once by saying:

On the basis that one thinks only of oneself as modern, and declares others to be either old-fashioned or misguided, one will not achieve a desirable people's art.[71]

82 © Association of Art Historians 1997

He even, perhaps a little grudgingly, has some appreciation of '*Rembrandt als Erzieher*' published anonymously '*von einem Deutschen*' in 1890 – later to be revealed to be Julius Langbehn, who happens to have been known to Gurlitt personally. He occasionally, not unexpectedly, reveals that nationalism is frequently found in Wilhelmine Germany, but it never degenerates into xenophobia.[72]

Fritz Schumacher was born in Bremen in 1869 and died in Hamburg in 1947. The son of a Consular Official, he spent part of his childhood in Bogota and New York, until being returned to Bremen with his brother to the care of his aunt Louise and in order to attend school. After university in Munich and two semesters in Berlin, he graduated in 1895. A few months of work in Gabriel Seidl's office in Munich, as well as some private commissions which included work at the castle of Prösels near Blumau, said to be the greatest in the Tyrol, the ancient seat of the Counts of Völs-Colonna, were followed by his acceptance of an appointment to the Leipzig city architect's department under Hugo Licht.[73] In 1899, he was called to be 'Professor for Design in the fields of interior architecture and decoration'[74] a post he held until 1909, when he was appointed '*Oberbaumeister*' (Chief Architect) of the city of Hamburg, a post he held till 1920.[75]

His courses in Dresden were not only very well attended by the *Brücke* students, but his autobiographical writings give an exceptional insight into both the man and his relationship with his students. In one article, written in 1932, he dealt specifically with the '*Brücke*' students, based of course, on his recollections of some thirty years earlier, and written with hindsight about artists who had by then achieved wide acceptance.[76] Here he describes how Kirchner attempted to persuade his professor to allow some of his designs of modern interiors to be submitted for a doctorate. Professor Schumacher had to point out to him that scholarly research was a necessary basis for achieving a doctorate, rather than mere artistic sketches. What is rather surprising to note, however, is that having achieved his diploma, Kirchner remained interested in improving his qualifications as an architect, while simultaneously expected to embark, together with his fellow students, on a career as an artist.

In his autobiography Schumacher describes his arrival in 1899 at the Dresden Technical School – he calls it a venerable educational institution – to find his lecture room filled with dust-covered junk, and how, with some difficulty, he found a lectern. But his real problem was the preparation of his lectures. Having chosen, for his first Semester, *Stil und Technik* and *Antique Baukunst*, he found the latter had more literature than he could manage, while the former had none. As a result, he admits that he was learning alongside his students rather than teaching them.[77] Of course, by the time Kirchner and Bleyl arrived in 1901, we may assume he was somewhat better prepared. *Antique Baukunst* may have been re-vamped as *Bauformen der Antike*, which was later taken by Kirchner and Schmidt, and *Stil und Technik*, followed by another course entitled *Stil und Form*, may well have been developed into *Stillehre des Kunstgewerbes*, a course taken by all four students. In the first Schumacher sought to emphasize the principles of truth to material and the technical forms various materials created; in the second he dealt with the '. . . typical forms to which the recurring architectural tasks lead'.

These seminars enabled him to discuss contemporary problems and relate them to their historical context. During his lectures he illustrated his words with rapid drawings on the blackboard: art forms, perspectives and technical sections. He found it necessary to provide these simultaneous illustrations which students were encouraged to copy; nevertheless, he admits that it proved difficult to draw on a large scale while close to the blackboard and that it needed considerable skill to avoid the almost inevitable distortions.[78]

To achieve pedagogic success in the 'Drawing Studio' was far more difficult, particularly in 'Freehand drawing'. More than eighty students sat around and waited to be instructed in the art of drawing: there was need to register, to allocate space, to issue tasks and indicate possible solutions, to correct – it was all commotion, and Schumacher confesses that an old studio servant of 'philosophical leanings' was a help to him in all this turmoil. One task was to change the existing teaching material. The room was filled with dusty casts of commercially available builders' ornament, which had to be replaced by casts of precious works of art, woodcarvings and coloured textiles, as well as by natural plants, butterflies and shells. After that, work with charcoal, brush and pencil was done, according to the inclination or ability of individual students.

Schumacher's relationship with students seems to have been very friendly and unusually informal. Indeed he confesses that at his age – he was only twenty-nine years old when he took up his appointment in 1899 – he thought himself merely an 'older student', and found it difficult to accept his position 'outside their circle'. Recalling his impressions of the students who later founded the 'Brücke, he calls them *junge Stürmer* (young go-getters). One day, after they had seen 'an exhibition' of Van Gogh and Gauguin, there was no holding them.[79] He had to admit that work of theirs that was shown left him somewhat non-plussed, and only proved to him that the drawing instructions they had enjoyed under him, had, judging by common consent, been very unsuccessful. He claims to have avoided any attempt to control them in schoolmasterish fashion, because he felt too strong an aura surrounding their work, but nevertheless he felt the worries of 'a hen deserted by her ducklings'. He goes on to recount an anecdote. Heckel and Bleyl are said to have joined a student excursion to Aschaffenburg.[80] As they were all sketching in the 'Cathedral', as Schumacher calls it, he noticed Heckel in deep thought in front of Grünewald's *Pietà*.[81] He drew the hands of the mourning women, 'contrary to his normal habit', with the greatest care, into his sketchbook. However, when we all sketched some beauty spot, he sat idly by. But when we sat in the train and were singing, and speeding through a countryside with wide fields, where hundreds of farmworkers were harvesting, he would suddenly open his sketchbook and rapidly, in wild enthusiasm, put obsessive lines on the paper. Everyone laughed at the eccentric, and there was endless teasing. At the end of the day, a general exhibition was arranged. Schumacher offered three prizes for the best drawings – to be decided not by him but by a students' jury. He was very pleased to see that Heckel's drawing made in the train was awarded a prize unanimously. Clearly, the students sensed a certain power despite the apparent oddity.

It is, of course, clear that Schumacher's views in 1935 may well be coloured by hindsight. However, his openness and his appreciation of the new trends in the

© Association of Art Historians 1997

arts may well have been as sympathetic as he claims, although he admits that he, as well as most others, found it difficult to accept the early work of his 'Expressionist' students. But his knowledge at the time included a quite wide awareness of contemporary trends. Through the banker Heinrich E. Osthaus, for whom he was designing a private house in Hagen, Westphalia, Schumacher was introduced to his cousin, the wealthy collector Carl Ernst Osthaus, the founder of the Folkwang Museum, which was opened to the public in 1902.[82] Schumacher describes visits to the collection before that date, when it was so enjoyable to view it as a private house rather than as a museum. He characterizes the collection of modern pictures, as 'making it not easy for his fellow countrymen' because, instead of displaying work that allowed them to experience the historical development which art had pursued over a period of time, it presented them straightaway with the latest forms, leaping from Vautier at once to Munich, from Janssen at once to Hodler and Thorn Prikker, from Aschenbach to Van Gogh, from Begas to Maillol and Minne. That was *eine Gewaltkur* (a violent cure), not suited to everyone, but for those who experienced the museum 'without needing any conversion', it gave a rare sense of unity. One had the fresh experience of looking straight into most immediate contemporary art. Schumacher goes on to praise the achievements of an outstanding private collector, and, by implication, the wisdom of the choices he made. However, that view is likely to have been coloured by hindsight. His circle of friends in Dresden were his contemporaries, whose work was a good deal more conservative than that collected by Osthaus. Among those whose work he most admired, were Wilhelm Kreis (1873–1955), who succeeded Peter Behrens (1868–1926), mainly a creator of large public decorative schemes of wall paintings, mosaics and stained glass; Wilhelm Lossow (1852–1914), who designed the new building of the School of Applied Arts in Dresden and who later became its Director; his successor Karl Groß, and Oskar Seyffert, who succeeded after many years of dedicated work in founding 'the wonderful *Volkskundemuseum*' (Folkmuseum) in Dresden. His own creative work as architect and town planner made a considerable contribution to German architectural history. In the Dresden period it included the Crematorium, built in 1908, which has been characterized as illustrating the expressive megalomaniac tendencies of the Wilhelmine period, and it was followed later in Hamburg by the many schools and other important buildings he built before World War I, which are simpler and more comparable to the better work of Peter Behrens and established a tradition of brick building in Hamburg which lasted well into the 1920s.[83] But in the final analysis, Schumacher confessed that in the early years, he was not able to be in total sympathy with the direction taken by the creative work of the *Brücke* students, and, at the time, admitted to himself that he must have given them very poor tuition in drawing.[84]

Peter Lasko
Norwich

© Association of Art Historians 1997

Appendix A – List of the documents contained in the *Studien Bücher* of the founders of the 'Brücke' in the archives of Dresden University

HILMAR FRIEDRICH WILHELM BLEYL File no. 2539
1. Anmeldung zum Eintritt in die Königl.Sächs.Technische Hochschule, dated 15 April 1901.
2. Document authenticated by the city of Zwickau, on the 3 Mai 1901 on the Bleyl family income.
3. Request for a Stipendium, dated 7 Mai 1901.
4. Einschreibebogen, Sommer Semester 1901; Winter Semester 1901/2; Sommer Semester 1902; Winter Semester, 1902/03; Sommer Semester, 1903; Sommer Semester, 1904; Winter Semester, 1903/04; Winter Semester, 1904/05; Sommer Semester, 1905.
5. Request for financial support for the student excursion, dated 16 Juli 1902.
6. Diplom Verprüfung, Studienzeichnungen (no date).
7. Diplom Vorprüfungs Protokoll, dated 30 April 1903.
8. Request for the continuation of the Stipend granted, dated 6 November 1903.
9. Request for a Stipendium, dated 6 Mai 04.
11. Diplom Schlußprüfung, Studienzeichnungen (no date).
12. Protokoll, Diplom-hauptprüfung (including oral examination marks, and summary of results), dated 1 Juli 1905.

ERNST LUDWIG KIRCHNER File no. 5836
1. Reifezeugnis des städtischen Realgymnasium zu Chemnitz, dated 29 May 1901.
2. Anmeldung zum Eintritt in die Königl.Sächs.Technische Hochschule, dated 15 April 1901.
3. Einschreibebogen, Sommer Semester 1901; Winter Semester 1901/02; Sommer Semester, 1902; Winter Semester, 1902/3; Sommer Semester, 1903.
4. Diplom Vorprüfung, Studienzeichnungen (no date).
5. Diplom Vorprüfungs Protokoll, dated 30 April 1903.
6. List of all courses attended 1901–03, dated 5.10.1903.
7. Abgangs-Zeugnis, dated 5.10.1903.
8. Lebenslauf, dated 22.II.03.
9. Einschreibebogen, Sommer Semester, 1904; Winter Semester, 1904/05.
10. Diplom Schlußprüfung, Studienzeichnungen (no date).
11. Protokoll, Diplom-hauptprüfung (including oral examination marks, and summary of results), dated 1 Juli 1905.

REINHOLD ERICH HECKEL File no. 4654
1. Anmeldung zum Eintritt in die Königl.Sächs.Technische Hochschule, dated 21 IV 1903, but received 23.4.04.
2. Einschreibebogen, Sommer Semester, 1904; Winter Semester, 1904/05; Sommer Semester, 1905; Winter Semester, 1905/06.
3. Request for leave of absence in the Summer Semester, dated April 1906.
4. Request for release from the Hochschule. 17 Oktober 1906.

KARL FRIEDERICH SCHMIDT File no. 10307
1. Amneldung zum Eintritt in die Königl.Sächs.Technische Hochschule, dated 1905, 27 April.
2. Einschreibebogen, Sommer Semester, 1905; Winter Semester, 1905/06.
3. Request for leave of absence in the Summer Semester, received 1.5.1906.
4. Letter from the Rektor, Dr Drude, dated 1 Mai 1906.

© Association of Art Historians 1997

5. Request to have his leave of absence extended to the Winter Semester 1906/07, dated 15 October 1906.
6. Statement of the intention finally to leave the Hochschule, received 20.4.07.

Appendix B – Lists of lectures and practicals taken, by semester (*Übungen* = Practicals).

Lecture/seminars have marks noted ranging from the top mark 1a to 3a or the notation KZ, '*keine Ziffer*', (no mark). Where courses are crossed out on the forms, they are omitted. The names of the teachers are given in brackets.

SUMMER SEMESTER 1901

Differential und Integralrechnung. (Fuhrmann)	EK.	FB.
Anwendung der Elementarmathematik. (Fuhrmann)	EK	FB.
Geodätisches Zeichnen. (Fuhrmann)	EK(3a).	FB(2a)
Analytische Geometrie I. (Helm)	EK.	FB.
Analytische Geometrie I. Übungen. (Helm)	EK(KZ).	FB(3a)
Experimental Chemie (anorganisch). (Hempel)	EK.	FB.
Vorstellende Geometrie I. (Rohn)	EK.	FB(3a)
Vorstellende Geometrie I. Übungen. (Rohn)	EK(2a)	FB(1b)
Freihand und Ornamentzeichnen. (Schumacher)	EK(2a).	FB(1b)
Bauformenzeichnen. (Dix)	EK(1b).	FB(1b)
Die Bildhauerei des 19. Jahrhunderts. (Treu)	EK.	
Lichtpausen. (Krone)		FB.

EK paid 110 M, 13/5/01
FB paid 104 M, 19/6/01

WINTER SEMESTER 1901/02

Baukonstruktionslehre. (Böhm)	EK.	FB.
Baukonstruktionslehre. Übungen. (Böhm)	EK(2b).	FB(2b)
Statik und Festigkeitslehre. (Böhm)	EK.	FB.
Vermessungslehre. (Fuhrmann)	EK.	FB.
Analytische Geometrie II. (Helm)		FB(3a)
Analytische Geometrie II. Übungen. (Helm)		FB(3a)
Darstellende Geometrie II. (Rohns)	EK(KZ).	FB(3b)
Darstellende Geometrie II. (Rohns)	EK(2a).	FB(2b)
Freihand u. Ornamentzeichnen. (Schumacher)	EK(1b).	FB(1a)
Bauformenlehre der Antike. (Schumacher)	EK.	FB.
Bauformen der Antike. (Schumacher)	EK(2b).	FB(1b)
Geodätisches Zeichnen. (Fuhrmann)	EK(2a).	FB(1b)
Bildhauerei des 19.Jahrhunderts. (Treu)	EK.	
Über Bau und Funktionen des menschl.Körpers. (Schloßmann)		FB.

EK paid 104 M, 5/11/01
FB paid 116 M, 10/2/02

SUMMER SEMESTER 1902

Baukonstruktionslehre II. (Böhm)	EK.	FB.

Baukonstruktionslehre II. Übungen. (Böhm)	EK(2b)	FB(1b)
Statik und Festigkeitlehre. (Böhm)	EK(2b)	FB(2a)
Architektonisches Zeichnen. (Böhm)		FB(1b)
Geodätisches Praktikum. (Fuhrmann)	EK(2a)	FB(1b)
Experimentalphysik. (Hallwachs)	EK.	FB.
Formanlehre des Mittelalters. (Hartung)	EK.	FB.
Formenlehre des Mittelalters. Übungen. (Hartung)	EK(2a)	FB(KZ)
Mineralogie. (Kalkowsky)	EK.	FB.
Freihand und Ornamentenzeichnen. (Schumacher)	EK(KZ)	FB(1b)
Stillehre des Kunstgewerbes. (Schumacher)	EK.	FB.
Kunstgewerbliche Übungen. (Schumacher)	EK(−)	

EK paid 105 M. 13/5/02
FB paid 107 M, 4/7/02

WINTER SEMESTER 1902/03

Baukonstruktionslehre. (Böhm)	EK(2b)	FB(2a)_
Baukonstruktionslehre. Übungen. (Böhm)	EK(2b)	FB(2a)
Baumaterialien. (Foerster)	EK(KZ)	FB(1b)
Geodätisches Zeichnen. (Fuhrmann)	EK(2a)	FB(1b)
Einrichtung der Gebäude. (Hartung)	EK.	FB.
Innerer Ausbau. (Schumacher)	EK.	FB.
Die Kunst in Dresden. (Sponsel)	EK.	FB.
Ornamentstich der Barockzeit. (Sponsel)	EK.	FB.
Bildhaurei des Altertums I. (Treu)	EK.	FB.
Formenlehre der Rennaissance. (Weißbach)	EK.	FB.
Ornamentenentwurf, Figurenzeichnen, einschl. farb. Dekorat. u.angewandte Perspektive, Zeichnen nach dem lebenden Modell. (Weichardt)	EK(2b)	FB(2a)
Formanlehre der Renaissance. (Weißbach)	EK.	FB.
Backsteinbau. (Gurlitt)	EK.	
Geologie. (Kalkowski)		FB(2a)
Darstellende Geometrie II. (Rohn)		FB(2a)
Ueber ästhetische Prinzipienfrage mit bes.Beziehung auf die moderne Kunstentwicklung. Übungen. (Lücke)		FB(−)

EK paid 90 M, 13/11/02
FB paid 104 m, 7/2/03

SUMMER SEMESTER 1903

Baukonstruktionslehre IV (landwirtschaftliche Baukunst). (Böhm)	EK.	FB.
Baukonstruktionslehre IV (landwirtschaftliche Baukunst), Übungen. (Böhm)	EK(2b)	FB(2a)
Geschichte der Baukunst (Renaissance). Gurlitt)	EK.	FB.
Ausgewählte Kapitel aus der Ästhetik. (Gurlitt)	EK.	FB.
Einrichtung der Gebäude. (Hartung)	EK.	FB.
Entwerfen von Hochbauten. (Hartung)	EK(2a)	FB(2b)
Kunstgewerbliche Übungen. (Schumacher)	EK(−)	FB(2a)
Ornamententwerfen und Figurenzeichnen, einschl. farbiger dekorationen und angewandter		

© Association of Art Historians 1997

Perspektiven. (Weichardt)	EK(2a)	FB(2a)
Skizzieren aus dem Gebiete des Hochbaus. (Wallot)	EK	(KZ)

EK paid 101 M, 13/5/03
FB paid 95 M, 11/7/03

WINTER SEMESTER 1903/04

Geschichte der Baukunst vom Barock bis zur Neuzeit. (Gurlitt)	FB.
Holzbau. (Gurlitt)FB.	
Entwerfen von Hochbauten. (Hartung)	FB(1b)
Die Kunst der italienischen Renaissance. (Lücke)	FB.
Freihandzeichnen. (Schumacher)	FB(KZ)
Griechische Bildhauerei II. (Treu)	FB.
Skizzieren aus dem Gebiete des Hochbaus. (Wallot)	FB(1a)
Ornamentenentw.u.Figurenzeichn., (Weichardt)	FB(1b)
öfftentliche Bauten u.Anlagen. (Weißbach)	FB.
Ästhetische Prinzipienfragen. (Lücke)	FB.

FB paid 103 M, 21/12/03

SUMMER SEMESTER 1904

Geschichte des Kunstgewerbes im Mittelalters. (Bruck)	EK.	FB.
Heizung u.Luftung. (Frühling)	EK(KZ)	FB(2a)
Geschichte der Baukunst.(Antike) (Gurlitt)	EK.	FB.
Die künstlerischen Aufgaben im Städtebau. (Gurlitt)	EK.	FB.EH.
Kunstgewerbliche Übungen. (Schumacher)	EK	(KZ)
Skizzieren aus dem Gebiete des Hochbaus. (Wallot)	EK(2a)	FB(1b)
Ornamententw.u.Figurenzeichn., farb.dekorationen u.angewandte Perspektive. (Weichardt)	EK(KZ)	FB(2a)
Öffentliche Bauten u. Anlagen. (Weißbach)	EK	FB.
Arbeiten im Atelier für Baukunst. (Weißbach)	EK(2a)	FB(2a)
Kunstgewerbliche Übungen ()?		FB(1b)
Architektonisches u.technisches Zeichnen. (Böhm)		EH(2b)
Differential u.Integralrechning. (Fuhrmann)		EH.
Geodätisches Zeichnen. (Fuhrmann)		EH(2b)
Experimentalchemie (anorganisch) (Hempel)		EH{KZ)
Darstellende Geometrie I. (Rohn)		EH(KZ)
Darstellende Geometrie I. Übungen (Rohn)		EH(2b)
Freihandzeichnen u.Ornamentenzeichnen. (Schumacher)		EH(KZ)
Stillehre des Kunstgewerbes. (Schumacher)		EH.
Ornamentstich u.Kunstgewerbe der deutschen Renaissance. (Sponsel)		EH.
Formenlehre des Mittelalters. (Hartung)		EH.

EK paid 93 M, 50, 30/5/04
FB paid 93 M, 6/7/04
EH paid 103 M, 14/5/04

© Association of Art Historians 1997

WINTER SEMESTER 1904/05

Arbeiten im Atelier. (Weißbach)	EK(2a)	FB(2a)
Geschichte der Baukunst. (Gurlitt)	EK.	FB.
Wohnungshygenie. (Renk)	EK.	FB.
Recht des Grund u.Bodens u.d.Verkehrs. (Esche)	EK.	FB.
Skizzieren aus d.Geb.d.Hochbaus. (Wallot)	EK(KZ)	FB(1a)
Veranschlagen u.Bauführung. (Böhm)	EK.	FB.
Baugeschichtliche Übungen. (Gurlitt)	EK(–)	FB.
Bruck (?). Dresdener Museen. (Bruck)	EK.	
Innerer Ausbau. Übungen. (Schumacher)	EK	(KZ)
Keramik im Bauwesen. (Gurlitt)		FB.
Darstellende Geometrie II (Rohn)		EH.
Darstellende Geometrie II Übungen (Rohn)		EH(–)
Baukonstruktionslehre.I (Böhm)		EH.
Baukonstruktionslehre.I (Böhm)		EH(2b)
Bauformenlehre d.Antike. (Schumacher)		EH.
Bauformenlehre d.Antike.Übungen (Schumacher		EH(–)
Statik u.Festigk. (Böhm)		EH(2a)
Freihand u.Ornamentzeichnen.Übungen (Schumacher)		EH(KZ)
Vermessungls. (Fuhrmann)		EH.
Anwendung d.Diff.u.Integral. (Fuhrmann)		EH.

EK paid 118 M, 5/11/04
FB paid 100 M, 21/12/04
EH paid 142 M, 2/11/04

SUMMER SEMESTER 1905

Kunst und Kunst gewerbe i.Bez.z.Industrie. (Bruck)	FB.	
Bauhistorisches Seminar. (Gurlitt)	FB.	
Stillehre d.Kunstgesch. (Schumacher)	FB.	EH.
Baukonbstr.l., II (Böhm)		EH.
Baukonstr.l., II. Übungen		EH(KZ)
Freihandzeichnen, Übungen (Schumacher)		EH(KZ)
3 St.Darstellende Geometrie I. (Distell)		KS(KZ)
2 St.Darstellende Geometrie I. Übungen (Disteli)		KS(3a)
5 St.Diff.u.Integralrechnung. (Fuhrmann)		KS.
2 St.Anwendung d.Elementarmath. (Fuhrmann)		KS.
2 St.Geodät.Zeichnen. Übungen. (Fuhrmann)		KS(2b)
6 St.Experimentalelimente. (Hempel)		KS(KZ)
2 St.Formenlehre d. Mittellalt. (Hartung)		KS.
3 St.Formenlehre d. Mittelalt. Übungen. (Hartung)		KS(–)
4 St.Ornament. Zeichnen. Übungen (Schumacher)		KS(KZ)

(The 3 St, etc. no doubt refer to the hours [Stunde]
 of teaching per week)
 given for the first time in Schmidt's *Einschreibebogen*).

FB paid 21 M, 7/7/05
EH paid 57 M, 12/5/05
KS. no payment recorded

© Association of Art Historians 1997

WINTER SEMESTER 1905/06

Innerer Ausbau. (Schumacher)	EH.	8 M.	
Innerer Ausbau. Übungen (Schumacher)	EH(KZ)	18 M.	
Volkswirtschaftliche Übungen (Wuttke)	EH.		
Baukonstruktionslehre. Übungen (Böhm)	EH(KZ)	18 M.	KS(KZ)
Baukonstruktionslehre I (Böhm)		KS.	
Innerer Ausbau. (Schuma\cher)		KS.	
Bauformen d.Antike (Schumacher)		KS.	

EH paid 45 M, 2/11/05
KS no payment recorded

Appendix C – The courses taken by the four 'Brücke' students as listed in their enrolment forms, arranged under the names of the teachers.

(Those later struck out and not taken are included).

(1) BÜHM THEODORE(1847–1921) Ord.Prof. from 1 October 1901
 Baukonstruktionslehre.
 Baukonstruktionslehre, Übungen.
 Baukonstruktionslehre,II.
 Baukonstruktionslehre,II, Übungen.
 Architektonisches und technisches Zeichnen.
 Statik und Festigkeitslehre.
 Architektonisches Zeichnen.
 Baukonstruktionslehre IV (Landwirtschaftliche Baukunst)
 Baukonstruktionslehre, IV, Übungen
 Veranschlagen u.Bauführung.
 Technisches Zeichnen. Übungen.

(2) BRUCK, ROBERT (1863–1942) Assistant, 1902; Priv.Doz. 1903;
 Prof. 1905 Geschichte des Kunstgewerbe im Mittelalter.
 Dresdner Museen.
 Kunst und Kunstgewerbe i.Bez.z.Industrie.
 Archäologie der christlichen Kunst I

(3) BUHLE, MAX (1867–1934). Prof.f.Hebe-u.
 Transportmaschinen, allg. Maschinenlehre, Eisenbahnmaschinenwesen u.techn.
 Zeichnen. 1902–1930.
 Abriß der Maschinenelemente.

(4) DISTELI, MARTIN(1862–1923). Prof. of Geometry, 1905–9
 Darstellende Geometrie.
 Darstellende Geometrie Übungen.

(5) DIX. Assistant appointment ceased 1901
 Bauformenzeichnen.

© Association of Art Historians 1997

(6) ESCHE, ARTHUR (1857–1940). Prof. for State Law for technical Professions, 1905–1919
Recht des Grund und Bodens u.d.Verkehrs

(7) FOERSTER, FRITZ (1866–1931). Prof. of Inorganic Chemistry and Technology, 1897–1931
Baumaterialien.

(8) FRÜHLING, AUGUST (1846–1910). Prof. for Civil Engineering, 1895–1910
Heizung und Luftung.
Elemente der Ingenieurwissenschaft

(9) FUHRMANN, ARWED (1840–1907). Prof. for Mathematics and Surveying, 1869–1906.
Differential und Integralrechnung.
Anwendung der Elementarmathematik.
Vermessungslehre.
Geodätisches Zeichnen.
Geodätisches Praktikum.

(10) GURLITT, CORNELIUS (1850–1938). Prof. for the History of Architecture and
Technical and Tectonic Art, 1893–1920. Rektor, 1903/04
Geschichte der Baukunst vom Barock bis zur Neuzeit.
Holzbau.
Backsteinbau.
Geschichte der Baukunst (Renaissance).
Ausgewählte Kapitel aus der Aesthetik.
Geschichte der Baukunst (Antike).
Keramik im Bauwesen.
Baugeschichtliche Übungen.
Die künstlerischen Aufgaben im Städtebau.
Bauhistorisches Seminar.

(11) HALLWACHS, WILHELM (1859–1920). Prof. of Physics, 1893–1920
Experimentalphysik.

(12) HARTUNG, HUGO (1855–1932). Prof. of Architecture, 1901–11
Formenlehre des Mittelalters.
Formenlehre des Mittelalters. Übungen.
Entwerfen von Hochbauten.
Einrichtung der Gebäude.
Entwerfen von Hochbauten.

(13) HELM, GEORG (1851–1923). Prof. of Mathematics, analytical Mechanics and
mathematical Physics, 1887–1920
Analytische Geometrie
Analytische Geometrie Übungen.
Analytische Geometrie II.
Analytische Geometrie II. Übungen.

(14) HEMPEL, WALTHER (1851–1916). Prof. of Chemistry. 1879–1912; Rector, 1901/02.
Rektor, 1901/02
Experimentalchemie (anorganisch).

© Association of Art Historians 1997

(15) KALKOWSKI, ERNST (1851–1938). Prof. for Mineralogy and Geology, 1894–1919
Mineralogie.
Geologie.

(16) KRONE, HERMANN (1827–1916). Prof. of Photography, 1896–1907
ichtpausen.

(17) LÜCKE, HERMANN (1837–1907). Prof. for middle and newer Art History, 1888–1907
Über ästhetische Prinzipienfrage mit bes, Beziehung auf die moderne
Kunstentwicklung.
Die Kunst der italienischer Renaissance.
Die Kunst des Mittelalters
Die niederländische, deutsche und französische Kunst des 15.u.16. Jh.

(18) OEHM, ERWIN (1831–1907). Prof. for Aquarell Painting, 1887–1907
Aquarellmalen

(19) ENK, FRIEDRICH (1850–1928).
Wohnungshygenie.

(20) RPHN, KARL (1855–1920). Prof. of projective Geometry, 1884–1904
Darstellende Geometrie.
Darstellende Geometrie Übungen.
Darstellende Geometrie II.
Darstellende Geometrie II Übungen.

(21) SCHLOSSMANN, ARTHUR (1867–1932). Prof. Chemistry and Physiology 1902–1906
über Bau und Funktionen des menschlichen Körpers.

(22) SCHMALTZ, GEORG, DOZENT (1903–05).
Verfassungsrecht

(23) SCHUMAKER, FRITZ (1869–1947). Prof. for Design of interior structure and
decoration, 1899–1909
Bauformenlehre der Antike.
Bauformenlehre der Antike Übungen
Freihand und Ornamentenzeichnen.
Freihand und Ornamentenzeichnen, Übungen.
Stillehre des Kunstgewerbes. (or d.Kunstgeschichte?)
Kunstgewerbliche Übungen.
Innerer Ausbau.
Innerer Ausbau, Übungen.
Ornamentstich und Kunstgewerbe der deutschen Renaissance.

(24) SPONSEL, JEAN, LOUIS (1858–1930). Prof. for the History of Architecture and the
Applied Arts, 1902–1908
Die Kunst in Dresden.
Ornamentik der Barockzeit.

(25) TREU, GEORG (1843 [St Petersburg]–1921). Prof. for the History of Sculpture, 1882–
1909. Awarded an Hon. Degree at Aberdeen University, 1906/07

© Association of Art Historians 1997

Die Bildhaurei de 19.Jahrhunderts.
Griechische Bildhauerei II.
Bildhauerei des Altertums, I.
Bildhauerei im Zeitalter des Phidias
Griechische Bildhauerei bis Phidias

(26) WALLOT, PAUL (1841–1911). Prof. for Civil Engineering, 1894–1911
Skizzieren aus dem Gebiet des Hochbaus.
 öffentliche Bauten und Anlagen.
 Arbeiten im Atelier für Baukunst.
 Skizzieren aus dem Gebiet des Hochbaus.

(27) WEICHARDT,l KARL (1846–1906). Prof. for Design of Ornament, incl. Figure drawing,
 coloured Decoration and applied Perspektive, 1900–1906
 Ornamententwerfen und Figurenzeichnen, einschließlich
 farbiger Dekorationen und angewandter Perspektive, zeichnen nach dem lebenden
 Modell.

(28) WEISSBACH, KARL (1841–1905). Prof. for Civil Engineering, 1875–1905
Arbeiten im Atelier für Baukunst.
 öffentliche Bauten und Anlagen.
 Formenlehre der Renaissance.
 Arbeiten im Atelier.

(29) WELCK KURT VON (1864–1903). Hon. Prof. of Law, 1901–1903
 Verwaltungsrecht.

(30) WUTTKE, ROBERT (1859–1914). Prof. for national Economics and Statistics 1903–1914
 Volkswirtschaftliche Übungen.

Appendix D – Addresses of the 'Brücke' students

As given on the *Einschreibebogen* or on the *Anmeldung* etc. The dates are those on which
 fees were paid or the date of the document

F. BLEYL
19.6.01 No address on *Anmeldung*
21.12.04 Johann-Georgen Allee, 18 IV (now Lingneralle, Dresden-Mitte, Altstadt)
7.7.1905 Bürgerwiese 18 IV, Pirnaische und Seevorstadt, (now Dresden-Altstadt).

E.L. KIRCHNER
15.4.1901 Schnorrstrasse, 56 II, Dresden-Süd, Plauen, on *Anmeldung*
5.11.04 Ostbahnstr. 15 III (Südvorstadt, Strehlen)

E. HECKEL
21.4.04 Berlinerstr.65 I, Dresden-West, Friederichstadt, on *Ammeldung*
2.11.04 Berlinerstr.65 I
12.5.05 Berlinerstr.65 I
2.11.05 Berlinerstr.65 I (on request for absence, Summer Semester, 1906)

 © Association of Art Historians 1997

23.10.06	Berlinerstr.65 I (on request for permanent absence)

K. SCHMIDT

27.4.05	*Anmeldung* – no address
1905,	Summer semester, Rosenstr.64 I, Dresden-West, Löbtau.
1905/06,	Winter semester, Rosenstr.64 I
1.5.06	Seminarstr. 8 III 1[links] Dresden-West. Friederichstadt, (on request for leave of absence for Summer semester 1906 – in order to devote himself to study painting)
18.10.06	Berlinerstr. 60 III (on request to extend leave of absence to Winter semester 1906/07)
20.4.07	Berlinerstr.65 I (on request for permanent absence)

Notes

1 I thank the Leverhulme Trust for a grant and the Wissenschaftkolleg in Berlin for their generous hospitality that have made my research on German Expressionism possible.

2 G. Reinhardt, 'Die frühe "Brücke"', Beiträge zur Geschichte und zum Werk der Dresdener Künstlergruppe Brücke der Jahre 1905 bis 1908, *Brücke Archiv.*, Heft 9/10, 1977–8, pp. 23 ff.

3 I am indebted to Dr doz. Mathias Lehnert and Mr Dieter Hufeld who kindly allowed me to examine the archives in July 1990, and to the latter for more much additonal help. Some of the information contained in these documents was already published, but in only summary form, by G. Krüger in 'Fritz Bleyl, Beiträge zum Werden und Zusammenschluß der Künstlergruppe "Brücke"', *Brücke Archiv*, Heft 2/3, 1968–9, pp. 27 ff.

4 To my knowledge, the only attempt made so far to give weight to these years is Jill Lloyd's, in her *German Expressionism, Primitivism and Modernity*, New Haven & London, 1991, pp. 13 ff.

5 The successful completion of their diploma examination is reported in *Bericht über die Königl.Sächs.Technischen Hochschule zu Dresden für das Studien-Jahr 1905–06*, Abgeschlossen 1 März 1906, Dresden, 1906, p. 29.

6 Fritz Bleyl's *Reifezeugnis* was returned to him on 2 February 1906. When, in October 1906, Heckel asked to have his *Matrikel* returned to him, it is noted on his request for release from the Hochschule, that it is missing.

7 See Fritz Bleyl's evidence on this parental pressure on both of them, in H. Wentzel, 'Fritz Bleyl, Gründungsmitglied der "Brücke"', including 'Erinnerungen', by Fritz Bleyl, written for Wentzel, dated 13 February 1948, *Kunst in Hessen und am Mittelrhein*, Heft 8, 1968, pp. 92, 93.

8 For Bleyl's recollections, see Wentzel, op. cit. (note 7), p. 94. It is sometimes doubted that Kirchner could read English, see J. Lloyd, op. cit. (note 4), p. 15. The publication of the *Studio* began in 1903, and articles like that by Praetorius on the Art of New Guinea in 1903, which would certainly have been of great interest to Kirchner. *Studio*, vol. 30 (1903), pp. 51 ff., first mentioned by L.D. Ettlinger, 'German Expressionism and Primitive Art', *Burlington Magazine*, vol. 90, (1968), pp. 192 ff.

9 Bleyl has outlined the same very accurately in his 'Erinnerungen ...', see Wentzel op. cit. (Note 7), pp. 92–3.

10 The notes on these two documents are not very clear. In 1903 it reads: *6.Sem. Ost[ern].03 Diplom Vorprüfung bestanden. Studienj[ahr]: 03/04: 300 M. 14/12,03: W.S. 03/04: 180 M. zurück. 2 Teil.* In 1904 it reads: *7.Semester.Ost[ern]. 03 Diplom Vorprüfung bestanden. Studienj[ahr] 03/04: 300 M. 4/7/04. Studienj[ahr]: 04/05: 460 M. zurück 1 Sem.z.*

11 *Bericht über die Königl.Sächs.Technische Hochschule zu Dresden für das Studien-Jahr 1901–02*. Herausgegeben von Rektor und Senat, Dresden, 1902, p. 13.

12 C. Gurlitt, *Altzella* 1922.12.22.

13 For the financial circumstances of the four founders, see also B. Hühnlich, 'Wohnstätten und Lebensumstände der vier "Brücke-Gründer" in Dresden', *Dresdener Kunstblätter*, (1985, no. 3), pp. 80ff.

14 It is also interesting to note that in the winter semester 1905–06, the contact hours taught by Professor Böhm amounted to twenty hours per week, those of Professor Schumacher to twenty-three hours, while Professor Gurlitt taught for fourteen hours.

15 After attempting to support himself by 'Applied Arts' and 'Graphic' work, he soon accepted the permanent teaching post. See Wentzel (Bleyl), op. cit. (note 5), p. 98. and G. Reinhardt, 'Die frühe Brücke', *Brücke Archiv*, Heft 9/10, 1977–8, p. 140.

16 F. Schumacher, *Stufen des Lebens* (2nd ed.), Stuttgart and Berlin, 1935, p. 237. For the conference, conceived and organized by Alfred Lichtwark, the Director of the *Kunsthalle*, the major art gallery in Hamburg, see *Kunsterziehung, Ergebnisse und Anregungen des Kunsterziehungstages in Dresden am 28.und 29.September 1901*, Leipzig, 1902. For Obrist's contributions, emphasizing the importance of workshop training for artists, see pp. 163, 193. The second conference dealt with German Language and Poetry, held in Weimar 1903, the third with Music and Gymnastics, in Hamburg 1904. For the Dresden Conference, see also J. Gebhard, *Alfred Lichtwark*, Hamburg, 1947, pp. 17 ff., 85–101, 197–212, 388–404.

17 See H. Eisenwerth, 'Die Münchener Debschitzschule', in H.M. Wingler (ed.), *Kunstschulenreform, 1900–1933*, Berlin, 1977, pp. 66–94.

18 'Die erste öffentliche Austellung der Lehr- und Versuch-Ateliers für angewandte und freie Kunst', *Dekorative Kunst*, vol. 12, 1904, p. 234.

19 His collected essays were published as early as 1903, and may have been instrumental in encouraging Kirchner to attend the school in Munich; see H. Obrist, *Neue Möglichkeiten in der bildenden Kunst*, Leipzig, 1903.

20 See 'Wozu über Kunst schreiben und was ist Kunst', (1899), op. cit., pp. 21–2: 'Kunst gibt gesteigerte, intensive Empfindungen, Kunst ist kondensiert empfundenes, kondensiert gegebenes und intensiv nachgefühltes Leben. Oder genauer ausgeführt: Für den produzierenden Künstler ist Kunst das Empfinden, Hören oder Sehen und das Geben von Gehörtem, Gesehenem oder Empfundenem, das er entweder wirklich oder in der Phantasie vibrierender fühlt, hört oder sieht als der gewöhnliche Mensch und losgelöster von Nebensächlichem und das er, es verdichtend, energetisch intensierend, in den jeweiligen Mitteln seiner Kunstart darbietet. Und für den konsumierenden Laien ist Kunst das Erhalten, das Nehmen, das Mitempfinden, das Nacherleben des so gegebenen gesteigerten Lebens des Künstlers. Und nur dann ist ein Werk künstlerisch, wenn derartige Wirkungen ausgelöst werden.'

21 ibid, p. 64; 'Gott schütze dich, junger Mann, vor jenem berühmten Professor, der seit Jahren nur noch gelb-grau-braune Leinewandstücke ausstellt; ibid, p. 65, '... so arbeiten jetzt auch zahlreiche junge Maler seit geraumer Zeit als halbe oder ganze Autodidakten für sich allein.'

22 'Mit dem Glauben an Entwicklung, an eine neue Generation der Schaffenden wie der Geniessenden rufen wir alle Jugend zusammen. Und als Jugend, die die Zukunft trägt, wollen wir uns Arm-und Lebensfreiheit verschaffen gegenüber den wohlangesessenden, älteren Kräften. Jeder gehört zu uns, der unmittelbar und unverfälscht das wiedergibt, was ihn zum Schaffen drängt.'

This programme was printed with the 'business' address 'Berlinerstrasse 65 I', occupied by Heckel at least until October 1906 (See Appendix D page 94), and was cut in wood by Kirchner, probably in 1906, see *Ernst Ludwig Kirchner 1880–1938*, exh. cat., Berlin 1979, p. 50, Abb.26,28.

23 ibid, p. 67: '... Sehnsucht in all der Jugend, die da Künstlerisches schaffen will ...'; ibid, p. 68, 'Und viele kämpfen und arbeiten lange hart genug, um das zu bleiben, was sie werden wollten: Künstler. Diese nun, die immer strebend sich bemühen, diese können wir erlösen'; ibid, p. 75, '... er solle das nun mit Lust vertiefen, verstärken, steigern zu etwas mehr als die bloße Natur, zu einer künstlerischen Leistung, indem er das, was ihn besonders ergriff, so intensiv gefühlt wiedergibt, daß der Beschauer dieselben starken Gefühle empfängt, wie der Künstler sie hatte.'

24 ibid., p. 96: 'Viel eher noch könnten wir solchen Völkern nachsinnen, die verhältnismäßig Ursprüngliches schufen, wie z.B.die ersten Griechen und die Gotiker, odern noch weiter zurück, etwa die alten Wikinger, ja sogar die Wilden der Südseeinseln ... Nein, sondern nur so sollen wir schaffen, wie sie schufen; unbewußt, wahr, einfach, wie es ihnen natürlich kam.' Op. cit., p. 97, 'Wir müssen wieder das werden, was die menschen früher waren: Schöpferisch. Wenn ihr nicht werdet wie die Kinder, so werdet ihr nicht eingehen in das Reich der schöpferischen Kunst.' It should also be noted that there was an increasing and serious interest in the art of children and its relationship to the art of 'primitive' and 'prehistoric' peoples, at this time. After Corrado Ricci's *L'Arte dei Bambini* was published in 1887 (translation by Karl Lamprecht in Leipzig in 1906), it was followed by such scholarly work as, for example, K. von Steinen, *Die Naturvölker Zentralbrasiliens*, 1897; F. Schultze, *Psychologie der Naturvölker*, 1900; S. Levinstein, *Kinderzeichnungen mit Parallelen aus der urgeschichte, Kulturgeschichte und Völkerkunde*, 1905; T. Koch-Grünberg, *Anfänge der Kunst im Urwald*, 1905. Others, like Max Verworn, in *Zeitschrift f.Ethn.*, 1906, 654, and later books, strongly denied any such links. For a good summary of the position in 1910, see J. Kretzschmar, 'Kinderkunst und Urzeitkunst', *Zeitschrift f.pädag.Psychol, Pathologie und Hygiene*, 11 Jg., Heft 7/8, (1910), 1354–66.

25 Although Kirchner could already have seen work by Hölzel in an exhibition at the Ernst Arnold Gallery in Dresden, in January 1903; see review in *Dresdener Anzeiger*, no. 4, 4 January 1903.

26 Both are reviewed in *Münchener Neuesten Nachrichten*, the 'XI Graphik', and the 'IX Impressionist', 30 April 1904.

27 He was in Munich by 16 October 1903: Postcard to Bleyl, see *Ernst Ludwig Kirchner, 1880–1938*, exh. cat., Berlin, 1979, p. 48 and Abb. 22, and certainly back in Dresden by 30.5.04 when he paid his fees for the summer semester.

© Association of Art Historians 1997

28 O. Mothes, *Unser Heim im Schmuck der Kunst*, Leipzig, 1879. It should be noted, however, that his proficiency in this area might have increased some twenty-five years later.

29 See 'Die Austellung von Werken Leipziger Künstler im Leipziger Kunstverein', *Kunstchronik*, Neue Folge 6 (1895), Leipzig, p. 11.

30 See Erwin Oehme, in Thieme-Becker, *Allgemeiner Lexikon der Bildenden Künstler*.

31 See, for example, H. Wentzel, 'Zu den frühen Werken der "Brücke" – Künstler', *Brücke-Archiv*, Heft 1, (?1967), Abb.7; G. Krüger, 'Glasmalereien der "Brücke" – Künstler', ibid, Abb. 13–16, and 'Fritz Bleyl. Beiträge zum Werden und Zusammenschluß der Künstlergruppe "Brücke"', ibid, Heft Abb.1,2.

32 Kirchner claimed to have discovered the Palau beams in the Ethnographical Museum, installed since 1902, see D.E. Gordon, *E.L. Kirchner*, Munich, 1968, p.18. It might also have been noted that Hermann Obrist, his teacher in Munich, was appreciative of Samoan Beam Carvings; see his essay on 'Wozu über Kunst schreiben und was ist Kunst' (1899), *Neue Möglichkeiten in der bildenden Kunst*, Leipzig, 1903, pp. 18–20.

33 M.M. Moeller, 'Die Jahresmappen der "Brücke"', 1906–1912, *Brücke Archiv*, Heft 17, 1989, pp. 17, 101–3, plates 1, 3–5.

34 In the Bleyl 'Protokoll', this average mark is signed by K. Rohn, but the name is crossed out, and in Kirchner's, no signature appears. Clearly an average mark was conflated.

35 *Stadt und Landbau, Oeffentliche Gebäude*, (Weißbach) 2a and 2a; *Wohnungsbau* (Hartung) 2a and 2a; *Baukonstruktionslehre mit Anw.d.Statik*, (Böhm) 2b and 2b; *Heizungs u. Lüftungsanlagen mit Berücksichtigung der Hygiene* (Frühling) 2b and 2b; *Formenlehre u.Geschichte der antiken, der altchristlichen, mittelalterl. u.Renaissance Baukunst* (Gurlitt) 2a and 2b; *Stillehre des Kunstgewerbes* (Gurlitt) 2a and 2b.

36 F. Schumacher, 'Aus der Vorgeschichte der Brücke', *Der Kreis*, vol. 9, 1932, quoted by Lloyd, op. cit., p. 15.

37 Schumacher, op. cit. (note 16), pp. 217 ff. See below.

38 His only publication known to me is the *Handbuch der Holzkonstruktionen des Zimmermanns mit besonderer Berücksichtung des Hochbaus*, 1911. I am indebted to Dr Karin Fischer of Dresden University for the information about Böhm, who does not appear in any biographical lexicon.

39 The Wallot and Weichard classes were especially remembered by Fritz Bleyl in his 'Erinnerung' in *Kunst in Hessen und am Mittelrhein*, Heft 8, 1968, p. 95. Bleyl's recollection of Wallot, written in 1948, states that he 'came over from the "Kunstakademie auf der Brühlschen Terasse"' (the Fine Arts Academy)'. If so, his appointment

at the Technical Highschool from 1894 to 1911 must have been held jointly with the Academy.

40 Schumacher, op. cit. (note 16), p. 225.

41 The gallery in Berlin founded by Fritz Gurlitt, which continued to bear his name after his death, showed the first major exhibition of the 'Brücke' in 1912. See *Ernst Ludwig Kirchner, 1880–1938*. exh. cat., Berlin, 1979, p.62, Abb.55,57.

42 O. Richter, *Geschichte der Stadt Dresden in den Jahren von 1871 bis 1902*, Dresden, 1905, p. 244.

43 Cornelius Gurlitt, *Die deutsche Kunst des neunzehnten Jahrhunderts. Ihre Ziele und Thaten*, 2nd ed., Berlin, 1900, pp. 509–10: 'Wir wollen die Sonne, das Licht, die freie Luft, eine klare, kecke Malerei, die das Ding darstellt, wie es im Lichte steht; wir wollen malen, was unsere Augen sehen und erfassen. Alles sehen und alles malen! Das Leben wie es auf den Strassen lebt, das Leben der Armen wie der Reichen, auf den Märkten, und auf den Rennen, auf den Boulevards und in den Winkelgassen …'

44 ibid, p. 537: 'Die neue Auffassung sieht in jedem Licht Schönheiten, … daß am sonnigen Mittag ein blauliches Weiß, am Morgen ein tiefes Violett, am Abend ein rötliches Braun, endlich ein tiefes Blau über allen Farben liege, ein so starker Ton, das Umriß und Lokalfarbe unter ihnen verschwinden …'

45 ibid, p. 510: 'So ließ Zola 1886 seinen Maler sagen, was zwanzig Jahre früher in den jungen Köpfen in Paris brauste. Es ist Manet, den er schildert, es sind die Impressionisten. 1863 traten sie zuerst hervor, verhöhnt, verlacht. Heute giebt es keinen Maler mehr, der von ihnen unbeeinflußt wäre. Sie haben sich die Welt erobert, wie dreißig Jahre früher die Romantiker.'

46 In 'Moderner Naturalismus und künstlerische Wahrheit', in H. Konnerth (ed.), *Konrad Fiedlers Schriften über Kunst*, Munich, 1913, pp. 135–82. See also support given to Gurlitt's position by J. Meier-Graefe, *Entwicklungsgeschichte der Modernen Kunst*, Berlin, 1904, p. 520.

47 Gurtlitt, op.cit., p. 163.

48 ibid, p. 182; 'Es werden große Künstler wiedererstehen und dann wird man von diesen neuesten Naturalismus, der so anspruchsvoll auftritt und sich als so epochemachend brüstet, nur von einer der vielen Irrungen sprechen, die enstehen und vergehen, solange es Menschen gibt.'

49 J. Meier-Graefe, '*Entwicklungsgeschichte …*', op. cit., 1904.

50 Gurlitt, op. cit., p. 529; 'Die gesammte Kunst der Vergangenheit ist eine Beschönung, eine Verfälschung der Wirklichkeit.'

51 ibid, p. 543; 'Schon Zola nennt die Rübe als Gegenstand der Kunst gleichwertig mit all den geistreichen Sachen der Alten.'

52 ibid, p. 544: 'Es kommt nicht auf den Inhalt allein an, der Inhalt hat mit der Kunst nicht unbedingt etwas zu thun; eine gut gemalte Rübe, ist ein größeres Kunstwerk, als eine schlechtgemalte Himmelfahrt.'

53 ibid, p. 582. This refers to Henry van der Velde, who later concentrated on the Applied Arts, Willy Finch and especially to Théo van Rysselbergh.

54 ibid, p. 590.

55 It may be of interest to note that this concept was later developed by Kandinsky in his *'Über das Geistige in der Kunst'* Munich, 1912.

56 ibid, pp. 661 ff. While externally the design was dominated by the classical form language, he became internally stylistically free. That, which so many before him aimed at, 'the Being Modern', he achieved without violence. (*Während im Äusseren noch die klassische Formensprache den Entwurf beherrscht, wurde er im Inneren auch stylistisch frei. Das, was so viele vor ihm erstrebten, das Modernsein, führte er ohne Gewaltsamkeit durch.*) Very much the same opinion is expressed in Wallot's obituary by W.C. Behrendt, *Kunst und Künstler*, vol. 11 (1913), pp. 54–6. For a contemporary assessment see H-R. Hitchcock, *Architecture: Nineteenth and Twentieth Centuries*, Pelican History of Art, 4th ed., Harmondsworth, 1977, pp. 224, 228.

57 ibid, p. 673: 'Der Ausgangspunkt des künstlerischen Schaffens müsse das moderne Leben sein.'

58 ibid, p. 673: 'Wie klein stand die Secession in ihrem strahlenden Weiß und ihrem bescheidenen Gold inmitten der Gewaltsbauten ... die Wirkung des Inneren gehörte hinsichtlich der Stimmung zu den feinsten Schöpfungen, die jeh auf mich einwirkten ...'

59 ibid, p. 693. The society exhibited their own work and that of progressive foreigners in Brussels from 1884 to 1893. See M-A. Stevens, 'Belgian Art: Les XX and the Libre Esthétique', *Post-Impressionism, Cross-currents in European Paining*, exh. cat., London, 1979, pp. 252–9.

60 ibid, p. 691; 'Es geht ein stark revolutionärer Zug durch das Kunstgewerbe, ähnlich des jenem des malerischen Realismus. Einer der meist genannten Vertreter dieser Richtung, van de Velde, ist der Meinung, bevor man nicht das Gegenwärtige zerstöre, werde die Kunst in neuer Form nich zum Licht aufsteigen; werde dem Boden der Arbeit die Blume nicht erblühen. Völliges Vergessen der alten Stile ist sein Grundsatz.'

61 For example, the whole tenor of periodicals like *Dekorative Kunst*. For Van der Velde, see H. Curjel (ed.), *Geschichte meines Lebens*, Munich 1960, especially 'Renunciation of Painting – The Road to the Applied Arts', pp. 56–9.

62 ibid, p. 677: 'Mir will scheinen, als werde hinter dem, was jetzt als neue Kunst im Gewerbe sich zeigt, bald das kommen, was ich eigenartigen Stil nennen möchte.'

63 ibid, p. 677: 'Einen starken Bundesgenossen fand dies junge Kunstgewerbe in der Farbe ... Mit Staunen sah man die Bilder Ludwig von Hofmanns. Welch schreiendes Rot, welch

aufflackerndes Gelb, welch giftiges Grün, welche Nachlässigkeit in der Zeichnung. Und doch, wenn man sich hineinsah: eine Seligkeit, eine Ruhe, ein milder Glanz lag über all den leuchtenden Farben.' Ludwig von Hofmann (1861–1945) studied at the Dresden Academy 1883–6 and in Paris, at the Académie Julian in 1889. He was a founder member of the Berlin Secession and taught at Weimar 1903–16, and at the Dresden Academy after 1916. Later, on pp. 678–9, Gurlitt also discusses the work of Walter Leistikow, as one of those who 'walked the same path as Hofmann'.

64 ibid, p. 689: 'Die dekorative Malerei, die nun enstand, nahm eine Reihe von Anregungen aus der mystischen: Namentlich die übertreibung der Farbe, die auf die Modellierung fast ganz verzichtet, das Bild nur in seinen Hauptformen festhält. Es ist dies eine Art Entkörperung des Gegenstandes, wie die zeichnerische Auffassung früherer Zeit eine Entfärbung mit sich führte. Die Farbe allein spricht in lauten oder zarten Worten, in sie ist der volle Reiz des Ausdrucks gelegt. Diese Farbe ist aber nicht mehr die alte, auf Braun gemischte, sondern hat eine Kraft und Frische erreicht, wie sie uns aus früherer Zeit nicht erhalten ist, wie sie vielleicht nie gehandhabt wurde.

65 He was Director of the Royal collections in Dresden, and published a history of Japanese coloured woodcuts in 1897.

66 ibid, p. 687; 'Überall begannen die Versuche, in japanischer Weise die Flächen zu behandeln; bis tief in das Illustrationswesen erstreckte sich der befreiende Einfluß des fernen Osten. Der Handel mit echten Japanwaren nahm immer größeren Umfang an, Zeichner wie Hokusay wurden deutschen Künstlern bekannt und lieb, als gehörten sie zu ihnen. Unvergleichlich ist Japans Einfluß of alle zeichnende Künste. Man ahmte die eigentümliche Art nach, mit andeutungsweisen Strichen viel zu sagen: So die Radierer.'

67 ibid, p. 689: 'Japan ist aber zweifellos der wichtigste unter diesen anderen [Anreger] gewesen. Jedenfalls aber steht ihm die Kunst der Plakate nahe, die Kunst, durch das Bild in die Ferne zu wirken, von weither die Aufmerksamkeit zu erregen ... Denn das Plakat soll laut in die Menge hinausschreien; es muß daher Form und Farbe übertreiben; muß mit dem Geschmack der Massen rechnen. Heute ertragen die Künstler den Vorwurf solches zu erstreben mit größter Ruhe. Denn das entwerfen von Plakaten ist zu einem Kunstzweig geworden, durch den man Ruhm erwerben kann. Sie wissen, daß die Kunst nicht ein Gesetz hat, sondern daß sie reich und vielartig zu werden streben soll wie die Natur.'

68 ibid, pp. 690–1: 'Neben den Japanern bereiteten die Engländer, die aus der Schule von William Morris, Walter Crane u.a. hervorgingen, den

© Association of Art Historians 1997

Umschwung vor. In den Jahren 1893 begannen namentlich die Berliner Leiter des Kunstgewerbes, Peter Jessen an der Spitze, auf die englische Kunst hinzuweisen ... Es geht ein stark revolutionärer Zug durch das Kunstgewerbe, ähnlich jenem des malerischen Realismus.' Peter Jessen (b. 1858) was librarian at the Kunstgewerbemuseum, Berlin.

69 ibid, p. 691. The English Periodicals, especially the *Studio*, found many readers and admirers among us. (*Die englischen Zeitschriften, namentlich das Studio, fanden bei uns zahlreiche Leser und Bewunderer*).

70 ibid, p. 688: 'Aber erst in den Zeitschriften Jugend und Simplicissimus wurden die Kräfte vollends frei. Da kommt's gelegentlich zu einer Wucht des Ausdrucks, zu einer Gewalt des erfassens, aus der der Zorn stürmisch herausredet.' It should be remembered that Fritz Bleyl saw in the same periodicals, as well as *Kunstwart* much of their inspiration, F. Bleyl, 'Erinnerungen ...', op. cit. (note 7), p. 94.

71 ibid, p. 674–5: 'Modern ist die Socialdemokratie, sind die verschiedenen konservativen Parteien mit socialen Zielen; modern ist die Anarchie und sind die Bestrebungen der inneren Mission bis herunter zur Heilsarmee; modern sind noch eine Reihe von anderen geistigen Richtungen ist der Individualismus ... Man wird auf der Grundlage daß man bloß sich für modern, die anderen aber entweder für altmodisch oder irregeleitet erklärt, zu den gewünschten Volkskunst nicht kommen.'

72 ibid, p. 504–505. Gurlitt later wrote a small booklet about Langbehn, and he points out that his book was one of the few read by artists, see: 'Langbehn, der Rembrandtdeutsche', *Protestantischen Studien*, Heft 9, 1927, which includes reprints of two articles published by Gurlitt in *Die Zukunft*, 1907 and 1909. The overbearing nationalism of Langbehn's book appealed to many, with the Prussian victory against the French in 1871 still within living memory. The xenophobia among artists was later to lead to the '*Protest deutscher Künstler*' initiated by Carl Vinne, the Worpswede landscape painter, in 1911, see P. Paret, *The Berlin Secession*, Cambridge, Mass. and London, 1980, pp. 182 ff.

73 ibid, pp. 136, 143 and 162.

74 *Professor für Entwerfen auf dem Gebiete des inneren Ausbauen und dekorativer Ausbildung*

75 See Fritz Schumacher in Thieme-Becker, *Allgemeiner Lexikon der Bildenden Künstler*.

76 'Aus der Vorgeschichte der "Brücke"', *Der Kreis*, vol. 9, 1932, p. 10.

77 Schumacher, op. cit. (note 16), p. 217.

78 ibid, p. 219. He makes no mention of the use of other visual aids, such as slide projection. Although the use of slides in teaching art history was recommended by Dr Bruno Mayer on the first Congress of Art History in Vienna as early as 1873 and more cogently by Professor H. Grimm in Berlin University in 1897, it was strongly resisted and highly unlikely to have been introduced in Dresden at such an early date. See H. Dilly, 'Lichtbildprojektion – Prothese der Kunstbetrachtung' in I. Below (ed.), *Kunstwissenschaft und Kunstvermittlung*, Giessen, 1975, pp. 153–72; D. Hoffmann & A. Junker, *Laterna Magica*, Berlin 1982, pp. 49–50, 52–3. See also T. Fawcett, 'Visual Facts and the Nineteenth-Century Art Lecture', *Art History*, vol. 6, no. 4, 1983, pp. 454–7.

79 ibid, p. 283. This memory is thought to be supported by Fritz Bleyl's 'Erinnerungen ...', op. cit. (note 57), p. 96. Bleyl recalls that in the French section of the 3rd International Exhibition of Applied Arts (held in Dresden in 1906), they saw some large volumes with photographic reproductions of masterpieces of modern French art, including work by Van Gogh and Gauguin. One is bound to wonder whether there may be some confusion in these memories. Their interest in reproductions seems a little strange in view of the fact that paintings by both Van Gogh and Gauguin were exhibited at the Arnold Gallery in the same year, and it is this exhibition that Schumacher remembered. For a review of it by Dr Paul Fechter, see *Dresdener neuesten Nachrichten*, 10 November 1906. The exhibition presented 132 canvases (mentioned in *Kunst für Alle*, vol. 15, (1906–07), p. 196)., including six by Van Gogh and seven by Gauguin. Fechter congratulates the 'Salon Arnold' for showing these works in Dresden, although 'it might actually expect anything other than general approval.'

80 ibid, p. 283–4. His recollections are likely to be accurate; the excursion to Aschaffenburg in the summer of 1905 is reported in the *Bericht über die Königl.Sächs.Technischen Hochschule zu Dresden für das Studien-Jahr 1905–06*, Abgeschlossen 1 März 1906, Highschool; he asked for leave of absence for the Winter semester 1905–06 and did not return to his studies.

81 The painting, actually in the Collegiate Church of SS. Peter and Alexander, is the Predella of a dismembered Altar, other panels of which are in Stuppach (Parish Church) and Freiburg im Breisgau (Augustinermuseum).

82 ibid, pp. 244 ff.

83 H-R. Hitchcock, op. cit, (note 56), p. 461.

84 Schumacher, op. cit., p. 283.

Art History ISSN 0141-6790 Vol. 20 No. 1 March 1997 pp. 100–123

Defining *Hispanidad*: Allegories, genealogies and cultural politics in the Madrid Academy's competition of 1893

Oscar E. Vázquez

This essay examines the purpose and structure of a discourse of culture that attempts to construct and simultaneously negate its own definitions of culture. Specifically, it will examine a competition held in 1893 by Madrid's San Fernando Academy of Fine Arts, which called for the best pictorial representation of 'Spanish culture symbolized by the grouping of the great men who have contributed to its determination and development throughout the ages'. Although attracting few entries, much to the chagrin of academicians, the first- and second-place awards were given to José Garnelo y Alda (1863–1907) and Luís García Sampedro respectively (plates 24 and 25). The contest had its beginnings in a frustrated competition of twenty years earlier when the first-place slot was left vacant (clearing the way for the 1893 competition); it demanded the Sisyphean task of creating a single, holistic vision of Spanish culture, and *Hispanidad*. Few other late nineteenth-century academies attempted such a grandiose project as the defining of their culture in a *single* canvas depicting *all* the 'great' personalities from *all* major disciplines and historical periods. The Madrid competition of 1893 is unusual and intriguing in its ambitious magnitude. Yet, even more intriguing, although less unusual, is the contradictory nature of the debates attempting to define *Hispanidad*.

Academicians repeatedly accused the contestants of portraying foreign influences in their entries, of corrupting the truly Spanish, of seeking to find inspiration from elsewhere, even while they themselves pointed in contradictory fashion to an older, single source of Spanish culture outside of the peninsula: namely, Rome. The tendency of looking to Renaissance and Imperial Rome as the fountainhead of civilization was, of course, part of the nationalist and historicist currents in European academies of the eighteenth and nineteenth centuries. Yet, within the hundreds of transcribed folios from the academy debate, there is not the slightest mention of what is now so glaring a contradiction: on the one hand, Spain's cultural origins were attributed to Roman foundations (and even to the city of Rome), while on the other, these attributions were accompanied by xenophobic criticisms against any foreign influences in the construction of Spanish culture. What emerges from these lengthy debates are dominant languages of power which allowed academicians to choose a final winning canvas in 1893. However, this essay is less concerned with explaining the ideological underpinnings as a solution to these unpublished works.[1] Rather, it

© Association of Art Historians 1997. Published by Blackwell Publishers, 108 Cowley Road, Oxford OX4 1JF, UK and 350 Main Street, Malden, MA 02148, USA.

explores the changing language and context of the debate over *Hispanidad* itself; I hope to demonstrate that it is precisely the unrecognized limitations of their stated goals that defines the discourse of culture, as articulated by Madrid academicians in 1893. In essence, the 1893 competition represents a crucial moment in the political authority of the Madrid Academy; it was both a call to arms and an unstated recognition of the demise of the San Fernando Academy as the dominant arbiter of Culture, and of its status as the most powerful arts institution in Spain. Hence, what was at stake in these late nineteenth-century debates was not so much how Spanish culture was to be defined, as who had the authority to define it.

Because the 1894 competition's theme and call for entries mandated that the legitimacy of Culture be contextualized within an authoritative past, and because the idea for the competition itself began twenty years earlier in an 1873 contest for the best painting depicting the 'apotheosis of Spanish art' as 'symbolized by the grouping of the great men who have cultivated it', we need to examine the question of traditions and the competition's own genealogy.

The theme of great personages of Spanish culture belonged to a long tradition of visual representations of 'great men'; nineteenth-century Spanish examples include the 1825 ceiling decoration, *Parnassus of Great Men of Spain*, for the royal residence of El Pardo outside Madrid (plate 26), Ramón Barba's 1831 medallions on the exterior of the Prado Museum representing esteemed painters, sculptors and architects of Spain (plate 27), and the decorations of the Central University's Paraninfo library painted in 1855 by Joaquín Espalter. The competition's award-winning canvases, however, have some of their most obvious formal and conceptual roots in works such as Paul Delaroche's hemicycle (plate 28), and Ingres's *Apotheosis of Homer*, both of which in turn drew inspiration from Raphael's Stanza della Segnatura fresco, the debt to which was repeatedly acknowledged in the debates.

Questions of traditions, genealogies and continuity have been dealt with in a variety of ways, from those focusing on the mechanisms of the legitimacy of political authority, and those concentrating on rejection or purposeful misreading of historical forms, to those viewing tradition as a vehicle for the recognition of the present's constructed yet ever-changing difference, or horizon.[2] Traditions are not unlike the structuring codes described by Barthes: those off-stage voices of past performances that repeat earlier narratives, continue to utter instructions to present actors, and eventually are lost within the events that inevitably make up the play.[3] The metaphor of the stage is appropriate here as the temple-like setting in the paintings (as, for example, in plates 24 and 25), is not only a stage where the narrative is enacted in an unreal time, but also a space whose meanings are conditioned by the discourses and contexts of presentation, while simultaneously challenging the limitations of its presentation.[4] This becomes clearer if we understand the function and symbolic logic of the work, specifically, that act of re-presenting and transforming a 'traditional' (legitimacy) of academic authority.

The Spanish competitions – looking to earlier definitions of culture – depended upon a metanarrative, the truths of which rely on its own closed, symmetrical form.[5] However – through this genealogy, that is – the simulation of reiterating previously established themes and forms, there is always a

24 José Garnelo y Alda, *La Cultura Española*, 1894. Oil on canvas, 1.58 × 3.03 m. Madrid: Collection of the Real Academia de San Fernando. Permanent loan to Instituto de España, Madrid. Photo: Museo de la Real Academia de Bellas Artes de San Fernando.

© Association of Art Historians 1997

25 Luís García Sampredo, *Alegoría de la Cultura Española*, 1894. Oil on canvas, 1.6 × 2.98 m. Madrid: Real Academia de Bellas Artes de San Fernando. Photo: Museo de la Real Academia de Bellas Artes de San Fernando.

26 Juan Antonio de Ribera, *Hombres Célebres de España*, 1825. Ceiling fresco. Palacio de El Pardo (Madrid). Patrimonio Nacional Madrid. Photo: Copyright © Patrimonio Nacional, Archivo Fotográfico. Palacio Real, Madrid.

27 Ramón Barba. Medallions – exterior of Prado Museum, Madrid, *c.* 1831. Marble. Photo: author.

© Association of Art Historians 1997

28 Paul Delaroche. Detail (centre section) of reduction of hemicycle painted for Ecole des Beaux-Arts, Paris, *c.* 1831. Baltimore: Walters Art Gallery, Baltimore.

reformulation of that tradition. 'Genealogy', it has been written in relation to Nietzsche, 'proceeds from one interpretation to another; it discovers new meanings without ceasing. It is interminably translation and transposition. ...'[6] Spanish culture was defined in these paintings through themes and forms which were intended to translate and augment several earlier generations of works taken as a basis for the competition. In this way, the presumed origins and definitions of culture as configured by the late nineteenth-century academicians were partially constructed within the question itself. It is little wonder that *cultura española*, as defined by these academicians, was determined by the accumulation and repetition of signs within a very familiar, oft-repeated space. Here, Craig Owens's description of allegory – concerning itself with the spatial or temporal projection of structure as sequence – as 'static, ritualistic, repetitive' is especially applicable.[7] Both this stage-like space, which played a central role in the competition debates, and the discourse of constructing a visual representation of culture as dependent upon translation were, as we shall see, allegorical.

The theme of the 'Great men of Spanish Arts' was first introduced to the Academy in 1871 after the dethronement and exile of Queen Isabel II (1868), and on the eve of the short-lived First Republic (1873–74).[8] This six-year liberal period from 1868 to 1874, called the 'Sexenio liberal' sought greater suffrage, and instituted education reforms and new local libraries. Just as important, it witnessed new regulations in the Academy, and the biennial salons being opened for the first time to foreign competitors – an especially sensitive point.

The period of the Sexenio liberal included educational reforms, a re-evaluation of the genealogy of civil and artistic traditions, and an emphasis of the idols of the past as well as a focus on new heroes. Accordingly, interest in the stagnated project of the 'Pantheon of Illustrious Men', an architectural shrine devoted to the remains of Spain's heroes, was rekindled during this period; the cult of death and religion, like nationalism, offers a link both to the past and to the future.[9] Among the principal motivations for the 1873 competition was the 'promotion of a truthful emulation' of the achievements of past artistic immortals, but the

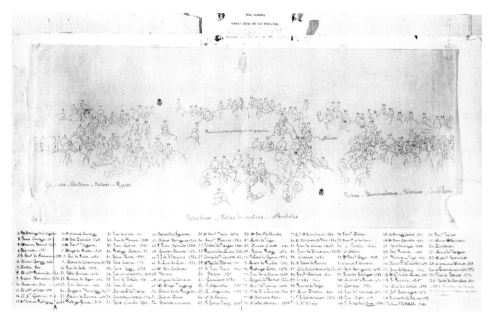

29 Juan José Martínez Espinoza, Explanatory drawing for *Apotheosis of Spanish Art*, 1873.
Pencil on paper, 63 × 21 cm. Madrid: Real Academia de Bellas Artes de San Fernando. Photo:
Museo de la Real Academia de Bellas Artes de San Fernando.

competition theme was also defended by the belief that the reconstruction of a
national identity built upon a humanist tradition aided by representations of
'great men', and the desire to maintain the 'highest level of the arts' for which the
academy is encharged, would be an inspiration to a younger generation of
artists.[10] Likewise, for the 1893 competition, the academicians spoke of the
academy's 'authority and prestige' whilst stressing the subject of the great Spanish
men of all time.[11]

The composition by Juan José Martinez de Espinosa (1826–1902), which won
the runner-up prize in an otherwise winnerless 1873 competition (plate 29), for
instance, showed an inscription *Renacimiento* above a Roman-like temple which,
according to the jury, was 'a place most appropriate for an apotheosis'. Below this
inscription and within an apse was an allegorical statue of 'Christian religion, the
sublime focus and inspiration of all genius'.[12] In front of the temple were arranged
various historical figures. The composition's only significant difference from the
other entries was the figures relegated to the middle- and background. The
novelists and poets have been given centre stage, while the triumvirate of painters,
Diego de Velázquez, Esteban Murillo, and Jose Ribera, are flanked by Alonso
Cano, Miguel de Cervantes, and the playwright Francisco de Quevedo in an
elevated centre position. Other painters included in the composition are Francisco
de Goya, Pedro Berruguete and Francisco de Herrera (the elder). The groups on
either side of these are dedicated to architects, sculptors, guilders and *rejeros*
(decorative iron workers) on the left; painters, illustrators, glass painters and
engravers on the right.

106 © Association of Art Historians 1997

Almost the same players were given pride of place in the 1893 competition entries. Given the academy's stress on continuity or revival of tradition, the formal similarities among the two contests' final entries are striking. This is not wholly to be explained by the conditions of the competition's guidelines. Indeed, it is significant that there was an almost complete absence of debate over who were the 'great men' of Spanish arts in 1873 or in 1893 for that matter. That hierarchic tradition of Spanish artists was extremely well ingrained within academic circles, as manifest by the cover of the magazine *El Arte en España* which, forty years earlier, had used the nearly identical set of artists and elements (plate 30).[13]

Academicians argued not so much over the list of immortals, but rather over practical questions of the competition, such as the need for stricter deadlines and conflict of interest among voting academicians secretly participating in the competition. It was discovered, for example, that the runner-up was Martínez de Espinosa, the same academician who argued so vehemently against leaving the first prize vacant.[14] They also debated definitions of *boceto* (cartoon), finish and 'perfection' in a painting. Even so, the problem that provoked the most heated debate was the 'notorious inferiority' of the works submitted, which was cited as the principal reason for not reaching a consensus regarding the first prize.[15]

There was, however, more involved in the Academy's indecision than merely a question of the inferior technical quality of the entries. After all, alarmist cries of artistic decline in Spain had been heard regularly on the Academy floor since the late eighteenth century and were a significant reason for the creation of state-funded national exhibitions in 1856. Why was there such dissatisfaction with the quality of submissions during the first half of the 1870s?[16] The economic difficulties following a revolutionary period can offer only a partial explanation. We can only speculate about specific technical differences because only one sketch from the approximately five 1873 finalists survives. However, the emphasis on definitions of perfection, and *boceto*, and the academician's acceptance of the traditional group of immortals comprising the representation of Spanish arts (Velázquez, Murillo, Zurbaran etc.), indicate that at the heart of the indecision over first place was not so much the question of content, but rather its changing modes of representation.

The Academy's sensitivities concerning finish and formal quality demonstrated changing European attitudes within official arts institutions and public exhibitions. The Academy's reluctance to award first prize manifests changes in the relation between signs and their signified. The debates suggest the attempts by academicians to contain and replicate formulaic, art-institutional signs (the appropriation of a lengthy tradition of cultural forms) while re-presenting these with evidently looser surface treatment. Their inability to reach a consensus regarding the how rather than the what of cultural representation occurs at a time of the Sexenio liberal, a period of political transition from provisional, democratic and republican governments to the restoration of a monarchy. That is not to say that the indecision over the award of the first prize here was a product of the liberal government's inabilities to maintain political stability. Rather, there was increasing uncertainty over, and 'challenges to, the *forms* of expression that those political and artistic definitions should take within officials arts and governmental institutions. Ruling academicians then found

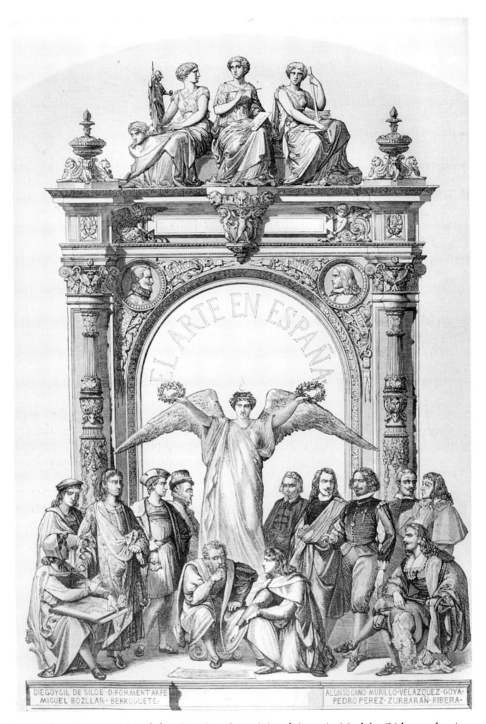

30 Isidoro Lozano, original drawing; Jose Serverini and Antonio Machón (Lithographers):
Cover of *El Arte en España*, 1860. Wood Engraving and Sepio cromotipography (background).
Photo: Courtesy of Harvard College Library.

© Association of Art Historians 1997

themselves having either to accept the translation of a tradition now contextualized in a fairly liberal, but swiftly changing political climate, to reject it altogether by constructing a new genealogy, or to find the means of reconciling these extremes. The final decision to leave vacant the first-place slot seems to have been judged the lesser of all evils: for in the end, the very act of staging the competition and debating the codes and genealogies that constituted *Hispanidad* served a more important culturally and politically symbolic function than any lasting changes the competition may have invoked. If the forms of cultural representation were challenged at a time of dramatic political and institutional change, then the inability of the Academy to reach a consensus may have served as a strategy for maintaining the stability necessary to continue seeing itself as the standard-bearer of Culture.

By awarding *only* a runner-up prize to a composition that was defended via its Renaissance-humanist *theme*, the academic debates over definitions of execution and 'perfection' were curtailed and left unresolved. In the end, the 1873 entries exacerbated feelings of Spanish inferiority in the arts and reinforced the need for a reappraisal of the internal mechanisms for academic competitions. Yet, the 1873 competition did leave its mark. Firstly, it set in motion the debates over contradictory regulations governing academic competitions. Secondly, the vacancy of a first-place prize motivated the renewal of the competition's theme twenty years later. In this way the 1893 competition inherited many of the formal difficulties and unresolved ideological issues of its counterpart twenty years earlier. By then the political climate had changed considerably; the frank, uncomfortable awareness of disharmony in 1873 was to contrast painfully with the empty gesture of unanimity in the awards of twenty years later.

In 1893 the Academy received and awarded a prize to the best work representing Spanish Culture. The winning panel *La Cultura Española* by Garnelo y Alda (plate 24) receiving first prize, and the runner-up prize going to *Alegoría de la Cultura Española* (plate 25) by García Sampedro. The only significant difference between this and the earlier 1873 competition theme was the substitution of the word 'culture' for the earlier 'arts'. This change alluded to the intended destination of the winning panels in a public, cultural institution, while also indicating an amplification of the disciplines defining Culture. Thus, the 1893 panels encompassed law, science, geography, philosophy and religion, as well as the various branches of the fine arts.

While the 1893 competition called for Spanish culture *symbolized* by the grouping of personalities and did not specify allegory, several of the entries employed the latter term in their titles, such as García Sampedro's *Alegoría de la Cultura Española*. The naming of these canvases as allegories is telling. The competition's call for multiple figures instructed the competitors to create a series of symbols representing culture, rather than single emblems — like the familiar image of Spain's First Republic (plate 31).

The individual authors, artists and intellectuals represented in the competition entries either index their creations with architectural plans, paintings and books, or represent particular historical events (such as the 'discovery' of the new world) through a metonymic relation to items such as globes, maps, battle standards. In this way a palette and the red cross of the Order of Santiago on the lapel came to

31 Signed García, Cover of *La Ilustración Republicana Federal*, Madrid, 1873. Metal Engraving.
Photo: Courtesy of Harvard College Library.

© Association of Art Historians 1997

signify Velázquez, and the book of *Quijote* signified Cervantes. However, in order for these portraits to be simultaneously understood to mean an apogee of Castillian ('Spanish') painting or literature, or even of Spain's contributions to the larger European cultural history, they are dependent on syntagmatic relations of proximity or distance to their colleagues within this elite male club. For example, in García Sampedro's work (plate 25), Velázquez and Cervantes, identified through their attributes as the figures on the far right and left of the composition, signify other relations of hierarchical values in history and the arts because of their elevated or separated positions. (An understanding of this compositional device as designating rank and distinction was, of course, part of the tropes continued by the academic contest.) The representations of famous personages are, therefore, metaphors for their respective disciplines, or epochs, of genius only through a series of relations to those attributes, and the compositional devices designating distinction, which in turn are dependent themselves upon other structured, formal elements, namely, the temple-like stage setting of a pantheon. In other words, for these paintings to function as allegories of Culture, the artists were dependent upon a chain of metonymic and synecdochical visual relations.

Obviously, choices had to be made in order to prevent the canvases from becoming vast landscapes of miniature, unrecognizable portraits. Like Borges's mythical map, the details of which came to fill the entire territory it represented, such a totalizing concept of culture would have been inconceivable.[17] After all, the competition's theme had already circumscribed the definition of culture by the two words 'great men'. Nonetheless, it was, in this case, the allegorical site represented in the works which helped to control the parameters of meanings.

So important was the representation of this imaginary space that it was one of the principal arguments in the 1893 debates. The language of these debates conflated the site of the apotheosis of Spanish culture with concepts of nation and religion. A decade earlier in 1882 the President of Spain, Antonio Cánovas del Castillo, in his important 'Concepto de Naciones' – modelled largely upon Ernest Renan's famous essay 'Qu'est-ce qu'une Nation?' published a few months earlier – had already employed the imagery of the cult temple (significantly in a Greco-Roman context) in his definitions of Nation: a 'unique temple in which each could practise his cult'.[18]

In order to ensure anonymity, all contestants had to submit, along with their entries (identified solely by a slogan or rubric), a sealed envelope with that rubric on the exterior and the author's name and signature within. Two of the four entries in 1893 carried the identifying rubrics of *Hispania*. This further suggests the conflation of *Patria* (nation) and culture, the latter often associated with that other key word *civilization*, hence designating class-biased definitions.[19] In this way, by placing in that religio-cult 'temple of immortality' a fraternity of renowned Spaniards from all major historical periods – namely, the academic founding fathers of the arts, letters and sciences representative of civilization – the Academy had been conflated with the nation which, in turn, had become atemporal and nearly eternal, placing its origins, heritage, and even its future, beyond consideration. Yet, this move was done only at the risk of several contradictions and formal problems, such as how simultaneously to represent the nation's contemporaneity and its traditionalism. One solution is evidenced by the

32 Artist unknown [Jose Yxart?], Cover to *Arte y Letras*, Barcelona, 1882. Etching. Photo: Courtesy of Harvard College Library.

frontispiece of the liberal and short-lived, Barcelona-based magazine *Arte y Letras* of 1882, which attempted to internationalize Spain's modern art world. Here, the most prestigious of *contemporary* Spanish artists from diverse provinces all pose comfortably beside their French and Belgian peers (plate 32). Despite its cast of modern actors, the frontispiece still follows the ubiquitous conventions of placing a pantheon of illustrious men against a stage-like temple of immortality with its allegorical female figure, and thus has direct formal connections to the tradition followed by the 1893 competitions. Incidentally, in the upper left-hand corner of the frontispiece is the slogan *'Per angusta ad augusta'* (Through difficulties to honour), the almost identical identifying rubric used by Garnelo in his 1893 preliminary submission.

The displacement of pan-historic figures into an imaginary temple of immortality referencing antiquity also served another purpose. These competition entries are panoramas which create a mythical time and place where a homogeneous Spanish culture, and by implication also a unified Spanish nation, might exist. Homi K. Bhabha tells us that a nation's fictitious political unity rested precisely on the continual displacement of its heterogeneous modern space into an archaic mythical one that, paradoxically, was represented by the 'patriotic, atavistic temporality of Traditionalism'.[20] In the later competition paintings the diachronic narrative of Spain's 'great men' grouped in an imaginary synchronic

112 © Association of Art Historians 1997

moment partakes of the same nationalist historicism that promoted the large-scale revival of history painting in Spanish national exhibitions, and which reached its zenith a few years before the competition. In this way, allegory in the competition panels functioned to create a fictitious duration in order to enhance the illusion of continuity.[21]

Both the winning and runner-up canvases used history as a unifying element. In Garnelo's work, the word *Historia* is inscribed in the temple's pediment, while in García Sampedro's work, Father Time floats in the clouds above the apse writing out the phrase *cultura española* in the book of history. Both details give further weight to the contemporary view expressed by the Catalán leader Enric Prat de la Riba: that there is no culture without history.[22] This essentializing argument determined that culture, and in the context of the Catalan's politics, also nationhood, be born of historical deeds and events. An age-old equation in any event. So why were academicians so sensitive to the proper representation of culture and its personages at this time that they should have revived the competition? What 'off-stage voices' in this chorus of allegorical representations had been excluded? Or, what new voices had been added now to cause such extraordinary dissonance in the academic debates of 1893? We find some answers by looking further into the proposed site of the finished winning composition.

The winning entries of the 1893 competition were intended to decorate the salons of the National Library and Museum building (today, the National Library and National Archaeological Museum),[23] whose exterior sculptural programme also included statues of the great men of Spanish learning and arts (plate 33). Though there were delays in both the academy competition and National Library projects, the deadline for the completion of these was October 1892 to celebrate the fourth centenary of the 'discovery' of the Americas.[24] The winning paintings were therefore destined for the National Library, Spain's emblematic centre of learning and a chief repository for the country's cultural and historical artefacts. The panels' intended destination and timeliness suggest that the 1893 competition was related to an academic discourse of cultural identity in the face of international economic trade and colonial concerns, both foreign and internal (with militant and economically powerful regions such as Catalunya).[25] That same year, of the fourth centenary – and six years before the loss of Spain's remaining colonies in the Spanish-Cuban-North American war of 1898 – President Joaquín de Costa lamented Spain's loss of prestige as a colonial world power: 'We were the first colonial power and [now] that solemn occasion [of the fourth centenary] finds us the last.'[26] An academy might thus designate itself an authority in matters of cultural definitions and so associate itself with nationhood. But the consequence was that it would also be equated with all other connotations that those laden terms signified at the time, including – possibly – national or cultural decline. The impossibility of policing the boundaries between notions of past glories and the reality of political decline, or of resolving the contradictions between tradition and modernity, was manifest in the debates themselves. The delay in the completion of the National Library building left these allegorical representations without an appropriate discursive site, without a frame of their own, so to speak, which could have defined and partially controlled the parameters of meaning. Instead, the final entries were shown in the halls of the

33 Celestino García, *Velázquez*, 1893. Marble & Granite. Lifesize. Madrid: Façade of the National Archaeological Museum. Photo: author.

Academy itself and eventually placed in storage or returned to their owners. It was, significantly, the allegorical site of the cult temple represented within the works that was the chief problematic site of debate on the real grounds of the academy floor.

The shift in emphasis from arts to culture in the two competitions had been accompanied by the Academy's decision to judge the 1893 entries on the 'purely pictorial, ignoring the scientific aspects but remembering the School of Athens [by Raphael]'.[27] The divide between the two terms pictorial and scientific was essentially one between content and execution. Both terms were linked to the increasing popularity of sketching societies, as well as the 'sketch–finish' debate

© Association of Art Historians 1997

that partially determined who could enter academic contests.[28] These arguments were also part of ongoing philosophical debates concerning Positivism/Idealism and which reduced Positivism to materialism and superficiality; in artistic terms, this superficiality was translated as an excessive emphasis upon surface qualities and a negation of traditional compositions and subjects.[29] Given this equation, and given the tendency by contemporary academic criticism further to equate poor execution with artistic and cultural decline, the decision to emphasize content is understandable. (While such equations extend throughout Spanish nineteenth-century criticism, it will be remembered that in 1873 the 'inferior quality' of the entries [based principally upon execution], was the major hindrance in selecting a winner. In any event, the 1893 debate's emphasis on content, that is the 'purely pictorial' merits of the works, and the decision that a cartoon was 'any preliminary study for a painting even if executed in oil and colours', at least settled the earlier 1873 unresolved question over what was understood to be the 'scientific'; that is, finish and execution.)

The question of whether Culture should be represented by personalities or background and props remained; members warned of artists who were over-zealous in showing erudition.[30] One painter mocked the accoutrements of erudition in García Sampedro's runner-up work – the numerous books, scrolls, prints, banners and plans – describing the contents as 'the rejected paraphernalia from the large library of an important man who has died'.[31] Having decided that Spanish culture should be represented by historical figures as opposed to objects, academicians nonetheless failed to stipulate the hierarchy of artistic personalities in Spanish history. Moreover, they rarely remarked upon the issue of how the various peoples from diverse historical and geographic regions comprising *Hispania* might be visualized. One painter acknowledged that 'in order to represent Spanish culture in the Middle Ages, one must inevitably consult Hebrew [Jewish] culture since of the Spanish, strictly speaking, little existed in those centuries ... The true Spanish culture is to be found in the Renaissance.'[32] And if the only 'true Spanish culture' existed from the Renaissance onward, that is, the era of Catholic Kings, then it is understandable that almost eight hundred years of Islamic history on the peninsula were hardly given any mention in the hundreds of folios of the competition's proceedings. The 'Arabs' were so designated in the debates through their costumes (far-right background in García Sampedro's work; left foreground in Garnelo's work). However, for the majority of academicians, with the exception of a few apologists such as José Amador de los Ríos, the reign of Islam in Spain was a brief parenthetical interlude between 711 and the capture of Granada by Christian forces in 1492, the dates of which, painted on banners in the central background of García Sampedro's work, were resoundingly applauded. Their approval is in keeping with the heavy nationalist rhetoric of contemporary criticism and the principal themes of late nineteenth-century Spanish history painting: discovery, conquest and Golden Age empire.

The representation of Culture via personalities posed contradictions and difficulties, for it required the type of careful coding previously mentioned which made attribution and hierarchization possible. In order to build a panorama of personalities within an historically determined pan-European format, the alterity of Spain's national genius had to be represented by the very objects that

academicians concluded were not true signifiers of culture. And if props had been deemed inappropriate, it meant finding other symbolic repositories of culture. Thus, here we see reified the conflict between the use of allegorical interpretation with its freedom of associations, on the one hand, and the attempted construction of a fixed system of cultural hieroglyphs on the other.[33] In this way, despite all claims to the contrary, the debate over how true Spanish culture should be defined was silently transferred from a focus on personalities to one that employed architecture as the chief signifier of *Hispanidad*.

Spain's greatness from all periods needed to be illustrated. Therefore, the hierarchy of Spain's multiple architectural styles was questioned. The outcome of the architecture debate became the criterion for determining the best representation of Spanish culture. Thus, a heated argument developed over the site of culture, that is, the various temples of immortals, and historic structures painted in all the contestants' panels. This may be understood in allegorical terms. The Academy's position was legitimized by the suggestion that the forms through which it chose to represent itself were omnipresent and atemporal. The questions of the legitimacy of the Academy as an intellectual, discursive site, of its determination, control and dissemination of definitions of culture, were never openly posed. Rather, the arguments over temple building styles replaced questions over what went on 'inside' the walls of that temple, which was the San Fernando Academy. Indeed, the legitimation process at stake here was indexed precisely by the reification of the definition of Culture on that mythical site of cultural production. What was suggested by the panels, in short, was that the site of cultural production, *was* the definition of Culture.

Among the critics of the 1893 entries were those who complained of the Pompeian wall frescos on the Pantheon-like structure of Garnelo's entry *Ad Augustua per Angusta* [final version title, *La Cultura Española*, plate 24] and of the cathedral constructions in the background of García Sampedro's *Hispania (bis)* [*Alegoría de la Cultura Española*, plate 25] – even while they ignored the historical incongruity of the grouping of personalities from various periods. But a work was considered most flawed if it was believed to show foreign influences. For example, the architecture in Garcia Sampedro's work was faulted for not being 'genuinely Spanish' and for mistakenly having suggested 'as expressive symbols of our culture, architectural monuments which are the fruit of foreign influences and even of authors'.[34] Even well-established, Greek architectural motifs were eschewed as having 'nothing to do with Spanish culture'.[35] The competition's emphasis on architecture as the most appropriate signifier of Spanish culture continued a wider debate in the 1880s over which architectural style should represent Spain in the universal expositions. What is most striking about Spain's tourist-influenced economic choices for these fairs is that rather than Spanish or Italian classicizing motifs, they often emphasized neo-Arabic and neo-Mudejar architecture, frequently with allusions to the Alhambra of Granada.[36] By the 1893 competitions, however, a preference for the Spanish Renaissance plateresque style was returning, and by the end of the century (after the 1898 war) the revived plateresque style would be considered *the* Spanish style.[37] That classicizing preference was already evident in the 1893 competition debates. For example, García Sampedro's work, in which it was claimed 'are

116

found all the orders of Spain', the plateresque was highlighted by the large background arcade representing the Palacio de Monterrey (Salamanca).[38] The Gothic ogival was represented by Burgos Cathedral, the Greco-Roman by the Escorial, and the Roman by the Segovia Aqueduct. Islamic architecture was represented as a mere silhouette of Seville's Torre de Oro seen in the distance through the arch on the left.

Fifteen years earlier the Catalan architect Lluís Domenèch y Montaner, in his discussion of the search for a national architecture, had linked particular architectural styles to Spain's regions while doubting that any synthetic functional unity was possible.[39] Thus, in paintings, words and international fairs, regional traditions and history were represented emblematically through a particular architectural style. In this way, Romanesque, Visigothic, Gothic and Mudejar architectural monuments came to be defined by regional associations. Like the paradigmatic historical figures in front of the temples in these competition canvases, these monuments were transformed into a political allegory of the history of Spain and its 'evolutions' towards either a diversified nation of autonomous regions, or an homogenous whole. Significantly, the important monuments of 'peripheral' regions such as Catalunya, Galicia, Asturias, Valencia and the Basque provinces, were ignored in these representations.

Contemporary dictionaries indicate that '*Patria*' was almost synonymous with Madrid, the capital of the nation and of Castile.[40] Joaquín Costa, a staunch anti-separatist advocating a type of federalism and a fervent defender of a unitary Spain, also regarded Spanish culture and nationality as rooted in Castile. A decade before the 1893 competition he had condemned the rising tides of regional militancy – those 'provinces against Madrid', as he called them – and lamented the declining 'hegemony of Castile in the dawning of nationalism [which] has cost our race the sceptre of the world'.[41] The rising tide of militant separatism, anarchism and violent regional politics was again threatening the control of the central Castilian government. The same year that the Academy was deliberating over the competitions, the *Centro Vasco* or Basque Centre (later the *Partido Nacionalista Vasco*, Basque Nationalist Party) was founded; the previous year had witnessed the first congress of the *Unió Catalanista*, a principal political organ for the promotion of Catalan autonomy. The region of Catalunya, and to a lesser extent Valencia, had revived its language and had promoted a self-proclaimed *Renaixença* of the arts based upon the region's particular historical (mostly medieval) forms.

In terms of the art world, the political and economic powers of Madrid's San Fernando Academy had been a thorny issue since mid-century, when various reforms had granted centralizing powers to that Academy over others, such as those in Barcelona, Cadiz, Sevilla, Valencia, Valladolid and Zaragoza. By the end of the century many of these academies enjoyed increasing political and economic autonomy. More importantly, by the 1890s, most of the prosperous academicians were making use of private exhibition and gallery spaces, for example, in Barcelona, but also of the foreign markets, in Paris, London and even the United States.[42] Hence, by the time of the competition's call for entries in 1891, Madrid's San Fernando Academy, although still the symbolic and legislative seat of artistic

authority in Spain, had been economically and politically eclipsed as the leading centre of the debate, dissemination and control of notions of artistic 'progress', and as the chief market for artistic cultural products.

Despite the rising relative strength of provincial markets and the intensification of provincial autonomous movements, the question of regionalism was never introduced in the debates over cultural definitions because they necessitated a concentration on the most common signifiers of regional or ethnic affiliation, that is folkloric costumes and props. Signs of ethnicity and common local history are, according to Eric Hobsbawm, incompatible with a belief that nascent nationalisms have something to gain by merging with larger nations.[43] Yet the silence on the academy floor with regard to regionalism is intriguing because, precisely at this time, regionalist-inspired, large-scale genre paintings focusing on the working classes had begun to appear in increasing numbers in the national exhibitions. Clearly, tightly controlled academic painting competitions produced works very different from the large-scale genre paintings made essentially for the wider, consumer-driven market of the national exhibitions and galleries. Yet, we should be careful here not to see the 1893 competition's avoidance, or suppression, of the regionalist debate as necessitated by the central-state's unification or totalizing control.[44] For in terms of the architecture, or for that matter, the costuming and props, the academy's choice of winners foregrounded neither regional nor national paradigms. In 1893 the first prize was awarded by nearly unanimous vote not to an entry championing Spanish historical, plateresque monuments, but rather to a painting which, according to the academic debates, ascribed Spanish architectural foundations to Rome. In spite of their xenophobic cries, the academicians repeatedly praised Italian or Roman motifs in Garnelo's prize-winning entry *Ad Augusta per Angusta* because in their estimation it traced more correctly than others the lineages of Spanish civilization to Roman architecture:

> In as much, it is declared that, in depreciation of the numerous influences in the determination of our nationality, the one which with all certainty has served as a basis [...] for the major portions [and] expressive manifestations of our nationality is legitimately derived from the Roman. [...]t is indisputable that Spanish civilization sprouted forth from our soil under Roman domination.[45]

Curiously, the birth of Spanish civilization is acknowledged here as born under colonial rule, and hence could have helped justify Spain's control over its own diminishing colonial possessions. Yet, the use of such justifications was contradicted by contemporary, essentializing constructions of national or even ethnic identity.

While it is true that ancient Rome left its mark upon the formation of Spanish culture, it is also true that the Visigoths, the Muslims and the early Iberians provided a legacy unique to the peninsula. If academicians could rely on classicizing architectural and pictorial traditions to help them decide that the origins of a true Spanish culture lay with the Roman conquest, then how could they reconcile the government's simultaneous declaration (1882) as a

© Association of Art Historians 1997

national monument of the ruins of Numancia, one of the last strongholds of *resistance against* the Romans? Equally contradictory were the history painters who interpreted scenes such as the Siege of Sagunto by the Romans, or the death of the Visigothic King Viriato in the defence *against* Rome, as standards of nationalism.

In short, Spanish academicians could not present themselves as purely Spanish, as members of a nation free of foreign influences and with closed borders, whilst simultaneously claiming citizenship in an active, wider global community claiming various foreign heritages.[46] The question then remains, as to how academicians were able to validate a constructed Spanish cultural identity by rallying around xenophobic cries of corruptive foreign influences in the arts, while simultaneously seeking to integrate more fully the national character into a longer, more glorious, but nonetheless foreign-based tradition? Or to put it another way, why were these arguments not seen as contradictory? In the face of such reductivist polarizations of identity, what would have permitted individual academicians from seeing themselves as Castilian, Catalan or Basque, while simultaneously Spanish, Latin, and European?

Two important strategic tools for Spanish academicians were the concepts of 'Latinismo' and its related 'Hispanismo' (Hispanidad),[47] both of which played prominent roles in the 1893 competitions. For example, one academician felt that Garnelo's *Ad Augusta per Angusta* most correctly traced Spanish cultural history and demonstrated 'through such a construction, that our national culture is Latin'.[48] Like the pan-Slavic, pan-Germanic and other pan-ethnic movements, both Latinismo and Hispanismo were attempts to find a basis for the unity and commonality of a people through social-political ordering, customs or through linguistics; thus, in the case of Hispanidad – Castilian, while in the case of Latinismo – a common heritage in ancient Latin civilization. (There were also current attempts to forge an *Iberismo* and *Mediterranismo*.) Both Latinismo and Hispanismo are directly related to a cultural politics of a nation contending with four principal linguistic groups traditionally represented by geographical regions with increasing workers' migrations, political militancy, divergent economic strategies, independent cultural histories and, more importantly, with several nationalist movements struggling to gain a form of autonomous, or even separate, statehood.

Latinismo and Hispanismo offered debating academicians a partial, fictive solution to the problem of attempting to fix a representation of cultural unity and nationalist sentiment. It did so by first proposing that the nation's rightful cultural heritage could be traced to a Latin-based group (in spite of contemporary interests in the origins of the Basque language). Secondly, it set the place of that birth in a pan-Mediterranean (Latin) civilization derived from the Italian Renaissance and ancient Rome. By calling for representations of *Cultura Española* in the context of *Madre Patria* and *Hispania* – the Roman name for the peninsula – they maintained pan-European classicizing traditions, and nationalisms that linked a Spanish identity to notions of empire and antiquity. Pan-ethnicity, itself a form of nationalism which re-defines individual groups as part of a larger genetic unit, sheltered academicians from confronting the very contradictions posed by more restrictive constructions of Spanish identity.

© Association of Art Historians 1997 119

In their definitions of Spanish cultural identity, or *Cultura Española*, academicians frequently emphasized what was not 'purely' Spanish. If, as Perry Anderson and others have argued, nationality is a relational identity, the definition of which is largely dependent upon an element of alterity,[49] then it seems that academicians were caught in a double bind in their attempts to locate the purely Spanish by emphasizing the historical construction of Roman architecture. Such a move gained them, on the one hand, associations of longevity (tradition to the academy and unity and empire in terms of the nation) while, on the other, denying them any form of true alterity from other European communities. Indeed, the solution as to where national, cultural differences should reside would undoubtedly have had to be signified by the props and historic or regional costumes they claimed were not legitimate forms of culture. Further, by not historicizing those unique forms of the nation's diverse (for example, regional) constituencies, Spanish academicians controlling the competition effectively suppressed the 'politics of subalternity'.[50]

What then was at stake for these academicians? That is, why so much debate over what was seemingly a tradition-based, academically defined notion of Culture? It was certainly not the notion of *Hispanidad* that was at stake: conservative academicians, through their artistic interventions and in spite of winning a decisive vote, could hardly have controlled the politically volatile dynamics of such concepts. Were they trying?

If the academy felt compelled, as it had in 1873, to design a competition the purpose of which was to define Spanish culture according to a genealogy of academic traditions, and if it felt it necessary to suppress the politics of alterity, it did so less from any altruistic or homogeneously conceived universal notions of Spanish culture or nationhood – although this was certainly one of the proclaimed intentions. Nor was the competition driven solely by political pressures at a time of increased concern over cultural parity with European colonial powers. These formed only the political frame. If academicians argued at length over the forms and site of cultural production, then it seems that the legitimacy of that very site as chief definer of culture was felt to be endangered. The admission of a politics of difference would have brought into question the legitimacy of the very processes of cultural definition within that site. By concentrating their debates upon the *forms* that cultural imagery should take (namely the academic pantheon of immortals rather than on the individual figures, regional presence, or dynamics of the academic process) academicians gave substance to their unquestioned, self-determined, central role as *the* authoritative producer of cultural definitions. In this way, it may be seen that by defining what was not Spanish, academic discussions were extended metaphors for the political debates concerning autonomy versus unity within late nineteenth-century Spain.

Whereas academicians failed in 1873 to arrive at a satisfying visual representation of the Spanish arts as allegory of culture, in 1893 a resolution was achieved: albeit a pantomine in the dismally quiet halls of Madrid's Academy, for, by that date, the most successful and acclaimed Spanish artists had long since been making use of markets and auction houses in centres where a vital vanguard had been critically debated already for nearly two decades (namely, Paris, London and increasingly Barcelona). Madrid academicians, in arguing for Garnelo's

© Association of Art Historians 1997

winning canvas with its veneration for the site of tradition, were aware that within that site, as well as outside in the militant and anarchist-stricken provinces and colonies, definitions of Spanish culture, *Hispanidad*, would have to entail more than the collecting of dead figures within the sterile arcades of cold pantheons. If the 1893 competitions were a final, futile attempt to resuscitate the cultural authority of the Madrid academic body and its role within the social structures of institutions of knowledge, then the academy's production of cultural definitions was allegorical in content as well as method.

Oscar E. Vázquez
Binghamton University

Notes

A warm thank you to Margaret Sevcenko for her editorial comments on an early version of this essay.

1 Of the various entries I will discuss, only José Garnelo's *La Cultura Española* (1894, Instituto de España) has been reproduced: *Enciclopedia Universal* (Madrid), vol. 21, 1923, pp. 836; and Anonymous ('A'), 'La Agrupación de los Grandes Hombres Que Personificaron la Cultura Española. Cartón de D. José Garnelo', *Historia y Arte* (Madrid), vol. 1, no. 1, May 1945, p. 15.

2 Among these include: Eric Hobsbawm and Terence Ranger, *The Invention of Tradition*, Cambridge, 1983; Harold Bloom, *Anxiety of Influence*, Oxford and New York, 1973; Norman Bryson, *Tradition and Desire. From David to Delacroix*, Cambridge (MA), 1984; and Hans-Georg Gadamer, *Truth and Method*, New York, 1975.

3 Roland Barthes, *S/Z*, New York, 1974, p. 21.

4 John Tagg, *Grounds of Dispute. Art History, Cultural Politics and the Discursive Field*, Minneapolis, 1992, p. 31.

5 Tom Conley, foreword to Louis Marin's *Portrait of the King*, Minneapolis, 1988, p. iv.

6 Eric Blondel, 'The Question of Genealogy', in Richard Schacht (ed.), *Nietzsche, Genealogy, Morality*, Berkeley, 1994, p. 314. Similarly, Craig Owens has observed that 'the allegorist does not invent images but confiscates them [...] He does not restore an original meaning that may have been lost or obscured; [...] Rather, he adds another meaning to the image.' Craig Owens, 'The Allegorical Impulse: Toward a Theory of Postmodernism', *October*, no. 12, Spring 1980; and no. 13, Summer 1980. Reprinted in Brian Wallis and Marcia Tucker (eds), *Art after Modernism: Rethinking Representation*, New York, 1989 (4th printing), p. 205.

7 Owens, op. cit. (note 6), pp. 207–208.

8 First put forward by José Amador de los Ríos, the academy 'censor' and secretary, in the Academy general session of 8 May 1871. [San Fernando Academy Archives Book 3/95, p. 227.] Hereafter the Academy Archive Documents and Books are cited as: S.F. Acad. Doc., or S.F. Acad. BK.) The competition was announced in the *Gaceta de Madrid*, 21 April 1872, and by printed circulars [S.F. Acad. Doc. 169–6/5.] The final submission date was set for one year from the date of the printed circular.

9 Benedict Anderson, *Imagined Communities. Reflections on the Origin and Spread of Nationalism*, London, revised edition, 1991, p. 10.

10 8 April 1872. S.F. Acad. Doc. 169–6/5; Junta General, Sección Extraordinaria, 2 June 1873, p. 536.

11 SF 3/100 Libro de Actas, Junta General, Mon. 29 Feb. 1892, p. 595; SF 3/101 Libro de Actas, Junta General, Mon. 20 Feb. 1893, p. 200 'Programa para concurso del premio de pintura'.

12 Unsigned and undated brief. S.F. Acad. Doc. Sección de Pinturas. 169–6/5.

13 In another context, Francis Haskell has suggested that such silences in academic debates were born more from the 'desire not to disturb a *status quo*'. Francis Haskell, *Rediscoveries in Art. Some aspects of taste, fashion and collecting in England and France*, Ithaca (NY), 1976, pp. 18–19.

14 30 April 1874. S.F. Acad. Doc. 169–6/5. Letter of Reply by Pedro de Madrazo dated 3 June 1874. S.F. Acad. Doc. 169–6/5.

15 S.F. Acad. Book 3/95, p. 537; 30 June 1874. S.F. Acad. Doc. 169–6/5; and 'Bases de la Dictamen que eleva a la Academia la Sección de Pintura en el concurso actual'. S.F. Acad. Doc. 169–6/5.

16 While first prizes had been consistently awarded earlier, none were given for the 1873 competition nor the 1876 National Exposition because of the perceived inferiority of submissions. (The first Medal of Honour at the National Exhibitions

was not awarded until 1878.)

17 Borges's story is mentioned without reference by Jean Baudrillard in 'The Procession of the Simulacra', reprinted in Brian Wallis and Marcia Tucker, op. cit. (note 6), p. 253.

18 Antonio Cánovas del Castillo, 'Concepto de las Naciones,' *Revista General de Legislación y Jurisprudencia* (Madrid), 61 (1882), p. 402. The word 'cultura' in antiquated Castillian also had religious connotations of 'culto' in terms of adoration or the devotional. See *Diccionario de la Lengua Castellana por la Academia Española*, 11th ed. (1869), p. 232.

19 In Roque Bárcia's 1881 *Primer Diccionario General Etimológico de la Lengua Española* (vol. I, p. 903), in differentiating the two words, stated 'there are entire classes [of civilization] which invariably cannot be given that title [of cultured].' Similarly, the 1869 (11th ed.) dictionary of the Academia Española (pp. 177 & 232) saw civilization as a grade of culture. For a brief discussion of the terms 'nation', 'nationality' and 'state' in the Royal Academy Dictionaries, see Lluís Garcia i Sevilla, ' "Llengua", "Nació" i "Estat",' in *L'Avenç* (Barcelona), no. 16, 1979, pp. 50–5.

20 Homi K. Bhabha, 'DissemiNation: time, narrative, and the margins of the modern nation' in Homi K. Bhabha (ed.), *Nation and Narration*, London, 1990, p. 300.

21 '[…] in the world of allegory, time is the originary constitutive category.' Paul De Man, 'The Rhetoric of Temporality', *Blindness and Insight*, (2nd ed.), Minneapolis, 1983, reprinted in Hazard Adams/Leroy Searle (eds), *Critical Theory Since 1965*, Tallahassee, 1986, p. 209f.

22 Similar sentiments are repeated in Antonio Rovira i Virgili, *El Nacionalismo Catalan* (1917, p. 23); Cf: Francesc Mercadé, 'El Marco Ideológico de los Nacionalismos en España, (Siglos XIX, XX)' in Cristina Dupláa, Gwendolyn Barnes (eds), *Las nacionalidades del Estado Español: Una Problemática Cultural*, Minneapolis, 1986, pp. 45–6. This view is further evidenced by the fact that Garnelo's winning panel was used as late as 1923 to illustrate the Espasa-Calpe *Enciclopedia Universal* (see note 1) article on the 'Archaeology and History' of Spain, rather than on Spanish arts or culture, as might have been suggested by the painting's title.

23 S.F. Acad. Libro de Actas. Juntas Generales. 3/101. Monday, 20 February 1893. pp. 200–201.

24 *Gaceta de Madrid*, vol. 201, no. 192, Saturday 11 July 1891, pp. 107–108.

25 For one aspect of this international context, see the author's 'Translating 1492: Mexico's and Spain's First National Celebrations of the "Discovery" of America', *Art Journal*, vol. 51, no. 4, Winter 1992, pp. 21–9.

26 Joaquín Costa, 'Centenario de Colón', 13 October 1892 in *Maestro, Escuela y Patria*, Madrid (1916), pp. 327–31. Quoted by Jordi

Bonells, 'La Dinámica Centro-Periferica en Joaquín Costa', in Université de Clermont II, Département d'Études hispaniques, *Centres et périphéries*, Clermont-Ferrand, 1985, pp. 144–5.

27 S.F. Acad. Libro de Actas. Sesion Ordinaria. Monday 7 January 1895, pp. 28–9.

28 The bibliography on the debates over sketch and finish is quite large. Still required reading is Albert Boime's *The Academy and French Painting in the Nineteenth Century*, Princeton, 1986 (original 1971), especially pp. 81–90. Also helpful are, Alison Hilton, 'The Exhibition of Experiments in St. Petersburg and the Independent Sketch', *Art Bulletin* 70:4 (December 1988), and David Summers, ' "Form", Nineteenth-Century Metaphysics and the Problem of Art-Historical Description', *Critical Inquiry* 15 (Winter), pp. 372–406.

29 A decade before the 1893 competitions, Cánovas del Castillo in his aforementioned *Concepto de Naciones* criticized the many 'illusions engendered by positivists', adding that the sciences should respect less 'matter, as presented in [these] new systems' than the 'theological absolute'. Antonio Cánovas del Castillo, (op. cit., [note 18]), pp. 388f. Some contemporary examples of the debate within the arts academy include: Mariano Nougués y Secall 'Influencia civilizadora de las Artes y en especial de la Pintura', *Discurso leido en la Recepción Pública … (1867)*, Madrid, 1872, pp. 453–73; L.A. de Cueto, *El realismo y el idealismo en las artes. Discurso leidos ante la Real Academia de Nobles Artes de San Fernando en la recepción de …* 1872, also published in *Gaceta de Madrid*, 6,7,9 May 1872. On Cueto, cf: Javier Hernando Carrasco, *Las Bellas Artes y la Revolución de 1868*, Oviedo, 1987, pp. 19–21.

30 S.F. Acad. Libro de Actas. Sesion Ordinaria. Monday 7 January 1895. pp. 28–9; Monday 21 January 1895, p. 45 and Wednesday 23 January 1895, p. 71.

31 Angel Fernández de los Ríos; S.F. Acad. Libro de Actas. Sesion Ordinaria. Monday 21 January 1895, p. 48

32 Fernández y Gonzalez. S.F. Acad. Libro de Actas. Sesion Ordinaria. Monday 21 January 1895, p. 47.

33 On these contradictions, see Walter Benjamin, *The Origin of German Tragic Drama*, translated by John Osborne, London & New York, 1994 (original 1963), p. 175.

34 Sr. Riaño and Pedro de Madrazo; S.F. Acad. Libro de Actas. Sesion ordinaria. Wednesday 23 January 1895, pp. 66, 70 and 74.

35 Fernández Casanova and Alvarez y Capra; S.F. Acad. Libro de Actas. Sesion Ordinaria. Monday 21 January 1895, pp. 45, 47.

36 María José Bueno, 'Arquitectura y Nacionalismo. La Imagen de España a través de las Exposiciones Universales', *Fragmentos* (Madrid), nos. 15–16, 1989, pp. 58–70.

© Association of Art Historians 1997

37 ibid, p. 66f.

38 Likewise, other 1893 competition entries stressed Christian and Renaissance architectural styles as chief representatives of Spanish culture. 'Sección de Pinturas. Cartones presentados en el concurso al premio de pintura.' *Boletín de la Real Academia de Bellas Artes de San Fernando*, vol. 15, no. 141, January 1895, pp. 37, 42f. Also S.F. Acad. Libro de Actas. Sesion Ordinaria. Wednesday 25 January 1895, pp. 59f.

39 Lluis Domènech y Montaner, 'In Search of a National Architecture', *La Reniaxensa* (1878), reprinted in translation in Elizabeth Gilmore Holt, *The Expanding World of Art, 1874–1902*, New Haven, 1988, p. 58–61.

40 See, for example, D. Roque Bárcia, *Primer Diccionario General Etimológico de la Lengua Española*, (Madrid), 1881, vol. 4, p. 130 which repeats the Royal Academy's dictionary definition of 1869 (11th ed.), p. 583.

41 Joaquín Costa, 'Cómo pensaba Costa en 1883. Estado de la marina española y medios para fomentarla (1883)', in *Estudios jurídicos y políticos*, (Madrid, (1884), chap. 4, article 5; and J. Costa, *Teoría del hecho jurídico, individual y social*, Madrid (1881). Both cited by Jordi Bonells, op. cit. (note 24), p. 151.

42 A study of the late nineteenth-century Spanish art market has yet to be written, but aspects of the increased international participation of Spain's artists can be found in: Carmen Gracia, 'Francisco Domingo y El Mercado de al "High-Class Painting"', *Fragmentos*, nos. 15–16 (1989), pp. 130–9; Carlos Reyero, *Paris y la crisis de la pintura española, 1799–1889. Del Museo del Louvre a la torre Eiffel*, Madrid, Ediciones de la Universidad Autónoma de Madrid, 1993, pp. 150ff; Edward J. Sullivan, 'Fortuny in America: His collectors and disciples', in Fundación Caja de Pensiones, *Fortuny. 1838–1874*, Madrid, 1989, pp. 99–117; and also Robert Jensen, *Marketing Modernism in Fin-de-Siècle Europe*, Princeton University Press, 1994, who, although

concentrating on England and Germany, regularly refers to other figures of the 'international *juste milieu*' among whom he includes Raimundo de Madrazo and Joaquin Sorolla.

43 Eric J. Hobsbawm, *Nations and Nationalism since 1780. Programme, myth, reality*, Cambridge, 1990, p. 33–4.

44 Ernesto Laclau and Chantal Mouffe have criticized the reductivist problem whereby difference appears in one of two forms of identity: either as an act of concealment, or as an expression of essence. Ernesto Laclau & Chantal Mouffe, *Hegemony & Socialist Strategy. Towards A Radical Democratic Politics*, London, 1992 (reprint of 1985 original), pp. 21–2.

45 Riaño; S.F. Acad. Libro de Actas. Sesion Ordinaria. Wednesday 23 January 1895, pp. 63–4 and 70.

46 This same xenophobic-xenophilic dilemma, which has continued even in parts of the present world, was also present in the protectionist and free-trade debates between, for the most part, Catalunya and Castile.

47 In various Castilian dictionaries the terms 'Hispanidad', and 'Hispanismo' are seen as equivalent. For example, Roque Bárcia (op. cit., note 17), vol. 2, p. 1195; and Ramón Joaquin Dominquez, *Diccionario nacional o Gran Diccionario Clásico de la Lengua Española*, Madrid, 1882, vol. I, p. 954. It is not until the teens of this century that a distinction was made.

48 Riaño; S.F. Acad. Libro de Actas. Sesion Ordinaria. Wednesday 23 January 1895, pp. 63–4.

49 Perry Anderson, 'Nation States and National Identity', *London Review of Books*, 9 May 1991, p. 7.

50 R. Radhakrishnan, 'Nationalism, Gender, and the Narrative of Identity' in Andrew Parker, Mary Russo, Doris Sommer and Patricia Yaeger (eds), *Nationalisms and Sexualities*, New York & London, 1992, pp. 86, 88.

© Association of Art Historians 1997

Art History ISSN 0141-6790 Vol. 20 No. 1 March 1997 pp. 124–153

The flight from South Kensington: British Artists at the Antwerp Academy 1877–1885

Jeanne Sheehy

The first 'Government School of Design' was founded in London in 1837, with the aim of improving design for manufacture. For the next three or four decades new schools were set up all over Great Britain and Ireland, and old schools were assimilated into the network. From 1847 a formal 'system' of art education was applied in all these schools. After the Government School of Design moved to South Kensington in 1854, and became the National Art Training School, this was popularly called 'the South Kensington system', and was administered by the Department of Science and Art in London. As time went on the South Kensington system increased its stranglehold on art education, because many teachers in the provincial schools were trained within the system, and conformity to it was tested each year in the National Competitions, when work was sent to South Kensington to be judged. By 1884 there were nearly 180 state-run schools in Britain and Ireland.

Although the Schools of Design has been intended to train artisans, and improve design for manufacture, 'fine' artists increasingly went there for elementary instruction.[1] By the 1870s the Schools of Design, now called Schools of Art, had reconciled themselves to the fact that they were not only training designers, but also painters. However, the 'National Course of Instruction', laid out in 1854 as the basis of a training for designers, was still aimed primarily at artisans. Drawing and painting the human figure, which was the only recognized training for fine artists at the time, made up only five of the twenty-three stages of which the course consisted. Each part of the figure course was intended to develop a particular skill. Pupils began by drawing outlines of figures from the flat (engravings), to develop an eye for proportion, and then they were allowed to draw figures from the flat, shaded. When they had mastered that, they followed the same procedure with plaster casts: first outlines, then shaded drawings. They worked from casts of hands and feet at first, then the full antique figure. The advanced class went on to paint in *grisaille* (tempera or oil) from antique casts. The most senior figure section was painting from the living model, nude or draped, in colour.[2] The training was long and laborious, and the most valued quality was a high state of finish.

Schools in the South Kensington system were so numerous, and spread so widely over Great Britain and Ireland, that there were very few artists active in the last third of the nineteenth century who did not, at some time, benefit from their

© Association of Art Historians 1997. Published by Blackwell Publishers, 108 Cowley Road, Oxford OX4 1JF, UK and 350 Main Street, Malden, MA 02148, USA.

courses. Most went for preliminary training, and confined themselves to the antique and life classes. For serious artists a further period of study was considered essential. The Royal Academy Schools in London were the obvious place for this, and by 1884 South Kensington could boast that 'the Academy ... receives from the Schools of Art some of its most promising recruits.'[3]

The teaching of figure drawing and painting under the South Kensington system was very similar to that in the schools of the Royal Academy, because there had always been a relationship between the two institutions, and also because South Kensington hoped to get pupils into the Royal Academy schools, and had to conform to their standards. Both institutions were very suspicious of colour. Under the South Kensington system, though designers were trained in the use of colour, students in the figure classes worked in *grisaille* until a very late stage in their training. At the Royal Academy Schools students were only allowed to paint the figure in colour when they had reached the Upper School of Painting. In the Preliminary School of Painting they painted antique casts in monochrome 'to acquire the power of modelling forms from nature, and familiarity with pigments'. When this work had achieved an approved standard, they moved on to copying portions of paintings, 'to acquire the power of execution', and finally they painted still lives of armour and terracotta and metal vessels, and once a week, drapery, in colour.[4] The experience of Herbert Schmalz, the religious painter, was fairly typical: after a year at Newcastle School of Art, a further year at South Kensington, and eighteen months in the RA Schools, he 'had but small knowledge in handling colour'.[5]

The other major London art school was the Slade, founded under the aegis of University College, London, in 1871. Edward Poynter, first Slade Professor of Fine Art, was responsible for setting up the course, and running it from 1871 to 1875. Poynter was critical of both the Royal Academy and South Kensington systems, particularly the fact that students were obliged to prove themselves by working from plaster casts before they were allowed into the life class. He argued that it was better for students to learn from the living model before they moved on to the generalized and idealized forms of Greek sculpture, and that working for long years from static casts was no preparation for dealing with live figures. In the Slade Schools the human figure was to be paramount. This ideal was soon abandoned, however, and by 1873 there was a rule stating that every student entering the schools would be required to make a drawing from the antique as a test for passing into the Life School. The Slade School, as an alternative to the Royal Academy Schools, was an almost instant success, and by 1878 the number of pupils registered in a year was limited to one hundred.[6]

Increasingly, towards the end of the century, it was considered essential that an artist's training should be rounded off by a spell on the Continent, and even students from the Royal Academy went abroad. Under Poynter, and later under Alphonse Legros, the Slade was French-oriented, and Slade students were attracted to Paris. The merits of the French system were extolled by Poynter in his lectures as Slade Professor, and in the Reports of the National Art Training Schools at South Kensington, of which he was Director (1875–81).[7] Many students from the provincial schools of art by-passed London altogether. There was a growing disillusion with the Royal Academy, and places at the Academy Schools

were limited. Although the Slade was rapidly replacing the Royal Academy, it was fee-paying. Students who came from outside London found it cheaper to live abroad, quite apart from the prestige of attending a foreign school.

Paris was much the most popular destination, with established supremacy in the arts, numerous independent studios, and the free, state-run École des Beaux-Arts.[8] Like every other European fine-art school the École des Beaux-Arts was organized around a belief that drawing and painting the human figure was central to the training of an artist. It also remained firmly committed to a classical ideal of history painting going back to David. The pinnacle of achievement for painters was to win the Grand Prix de Rome, for history painting, the subject each year being chosen either from classical Antiquity or the Bible. Teaching at the École des Beaux-Arts in Paris was, therefore, entirely geared towards the needs of the history painter, with training in drawing from the Antique, from the nude model in 'academic' poses, and classes in expression, anatomy and ancient history. Once admitted to the École, students worked from the Antique in the great cast court, and sometimes a master would appear and correct their work.[9] Every six months there was a competition, the *Concours des Places*, for the *Cours du Soir*, the main drawing class. Here students drew, in alternate weeks, from the antique or the living model, and had twelve hours (six two-hour sessions) to complete a drawing. The class was taught by four professors, painters, who each taught for a month, in turn, every day from 4pm to 6pm. Up until 1863, when three painting studios were introduced, only drawing was taught at the École.[10] Each painting studio was presided over by a master, and admission was entirely at his discretion. Here students painted from the nude model, and the master came in twice a week, on Wednesday, to correct, and on Saturday, to place the works in order of merit. The painting studios worked in the mornings, and many students also attended the *Cours du Soir* drawing classes in the evening.[11]

Though Paris was the most popular, and carried the highest prestige, other Continental art schools also attracted students from Great Britain and Ireland. One of these was the Académie Royale des Beaux-Arts in Antwerp. There had been a trickle of British students to Belgium from the 1840s onwards. In the late 1870s the numbers became significant, and by the early 1880s there were often more than thirty registered for each session (see Appendix, page 139). A whole generation of English, Irish, Scottish and Welsh artists were students at Antwerp.[12] As a writer in the *Studio* put it, the number of those who, 'fleeing South Kensington and her system', chose Antwerp in preference to Paris would probably surprise many who thought that all foreign influence on British art must be French.

The article in the *Studio* mentioned a number of reasons for choosing Antwerp: the school was long established; strict discipline was enforced; most of the teachers spoke English; there were good museums; entry to the schools was free of charge; living in Antwerp was cheap and student life there was pleasant. Finally there was the Antwerp manner of painting:

> The art of the Antwerp Schol is characterized by a breadth and manliness which places it halfway between the modern British School and the French;

© Association of Art Historians 1997

and for technique and feeling the work turned out could, at one time, cope with any on the Continent.[13]

A more immediate reason why so many students from the South Kensington system went to Antwerp was a glowing report of the school by John Sparkes, published in 1877.[14] Sparkes had been made Headmaster of the National Art Training School at South Kensington in 1875, at the same time as Edward Poynter R.A. was made Principal and Director of Art.[15] Sparkes had scarcely been a year in the job when he was despatched on the first of two visits to Belgium and Germany to examine the systems of art education there. He devoted a large section of his report to the Antwerp Academy, saying, in conclusion: 'I cannot speak too highly of the excellence of the drawings and paintings executed at this School. A great amount of power and handicraft is developed, but this is properly subservient to the thorough understanding of the model, and also to the student's individuality.'[16] It was shortly after this that the British presence at Antwerp increased dramatically, and for the next few years students from Britain were the biggest group of foreigners in the Antique and Life classes. Most of these students had been trained in the schools of the South Kensington system, and had chosen Antwerp in preference to the Royal Academy or the Slade in London. Frank Bramley and William Logsdail went to Antwerp from the School of Art at Lincoln. They were probably encouraged in this by E.R. Taylor, headmaster at Lincoln. Shortly after he transferred to Birmingham in 1877, his students there also began to go to Antwerp. There were eight, including William Wainwright and Edwin Harris, in the Antwerp classes in 1880. Many of Sparkes's own students from South Kensington, including Blandford Fletcher and Francis Bate, went to Antwerp to complete their training. There was also a significant Irish contingent, including Walter Osborne and Roderic O'Conor. Osborne trained in the schools of the Royal Hibernian Academy, but also attended life classes at the Dublin Metropolitan School of Art, which was under the South Kensington system.[17] O'Conor spent several years at the Metropolitan School of Art in Dublin before going to Antwerp.[18] In 1883 there was a small 'Scottish band of hopefuls' from the Trustees Art Academy in Edinburgh, led by E.A. Hornel.[19]

It is clear that students chose Antwerp as an alternative to the Royal Academy Schools, as only two students are to be found on the books of both institutions in the period under discussion. Herbert Lyndon entered the RA Schools as probationer in 1879, having spent two years in the Antique class at Antwerp. Herbert Schmalz went from the RA schools to the life class at Antwerp in 1876, and then back to the Academy.[20] Six students registered at the Slade between 1874 and 1883 were also at the Antwerp Academy, including Schmalz, T.C. Gotch, and Vincent Van Gogh's friend Horace Livens. For all except Gotch the period at Antwerp came after the Slade.[21]

The Antwerp Academy, founded in 1663, claimed to be one of the oldest in Europe. However, the school that the British students knew was effectively created under the French, during the Napoleonic occupation of the Netherlands. In 1810 the Académie de peinture, sculpture et architecture de la ville d'Anvers was granted the monastery of the Minderbroeders (Franciscan Friars Minor) 'pour y ériger une académie et un musée'.[22] The *Grand Prix de Rome* was open to

all parts of the Napoleonic Empire, and so, naturally, training at the Antwerp Academy was built around the skills necessary for history painting. This set a pattern of teaching based on the French system, but as time went by it received many modifications, so that by the 1870s it differed in many ways from the École des Beaux-Arts in Paris.[23]

Like the École the Antwerp Academy held out for a long time against the admission of women, and though, under pressure from the government, they were accepted as students in 1889, they were segregated in a separate 'class for young women'. Throughout the period with which we are concerned the art school at Antwerp was all male, except for some clothed models in the life class.

Training for painters at the Antwerp Academy was based on premises very similar to the French system: history painting was the highest form, and to be equipped for it artists needed to work from the human figure, and learn about classical antiquity. It is true that the syllabus at Antwerp listed a separate section for genre painters, where drawing and painting from the clothed model, with accessories, replaced drawing and painting from the living model, but in practice these classes were not separated, and history painters and genre painters worked together.[24] The upper sections of the school were divided into intermediate and senior classes.[25] The intermediate classes practised Historical Composition and Drawing from the Antique, and attended lectures in Expression, Anatomy, Perspective, History, Antiquities and Costume. The senior classes were the same, except that Drawing from the Antique (known as *antiek*) was replaced by Drawing and Painting from the Living Model (known as *natuur*). The most important class was Historical Composition, which was taught by the Director, a position which was generally held by a painter: Gustave Wappers from 1840 to 1853, Nicaise de Keyser from 1855 to 1879, and Charles Verlat from 1885 until his death in 1890. Unlike Paris, where students might work in a painting studio in the morning and attend the drawing class in the afternoon, and where the antique alternated with the living model, classes at Antwerp seem to have been more strictly graduated. Once successfully through *antiek* they left classical antiquities behind them, and worked from the living model in the drawing and painting classes.

British students at Antwerp joined only a limited number of the classes on offer. Because they had all got some elementary instruction, they went straight into the intermediate or senior sections, and were mainly interested in the *antiek* and *natuur* classes. The *antiek* class was taught by Polydore (generally known as Pierre) Beaufaux, who was Professor of Drawing from Life and from the Antique from 1864 until 1883. Like most of the other teachers at the Academy, Beaufaux was a former pupil, and had won the *Concours de Rome* in 1857.[26] The *antiek* class took place in an amphitheatre, and students drew from a plaster cast of some famous piece of sculpture from classical antiquity. The figure, chosen by the master, was placed on a platform under strong gas-light which threw it into high relief.[27] This was very similar to the *Cours du Soir* at the École des Beaux-Arts, which was also held in an amphitheatre, the model lit by an enormous lamp with a reflector, so that the forms were powerfully modelled by the strong light. Another similarity between Antwerp and Paris was the strict time limits for the completion of a drawing. The *Cours du Soir* ran every afternoon from 4pm to

128 © Association of Art Historians 1997

6pm, and the student had twelve hours (a week of two-hour sessions), to complete a drawing.[28] At Antwerp the hours in drawing class were longer, but students worked on several drawings at once. The *antiek* class worked on a cast for two hours from 8am until 10am, then changed to another subject until 12 noon. In the afternoon they worked from 1.30pm until 4.30pm.[29] There was a time limit of sixteen hours for each drawing, and the models were changed very eight days.[30] In the South Kensington system the only time limits were in the life class, and they depended upon the length of time a model could be expected to pose. Otherwise students were expected to work on a drawing until it was perfect.[31] Edward Poynter claimed that few of the drawings sent for competition to South Kensington from the provincial schools of art had been 'executed in under six weeks of painful stippling with chalk and bread', and that the elaborately stippled backgrounds of some of the prize drawings must have taken at least a fortnight. He blamed the Schools of the Royal Academy, which, by requiring highly finished drawings from the antique as proof of proficiency before admitting a student, encouraged them to consider 'trivial minuteness of execution' of more importance than knowledge of form.[32] He contrasted this with the time limits enforced at the École des Beaux-Arts. Similarly, John Sparkes was impressed by the imposition of a time limit at the Antwerp Academy, which meant, he said, that in a year's practice a student completed thirty-three full-length antique figures.[33]

However, the Continental system was very slow to be adopted in Britain, and there were continual complaints. Sparkes, like Poynter, blamed the Royal Academy for prizing high finish above all else.[34] The rules of the Royal Academy did not concern themselves much with time limits. A probationer had three months in which to make a finished drawing in chalk, not less than 2 ft high, from an undraped antique statue, together with an outline drawing of the same figure showing bones and muscles.[35] As late as 1884 the Keeper, F.R. Pickersgill, was recommending that students should only be admitted to the Upper Schools twice a year instead of four times, so as to oblige them to remain in the lower schools for five months, and so have longer to complete the work required from them.[36] Things speeded up a bit in the life drawing and painting schools, where the model sat for twelve hours, but this could be extended at the discretion of the Visitor, and there was no limit on the time spent on a work.

In the Antwerp *antiek* class the student began by outlining the subject as it was presented to him, in order to get the proportions right, but the importance of modelling was always stressed, teachers insisting that 'form consists not only of outline in profile, but in actual projection towards the spectator.' Purely mechanical work was discouraged, so stippling or the elaboration of tints with stump or chalk were forbidden in the intermediate and senior classes.[37] In contrast, the outstanding characteristic of the South Kensington system was its insistence on high finish, and each drawing had to be brought to a condition of polished perfection, which made progress from elementary to advanced very slow and painful. 'Stippling', that is, building up the shadows by a painstaking system of tiny dots, persisted in spite of growing criticism. John Sparkes contrasted this with the methods encouraged in the elementary class at Antwerp:

... the stump is employed with a restricted use of chalk added to it, but nothing like our method of 'stippling' is permitted, and the head is treated in the largest, broadest method of light and shade; no reflections are represented, and only the largest half-tones are expressed. It is an exercise to help the student master his material, while at the same time he learns to see the model in its simplest masses.

Foreigners arriving at the Antwerp Academy were generally put through their paces in *antiek* before being admitted to their real goal: the life class. When Blandford Fletcher, and his friends Godfrey Merry, Walter Roe and Fred Millard, all from the National Art Training Schools at South Kensington, presented themselves at the Academy on 10 May 1880 they went straight into *antiek*, and were put to work by M. Beaufaux 'to do an outline from the flat', an elementary exercise designed to test them at the most basic level. Fletcher had completed his satisfactorily by the end of the day, and was given a plaster cast of a head from which to work. By Thursday afternoon they were allowed to graduate to the antique figure, and by the end of the week had completed four drawings. He contrasted this with South Kensington, where, 'if we worked very hard, we might have succeeded in half-finishing one!' 'We all hope to be in the Painting Room soon,' he wrote, and, indeed, after just over two weeks he was allowed to go forward to *natuur*.[38] Roe, Merry and Millard, however, spent a whole session in *antiek*. The experience of Walter Osborne, J.M. Kavanagh and Nathaniel Hill from Dublin was similar. Osborne went straight into the *natuur* class, but Hill and Kavanagh spent two seeks in *antiek* before they were allowed into *natuur*. Some students never made it out of *antiek*. Norman Garstin, for example, was there for three sessions, and was never registered in *natuur*, though he later described himself as studying under Verlat, who was Professor of Painting and who did not teach drawing.[39] T.C. Gotch, on the other hand, having done brilliantly in *antiek*, abandoned Antwerp altogether.

The *antiek* and *natuur* classes were supplemented by composition exercises done at home. Each week students were given a topic from which they made a sketch composition, which was criticized by the professor in class the following week. These exercises gave them practice in manipulating groups of figures for large-scale compositions, which was particularly important for British students, who had not had such training at home. The only compositions done in the South Kensington system were still-life, from objects set up in the studio, or 'ornamental and decorative designs ... selected as suitable for the purposes of decoration', and which were for the benefit of designers rather than artists.[40] In the Schools of the Royal Academy the only exercises in composition came from making copies of old masters. Composition exercises were introduced at the Slade after Alphonse Legros took over as Professor in 1876. The École des Beaux-Arts, like Antwerp, also used the system of weekly composition exercises, but only in the painting studios, not in the drawing classes. In Paris the size of these sketches, called *esquisses*, was strictly regulated at 40 × 32 cm, (about 16 × 13 in), which was not very big.[41] It is not clear what size the oil sketches were at Antwerp, but pencil sketches were sometimes so big that they would not fit on an ordinary drawing board:

130

© Association of Art Historians 1997

The sheets of paper on which I drew some of these compositions were so large that I used to pin them up against the wall of my sitting room. ... This got one into a very bold, free way of drawing ... and, as it was drawn without any maul-stick or support to the wrist, it gave great power and freedom of execution.[42]

The principal reason why most foreign students went to Antwerp was to get into the life class. Beaufaux, who had presided over *antiek*, also taught drawing in *natuur*, but the chief benefit of graduating from *antiek* was that students were allowed to paint. Many, as we have seen, had to prove their proficiency in *antiek*, though a few, like Walter Osborne and William Wainwright, were allowed to go straight into the life class. When Wainwright arrived in Antwerp in October 1880, he showed his drawings, and photographs of his pictures, to the Professor of Painting, Charles Verlat, who told him to get his colours and begin to paint at once, thus putting him in the most advanced section of the Academy.[43]

In the Antwerp life classes four or more models posed daily.[44] The nude model was generally draped from the waist down, and only the top part, the *torse*, was painted. As in the drawing classes, there was a time limit for painting – twenty hours, five hours on four consecutive days, for a *torse*.[45] The drawing class, however, worked from the full-length model, with sixteen hours to complete each drawing. As late as 1886 there were no unclothed, or even semi-draped female models, though they had been introduced by 1892 (plate 34).[46] Sometimes the models were posed in 'groups', a pair of wrestlers, perhaps, or a mother and child.

One way in which Antwerp differed radically from London and Paris was that students could work from costumed models. In the Royal Academy drawing school students devoted two or three evenings a month 'to the Study of Drapery (not Costume), arranged on a Living Model', and in the Upper School of Painting the nude alternated with the draped figure.[47] In Paris the École was 'determined to teach students the nude above all,' and so, in the painting studios, they worked from the undraped male and female model. Costume was taught in the archaeology class, where students were allowed to sketch, but they were 'taught only how to dress the Antique', except for a couple of sessions in June, when they were allowed to sketch other kinds of costume.[48] The life class at Antwerp allowed clothed models – single figures and even groups. This had been introduced in 1843, for the benefit of genre painters.[49] It was not uncommon for them to be dressed in peasant costume. In 1856 George du Maurier painted a three-quarters-life-size group of an old woman with a sleeping boy in her lap (plate 35).[50] A late example is Dermod O'Brien's picture of a young working woman with a sleeping girl at her knee, painted in the life class in 1890 (plate 36).[51] By the 1880s, alongside general descriptions of clothed models to be set up in the annual competitions, such as *homme habillé* or *femme habillée*, we find the peasant genre aspect more precisely signalled by the designation of particular costumes such as *matelot* (sailor) or *laitière* (milkmaid).[52]

During the period with which we are concerned there were two significant professors of painting: Josef Van Lerius (1823–76) and Charles Verlat (1824–90).

© Association of Art Historians 1997

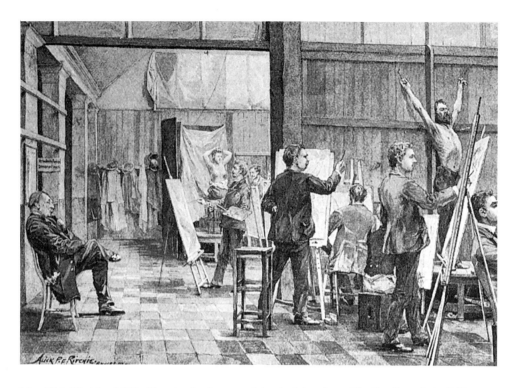

34 Alick Ritchie, *A Life Class in the Antwerp School of Art*, from *The Studio*, vol. 1, 1893, p. 141.

Van Lerius was Professor of the Principles of Painting and Genre from 1854 until 1876. From the beginning he was famous for his high-handed teaching methods, and his insistence on rapid execution and bold colour:

> The teaching was of a sound, practical nature, strongly imbued with the tendencies of the colourist school. Antwerp ever sought to uphold the traditions of a great Past ... A peculiar kind of artistic kicks and cuffs were administered to the student by Van Lerius as he went his rounds. 'That is a charming bit of colour you have painted in that forehead,' he said to me on one occasion – 'so delicate and refined. Do it again,' he added, as he took up my palette knife and scraped off the 'delicate bit'. 'Ah, you see, *savez-vous*, you can't do it again; you got it by fluke, some stray tints off your palette, *savez-vous*,' and, taking the biggest brush I had, he swept over that palette and produced enough of the desired tints to have covered a dozen foreheads.[53]

Much anecdotal evidence testifies to the fact that, twenty years later, he was still pursuing the same teaching methods:

> Mr Van Lerius stood for a moment before the enamelled-looking piece of work, but which in spite of its smoothness blushed with the colour of a

© Association of Art Historians 1997

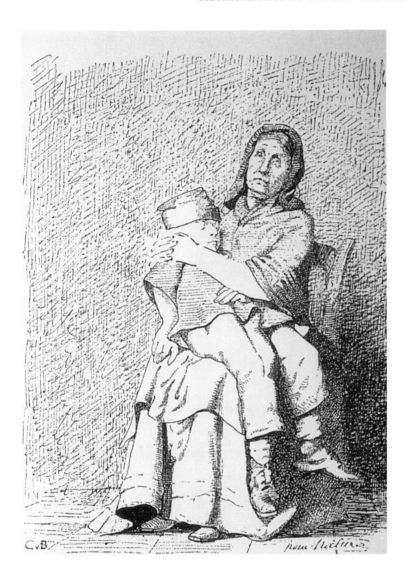

35 A pen and ink drawing by George du Maurier, after a painting done in the life class at the Antwerp Academy, 1856–57. From Felix Moshceles, *In Bohemia with Du Maurier*, London, 1896, p. 30.

rosy dawn. 'Have you any green on your palette?' he asked. The student happened to have a dab of Zinnober green with which he had been painting a landscape. M. Van Lerius took a large brush, and dipping it into the violent green swept it across the timidly painted and ruddy *torse*, with the remark, 'There! You want more of that.'[54]

Josef Van Lerius died in February 1876, and was succeeded by Charles Verlat, who had been a contemporary of his in the studio of Gustave Wappers.[55] Verlat had spent eighteen years in Paris, and studied in the studios of Couture, Flandrin and the Dutchman Ary Scheffer. He was also an admirer of Courbet. However, he kept in touch with his Netherlandish roots by studying

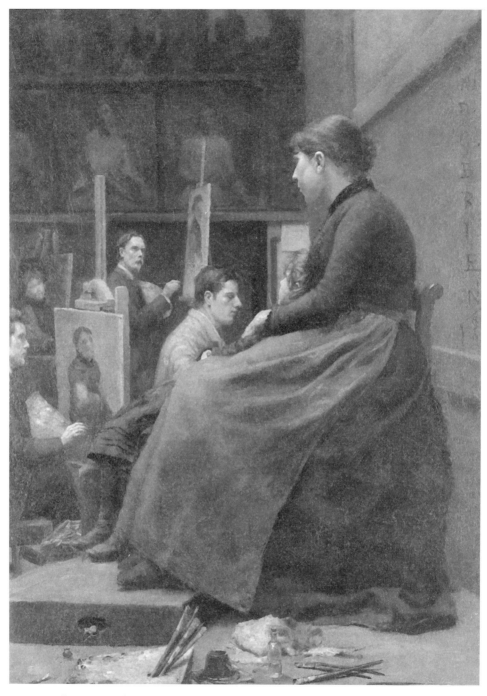

36 Dermod O'Brien, *The Fine Art Academy, Antwerp, 1890*. Ulster Museum, Belfast.

 © Association of Art Historians 1997

Rubens's *Medici Cycle* and Dutch seventeenth-century work in the Louvre. He spent six years teaching at the Weimar art school, then two years travelling in Egypt and Palestine, before returning to take charge of the senior painting class at Antwerp. He thus had experience of the French and German systems, and a passionate interest in art education which he developed in his *Plan générale des études de l'académie royale d'Anvers* in 1879. He felt that the fine art course at Antwerp was good, particularly as it did not try to impose a uniform manner, but wished to preserve the students' personality. Verlat was very keen on the Flemish tradition, especially that of the great colourists. Drawing and style, he said, could be studied from the French, whereas 'colour belongs to us and should be studied in Flanders.'[56] Teachers should make their pupils understand that they should be true to their own race, to their own land, and that to cultivate tradition and respect the old masters did not rule out modernity in art.[57] Like Van Lerius before him, he admired bold and vigorous handling, and was proud of his own speed and facility in painting:

> I am like a racehorse ... who, having done a few laps of the course at great speed, is more worn out than the poor hack who trots from morning till night.[58]

It was Verlat who presided over the painting class during the period when the bulk of students from the British Isles were at Antwerp, from 1879 until 1885. They were much impressed by his teaching, compared with what was available in London, at South Kensington and the Royal Academy. As Blandford Fletcher wrote home to his family:

> my opinion is that most of the Academicians (of London) might consider themselves 'licked into a cocked hat' if they were to see these paintings, and that the South Kensington Schools are a farce and the Academy a greater farce. There is no 'stippling' here, you have to pile on the chalk and lump on the paint and if a student shews anything individual M. Verlat recommends him to stick to it, this is again the opposite of Poynter's system who has an idea that his style and method is infallible.[59]

William Wainwright, from Birmingham, studied at the Academy in 1880–81. Like Fletcher, he was impressed by the way in which Verlat encouraged students to develop their natural talents. In Wainwright's case this was for watercolour rather than oil, so that when he was put into the senior class, he got to work at once on a watercolour: 'a bold thing to do, seeing that water colour painting was probably never done there before'. Verlat was greatly impressed with this, and advised him to keep on with watercolour, as it would be better to be first class in that than second in oil painting.[60]

The close relationship of Verlat with his pupils was in contrast to the situation at the École des Beaux-Arts in Paris, where students identified with whichever of the three painting studios they had entered, but where the master, however revered, was a remote personage, who only appeared twice a week to correct. The drawing classes were even more impersonal, with teachers who taught a month at a time,

three months of the year.[61] At Antwerp the relationship between master and pupil was much closer, especially as there was only one master for any given subject. Verlat was strongly Anglophile, and went out of his way to help the English students, both within the schools, and by introducing them to influential people outside. So important was he for British naturalists, such as the painters of the Newlyn School, that the 'Royal Academy of Fine Arts' is sometimes referred to in the Newlyn literature as 'Verlat's Academy' at Antwerp.[62] Though Verlat played a very active role within the school, he also pursued a career as a painter outside. However, the principal occupation of the drawing masters, Beaufaux and his assistant Eugène Siberdt (who taught drawing from the antique in the junior classes, and replaced Beaufaux as Professor in 1883), was teaching. During drawing classes Beaufaux continually passed round the theatre correcting and commenting.[63] As Fletcher put it 'the fact of the matter is that the masters are fine fellows for teaching, they come and sit in the room with the students all the morning.'[64]

The close relationship between Verlat and his pupils was strengthened by the system of what Nikolaus Pevsner has called 'masterclasses', borrowed, not from France, but from Germany. Masterclasses had first been introduced at Düsseldorf by Wilhelm Schadow in 1831, and soon became established practice in the German schools of art.[65] When the Antwerp Academy was being reformed in the 1840s, six extra studios were built, so that students who had completed their basic training could work in small groups under the direction of a master. With this system it was hoped to 'rival the greatest German art establishments, by offering its best students a quiet place in which to continue and perfect their studies'.[66] These differed from the three painting *ateliers* introduced in Paris in 1863 in that there were never more than four or five students, whereas there were generally around thirty pupils in Gérôme's studio at the École.[67] Until Verlat's time at Antwerp masterclasses were the privilege of Belgian students – *Concours de Rome* hopefuls and other promising seniors. Verlat, as we have seen, went out of his way to help the British students, and admitted Frank Bramley and William Logsdail to his *atelier* in the academic session 1879–80. Soon, however, there were too many high-achieving British students to be accommodated in this way. In 1880 Fletcher wrote home describing how Verlat was trying to get extra studios, so that the more talented of the English students, the ones who took prizes in the *concours*, would have somewhere to work.[68] He selected ten or twelve of the 'strongest students', including Bramley and Wainwright, and put them into a separate studio, 'of palatial dimensions' where they worked from life, life-size. On one occasion it was a Crucifixion pose:

> ... a splendid Italian on a cross fourteen feet high and at the end of a five-and-a-half hour posing he is very impressive to look upon He stands with his arms out on a large cross ... I am making a large study of it in oil colours.[69]

Like the École des Beaux-Arts in Paris, the Antwerp Academy worked on a system of competitions, or *concours*. Antwerp, however, was not nearly as competitive as Paris. At the École there were *concours* all the way from the point of entry to the school up to the *Grand Prix de Rome*. There were also *concours* at

© Association of Art Historians 1997

three-monthly intervals between students in a particular class. For painters these consisted of drawing from the antique and the living model, in alternate terms, composition sketches done in twelve hours, *en loge*, and one composition completed within one month. In the painting studios there were fortnightly competitions for good positions in the studio.[70] At Antwerp the *concours* were held annually at the end of the winter term, between January and March. Regular students, the Belgians and Dutch mainly, took part in the full range of *concours*, from 'Historical Composition' at the top to 'History and Costume' at the bottom. The senior *Concours* in historical composition was the major competition in the school.

Some students who had spent time in the South Kensington system had experience of competitions. These, however, were very different from Paris or Antwerp, and took place nationally. Schools of Art all over Britain and Ireland sent work to South Kensington, where the National Competitions were held annually, judged by a panel consisting largely of Royal Academicians. As the schools were judged by results, only the work thought likely to do well was sent in, and producing the winning formula was often more important than the process of learning to draw. Several of the British at Antwerp had been prizewinners in the National Competitions, notably Logsdail, Bramley, Fred Hall, Fred Harris, Herbert Schmalz, Walter Roe, Nathaniel Hill, William Spittle, George Winkles and Francis Bate.[71] Most of those who entered the National Competitions, however, were artisans, or people who intended to be teachers, and not all the artists who attended classes bothered to compete. At Antwerp the *concours*, which took place at the end of the winter session, were between all of the members of a particular class, and were judged by a panel of masters who taught in the Academy. As far as the British were concerned the important *concours* were those in painting and drawing in the *antiek* and *natuur* sections. Most students joined in – it was obligatory if one wanted to pass from *antiek* to *natuur*, or register for the following session (see Appendix, page 139). As one might expect the foreigners had mixed results in the *concours*. Nevertheless, by the late 1870s they were offering the locals some stiff competition. In 1878 T.C. Gotch came first in the *antiek* section. In 1879 Logsdail was first in the painting class with a torso in oils, and the year after that Frank Bramley came first in two sections: painting a torso, and painting the clothed model. The following year William Wainwright very nearly won the top prize when he entered a life-size watercolour, *Job*, for the *concours*. It was considered the strongest drawing in the competition, and brought Wainwright into notice, but it was the first time a watercolour had ever been entered, and it was not thought proper to treat it as if it were equal to an oil. So Wainwright got second place and first place was given to a local, Léon Demeuther, who had worked in oil.[72]

There was one class at the Antwerp Academy that had no counterpart in either the British or the French system – Landscape and Animal Painting. It had been established early in the century, and from 1843 until 1879 was taught by Jacob Jacobs. Like the figure-painting classes, landscape was divided into sections: Landscape Composition, Landscape Painting from Nature, Landscape Sketch, Pictorial Perspective, and Animal Painting from Life. Just as the elementary figure classes were set to work from the flat, landscape students were set to copy

engravings. Some practices in the landscape classes were sneered at by modernists later on, when *plein-air* and 'truth to nature' were all the rage. It was said that students were taught to compose a landscape by combing several sketches done at different times, in different places. One account describes the class working from *la trophée*, which consisted of 'a couple of barrowloads of bricks, paving stones, gravel and earth piled in great disorder around a barkless tree-trunk; the whole thing decorated here and there with a grassy sod or some plant or other ...'. Théodore Verstraete, a pupil in the 1860s, claimed that one could win the gold medal without ever having painted the smallest detail from nature itself.[73] By the 1870s things had improved, and the landscape students worked out of doors in summer. The animal painting class worked in the studio, sometimes from live animals, but mostly from heads of horses, calves or sheep, brought fresh from the slaughterhouse, and arranged on the platform under a strong light. Students were also given free admission to the zoo, and offered every facility to draw the animals there from life.[74] Landscape and Animal Painting came quite low in the hierarchy, and only counted as an Intermediate Course until 1883 when senior *concours* were introduced. It was not well subscribed, and especially not by foreigners, who came mainly for the figure painting. Even Isaac Cullin, who later made a career as a horse painter in England, was in the life class, not the landscape and animal class, during his two years at the Academy, 1877–9. One Englishman, Thomas Lucas, went especially to Antwerp for the Landscape and Animal course, though it must be admitted that he considered it, once he was there, 'little attended and indifferent', and there was a small clutch of English and Scots in the 1880s, after Josef Van Luppen took over from Jacobs. Some foreigners not in the animal class availed themselves nevertheless of the opportunity to draw at Antwerp Zoo – E.A. Hornel's registration card is marked in pencil by Verlat '*avec prière de permettre l'étude au Jardin Zoologique*'.[75]

What did British students get from their Antwerp experience that they could not get just as well at home, or in Paris? The advantage over home is easy enough to see. The South Kensington system was primarily for designers and artisans, and provided only limited training for artists. The Royal Academy Schools, which were expected to provide the most senior training for artists, still worked almost entirely on a neoclassical system based on the human figure, nude or classically draped. The main emphasis was on laborious work and high finish; there was no training in composition, and little attention to colour or the handling of paint, except what could be gained from copying old masters. Teaching in the Royal Academy Schools was also rather fragmented, as each academician taught only for one month out of the ten in each academic year. The Slade School came nearest to providing the kind of teaching that artists associated with the Continental schools, especially after the appointment of Alphonse Legros as Professor in 1876. It was more enlightened than the other London schools in allowing students to work from the living model at an early stage in their training, and Legros introduced the Continental custom of exercises in composition. The Slade took a while to establish itself as the school which was opening up British art education to foreign influence, and, even when it did, British students continued to complete their education abroad. What none of the London schools could provide was the cosmopolitan crowd to be found in the major Continental schools.

138

© Association of Art Historians 1997

The Antwerp Academy offered artists a solid grounding in drawing and painting the figure. The aim was to get them to master their craft, rather than to achieve polished perfection. In contrast to the British schools, boldness of handling and colour were encouraged. Composition exercises provided training in handling groups of figures, one of the serious gaps in the British system until they were introduced at the Slade. The opportunity for genre painting at Antwerp, and the fact that landscape and animal painting were taught within the school, provided alternatives to the classical tradition that formed the basis of art education in Britain. Teaching at Antwerp, drawing as it did on the French and German systems, as well as the native Flemish tradition, introduced British students to broader currents in European painting.

Though it had considerably less prestige, the Antwerp Academy had some advantages over the École des Beaux-Arts in Paris. It was smaller and more intimate, permitting a closer relationship between master and pupils. Teaching was more broadly based, with a strong bias towards realism, and was less fixated on neoclassicism than at the École. However, this broader education was also available in Paris, in the private *ateliers*, and in summer art colonies like Grèz-sur-Loing and Pont-Aven. In the end British students at Antwerp got the benefit of both traditions, as many of them went on to study in Paris, and others joined up with their Paris-trained compatriots in the villages of Brittany.

Jeanne Sheehy

Appendix – List of British and American Students at the Académie Royale des Beaux-Arts, Antwerp, 1877–85.

The information below comes from two sources:

I. The *Livres d'Inscription*, giving name, age, place of origin and date of inscription. There were two sessions each year, Summer, May–August, and Winter, October–March.

II. *Concours Annuels, Jugements*, giving marks obtained in the annual *concours*. These figures are given in square brackets. The maximum mark in each category is 60. The *concours* took place at the end of the winter session.
Natuur: marks given are for: (a) painting from life; (b) drawing from life.
Antiek: marks given are for drawing from the antique.
Landscape and Animal: marks given are for: (a) landscape composition; (b) landscape painting from nature; (c) landscape painting from nature, sketch; (d) perspective (line), marks out of 10; (e) perspective (pastel), marks out of 20. Total numbers in each class are given in square brackets. Students are numbered in order of registration. The spelling of names and places have been standardized as far as possible.

SUMMER 1877
NATUUR. [16]
 9. Whitaker, William, 27, Bath, 18/5/77.

© Association of Art Historians 1997

ANTIEK. [34]
9. Whitaker, William, 27, Bath, 8/5/77, to *natuur* 18/5/77.
12. Prynne, Fellowes, 22, Plymouth, 8/5/77.
20. Lyndon, Herbert, 22, London, 14/5/77.
25. Barfield, Thomas Kane, 18, Leicester, 22/5/77.
27. Lister, George, 25, London, 24/5/77.
28. Downing, de la Poer, 26, London, 24/5/77.
32. Gernon, Vincent, 21, Dublin, 15/6/77.
33. Hemy, Thomas, 25, Newcastle, 19/6/77.
34. Sumner, John, 32, Ipswich, 26/6/77.

WINTER 1877–78
NATUUR. [24]
6. Roskell, Nicholas, 40, Liverpool, 8/10/77. [57.9, 28.5]
13. Prynne, Edward, 22, Plymouth, 9/10/77. [49.8, 51]
17. Spread, William, 31, Queenstown, Irlande, 19/10/77. [58.5, 45]
19. Landis, Benjamin, 23, Enterprise (Amérique), 22/10/77. [-, 3]

Inscribed in *antiek*, but entered *concours*:
Barfield, Thomas, [35.1, -]
Gotch, Thomas, [33.6, -]
Hemy, Thomas, [30, -]
Lister, George, [39, -]
Lyndon, Herbert, [27, -]

ANTIEK. [46]
24. Lyndon, Herbert, 22, London, 4/10/77. [45]
25. Cullin, Isaac, 19, New York, 8/10/77. [55]
28. Gernon, Vincent, 22, Dublin, 9/10/77. [45]
29. Laurie, Edward, 19, London. 9/10/77. [24]
30. Gotch, Thomas, 22, Kettering. 9/10/77. [60]
34. Hall, Hamilton, 25, Honfleur, 9/10/77.
35. Hemy, Thomas, 26, Newcastle, 9/10/77. [46.5]
38. Lister, George, 26, London, 9/10/77. [34.5]
39. Barfield, Thomas Charles, 19, Leicester, 12/10/77. [52.5]
44. Downing, de la Poer, 25, London, 9/11/77.

SUMMER 1878.
NATUUR. [27]
1. Cullin, Isaac, 19, New York, 6/5/78.
6. Hemy, Thomas, 27, Newcastle, 7/5/78.
16. Spread, William, 31, Queenstown, 9/5/78.
17. Roskell, Nicholas, 40, Liverpool, 9/5/78.

ANTIEK. [20]
2. Laurie, Daniel, 19, London, 7/5/78.
3. Lyndon, Herbert, 22, London, 7/5/78.
6. Wright, John, 20, Harrogate, 7/5/78.
7. Sykes, Henry, 23, Huddersfield, 7/5/78.

© Association of Art Historians 1997

8. Hall, Bernard, 18, Liverpool, 7/5/78.
9. Sylvester, John Henry, 40, Deene, 7/5/78.
10. Gernon, Vincent, 22, Dublin, 7/5/78.
14. Barfield, Thomas, 19, Leicester, 20/5/78.
18. Lister, George, 27, London, 12/6/78.

WINTER 1878–79.
NATUUR. [38]
14. Cullin, Isaac, 20, New York, 1/10/78. [27.3, 27.6]
17. Roskell, Nicolas, 41, Liverpool, 12/10/78/ [52.8, 24.6]
22. Sykes, Henry, 24, London, 21/10/78. [50.1, 45.6]
23. Hall, Bernard, 18, London, 21/10/78. [36, -]
35. Hemy, Thomas, 28, Newcastle-on-Tyne, 16/11/78. [30.3, 15.6]
36. Adams, Willis, 24, Boston, 16/12/78. [42.6, 32.1]
38. Bramley, Francis, 21, Lincoln, 24/12/78. [-, 39.6]

Inscribed in *antiek*, but entered *concours*:
Bannerman, Hamlet, [21.3, -]
Gernon, Vincent, [33.3, -]
Lister, George, [24.3, -]
Logsdail, William, [60, -]
Sylvester, John, [35.4, -]

ANTIEK. [48]
2. Gernon, Vincent, 22, Dublin, 30/9/78. [42]
21. Sylvester, John, 40, London, 8/10/78. [28.2]
22. Hughes, Edmund, 34, London, 8/10/78.
25. Keelan, Peter, 22, Irlande, 8/10/78. [12]
28. Wright, John, 20, Harrogate, 14/10/78.
33. Sykes, Henry, 24, London, to *natuur* 21/10/78.
34. Lister, George, 27, London, 9/11/78. [31.5]
36. Laurie, David, 20, London, 16/11/78. [25.5]
43. Thompson, George, 24, Southampton, 22/11/78.
44. Bannerman, Hamlet, 27, London, 22/11/78. [50.1]
45. Logsdail, William, 19, Lincoln, 22/11/78.
48. Bramley – transferred to *natuur* 24/12/78.

SUMMER 1879.
NATUUR. [29]
1. Bramley, Frank, 21, Lincoln, 5/5/79.
15. Logsdail, William, 20, Lincoln, 6/5/79.
20. Cullin, Isaac, 20, New York, 12/5/79.
22. Hall, Bernard, 19, Liverpool, 19/5/79.
24. Sykes, Henry, 24, Huddersfield, 24/5/79.

ANTIEK. [33]
1. Keelan, Peter, 22, Dublin, 5/5/79.
2. Bramley, Francis, 21, Lincoln, 5/5/79, transferred to *natuur*, no date.
21. Litcomb, William, 21, Cambridge, 16/5/79.

22. Hart, Horace, 24, Kent, 16/5/79.
27. Gernon, Vincent, 23, Dublin, 24/5/79.
30. Thompson, George, 25, Southampton, 30/5/79.
33. Cox, Charles, 22, Liverpool, 16/6/79.

WINTER 1879–80.
NATUUR. [39]
 3. Cullin, Isaac, 21, New York, 30/9/79. [35, -]
 8. Bramley, Frank, 22, Lincoln, 7/10/79. [55.5, -]
32. Gernon, Vincent, 23, Dublin, 10/11/79.
38. Logsdail, William, 20, Lincoln, 2/1/80.

Inscribed in *antiek*, but entered *concours*:
Lister, George, [16, -]

ANTIEK [53]
12. Keelan, Peter, 23, Dublin, 1/10/79. [27.5]
15. Hart, Horace, 25, London, 3/10/79.
19. Temple, Edward, 30, Worcester, 6/10/79. [24.9]
20. Burn, Gerald Maurice, London, 6/10/79. [26.4]
38. Simpson, Henry Hardy, 21, Lyme Regis, 9/10/79.
43. Crump, William, 22, Lincoln, 20/10/79.
44. Thompson, George Henry, 25, Southampton, 20/10/79.
50. Cox, Charles, 22, Liverpool, 3/11/79. [29.4]
51. Arnott, James George, 20, Dumfries, 19/11/79. [43.2]
52. Lister, George, 28, London, 21/11/79.

Not inscribed, but entered *concours*:
Oldfield, James, Ilkley. [27.9]

LANDSCAPE AND ANIMAL. [12]
 1. Allan, George, 15, Glasgow, 29/9/79.

SUMMER 1880.
NATUUR. [25]
25. Fletcher, Blandford William, 21, London, 27/5/80.

ANTIEK. [34]
 3. Zuthers, John Leghe, 25, Oldham, 10/5/80.
 4. Todd, Ralph, 23, London, 10/5/80.
 5. Millard, Frederic, 22, London, 10/5/80.
 6. Roe, Walter, 20, London, 10/5/80.
 7. Merry, Godfrey, 19, Brighton, 10/5/80.
 8. Fletcher, Blandford William, 21, London, 10/5/80, to *natuur* 27/5/80.
14. Oldfield, Reffitt James, 22, Jersey, 11/5/80.
15. North, Arthur William, 22, Huddersfield, 11/5/80.
17. Temple, Edward, 31, Worcester, 11/5/80.
18. Finnemore, Joseph, 20, Birmingham, 11/5/80.
20. Simpson, Henry, 24, Lyme Regis, 20/5/80.

© Association of Art Historians 1997

29. Thompson, Ivan, 18, Paris, 25/5/80.
30. Wilkinson, William, 24, Patricroft, 25/5/80.
31. Burn, Gerald, 21, London, 25/5/80.
32. Garstin, Norman, 32, Limerick, 2/6/80.
34. Brown, Oswald, 27, London, 8/7/80.

LANDSCAPE AND ANIMAL. [6]
 1. Allan, Georges, 19, Glasgow, 10/5/80.
 3. Jordan, Hubert, 18, London, 28/5/80.

WINTER 1880–81.
NATUUR. [54]
36. Roe, Walter, 21, Gravesend, 13/10/80. [43.8, 35.4]
37. Fletcher, Blandford, 23, London, 13/10/80. [37.2, 42.9]
39. Zuthers, John Leghe, 25, Oldham, 14/10/80. [38.4, 50.7]
43. Bramley, Frank, 23, Lincoln, 19/10/80.
44. Merry, Godfrey, 19, Brighton, 19/10/80.
53. Hall, Frederic, 25, Yorkshire, 7/12/80. [44.4, 36.9]
54. Millard, Frederick, 23, London, 5/1/81. [45.9, 34.2]

Inscribed in *antiek*, but entered *concours*:
Arnott, James. [36, -]
Avery, Henry. [36.6, -]
Burn, Gerald. [32.1, -]
Finnemore, Joseph. [33.9. -]
Harris, Edwin. [50.1, -]
Simpson, Henry, [41.1, -]
Todd, Ralph, [33.3, 40.2]
Wainwright, William, [59.7]
Wilkinson, William, [34.8]

ANTIEK. [58]
16. Garstin, Norman, 23, Limerick, 4/10/80. [51.6]
17. Temple, Edward, 31, Worcester, 4/10/80. [44.4]
18. Greene, John, 20, Dublin, 4/10/80. [40.5]
20. North, Arthur William, 22, Huddersfield, 4/10/80. [43.8]
21. Brown, Oswald, 27, London, 4/10/80. [51.3]
22. Oldfield, James Reffitt, 22, Ben Rhydding, 4/10/80. [39.6]
23. Zuthers, Leghe, 25, Oldham, 4/10/80, to *natuur* 14/10/80.
24. Finnemore, Joseph, 21, Birmingham, 4/10/80.
25. Pratt, Claude, 21, Birmingham, 4/10/80.
26. Wainwright, William, 25, Birmingham, 4/10/80.
30. Janssens, John, 19, Deptford, Kent, -. [31.5]
36. Millard, Frederick, 23, London, 12/10/80, to *natuur* 5/1/81.
37. Todd, Ralph, 24, London, 12/10/80.
39. Thompson, Ivan, 18, Paris, 14/10/80. [4.5]
42. Browne, Rupert, 24, Chorton Heath, London, 15/10/80. [49.8]
43. Avery, Henry, 19, Birmingham, 16/10/80. [39]
44. Harris, Edwin, 25, Birmingham, 16/10/80.
45. Hall, Fred, 20, Yorkshire, 16/10/80, to *natuur* 7/12/80.

46. Simpson, Henry, 24, Lyme Regis, 16/10/80. [52.5]
47. Wilkinson, William, 24, Manchester, 16/10/80. [42]
48. Arnott, James, 17, Dumfries, 20/10/80. [46.8]
49. Gledhill, James, Chelmsford, 20/10/80. [24]
52. Burn, Gerald, 21, London, 23/11/80. [18]
53. Dodds, William, 20, London, 14/12/80. [21]
54. Thompson, Ivan, 18, Paris, 14/12/80.
55. Bunbury, Henry, 26, London, 14/12/80.
56. Winkles, George, 22, Birmingham, 11/1/81. [36]
57. Davis, Frederic William, 18, Birmingham, 11/1/81. [15]
58. Spittle, William, 23, Birmingham, 11/1/81. [60]

Not inscribed, but entered *concours*:
Bunbury, Henry. [27]
Paley, Robin. [33]

LANDSCAPE AND ANIMAL. [18]
 3. Allan, George, 16, Motherwell, 28/9/80. [54, 48, 49.5, 9.2, 18.4]
16. Paley, Robin, 21, Halifax, 29/11/80. [58.8, 58.8, 59.1, 9.4, 18.7]. First.

SUMMER 1881
NATUUR. [37]
 3. Fletcher, Blandford, 22, London, 3/5/81.
22. Todd, Ralph, 24, London, 10/5/81.
29. Simpson, Hardy, 25, Lyme Regis, 24/5/81.
30. Zuthers, John Leghe, 25, Oldham, 24/5/81.
31. Brown, Oswald, 28, London, 7/6/81.

ANTIEK. [32]
 3. Thompson, Ivan, 19, Paris, 3/5/81.
 4. North, Arthur William, 24, Huddersfield, 3/5/81.
 5. Wilkinson, William, 25, Patricroft, 3/5/81.
 6. Adams, Ronald, 23, London, 3/5/81.
 7. Bate, Henry Francis, 22, London, 3/5/81.
 8. Garstin, Norman, 33, Limerick, 4/5/81.
 9. Green, John, 20, Dublin, 4/5/81.
10. Dodds, William, 21, London, 4/5/81.
11. Gledhill, James, 26, Cheshire, 4/5/81.
16. Avery, Henry, 20, Birmingham, 10/5/81.
17. Winkles, Georges, 22, Birmingham, 10/5/81.
18. Oldfield, Reffitt, 23, Ben Rhydding, 10/5/81.
19. Williams, Edwin, 27, London, 10/5/81.
22. Spittle, William, 23, Birmingham, 16/5/81.
23. Davis, Frederic, 18, Birmingham, 16/5/81.
24. Temple, Edwin, 32, Worcester, 25/5/81.
25. Bunbury, Henry, 26, London, 27/5/81.
26. Burn, Gerald, 22, London, 7/6/81.
29. Brown, Frederic, 21, Birmingham, 8/6/81.
32. Potts, Arthur, 45, Ailesbury, 17/7/81.

144

© Association of Art Historians 1997

LANDSCAPE AND ANIMAL. [9]
 6. Allan, George, 16, Motherwell, 14/5/81.

WINTER 1881–82.
NATUUR. [52]
 4. Osborne, Frederick, 22, Dublin, 29/9/81. [57.3, 52.5]
10. Brown, Oswald, 28, Ayr, 30/9/81. [32.1, 57.3]
20. Temple, Edwin, 32, Worcester, 3/10.81. [20.1, 24]
35. Green, John, 20, Dublin, 12/10/81. [46.5, 48]
37. Spittle, William, 23, Birmingham, 13/10/81. [56.4, 15]
38. Kavanagh, Joseph, 25, Dublin, 13/10/81. [42.3, 54.6]
39. Hill, Nathaniel, 20, Dublin, 13/10/81. [48, 56.1]
40. Wilkinson, William, 26, Patricroft, 13/10/81.
44. Newton, Charles, 25, Santa Cruz, Antilles, 24/10/81. [44.4, 37.5]
46. Fletcher, Blandford, 22, London, 26/10/81. [55.2, 47.4]
50. Simpson, Henry, 25, Lyme Regis, 25/11/81. [42.9, 37.2]

Inscribed in *antiek*, but entered *concours*:
Adams, Ronald. [51.6, 44.4]
Avery, Henry. [49.5, -]
Bate, Henry. [42.6, 44.7]
Davis, Frederick. [50.7, -]
Lloyd, Oswald. [44.7, -]
North, Arthur. [50.4, 48.3]
Oldfield, Reffitt James. [38.1. -]
Sharp, Joseph Henry. [48.6, -]
Widgery, Frederick. [35.1, -]
Winkles, George. [41.1, -]

ANTIEK. [55]
 8. Hill, Nathaniel, 20, Dublin, 29/9/81, to *natuur* 13/10/81.
 9. Kavanagh, Joseph, 25, Dublin, 29/9/81, to *natuur* 13/10/81.
12. Adams, Ronald, 22, London, 29/9/81.
13. Widgery, Frederick John, 20, Exeter, 30/9/81. [52.5]
14. North, Arthur, 24, Huddersfield, 30/9/81.
15. Bunbury, Henry, 27, London, 30/9/81.
18. Milner Kite, Joseph, 19, Taunton, 1/10/81. [39]
19. Thompson, Ivan, 19, Paris, 3/10/81. [37.8]
20. Gledhill, James, 26, Cheshire, 3/10/81. [27]
21. Spittle, William, 23, Birmingham, 3/10/81, to *natuur* 13/10/81.
22. Winkles, George, 22, Birmingham, 3/10/81. [3]
23. Becker, Henry, 19, Colchester, 3/10/81. [55.5]
24. Avery, Henry, 20, Birmingham, 3/10/81.
27. Davis, Frederick William, 19, Birmingham, 3/10/81. [39.6]
30. Janssens, John, 20, Deptford, Kent, 5/10/81. [45.3]
37. Sharp, Joseph Henry, 22, Bridgeport, Ohio, 10/10/81. [57]
38. Bate, Henry, 23, London, 10/10/81.
39. Oldfield, Reffitt James, 23, Ben Rhydding, 12/10/81. [30]
43. Lloyd, Oswald, 18, Lincolnshire, 17/10/81. [53.4]
44. Newton, Charles, 25, Antilles, 17/10/81, to *natuur* 24/10/81.

© Association of Art Historians 1997

45. Bell, Malcolm H., 23, London, 24/10/81. [28.5]
49. Burrowes, Thomas, 25, Dublin, 8/11/81. [24]
51. Ker, Gervase, 21, London, 10/11/81.
52. Thors, Samuel, 18, London, 2/1/82.

not inscribed, but entered *concours*:
Haider, Charles, Cincinnatti. [40.3]
Paley, Robin. [39.9]
Williams, Edwin. [3]

LANDSCAPE AND ANIMAL. [16]
 6. Allan, George, 17, Motherwell, 26/9/81. [50.4, 59.4, 56.7, 57.9, 18.2, 18.4]
 8. Williams, Edwin, 27, Devonshire, 5/10/81. [53.4, 58.8, 53.7, 57, 18.9, 18.5]
11. Paley, Robin, 22, Halifax, 24/10/81. Working *in atelier*.

not inscribed, but entered *concours*:
Berens, Alex, Ashby St Legers. [48.6, 56.4, 27, 51, -, -]

SUMMER 1882.
NATUUR. [38]
 5. Spittle, William, Birmingham, 24, 9/5/82.
 9. Becker, Henry, Colchester, 16, 9/5/82.
12. Bate, Henry Francis, London, 23, 9/5/82.
14. Adams, Ronald, London, 25, 12/5/82.
16. Newton, Charles, London, 26, 13/5/82.
19. Sharp, Joseph Henry, 23, Bridgeport, Ohio, 15/5/82.
23. Hall, Frederick, 23, Yorkshire, 24/5/82.
27. Green, John, 20, Dublin, 26/5/82.
28. Widgery, Frederick John, 21, Exeter, 27/5/82.
30. Osborne, Frederick, 23, Dublin, 30/5/82.
31. Kavanagh, Joseph, 25, Dublin, 30/5/82.
32. Winkles, George, 23, Birmingham, 30/5/82.
33. Hill, Nathaniel, 21, Dublin, 30/5/82.
34. Davis, Frederick, 19, Birmingham, 30/5/82.
35. Samuel, Charles, 21, London, 21/6/82.
38. Browne, Oswald, 29, London, 24/7/82.

ANTIEK. [38]
 1. Avery, Henry, 21, Birmingham, 9/5/82.
 2. Samuel, Charles, 21, London, 9/5/82, to *natuur* 21/6/82.
 3. Winkles, George, 23, Birmingham, 9/5/82, to *natuur* 30/5/82.
 4. Davis, Frederick, 19, Birmingham, 9/5/82.
 5. Janssens, John, 21, Deptford, Kent, 9/5/82.
21. Everett, Edwin, 22, Southampton, 12/5/82.
23. Widgery, Frederick John, 21, Exeter, 13/5/82, to *natuur* 25/5/82.
25. Bell, Malcolm H., 23, London, 16/5/82.
31. Burrowes, Thomas, 25, London, 20/5/82.
32. Arthur, Reginald, 20, Levan, Wales, 20/5/82.
33. Stephenson, Charles, 22, Bradford, 20/5/82.
34. Fitt, James, 22, Wallop, 20/5/82.

© Association of Art Historians 1997

35. Kite, Milner, 19, Taunton, 20/5/82.
38. Eldridge, Edwin, 31, Elmira, New York, 27/6/82.

LANDSCAPE AND ANIMAL. [13]
 2. Berens, Alexander, 16, Ashby St Ledgers, 9/5/82.
 3. Hill, Edward, 21, London, 9/5/82.
 4. Bury, Joseph, 20, London, 9/5/82.
 9. de Rosen, Jervas, 20, Upton Park, 21/5/82.
10. Williams, Edwin, 28, Devonshire, 24/5/82.
11. Stevens, Rupert, 32, London, 24/5/82.
13. Thors, Samuel, 19, London, 27/6/82.

WINTER 1882–83
NATUUR. [53]
 1. Osborne, Frederick, 23, Ireland, 26/9/82.
10. North, Arthur William, 25, Huddersfield, 29/9/82. [-, 39]
11. Davey, Edward, 21, Romford, 29/9/82. [41.1, 40.8]
12. Hill, Nathaniel, 21, Drogheda, 29/9/82. [59.1, 52.5]
13. Bate, Henry Francis, 24, London, 29/9/82.
14. Becker, Henry, 16, Colchester, 2/10/82, to *antiek* 23/11/82. [38.7, -]
15. Tisdall, Henry, 20, Dublin, 2/10/82. [50.1, 53.4]
18. Kavanagh, Joseph, 25, Dublin, 2/10/82. [49.5, 50.4]
25. Davis, Frederick, 20, Birmingham, 4/10/82.
26. Spittle, William, 24, Birmingham, 4/10/82.
32. Hall, Frederick, 22, Yorkshire, 7/10/82.
33. Samuel, Charles, 21, London, 10/10/82. [48.6, 33]
34. Lloyd, Oswald, 19, Lincoln, 10/10/82.
42. Whitaker, William, 33, Bath, 8/1/83. [9, 6]

not inscribed but entered *concours*:
Adamson, David. [-, 45]
Arthur, Reginald. [9, -]
Charde, Hugh. [45.3, -]
Ellis, Edwin. [44.7, -]
Janssens, John. [9, -]
Stephenson, Charles. [57.6, -]
Thompson, Ivan. [40.2, -]

ANTIEK. [68]
 6. Gledhill, James, 28, Cheshire, 26/9/82. [33.3]
20. Dyson, Lester, 25, Yorkshire, 29/9/82. [31.2]
27. Wilson, Walter, 20, London, 3/10/82.
28. Peart, Sidney, 21, London, 3/10/82.
29. Janssens, John, 21, Deptford, 3/10/82. [40.8]
38. Fitt, James, 24, Rockliffe, 4/10/82. [34.5]
40. Stephenson, Charles, 22, Bradford, 6/10/82. [59.1]
41. Everett, Edwin, 32, Southampton, 10/10/82. [12]
42. Arthur, Reginald, 21, Levan, Wales, 10/10/82. [48]
48. Milner Kite, Joseph, 19, Taunton, 16/10/82. [46.2]
51. Bell, Malcolm, 23, London, 17/10/82. [27]

55. Avery, Henry, 21, Birmingham, 25/10/82.
58. Charde, Hugh, 23, Cork, 7/11/82. [40.2]
60. Thompson, Ivan, 20, Paris, 22/11/82. [9]
61. Bentz, Frederick, 29, Manchester, 22/11/82. [44.4]
62. Ludby, Max, 24, London, 22/11/82. [3.9]
64. Becker, Henry, 17, Colchester, 23/11/82. [49.5]
65. Burrowes, Thomas, 25, Dublin, 28/11/82. {22.5]

not inscribed but entered *concours*:
Lister, George. [31.2]

LANDSCAPE AND ANIMAL. [28]
 8. Sanders, Standfield, 21, London, 29/9/82. [58.5, 49.9, 56.7, 54.3, 18.4, 19.5]
13. Berens, Alexander, 16, Ashby St Ledgers, 4/10/82. [60, 49.2, 57, 43.5, 4, 19.7]
14. Hill, Edward, 22, London, 9/10/82. [55.8, -, 53.7, -, 17.4, 19.6]
17. Thors, Samuel, 19, London, 30/10/82. [45.6, 46.2, 49.5, 39, 5, 19.3]
27. Stephens, Rupert, 32, London, 7/12/82.

SUMMER 1883.
NATUUR. [33]
 1. Stephenson, Charles, 23, Brighton, 8/5/83.
22. Whitaker, William, 33, Bath, 15/5/83.

ANTIEK. [50]
 1. Bentz, Frederic, 30, Manchester, 8/5/83.
 5. Ball, Thomas, 45, Seacombe, 8/5/83.
12. Gledhill, James, 28, Cheshire, 15/5/83.
13. Dyson, Lister, 25, Yorkshire, 15/5/83.
15. Charde, Hugh, 23, Cork, 15/5/83.
17. Thompson, Ivan, 21, Paris, 15/5/83.
18. Wright, Robert M., 21, London, 15/5/83.
21. Janssens, John, 22, Deptford, 15/5/83.
22. Milner Kite, Joseph, 20, Taunton, 16/5/83.
29. Finn, Herbert John, 22, Dover, 17/5/83.
30. Prioleau, Eugen, 19, Liverpool, 17/5/83.
34. Hill, Edward, 23, London, 18/5/83.
39. Burrowes, Thomas, 25, Dublin, 22/5/83.
40. Turner, William, 25, Wakefield, 22/5/83.
46. Corbould, Walter, 22, London, 23/5/83.
47. Graham, George, 22, illegible, 2/6/83.
49. Yeates, Georges W., 22, Irlande, 19/6/83.
50. Arthur, Reginald, 21, Levan, Wales, 19/6/83.

WINTER 1883–84.
NATUUR. [57]
17. Gledhill, James, 28, Cheshire, 2/10/83.
20. Janssens, John, 22, Deptford, 2/10/83.
27. O'Conor, Roderic, 22, Roscommon, 3/10/83. [36.3, 38.4]
38. Adamson, David, 24, Glasgow, 8/10/83.
39. Becker, Henry, 17, Colchester, 9/10/83.

© Association of Art Historians 1997

43. Corbould, Walter, 23, London, 11/10/83. [38.1, 46.5]
46. MacGeorge, William, 22, Castle Douglas, 13/10/83. [55.5, 58.2]
51. Burn Murdoch, William, 21, Edinburgh, 15/10/83. [39.9, 44.7]
53. Atkinson, Robert, 19, Leeds, 17/11/83. [41.7, 58.5]
54. Walls, William, 23, Dunfermline, 17/11/83. [53.4, 32.7]
55. Hornel, Edward, 19, Kircudbright, 20/11/83. [-, 33.9]

Inscribed in *antiek*, but entered *concours*:
Charde, Hugh. [37.5, -]
Fenn, John Herbert. [44.1, -]
Lonsdale, Walter. [48.9, -]
Moynan, Richard. [60, 42.6]
Turner, William. [-, 39.9]
Wilson, Walter. [45.9, -]

ANTIEK. [71]
18. Gledhill, James, 28, Cheshire, 27/9/83, to *natuur* 2/10/83.
19. Charde, Hugh, 24, Cork, 27/9/83. [52.5]
20. Corbould, Walter Edward, 22, Surrey, 28/9/83.
22. Fenn, John Herbert, 22, Dover, 1/10/83.
24. Dyson, Lester, 25, Yorkshire, 1/10/83.
26. Burn Murdoch, 21, Edinburgh, 1/10/83, to *natuur* 15/10/83.
27. Hornel, Edward, 19, Kircudbright, 1/10/83, to *natuur* 20/11/83.
28. Walls, William, 23, Dunfermline, 1/10/83, to *natuur* 17/11/83.
29. MacGeorge, William, 22, Castle Douglas, 1/10/83, to *natuur* 13/10/83.
30. Lonsdale, Walter, 39, London, 1/10/83. [50.4]
33. Wilson, Walter, 21, London, 1/10/83. [53.7]
39. Moynan, Richard Thomas, 26, Dublin, 2/10/83.
40. Davies, Alfred, 22, Llanrwst, 2/10/83.
45. Hill, Edward, 23, Dublin, 8/10/83. [3]
46. Baxton, William, 25, London, 8/10/83.
49. Atkinson, Robert, 19, Leeds, 9/10/83, to *natuur* 17/10/83.
53. Prioleau, Richard, 18, Liverpool, 10/10/83.
57. Carline, George F., 28, Lincoln, 15/10/83.
59. Ball, Thomas, 46, Seacombe, 15/10/83. [3]
63. Turner, William, 25, Wakefield, 19/10/83, to *natuur*.
65. Wright, Robert, 23, London, 19/11/83.
66. Wishart, Peter, 32, Aberdour, 19/11/83. [45.9]
68. Everett, Edwin, 23, London, 26/11/83.

LANDSCAPE AND ANIMAL. [26]
11. Mhorman, Henry, 26, San Francisco, 27/9/83.
13. Berens, Alick, 18, Ashby St Ledgers, 1/10/83. [48.3, 58.2, 57, 54, 18.5, 17.1]
17. Feeney, William, 25, London, 10/10/83.
22. Howie, William, 32, Hull, 22/10/83.
23. Brown, Michael, 24, Edinburgh, 31/10/83.

SUMMER 1884.
NATUUR. [43]
 4. Corbould, Walter, 23, London, 29/4/84.

7. Goldie, Charles, Nantes, 2/5/84.
8. Moynan, Richard Thomas, 28, Dublin, 2/5/84.
9. Whitaker, William, 34, Bath, 2/5/84.
10. Hornel, Edward, 20, Kircudbright, 2/5/84.
12. O'Conor, Roderic, 23, Roscommon, 8/5/84.
13. MacGeorge, William, 23, Castle Douglas, 8/5/84.
14. Burn Murdoch, William, 22, Edinburgh, 8/5/84.
16. Walls, William, 23, Dunfermline, 8/5/84.
29. Wilson, Walter, 21, London, 13/5/84.
31. Atkinson, Robert, 20, Leeds, 17/5/84.
32. Turner, William, 26, Wakefield, 17/5/84.
42. Eldridge, Edwin, 31, New York, 27/6/84.

ANTIEK. [35]
4. Livens, Thomas, 21, Croydon, 29/4/84.
5. Cooke, John, 18, London, 29/4/84.
6. Mhorman, Henry, 28, San Francisco, 30/4/84.
8. Allan, Henry, 18, Dundalk, 1/5/84.
10. Davis, Alfred, 22, Llanrwst, 1/5/84.
12. Fenn, Herbert, 23, Dover, 8/5/84.
16. Hill, Edward, 23, London, 8/5/84.
19. Wright, Robert, 24, London, 8/5/84.
20. Baxton, William, 25, London, 8/5/84.
21. Wishart, Peter, 32, Aberdour, 8/5/84.
28. Sheppard, Herbert, 25, Maesteg, 13/5/84.
31. Lonsdale, Horace, 40, London, 21/5/84.
34. Hardy, Dudley, 18, Sheffield, 14/6/84.
35. Arthur, Reginald, 22, London, 5/7/84.

LANDSCAPE AND ANIMAL. [11]
2. Wilson, Luke, 20, Bishop Auckland, 28/4/84.

WINTER 1884–85.
NATUUR. [63]
Marks are given for painting from life (torso), painting from life (model with helmet, cuirasse, pike), painting from life (clothed woman), drawing from life.
6. Moynan, Richard Thomas, 28, Dublin, 30/9/84.
7. Whitaker, William, 34, Bath, 30/9/84.
18. Corbould, Walter, 24, London, 7/10/84. [55.2, 56.7, 59, 57]
19. Wright, Robert, 25, London, 7/10/84.
20. Atkinson, Robert, 20, Leeds, 7/10/84. [56.1, 56.1, 58.8, 56.7]
21. Burn Murdoch, William, 22, Edinburgh, 7/10/84. [54.9, 51, 57, 48.6]
23. MacGeorge, William, 23, Castle Douglas, 7/10/84. [55.5, 57, 60, 54]
31. Goldie, Charles, 21, Nantes, 7/10/84.
35. Walls, William, 24, Dunfermline, 7/10/84. [57, 52.5, 54.6, 52.5]
50. Turner, William, 27, Liverpool, 30/10/84. [57.3, 53.9, 57.9, 53.4]
57. Cooke, John, 18, London, 10/11/84. [59.7, 54.9, 56.7, 50.4]
60. Lonsdale, Walter, 40, London, 1/12/84. [52.8, 55.5, 58.2, 52.2]
61. Wishart, Peter, 32, Aberdour, 1/12/84. [52.5, 52.2, 51.9, 48.9]
63. Wilson, Walter, 22, London, 'in class 2/9/84'. [58.8, 60, -, 58.5]

© Association of Art Historians 1997

Not inscribed, but entered *concours*:
Hornel, Edward, [57.6, 52.8, 54, 51.6]

Inscribed in *antiek*, but entered *concours*:
Davies, Alfred, [56.6, 47.4, 51, -]
Livens, Horace, [51.6, 49.8, 54.3, -]
Maud, William, [52.2, 50.7, 54.9, -]
Mildmay, Paulet, [6, 18, 9, -]

ANTIEK. [58]
 3. Mildmay, Paulet, 18, London, 30/9/84.
 8. Maud, William, 19, Grantham, 2/10/84. [50.4]
20. Allen, Henry, 19, Dublin, 3/10/84. [56.7]
21. Bentley, Joseph, 18, Lincoln, 3/10/84. [52.5]
23. Cooke, John, 18, London, 3/10/84. to *natuur* 10/11/84.
24. Wishart, Peter, 32, Aberdour, 3/10/84, to *natuur* 1/12/84.
28. Hardy, Dudley, 18, Sheffield, 3/10/84.
29. Davies, Alfred, 23, Llanrwst, 3/10/84. [60]
30. Knight, Paul, 19, Manchester, 3/10.84. [47.7]
32. Saltfleet, Frank, 24, Sheffield, 3/10/84. [55.2]
33. Hudson, Willis, 21, Sheffield, 3/10/84.
34. Hill, Edwin, 23, London, 3/10/84. [46.5]
37. Wild, Frank, 23, Leeds, 13/10/84. [49.5]
41. Sheppard, Herbert, 26, Maesteg, 15/10/84.
43. Lonsdale, Walter, 40, London, 1/12/84, to *natuur*.
46. Hunt, Carlton, 32, London, 28/10/84.
47. Hunt, Herbert, 27, London, 28/10/84.
56. Lowe, George, 26, Leeds, 22/12/84.
58. Livens, Horace, 22, Croydon, 22/10.84. [53.4]

not inscribed, but entered *concours*:
Thomas, Edgar Herbert, [3]

Notes

1 For an account of the schools up to 1854, and of the debate about the place of figure drawing in the training of designers, see Quentin Bell, *The Schools of Design*, London, 1963. For the subsequent period I have used *The Reports of the Department of Science and Art*, 1874–80. The texts of some key documents are given in Clive Ashwin, *Art Education*, Society for Research into Higher Education, London, 1975. For an important provincial school see John Swift, 'Birmingham and its Art School: Changing Views 1800–1921', *Journal of Art and Design Education*, vol. 7, no. 1, 1988, pp. 5–29.

2 *First Report of the Department of Science and Art*, 1854, Appendix B, pp. 25–9, quoted in Ashwin, *Art Education*, pp. 46–9; John C.L. Sparkes, *Schools of Art*, London, 1884, pp. 46, 70, Appendix A and passim, E.J. Poynter R.A.,

Ten Lectures on Art, London, 1879, p. 101, suggests that life drawing was not a significant part of the South Kensington system: 'It would appear to be considered a dangerous practice to begin studies from nature, until a long time had been passed in drawing from the antique, or from what are called drawing-models, or again, from ornamental designs.'

3 Sparkes, *Schools of Art*, op. cit. (note 2), p. 108.

4 *Royal Academy of Arts in London. Laws Relating to the Schools, the Library and the Students*, London 1871, pp. 6–14.

5 Trevor Blakemore, *The Art of Herbert Schmalz*, London 1911, pp. 15–18.

6 *University College, London, Calendar, Session* MDCCCLXXI–LXXII, London, 1871, pp. 42–43; *Session* MDCCCLXXIII–IV, London, 1873, p. 44, and *Session* MDCCCLXXV–LXXVI, London, 1875, p. 44.

7 Poynter, op. cit (note 2), pp. 107–133.
8 The standard modern work on the French academic system is Albert Boime, *The Academy and French Painting in the Nineteenth Century*, Phaidon, 1971. However, it deals mainly with the setting up of the system in the early to mid-century, and not with practice within the École later on. For this I have used Alexis Lemaistre, *L'École des Beaux-Arts*, Paris, 1889.
9 Lemaistre, op. cit (note 8), p. 51. Shirley Fox, RBA, *An Art Student's Reminiscences of Paris in the Eighties*, Mills and Boon, 1909, p. 112.
10 'Rapport sur L'École Impériale et Spéciale des Beaux Arts', *Gazette des Beaux Arts*, vol. 15, 1863, p. 152.
11 Lemaistre, op. cit. (note 8), pp. 39, 117, 131–9 and 326.
12 The Registers at Antwerp refer to all of these as 'Anglais'. For convenience I shall refer to them as British, which is more accurate. At this period the Irish, as well as the Welsh and Scots were politically 'British', besides which the movement in art to which they all belonged encompasses the two islands. Antwerp was also popular with American artists in the early 1870s, but in the period 1877–85 there were only seven.
13 Alick Ritchie, 'Académie Royale des Beaux Arts d'Anvers', *The Studio*, vol. 1, 1893, pp. 141–2.
14 John Sparkes, Report of the Head Master of the National Art Training Schools on his visit to the Art Schools of Belgium and Düsseldorf, dated October 1876, in *24th Report of the Science and Art Department*, 1877, pp. 476–88.
15 *23rd Report of the Science and Art Department*, 1876, p. 166.
16 Sparkes, *24th Report of the Science and Art Department* p. 479.
17 Jeanne Sheehy, *Walter Osborne*, Dublin, 1983, p. 12. For an account of the Dublin School of Art, and its relationship with South Kensington see John Turpin, *A School of Art in Dublin since the Eighteenth Century*, Dublin, 1995.
18 Jonathan Bennington, *Roderic O'Conor*, Dublin 1992, pp. 11–12.
19 Hornel Correspondence, Hornel Trust, Broughton House, Kircudbright.
20 *Probationers Admitted to the Royal Academy.* Ms volume, Royal Academy of Arts, London. Entries for 6 July 1874 and 31 December 1879.
21 The others were Alwyne Maude, Augustus Tulk (at Antwerp 1886–1888) and William O'Brien. *University College, London, Calendars*, MDCCCLXXI–MDCCCLXXXIV, 1871–1884, 'Lists of Students Registered in the Faculties of Arts, Laws and of Science'.
22 *Historiek Nationaal Hoger Instituut voor Schone Kunsten 1663–1884/1945*, Antwerp, 1985, pp. 24–8. See also Nikolaus Pevsner, *Academies of Art*, Cambridge, 1940, pp. 213–20; 'De Antwerpse Koninklijke Academie voor Schone Kunsten' in Anton W.A. Boschloo et al. (eds), *Academies of Art between Renaissance and*

Romanticism, Leids Kunsthistorisch jaarboek, vols 5–6, 1986–87, 'S Gravenhage, 1989.
23 Louis Alvin *Les Académies et les Autres Écoles de Dessin de la Belgique*, Brussels, 1865, p. 208. *Académie Royale des Beaux Arts d'Anvers: Rapports Annuels*, especially 1847 and 1887. See also *Académie Royale des Beaux Arts de Bruxelles, 275 ans d'enseignement*. Exhibition, Musée d'Art Moderne, Brussels, May–June 1987, p. 314.
24 *Règlement d'Ordre Intérieur*, MA 142 B, Antwerp Academy Library.
25 The day-to-day teaching has been worked out on the basis of information in the *Registres d'Inscription*, the annual *concours*, and the accounts of individuals.
26 Antwerp Academy, *Rapport Annuel*, 1861–62, p. 20.
27 Thomas John Lucas, 'Art Life in Belgium', *The Portfolio*, vol. 10, 1879, p. 179.
28 Lemaistre, op. cit. (note 8), pp. 27 and 131–9.
29 Blandford Fletcher, letter to his father dated 1 6 May 1880 (Fletcher Archive, formerly in the collection of Miss Rosamund Fletcher). Fletcher says that a six o'clock start was abandoned because it did not suit the English, but it was certainly reinstated after 1885, when the summer hours were 6–8am, 9–12am and 2–5pm. The 6–8am start was probably for the benefit of artisans.
30 Sparkes, in *24th Report of the Science and Art Department*, 1877 p. 477.
31 *23rd Report of the Science and Art Department*, 1876, p. 394: 'In the study of the antique the greatest completeness should be insisted on in every detail of form, whether shown in the contours or in the modelling of surfaces within them.'
32 Poynter, op. cit. (note 2), pp. 103–106.
33 Sparkes, in *24th Report of the Science and Art Department*, 1877, p. 478. He added 'In this matter especially the contrast of our system to that of Antwerp is seriously to our disadvantage.'
34 Sparkes, *Schools of Art*, op. cit. p. 88: 'The time limit has since been found to be the most effective mode of strengthening the work and maturing the experience of students, who without it would be apt to spend their time less usefully in attaining that elaborate refinement of finish deemed essential to secure admission to the schools of the Royal Academy ...'
35 *Royal Academy ... Laws*, p. 4.
36 *Annual Report from the Council of the Royal Academy to the General Assembly of Academicians*, London, 1885, p. 44.
37 Sparkes, *24th Report of the Science and Art Department*, 1877, p. 477, Lucas, p. 179.
38 Fletcher, letter, 16 May 1880.
39 'The March Hare Interviews Normal Garstin', in *The Paper Chase*, Newlyn, Summer 1909, p. 34.
40 Sparkes, *Schools of Art*, op. cit. (note 2), Appendix A.

© Association of Art Historians 1997

41 Lemaistre, op. cit. (note 8), pp. 40 and 348.

42 Lucas, p. 181.

43 Walter Turner (ed), *W.J. Wainwright RWS, RBSA*, Birmingham 1935, p. 6.

44 Antwerp Academy, *Rapport Annuel*, 1847, p. 23.

45 Sparkes, in *24th Report of the Science and Art Department*, 1877, pp. 477 ff. Turner, *Wainwright*, op. cit. (note 43), plate 2. Dorothy Weir Young, *The Life and Letters of J. Alden Weir*, New Haven, Yale University Press, 1960, p. 61.

46 Vincent Van Gogh, *Complete Letters*, vol. 2, pp. 476 and 494. Ritchie p. 141.

47 *Royal Academy ... Laws*, 1871, pp. 10 and 13.

48 Lemaistre, op. cit. (note 2), pp. 155–6.

49 Antwerp Academy, *Rapport Annuel*, 1843–44, p. 27: 'Among the Students in the painting class there are some who plan to be genre-painters: they have appealed to the President of the Administrative Council to ask for a class to be set up for drawing from the clothed model ... the Council acceded to their demand.'

50 Felix Moscheles, *In Bohemia with du Maurier*, London, 1896, pp. 29–30.

51 Dermod O'Brien, *The Fine Art Academy, Antwerp*, 1890. Ulster Museum, Belfast.

52 Antwerp Academy, Register of *Concours Annuels*, 11 March 1885, 29 March 1886 and 12 March 1887.

53 Moscheles p. 22.

54 Dewey Bates, 'George Clausen A.R.A.', *The Studio*, vol. 5, 25, April 1895, p. 4. Bates, an American, was in the life class for the summer session of 1874.

55 Antwerp Academy, *Rapport Annuel*, 1876–7, p. 21.

56 Charles Verlat, *Plan Général des Études de l'Académie Royal d'Anvers*, Anvers, 1879, p. 11.

57 For accounts of Verlat's career see Willy Koninckx, *Trois Peintres Anversois*, Bruxelles, 1944, Victoire et Charles Verlat, *Charles Verlat*, Anvers, 1925.

58 V. and C. Verlat, pp. 26, 84, 110.

59 Fletcher letter, 16 May 1880.

60 Turner, op. cit. (note 43), pp. 6–7.

61 Lemaistre, op. cit. (note 2), pp. 39, 51, 117 & 326. Shirley Fox, op. cit. (note 9), p. 112.

62 Caroline Fox and Francis Greenacre, *Painting in Newlyn 1880–1930*, Barbican Art Gallery, 1985, passim.

63 Lucas, op. cit. (note 27), p. 179.

64 Fletcher letter, 16 May 1880.

65 Pevsner, *Academies of Art*, pp. 213–20.

66 Antwerp Academy, *Rapports Annuels*, 1846, pp. 17–19; 1847 p. 4; 1853, p. 13; and 1865.

67 Weir Young, op. cit. (note 45), p. 22. Shirley Fox, op. cit. (note 9), p. 112. Weir was a pupil 1873–77, and Fox from 1882.

68 Fletcher letter, 16 May 1880. The admission of British students into Verlat's studio does not seem to have been official, for whereas some Belgian students are marked *in atelier* in the register, no British ones are.

69 Turner, op. cit. (note 43), pp. 5–8 and 99.

70 Lemaistre, op. cit. (note 2), pp. 31–2 and 348–50.

71 *Reports of the Department of Science and Art*, 1874–80, passim.

72 Turner, op. cit. (note 19), p. 14.

73 Pol du Mont, *Les Peintres Flamands du XIXie Siecle*, Anvers, s.d., p. 266.

74 Lucas, op. cit. (note 27), p. 180.

75 Hornel Collection, Kurcudbright.

Art History ISSN 0141-6790 Vol. 20 No. 1 March 1997 pp. 154–174

REVIEW ARTICLES

Palladianism via Postmodernism: Constructing and deconstructing the 'English Renaissance'
Elizabeth McKellar

Architecture Without Kings: The Rise of Puritan Classicism Under Cromwell by *Timothy Mowl and Brian Earnshaw*, Manchester and New York, Manchester University Press, 1995, 240 pp., 120 b. & w. illus., £45.00 hbk., £15.99 pbk.

Classical Architecture in Britain: The Heroic Age by *Giles Worsley*, New Haven and London, Yale University Press, 1995, 349 pp., 360 b. & w. and colour illus., £29.95 hbk.

Cultural studies of the early modern period, particularly eighteenth-century studies, have undergone a radical re-assessment in the past ten to fifteen years. Some aspects of artistic production have managed to stay untouched by this process of reconceptualization, but few can have remained as remote and undisturbed as that of seventeenth- and eighteenth-century architectural history. It is not an area without publishing activity and the contemporary nostalgic interest in all things 'Georgian', in particular, has resulted in a steady stream of lavishly illustrated coffee-table books, monographs and gazeteers devoted to the architecture of the period. Any works which make a serious attempt to engage with the subject in new areas, as these two do, are therefore eagerly awaited and welcomed as major additions to the pitifully small stock of interpretive literature.

Both these books are essentially attempts to grapple with an old chestnut: the nature and character of the 'English Renaissance'. This may be a familiar question, but it is one which remains unresolved and uncontested. In architecture the debate is still focused on establishing the basic chronology and pattern of classicism in Britain. Earlier generations of historians, such as Bannister Fletcher, depicted the Renaissance as stretching from the sixteenth century to the early nineteenth century, while more recent works have tended to differentiate between the Tudor and Stuart periods and the eighteenth century, leaving the late seventeenth century in a rather uncomfortable, indeterminate position.

The architectural history of the period has been presented almost entirely from within the framework of a nineteenth-century Wolfflinian notion of style, namely that of classicism. Using this model to trace 'the English Renaissance' becomes problematic because there is no clear chronological or stylistic development that can be established until at least the mid-seventeenth century. Both these works stay within this tradition to offer revealing new insights into the trajectory of classicism in this country. Mowl and Earnshaw concentrate on the Civil War and Protectorate of 1642–60, a period in which it has conventionally been held that little building took place at all. Their work forcefully dispels this idea and offers an analysis of a range of building types from town and country houses to churches, Oxbridge colleges and gardens in London, East Anglia, the North and

154

© Association of Art Historians 1996. Published by Blackwell Publishers, 108 Cowley Road, Oxford OX4 1JF, UK and 350 Main Street, Malden, MA 02148, USA.

the West Country. They carefully identify the competing architectural strands of the time and argue that they were all to be found within the work of Inigo Jones. Jones is presented as a pragmatic designer prepared to collaborate with either side rather than as the traditional isolated court genius. Although this contextualization of Jones is greatly to be welcomed, it has the unfortunate effect in Mowl and Earnshaw's reinterpretation of increasing his heroic status even further. According to their analysis, isolation is replaced by omnipresence and Jones turns out to be the designer of seemingly all the major buildings of the time, including – controversially and contentiously – Coleshill and Wilton.

Jones remains the key figure in any reassessment of English classicism and he plays a central role in Giles Worsley's book as well. Worsley seeks to prove that the Palladian style introduced by Jones in the mid-seventeenth century did not die with him only to be revived in the early eighteenth century, but that it remained a constant presence from that point until the end of the eighteenth century, even in the late seventeenth century. The diversity of Jones's sources is acknowledged by Worsley, following on from the picture of stylistic eclecticism established in Harris and Higgot's pioneering exhibition of 1989,[1] and herein lies the problem with his argument. Worsley never defines what he means by Palladianism. It therefore takes on a protean character being identified at one time in plan formation, as with the tripartite plan which was revived by Soane and others for country houses in the late eighteenth century,[2] at another in the elevational treatment and detailing of Chambers,[3] or in the use of Palladio as a source for information about the antique, as with Hawksmoor and Wren.[4] With as loose a framework for Palladianism as this, his argument is irrefutable and Palladian elements of varying types can be found at all points from the mid-seventeenth century onwards. However, Worsley uses his very clear and comprehensive elaboration of this central premise to construct an argument which has implications far beyond his stated intention, which is simply to show that architectural styles do not always supersede one another but can co-exist.

Worsley writes in the Prologue to the book that he wishes to replace the teleological assumptions of modernist historians such as Summerson, and he might have added Pevsner, with a view congruent with the postmodern age of stylistic diversity in which we live.[5] Mowl and Earnshaw also use the experience of postmodernism as a way of understanding the plurality of Commonwealth architecture, an idea first put forward by A.A. Tait.[6] However, while both works have absorbed the notion of stylistic plurality from postmodernism, the corollary of stylistic equivalence and consumer choice remains ignored. The supermarket of style is open here but it only stocks one brand: classicism. A hierarchy of styles in which classicism of a certain kind is privileged is still operating in both books. This results in frustration when the preferred stylistic development does not occur, leading to ahistorical comments on 'the baroque interlude',[7] or the 'backward spasm of building'.[8] The modernist hegemony of Pevsner and Summerson is here replaced with the equally teleological dominance of Palladian classicism, which ignores both other forms of classicism and the strong hybrid classical/vernacular tradition of the period.

Mowl and Earnshaw are quite explicit about what they consider to be the aesthetic disaster of the Protectorate and their own preference for neo-Palladianism. However, their constant denigration of the other works of the period raises the interesting question as to how far an historian can write about a style to which they are fundamentally hostile? Worsley is more measured in his analysis, which he says he developed in opposition to Summerson's *Architecture in Britain 1530–1830*. However, in asserting the primacy of Palladianism within English classicism, he owes a greater debt to Summerson than he acknowledges. Summerson wrote in *Georgian London*: 'Palladian taste represents a norm to which classical architecture in this country has returned over and over again'.[9] Summerson's preference for Palladianism, as with his contemporaries such as Reyner

Bahnam[10] and Colin Rowe,[11] arose from his modernist sensibilities which acclaimed its undecorated surfaces, geometricity and the primacy of the plain as form-generator. The irony here is that the modernist's preferred form of classicism has also become that of those for whom the modern movement is an abhorrence and an aberration. Worsley, as a central figure in the classical revival of the 1980s onwards, through his participation in the Georgian Group and as editor of *Perspectives*, is as keen to establish the primacy of classicism in British architecture as Summerson and Pevsner were of modernism. He presents the modern movement as a passing phase,[12] an 'interlude', indeed, like the late seventeenth century.

J.M. Richards was one of the few British modernists who dissented from this paean to Palladianism. He wrote in praise of Mompesson House, Salisbury, *c*.1701 as an example of 'the most perfect English product of the Renaissance'.[13] In this Richards was echoing an earlier interpretation of the English Renaissance, namely that put forward by Reginald Blomfield. Blomfield traced a line not from Jones to the neo-Palladians but from Jones to Wren. For Blomfield the arrival of Burlington and his friends signalled not the continuation of the classical tradition but its end, 'to the free masculine intelligence of Wren had succeeded mere scholarship rapidly degenerating into pedantry'.[14] Furthermore, unlike historians today, it was not just Wren, the Baroque designer, whom Blomfield valued but also Wren, the successor to Pratt and the consolidator of the mixed classical/ vernacular style which was such a key element of late seventeenth-century architecture: 'it was this, and not [the] Palladianism ... that became the vernacular architecture of the country. The fifty years from the Restoration to the death of Queen Anne were, in fact, the culminating point of modern English architecture.'[15]

Both these books make a substantial contribution to our knowledge of architecture in early modern England. One examines a period which has been completely ignored until now and the other offers a useful overview and many thoughtful insights over a longer time-span. However, it is the failure of Mowl and Earnshaw and Worsley to acknowledge the validity of the alternative non-classical tradition of the seventeenth century, and to examine the period on its own merits rather than within the stylistic blueprint that they wish to impose upon it, that fatally weakens both sets of arguments. The recent collection of essays in 'Albion's Classicism' (see shorter reviews, page 176) show how we might fruitfully begin to start re-examining English culture in its own terms rather than within an alien straightjacket of Italian classicism.[16] The content of both these books remains, for the post part, within internalized architectural debates. The relationship of Palladianism to nationalism and anti-French feeling is not explored, nor its movement between the court and the country and the urban and the rural. Although Worsley links building activity to the economic cycle and Mowl and Earnshaw equate the switch to brick and the simplification of ornament in what they term 'Puritan minimalism' to the straitened economic circumstances of the time,[17] the wider relationship between classicism and an increasingly consumer-oriented society is not explored. All this needs investigation before we have a fuller picture of the period and its buildings.

Elizabeth McKellar
Birkbeck College, University of London

Notes

1 See, John Harris and Gordon Higgot, *Inigo Jones: Complete Architectural Drawings*, New York, 1989.

2 Worsley, p. 294.
3 ibid, p. 245.
4 ibid, pp. 61–2.

© Association of Art Historians 1997

5 ibid, prologue, p. xi.
6 See, A.A. Tait, 'Post-Modernism in the 1650s', *Georgian Group 1986 Symposium*, Leeds, 1987.
7 Worsley, Chapter 4 is called 'Late Seventeenth Century Architecture and the Baroque Interlude'.
8 Mowl and Earnshaw, p. 168.
9 John Summerson, *Georgian London*, London, 1991 ed. (1st ed. 1945), p. 21.
10 See Mark Swenarton, 'The Role of History in Architectural Education', *Journal of the Society of Architectural Historians*, vol. 30, 1987, pp. 208–209. Swenarton shows how Anglo-Palladianism was one of the approved historical periods of study under Llewellyn Davies's modernist regime at the Bartlett in the 1960s

where Banham was in charge of history teaching.
11 Colin Rowe, 'The Mathematics of the Ideal Villa', *The Mathematics of the Ideal Villa and Other Essays*, Cambridge Mass., 1978, pp. 1–17.
12 Worsley, Prologue, p. xi.
13 J.M. Richards, *A Miniature History of the English House*, London, 1938, p. 32.
14 Reginald Blomfield, *A Short History of Renaissance Architecture in England 1500–1800*, London, 1900, p. 160.
15 ibid, p. 297.
16 Lucy Gent (ed.), *Albion's Classicism: the Visual Arts in Britain 1550–1660*, London, 1995.
17 Mowl and Earnshaw, p. 143.

Pushing Marcel Past the 'Post'
David Hopkins

Postmodernism and the En-Gendering of Marcel Duchamp by *Amelia Jones*, Cambridge University Press, 1994, 316 pp., 52 b. & w. illus., £13.95 pbk

Unpacking Duchamp: art in transit by *Dalia Judovitz*, University of California Press, 1995, 309 pp., 38 b. & w. illus., £28.00 hbk

These books represent a new wave of American scholarship which participates in, and problematizes, the notion of a 'postmodern' Duchamp; the underlying leitmotifs being authorial and gender indeterminancy in the case of Jones, and reproducibility and appropriation in that of Judovitz. However, whilst Judovitz seems content to situate herself in a tradition stemming from J.-F. Lyotard,[1] and rarely questions her terms of reference, much of Jones's book actively takes issue with the basis for the artist's American 'postmodern' reception.

Arguing that critics and historians in the USA have tended to set up Postmodernism in restrictedly one-dimensional, anti-Greenbergian terms, Jones spends much of the first part of her book attempting to show how, in opposing the 'masculinism' of Greenbergian criticism, with, for instance, its associated denigration of mass culture as the feminine 'other' of 'high' art, American postmodernist critics have developed the concept of a 'feminized' counter-tradition which duplicates precisely those theoretical shortcomings underpinning the ratification of Greenberg-style Modernism. These shortcomings are rarely articulated with clarity by Jones. However, they include the 'paradoxical construction of Duchamp as origin of a movement critical of artistic authority' (p. 50) when, as she says at one point with uncharacteristic and disarming directness, 'the author is supposed to be "dead" in postmodernism' (p. xv), and the related point that, as 'disseminating father' (p. 14), he is ironically placed in the position of setting in motion a male-dominated tradition of Neo-Dada, Minimalist, Conceptualist and Pop practice

which, in endorsing tendencies towards the performative and links with mass media, is typically characterized as 'feminine' in opposition to the hyper-masculinism of the preceding Abstract Expressionist generation. Fundamentally, Jones is opposed to what she calls the 'heterosexualizing tactics of critical discourse – in which all differences are condensed into poles of modernist/masculine (implicitly heterosexual) versus postmodernist/feminine, feminist or homosexual' – because she feels that such clear-cut distinctions have repressed the 'erotics put into play in the Duchampian oeuvre through sexual and gender confusion' (p. xvi), an oblique reference to his creation of Rrose Sélavy, which she later discusses. This 'binary staging' is seen as revealing 'a deep intimacy with the ostensibly outmoded, masculinist and homophobic oppositional logic' (p. 16) thought to exist only in modernism, the upshot being that 'power is in the process of being reterritorialized through the (appropriated) tropes of femininity, feminization, and (male) homosexuality (p. 54)'.

The invocation of questions of power in the last quotation holds, I think an interesting key to the early stages of Jones's book. It is clear that she sees herself as performing a political, feminist task in wresting Duchamp away from a close-knit group of writers and critics associated with *October* magazine, including such influential figures as Benjamin Buchloh and Hal Foster. Interestingly, she acknowledges the pre-eminence of Rosalind Krauss in this circle but seems somewhat less hostile towards her position, not least perhaps because Krauss in recent years has produced accounts of eroticized visuality in Duchamp increasingly at odds with what Jones perceives to be lacking.[2] Nevertheless, Krauss is still taken to task for having, ironically, duplicated modernism's idealist recourse to origins by situating Sherry Levine as the 'origin of a radically deconstructive postmodernism' (p. 57), whilst her fellow 'Octoberites' and Buchloh especially, are seen as criminally reliant on the view of the readymade as institutional critique borrowed from the Frankfurt-School-derived writings of Peter Bürger.[3] According to Jones, 'discourses of postmodernism tend to assume that their role is to decipher an immanent criticality residing within the fabric of the artistic product itself (the readymade being paradigmatic of the inherently critical object)' (p. 39). By contrast, she sees her own task as viewing Duchamp 'not as an abstract origin (the readymade Duchamp) or an individualist bundle of determinable intentions but as a construction, a frame, a performative signature whose cultural significance shifts from interpretive moment' (p. 13). In saying this, she sets herself up as closer to the poststructuralist sources for postmodern theory – particularly Derrida, Foucault and Lacan, all of whom she cites on numerous occasions – than the self-styled gurus of American postmodern criticism.

Jones should be congratulated for daring to question the rather complacent assumption of avant-garde radicality underpinning what is now an entrenched academic orthodoxy, but one sometimes has the feeling that her manoeuvres are motivated as much by the politics of academic succession as politics of a broader ilk. It is debatable how convincingly, or consistently, she carries out her counter-project. There are some rather ungainly attempts to 'have it all ways' and to defend in the midst of attack. At one point, justifying her laudable intention to pick through Duchamp's post-1960 reception (a useful contribution in its own right), she takes what one imagines to be a very deep breath and declares: 'I stage this tracing in a clumsily semichronological way, running the risk of simply reinforcing the spurious teleological logic driving art history's narratives of aesthetic progress.' Further down the page she continues: 'I perform this archaeological tracing self-consciously, under the Foucauldian presumption that an archaeological reiteration of these structures will expose the usually occluded discontinuities rupturing the regulatory and oppositional paradigms in place in the discourse of Duchampian postmodernism.' (p. 30) The reader, or rather this reader, gasps for air. But quite apart from the jargon-clogged nature of these apparent disclaimers, one is unsettled by the

158

© Association of Art Historians 1997

implication that there is some kind of moral virtue embedded in the project's incoherences, which can be offset by the appeal to authoritive 'names'. It hardly seems to occur to her that, in confronting the reader with an A–Z of cultural theorists, as she does throughout the course of the book, she is bolstering her own theoretical virility (I use the term advisedly in the absence of an adequate female equivalent) and participating in the kind of (masculinizing) self-legitimation, on the back of Duchamp's 'femininity', that she criticizes in other writers.

Having said this, there could be something perversely 'camp' in Jones's strategy, deriving from the structural peculiarities of adopting a (feminine) authorial expertise in relation to Duchamp's own constant denial of his own (gender-based) 'authority', and Jones is at her best when she 'flirts' with Duchamp on this issue rather than taking pot shots at others working in the field. The second half of her book, which is much more persuasive than the first, is taken up by a highly original discussion of the range and variety of Duchamp's authorial 'slippages' and subterfuges in little-discussed objects and interventions of the 1950s and 1960s and, most impressively, by a lengthy account of Rrose Sélavy, his female 'other half'. The attempt here is to 'expose [sic] sexual difference as an oscillating effect that social and cultural norms work to stabilize' (p. 62) and she convincingly argues that Man Ray's photographs of Duchamp as Rrose constitute a seductive challenge to the interpretive 'desires' of the art historian, deconstructing the 'fantasies of mastery and (asexual) disinterestedness underlying the self-empowering mechanisms of art interpretation' (p. 147).

In order to shortcircuit the kind of 'fixing' of authorial intentions she sees as suppressing Duchamp's eroticism, she employs the psychoanalytic model of the transferential relationship between analyst and analysand to 're-eroticise the repressed sexuality of interpretation' (p. 113). It is precisely at the point at which she renounces her own 'self-authorization', seeing herself, à la Derrida, as *implicated* in processes of interpretation which cannot be 'transcendentally secured' (p. 111) that Jones seems to be most convincing, so much so that the wordy disclaimers from earlier in the book gradually settle in an overall methodological rationale. However, as she freely admits, there are labyrinthine contradictions involved in her courting of a sexually indeterminate Duchamp. She discusses Rrose against a dazzling range of contextual backdrops – the notion of the dandy, representations of the 'New Woman' and commodified images of women in advertising, practices of cross-dressing and 'drag', for example – without opting for any clear-cut reading of the gesture, but comes up against one central difficulty. This resides in the fact that, whilst the model of gender unfixity in Duchamp might presumably require some degree of proto-feminism on his part, there are stubborn indications that what she at one point irritatedly describes as his 'egregious arrogation of the feminine' (p. 150) may well be part and parcel of a hidden shoring up of masculine control. In this respect, Jones points to the photograph of Duchamp playing chess with the naked Eve Babitz at his 1963 Pasadena retrospective as confirmation that Duchamp could, on occasions, 'act convincingly like a dirty old man' (p. 102). Whereas at one point in her book she seeks a Duchamp who is 'not masculine, heroic or fixed in his authority' (p. 62), she is forced to concede elsewhere that 'It is not entirely convincing to attribute to Duchamp an unequivocally feminist goal.' (p. 151)

One gets the striking impression, of course, that Jones finds herself rehearsing what Duchamp himself characterized as his 'little game between I and me'[4] (which may in this context be read as a bi-gendered split). In this sense she succumbs, like so many before her, to the traps Duchamp set for his interpreters – although she gamely attempts to make a virtue of this. At times, however, one wishes she could be more resolute in determining the *historical* conditions for his elaborate games, however much she wishes to keep open the gendered and transferential nature of her position. It could be asserted that a primary

determining factor behind Duchamp's concern with gender inversion was ambivalence around the phenomenon of the 'femme homme'; a theme which cropped up in his art as early as 1909–10.[5] To some extent his notorious *L.H.O.O.Q.* of 1919 may have been a wry acknowledgement of this issue, filtered through Apollinaire's *Les Mamelles de Tirésias* with its proto-Surrealist theme of male filiation, embarked upon as an outcome of the repudiation of child-bearing duties by contemporary 'femme-hommes'.[6] In a recent essay Dawn Ades explores the Rrose Sélavy images in the context of Duchamp's preoccupation with mirrors,[7] one possible implication of her argument being that, as linguistically based pendants of the 'shaving soap' portraits produced in 1923–4 as trial runs for the *Monte Carlo Bond*, the second series of Rrose Sélavy photographs of 1923–4 may well encapsulate a degree of narcissistic scrutiny in a mirror, with gender effectively mirror-reversed.[8] All of this would place Rrose Sélavy as a 'shaved' descendant of the parodic whiskered 'femme homme' of L.H.O.O.Q. In so far as Rrose is now actually a 'man' (i.e., Duchamp) he would appear to have achieved a complete structural reversal of the femme-homme's self-sufficiency, reinstating the masculine as the privileged (and generative/artistically procreative) term, especially when we note, as Ades does, that the eyes assert 'control and consciousness'.[9] This line of argument would suggest that, however much Duchamp deconstructs gender in accordance with a basic antipathy towards social constructions of sexual difference,[10] his project ultimately promotes a considerably expanded and sensitized masculine domain, to the extent of having the 'last laugh' at the expense of 'politically correct' readings of his motivations.[11]

If Duchamp manages to wriggle out of a too-easy alignment with the gender blurring of the 1980s, Jones admirably conveys the drama of her interpretive tussle with him (although she, with refreshing self-awareness, might liken it to seduction). By contrast, Judovitz provides an apparently seamless, if rather repetitive, survey of Duchamp's career, predicated on his abandonment of painting and his recycling, in various reproductive registers, of his own productions. For Judovitz Duchamp is instrumental in 'providing a conceptual basis for art, understood as a medium that reassembles already given elements, and thus as a medium of reproduction rather than creativity, as it is understood in the conventional sense' (p. 87). This emphasis on the 'already made' aligns her more closely with Baudrillard's concern with simulation and replication than Jones's predilection for the likes of Derrida and Lacan. Judovitz's title, of course, prepares us for something involving commodification or consumerism, presumably linked to Duchamp's ironic 'mass production on a modest scale' of his artistic wares in the form of the *Bôites-en-Valises*, but, as with so much that is excitingly packaged, the product is a little conventional. Whereas one might envisage a kind of thematic 'unpacking' of the consequences raised by the *Bôites* for issues of art reproduction and consumption, the book initially follows a chronological format, with much fairly standard material on early works repeated without self-reflexive irony. Having 'arrived' at Duchamp's abandonment of painting, Judovitz mercifully concentrates on more well-defined problems, such as the linguistic implications of the readymades, the economistic metaphors in Duchamp's output, and the late *Etant Donnés*, but her actual discussion of the *Bôites* is surprisingly brief.

This is unfortunate, as the pertinence of the *Bôites* to her central theme would be enormous, particularly if it was contextualised adequately in historical terms. As a succinct conflation of a museum and a salesman's set of samples, Duchamp's Box seemingly dramatizes the shift from an age-old European museum culture to a young and increasingly market-led American one, at exactly that period, immediately before and during World War II, when the art market in the West, like Duchamp himself, was gradually moving its base from Paris to New York. The fascinating interplay between the object's portable nature, Duchamp's itinerant existence as a kind of conduit between

160

avant-garde communities in Paris and New York, and the decline of art's 'auratic' status in accordance with changing cultural contexts, would help to create a sense of the social matrix in which Duchamp's object gains its poignancy. Judovitz, however, provides us with little sense of the social. One of her central concerns in the book is to demonstrate that Duchamp's readymades are essentially rhetorical devices, underwritten by his well-documented love of puns. The effect of this emphasis is ultimately derealizing (again, of course, making Baudrillard an appropriate model) and this is exacerbated by Judovitz's own authorial predilection for wordplay. Sometimes this is undoubtedly illuminating, such as when, playing interminably on Duchamp's rejection of painterly/'wet' retinal modes, she muses as to whether the bottle-dryer should be understood as a visual pun on the possibilities of 'dry art' (p. 104). Often, however, she interposes her 'interpretative desire' (to follow Jones) in ways which appear gratuitous. Regarding *Peigne* (1916), we are told that 'the static quality of this steel, or rather "still" comb is disrupted once when we consider its title.' (p. 102) Examples could be multiplied, but the cumulative impact arguably conveys more about Judovitz's powers of association than that of her subject. Perhaps, as Jones would probably concur, this is an outcome of the fact that Duchamp's deep preoccupation with puns positively invites the spectator's transferential 'completion' of the work. However, such issues cannot be considered in a vacuum. It might be asking a lot of the author to take on board, however selectively, the mass of material on Duchamp's possible interest in mathematics, science, alchemy and so on. However, her text frequently induces a longing for some terms of reference outside the artworks' not always pleasurable play of signification.

Despite these reservations, Judovitz has some very original insights on Duchamp's interrogation of artistic 'value', and her chapter on 'Art and Economics' opens up a whole new area of investigation. Her main premise here, as pre-empted earlier in the book, is that the '"delay" in establishing how value is vested in an object becomes the conceptual space within which Duchamp experiments speculatively with a new definition of art.' (p. 122) This allows her to demonstrate how, in certain instances, Duchamp 'banks' on his own previous aesthetic gambits. In the case of *L.H.O.O.Q.* he 'shaves' it and adds his signature of the *L.H.O.O.Q. Rasée* of 1965, thereby 'reinvesting' the Mona Lisa itself (or rather its reproduction) with a new kind of 'interest' accruing to his own, as well as Leonardo's 'account'. This notion of reducing art (or anti-art) gestures to 'bonds' is made fully explicit in her fascinating discussion of the *Monte Carlo Bond*, which is shown to trade, almost literally, on the fact that Duchamp had supposedly given up art in the early 1920s, and thus to constitute a humorous form of (financial) 'speculation' on the artist's ability to survive for posterity; artistic reputations, for Duchamp, being merely attributable to the fluctuations of fate. Not surprisingly, Duchamp expressed this more succinctly than anyone else could hope to: 'I haven't quit being a painter ... I'm drawing on chance.'[12] Judovitz next moves to an account of the rarely considered art medals, cast from the drain-stopper, *Bouche-Evier* of 1964. Here she sets up interesting links to Renaissance art medals such as Alberti's *Medallion Self-Portrait* of 1438 to assert that 'artistic glory is not assured but on credit.' (p. 190) In the wake of such a discussion, there can be no doubt that much of Duchamp's output derives its impetus from the relationship between his own cerebral/artistic economism and his sense of the disparity between cultural and economic value on the social plane – as if the artist's 'worth', in so far as this can be 'measured' in our age, could only be assimilated ironically to an internalized and arbitrary system of expenditure and rewards, (one thinks here of the radically incommensurate investment of time and effort in the *Large Glass* and *Fountain* relative to their potential cultural pay-offs). Whilst Judovitz, like Jones, steers clear of issues of (economic) social alienation, (the word 'class' hardly appears), the scope of her thought is sufficiently generous to open up this kind of inquiry.

The complex issue of determining the level at which social experience impacts on Duchamp's rarefied practice can perhaps be dramatized by considering one clear-cut instance of comparison between these two books: their chapters on *Etant Donnés*. Both authors acknowledge Lyotard's influence here, but offer strikingly different readings. I have commented elsewhere at some length on an earlier version of Judovitz's impressive chapter[13] but would emphasize in this context her tendency, consistent with her position throughout the book, to reduce the gross hyper-realities of the tableau beyond the door to a set of rhetorical 'givens'. Her brilliant analogy between the 'dead' nude in the work and the imagery of Magritte's *L'Assassin Menacé* (1926) certainly succeeds in establishing that 'the body of the nude ... emerges merely as a residue, the dead torture (*torture morte*) of a male gaze that has immortalized it in the history of painting', the underlying irony being that 'The violence of the gaze ... paradoxically kill(s) a mannequin, a figure embodying ready-made conventions.' (p. 207) Elsewhere, however, she asserts that the mannequin in question should be seen as 'merely a "hinge", a figurative device that acts like a pun, swinging back and forth between male and female positions' (p. 219). It is very hard to reconcile this view with the fact that the structural relation between the door and the tableau in *Etant Donnés* derives its logic from the interaction between the gender-specific domains of the *Large Glass*, from which it would follow that *Etant Donnés* implicitly parodies the male (Bachelor) spectator's desire to 'know' and 'fix' femininity (The Bride).

By contrast to Judovitz, Jones seems perfectly happy to engage with the critique of masculinity that it raises. Her observation that the mannequin's vulva, which so many commentators (including Lyotard) have been content to accept at 'face value', should more accurately be described as 'a visible and grotesque gash that goes nowhere' (p. 201) is both blunt and telling, as it allows her to argue that the figure refuses to hide her 'lack' and thus to 'lay [sic] bare the lack that a-priori destabilizes the subject, displaying the fact that this subject is not self-sufficient but constitutes his or her coherence in relation to that which he or she works to master' (p. 202). It is interesting here, of course, that Jones says 'he or she' and, notwithstanding its implications for the male spectator, her argument is unique in attempting to theorize a female viewer's response to the installation. In this respect, her brief attempt to harness accounts of female spectatorship by film theorists such as Mary Ann Doane, to the extent that '*Etant Donnés* ... arouses ... my homosexual desire. I become both the masculine viewer ... but also ... the desiring female viewer of another female body in representation' (p. 194) seems rather strained, given the distinct connotations of violation arising from the mannequin. I would argue that the *Large Glass* in fact opens up much more compelling possibilities for female identification; conventional codes of representation are abjured so that the Bride is constituted as much 'textually' as in an objectifying visual register, whilst here 'stripping' can be read as a form of 'striptease' and hence of parodic Masquerade, soliciting ironic female empathy at the expense of a set of rather ineffectual onanistic bachelors.[14] This is a relatively minor quibble, however. Jones succeeds in convincing us that *Etant Donnés* is not just an elaborate conceptual exercise but potentially affects our being in the world.

In the final analysis, both authors are agreed on one thing: to quote Judovitz, 'authorship [is] ... a process of engenderment, a commercial and erotic affair, which sets the author into motion as a relay of personas, thereby delaying, and thus postponing, the author or artist from attaining a proper or fixed identity.' (p. 109) It is certainly about time such defining features of a 'postmodern' Duchamp were (in)securely put in place, and both authors should be congratulated for taking on the task. It is tempting, though, to float the sense of a Duchamp who is, as Jones frequently discovers, *resistant*, even to those forms of discourse which would furnish him with his current 'relevance'. This unfashionable Duchamp is the one who, as quoted by Jones, made statements to the effect that he 'believed in the esoteric character of great art'[15] or who, when asked what

© Association of Art Historians 1997

adjective he would use to describe his activity replied 'Metaphysical, if any'.[16] Such utterances would preclude him from any easy consignment into a postmodern camp. This is also the one whose work is often rich in iconographic themes, stemming from Symbolist-derived hermeticism and his own Catholic roots, and such preoccupations would also need to be made sense of in postmodern terms instead of largely being ignored, as is the case with Jones and Judovitz, who would be hard pressed to account for Duchamp's relationship to Surrealism. Somehow this other Duchamp – the one who was moved to eulogise Breton after his death as 'the lover of love in a world that believes in prostitution'[17] – has to be made to sit beside, or even be reconciled with, the one presented in these books. There is still, clearly, a great deal of work to be done.

<div align="right">

David Hopkins
University of St Andrews

</div>

Notes

1 J.-F. Lyotard: *Les transformateurs Duchamp*, Paris: Galilée, 1977, translated as *Duchamp's TRANS/Formers*, Venice CA: Lapis Press, 1990.

2 See, for instance, her 'Where's Poppa' in Thierry de Duve (ed), *The Definitively Unfinished Marcel Duchamp*, MIT Press, 1991, pp. 433–59, or Rosalind Krauss, *The Optical Unconscious*, MIT Press, 1993, section three, pp. 96–146.

3 In this connection see the recent collection on Duchamp's post-World War II influence published by *October*: 'The Duchamp Effect', *October*, no. 70, Fall 1994.

4 Duchamp in conversation with Katherine Kuh in her *The Artist's Voice: Talks with Seventeen Artists*, New York, 1962, p. 83.

5 See my 'Questioning Dada's Potency: Picabia's *La Sainte Vierge* and the Dialogue with Duchamp', *Art History*, vol. 15., no. 3, Sept. 1992, p. 323 and passim.

6 ibid.

7 Dawn Ades, 'Duchamp's Masquerades' in Graham Clarke (ed), *The Portrait in Photography*, London: Reaktion Books, 1992, pp. 94–114.

8 The notion of 'mirroral return' in relation to gender seems crucial in Duchamp's output. See in this connection Craig Adcock, 'Duchamp's Eroticism: A Mathematical Analysis' in Rudolf Kuenzli and Francis M. Naumann (eds), *Marcel Duchamp: Artist of the Century*, MIT Press, 1989, pp. 149–67.

9 Dawn Ades, op. cit. (note 7), p. 110.

10 See my *The Bride Shared: Structures of Gender and Belief in Duchamp and Ernst*, Oxford University Press, forthcoming 1997.

11 This angle on Duchamp is, of course, played out in the current vogue for 'bad boy/girl' art amongst the 'Brit pack': Damien Hirst, Sarah Lucas et al.

12 Letter from Duchamp to Francis Picabia (undated, 1924), translated in Michel Sanouillet and Elmer Peterson (eds), *The Writings of Marcel Duchamp*, Oxford University Press, 1973, p. 187.

13 'De-essentializing Duchamp/or ... Rrose Sélavy: Dada's Mutter Stripped Bare', *Art History*, vol. 14, no. 2, June, 1991, pp. 276–7.

14 For a full discussion of this see chapter 2, section 1, of my forthcoming book on Duchamp and Ernst, op. cit. (note 10).

15 Duchamp: 'Apropos of Myself', Philadelphia Museum of Art, Duchamp Archives, as quoted by Jones, p. 102.

16 Interview with Duchamp by William Seitz, *Vogue*, New York, vol. 141, Feb. 1963, p. 133.

17 Duchamp: 'André Breton', *Arts-Loisirs*, Paris, no. 54, 5–11 October 1966, pp. 5–7, as quoted by Robert Lebel: 'Marcel Duchamp and André Breton' in Anne d-Harnoncourt and Kynaston McShine (eds), *Marcel Duchamp*, MOMA, New York and Philadelphia Museum of Art, 1973, reprinted London, 1974, p. 140.

Avant-Garde and Swish
Gavin Butt

Pop Out: Queer Warhol, edited by *Jennifer Doyle, Jonathan Flatley, & José Esteban Muñoz*, Durham and London: Duke University Press, 1996, 280 pp., 51 b. & w. illus., $49.85 hdbk, $16.95 pbk.

This collection of twelve essays takes as its point of departure the widespread 'degaying' of Warhol by art history, film studies and other related forms of discursive cultural management. 'For out as Warhol may have been,' Mandy Merck writes in her contribution here, 'gay as *My Hustler, Lonesome Cowboys, Blow Job* may seem, his assumption to the postmodern pantheon has been a surprisingly straight ascent, if only in its stern detachment from any form of commentary that could be construed as remotely sexy.' (p. 225) That is, in acceding to a position of canonical eminence, the queerness of Warhol and his cultural practices has been conveniently, if inconsistently, expunged from the vast majority of writings that make up the corpus of Warhol criticism. Such degaying, posited here as an effect of the heterosexist technologies of critical discourse, is taken to task by *Pop Out* in the belief that 'to ignore Warhol's queerness is to miss what is most valuable, interesting, sexy, and political about his work.' (p. 2) The book therefore sets out with the ambitious aim of reconstructing or re-remembering the various queer contexts, homoerotic subjects, and gay audiences, that were crucial to the (queer) production and reception of pop. However:

> This insistence on context displays not so much the desire to lay claim to a 'gay aesthetic' in Warhol's name or to define what is inherently gay in Warhol's aesthetic practices. Rather, *Pop Out* aims to help understand the multiple relations between Warhol and the worlds that he transfigured and in which he found a home, to point toward the recovery of the histories of homophobia and resistances to it in the queer communities of the 1950s and 1960s. (p. 6)

The book refutes any simplistic recuperative history bent on outing a 'hidden' gay Warhol, but seeks instead to reclaim those queer meanings and identifications that have accrued to Warhol and his art within the various social and cultural contexts in which he lived and worked. Above all, this is to lay claim to the writing of a political history, restoring to cultural analysis the contested position of queer identities and meanings as they criss-cross Warhol's world(s), and to frame finally the book's inquiry within the wider and mutually implicated histories of homophobia and queer resistance. In this way, Warhol is *re*gayed by being read in relation to, amongst other things, the cultural productivity of a queer childhood, the viewing habits of gay audiences in LA's Park Cinema, and the queer meanings of 'camp' and 'pop' in the 1950s and 1960s. By re-imagining these queer contexts for Warhol's work, *Pop Out* allows us to consider the paradoxical ways in which the rhetorics and strategies of pop can be understood both as the representational resources of queer symbolic expression and, *at the same time*, as the resources of queer *occlusion* through being articulated, in other contexts, most notably in the context of art history and criticism, as the features of an avowedly asexual (read straight) artistic practice. This doubling of pop's meanings points to the interplay between

© Association of Art Historians 1997

the queer and non-queer valencies of Warhol and his cultural milieu, and militates against any would-be essentialist constructions of a 'gay Warhol' or a 'gay aesthetic'. Indeed, it is rather the historical and performative mobility of Warhol's queerness across different social and interpretive contexts that the editors are keen to stress: 'Warhol was never entirely "out" nor "in" the closet. In turns, he was both and neither, depending on context, exigency, and survival. In part, Warhol cannot be described as an "out" "gay" man because so much of how he managed his identity and his cultural contexts is rooted in the fifties, before Stonewall and before identity politics.' (p. 4) The importance ascribed here to the historically variable conditions that determine Warhol's queer visibility/ invisibility is what I take to be *Pop Out*'s key methodological strength.

In addition to challenging the sexual politics of Warhol criticism, the book also ignores the typical divisions of Warhol's oeuvre effected by the disciplinary imperialisms of art history and film studies, encompassing essays on both his pop paintings *and* his films, as well as paying critical attention to aspects of his artistic and personal persona such as his now near-mythic shyness. Further, the book broadens its analytical scope beyond the boundaries of even the most expanded definition of Warhol's oeuvre by taking Warhol *as a context* to read, amongst other things, the strategies of disidentification in the work of Jean Michel Basquiat, the representation of Valerie Solanas's feminism in cultural studies, and the queer meanings of the *Batman* TV series. All of this gives the book a markedly interdisciplinary character which is only partially reflected in the list of contributors which, though sporting a mix of media, film and literary critics, tends to be dominated by the latter, and includes only one art historian: Simon Watney. This palpably reflects the institutional origins of the book on the Literature programme at Duke University. Many of the essays collected here were first aired at a conference organized by the editors, which goes part of the way towards explaining why some essays (particularly Eve Kosofsky Sedgwick's and Brian Selsky's) are a little on the short side, their analysis overly condensed and in need of further elaboration. In noting the dominance of literary studies, however, I wish to signal nothing more than the contradictions involved in a Foucauldian-style critique that becomes identical with the operations of an already existing disciplinary institution. This is a contradiction which shadows the book's conception and realization but does little to compromise the generally high level of analysis in each of the essays.

Pop Out flaunts the plural, and variously incommensurate, methodological approaches of its constituent essays as witness to the diversity of interpretive ways through which Warhol and his oeuvre might be queered: 'art history, critical race theory, feminist theory, psychoanalysis, cinema studies, popular culture and television studies, social theory, literary theory, and work on postmodernism' are the means by which the book does its job (p. 2). Mandy Merck's excellent essay takes up the latter, developing a much-needed and long-overdue queer critique of Fredric Jameson's now classic reading of Warhol's *Diamond Dust Shoes* as an icon of the postmodern. Rather than accepting Jameson's positing of the hermeneutic depthlessness of *Diamond Dust Shoes* as a given, Merck unpicks the logic of his argument by refiguring a local and historical causal scene (a sidewalk shoe sale in lower Manhattan in the early 1980s) and a social agent (the drag queen) for a sexually specific reading of Warhol's painting. Not only does this re-imagine a social world that Jameson, following Heidegger, admits for Van Gogh's shoes but rules out for Warhol, but it also refigures the representatively postmodern (the copy, superficiality, etc.) through the specifics of gender performance and the subcultural practices of gay male drag. Thus Jameson's analysis is queered and subverted by being re-rooted in gay culture, just as the forms and appearances of postmodernism become irrevocably shadowed by homosexual meaning. Similarly, in his 'Warhol Gives Good Face', Jonathan Flatley re-articulates Warhol's desire to create a public face for himself in

pop – his attraction to fame, commodity and star status – as a productive reaction to his private and 'shamed' status as a swishy gay man in 1950s America. Thus Warhol's 'pop' way of seeing is doubled as a gay identification with the supposedly levelling powers of the commodity, universalizing both himself and his abjected desire in that civic figure of modern capitalism: the consumer. As Warhol himself tellingly remarked, 'you can be watching TV and see Coca-Cola, and you know the president drinks Coke, Liz Taylor drinks Coke, and just think, you can drink Coke, too … All the Cokes are the same and all the Cokes are good.' (p. 118) In this way then, Flatley argues for a reading of Warhol's work as a form of gay survival in a homophobic world, symbolically articulating an empowered image of the homosexual citizen.

For Thomas Waugh, in his essay 'Cockteaser', Warhol's films are read in the light of the traditions of gay male pornography, arguing that some of the features which we now take to be typical of Warholian cinema should be more properly understood as a product of the commercial exigencies of 'physique' film practice, 'letting a reel of film run out while the trade model desperately continues his smile, his pose, or his mock-casual sunbathing was the simplest way to produce the standard mail-order product.' (p. 62) This analysis is undertaken not in order to challenge the 'originality' of Warhol's films, nor to accuse them of being derivative, but rather to restore them to their determined and determining historical position in the development of gay pornography. Also, through reconstructing the gay audiences of Warhol's films in the 1960s, Waugh rails against the like of Peter Gidal, Mark Finch and David James, who tend to see Warhol's relation to porn 'as a mediator and deconstructor' (p. 64). Waugh, on the other hand, declares that 'porn, pure and simple, is exactly the contextual framework that is indispensable for understanding the films', i.e., Warhol's films were not necessarily seen by their gay audiences as separate or distinct from the other 'erotic tease' films that were part of the emergent gay cinema – which is to say that they were consumed as simply and as straightforwardly pornographic (and, perhaps, as playfully deconstructive of porn's conventions) as the next skin flick.

In his provocative, though highly problematic, essay Michael Moon can be seen to develop the kind of analysis begun by Waugh (and the fact that it follows Waugh's essay in the book suggests, perhaps, that the editors are of the same opinion). However, whereas Waugh's historical recouping involves much empirical spadework, Moon, on the other hand, eschews any such endeavour in favour of the hermeneutical inventiveness of psychoanalytical inquiry. Rather than reading the more explicit homoerotic representations in Warhol's work as does Waugh (although these are by no means straightforwardly gay, as he argues), Moon attempts to extend an understanding of what might constitute a (homo)erotic image. He, therefore, refrains from any analysis of the boy drawings of the mid-1950s, or the *Sex Parts, Torso* and *Oxidation* works of the 1970s, in order to complicate an account of Warhol's eroticism and see 'a continuation by other means' of a perverse aesthetic in some of his early pop works, notably *Superman* and *Nancy*, both painted in 1960. This entails a reading which, like Eve Kosofsky Sedgwick's essay, takes him beyond any narrowly circumscribed account of gay meaning in favour of an attention to symbolic manifestations of perverse sexuality; 'In looking at some of the cartoon paintings that were among the key images through which Warhol established what I see as both a break with and a transformed continuation of his "fag" art of the fifties, I am concerned with his representations of a range of queer or perverse desires that include but are by no means restricted to male-male object choice.' (pp. 79–80) In order to do this Moon makes use of a broadly psychoanalytical interpretation of two recollections of a particular scene from Warhol's childhood – one recounted by Warhol himself in his *Philosophy* of 1975, and the second retold by Ultra Violet in her 1988 memoir – drawing out Warhol's erotic investments in the stars of his fantasies: Superman, Dick Tracey,

166

© Association of Art Historians 1997

Popeye and Charlie McCarthy. Moon takes such accounts as both Warhol's memory and fantasy, as both 'screen memory' and fantasmatic 'primal scene', articulating at one and the same time his real and imagined erotic investments in the subjects of his early pop paintings. This is not achieved, though, without a degree of critical contrivance on Moon's part. In interpreting Andy's claim not to understand a word of his mother's rendition of Dick Tracey as she reads to him at his bedside, Moon argues:

> ... it may be because the name of the comic strip 'dick' (that is, 'detective') resonates obscenely in the imagined/remembered child's ear, and by extension in the mother's, not only with 'dick' as the most ordinary vernacular term of 'penis' but also because of the way the figure's surname resonates with what appears to have been the adult Warhol's most intensely invested mode of contact with other men's penises: photographing or drawing or 'tracing' them. 'Dick' is 'trace-y' for Warhol in a double sense: it is a desired object to be 'traced' in the sense of being detected and pursued and also in that of being captured by being drawn ... (p. 82)

This contrivance is further exacerbated when Moon goes on to use such readings as interpretive contexts for constructing the erotic in Warhol's paintings. It is precisely when Moon turns to an analysis of *visual* representation that his argument comes unstuck, resorting to the worst kind of Freudian specularism where things that 'look like' the phallus or fecal matter are taken to *represent* it. That is, Moon's text speaks of the limits of its literary analysis, ignoring the important work of, for example, Nelson Goodman and his insistence on the insufficiency of resemblance as a condition for visual representation. However, it is precisely on such terms that Moon renders *Superman* and *Nancy* as images of perverse infantile eroticism; Warhol's representation of a gust of super breath in the former 'looks like a flood of water (or urine) loosed from on high' making the image 'potentially one of urethral eroticism', whilst the latter is seen to encode urethral eroticism by way of a field of yellow paint around the central figure which is read as a representation of piss in the snow.

This kind of analysis I take to be potentially damaging to any queer historical project in so far as it lays the ground for heterosexist disciplinary orthodoxies to marginalize queer reading as a kind of wilful projection. Although there is an attempt in Moon's essay to examine the historically specific meanings attributable to Warhol's screen memory, and to situate such readings in relation to queer communities (for example, the metonymic relationship explored between Warhol's evocation of Hershey Bars and the 'Hershey highway' as gay slang for the rectum), the reading of the queer eroticism in Warhol's paintings relies more heavily upon the projective fantasies of Moon's interpretive discourse. The context through which Warhol is queered, then, in this instance, is as much the discourse of the analyst, of Moon himself, as it is the historically reconstituted Warhol and his queer childhood memories. In this way, Moon's essay can be said to operate as the phantasmatic scene for the staging of queer politics as a kind of academic fiction, one which raises the whole question of what kind of a discourse might come up for the count as queer history, and what kind of an epistemological status it might have. Just as Moon addresses the doubledness of the accounts of Warhol's childhood as both memory and fantasy, then, the reader might productively read Moon's essay in the same light: as both history and fantasy – or even history-*as*-fantasy and vice versa – retaining the productive tensions between the two in any reading of it.

Other essays by Simon Watney, Eve Kosofsky Sedgwick and José Esteban Muñoz also take queer childhood as their context for reading Warhol but, unlike Moon's essay, they resort to more materialist and less psychoanalytical methods of interpretation. Watney's essay echoes some of the points made by Jonathan Flatley about Warhol's identifications

with media celebrities, whilst Muñoz compares the cultural survival strategies of queer and black children and their articulation in the work of Warhol and Basquiat. Whereas Muñoz insists on the specificities (as well as similarities) between black and queer forms of cultural resistance, Eve Sedgwick, on the other hand, risks collapsing such specificities into a more generalizable politics and poetics of shame. Through an analysis of Warhol's shyness and whiteness, Sedgwick gestures towards the transformational and productive politics of identities rooted in shame, although it remains difficult to assess such a politics on the basis of this short essay.

Finally, the book makes an analysis of what might be called Warhol's queer 'legacy', from the work of Gran Fury, Felix Gonzalez-Torres and Keith Haring, through to the 'bad' or 'punk' acting of Keanu Reeves. The editors refrain from thinking about any such legacy in terms of Warhol's authorial 'influence', choosing instead to view Warhol less as an author and more 'as a producer, an enabler, a stage setter' (p. 16). This is an area of inquiry upon which the book only touches, but the remarks that are made are no less interesting for that. However, I cannot help thinking that the connections made between Warhol and AIDS activist art, in particular the graphic work of Gran Fury, operate more as a way of politically redeeming Warhol, of atoning for his lamentable attitudes towards PWAs in his own lifetime, as opposed to the writing of any concrete post-history for his work. Only in this respect does the book verge on turning Warhol into some spurious queer icon, for the large part remaining a powerful and provocative read, holding in place the contradictoriness of Andy's queer face.

Gavin Butt
Central St Martin's College of Art & Design

The *Krazy Kat* Problem
Richard J. Williams

Robert Morris: The Mind/Body Problem, Solomon R. Guggenheim Museum, New York, 1994, 340pp., 11 col. plates, 267 b.&w. illus., $50.00

Continuous Project Altered Daily: The Writings of Robert Morris, Robert Morris, Cambridge: MIT Press, 1994, 344pp., 126 b.&w. illus., $24.95

Robert Morris, Centre Georges Pompidou, Paris: Editions du Centre Pompidou, 1995, 351pp., 54 col. & 174 b.&w. illus., FF200.

Earlier this year, whilst I was interviewing the editor of a short-lived New York art journal, the conversation turned to Robert Morris. 'Don't you think', he asked, 'that Morris must feel he hasn't gotten his due?' It was a puzzling remark: during the previous two years, Morris had been the subject of a huge retrospective exhibition, touring to the Guggenheim Museum New York, the Deichtorhallen Hamburg and the Centre Georges

© Association of Art Historians 1997

Pompidou, Paris. The American version had occupied not only the ramp of the Fifth Avenue building, but also the considerable exhibition space of the SoHo branch. Two vast catalogues, a collection of the artist's writings, and many articles on or by the artist had all appeared in the same period. I was no clearer when it transpired that my friend was referring to the artist's lacklustre performance at auction (a large Morris will not command anything like the $600,000 regularly achieved by a contemporary like Eva Hesse or Bruce Nauman), as his collected writings seemed to describe a career of active resistance to the market. Morris's strategy was clearly set out in the introduction:

> One of the first things I set out to shatter for myself, was the unity of a subject – both with itself, and with a monolithic, coherent style prescribed to flow from this ideological oppression. I rejected from the beginning the market- and media-driven prescription that the visual should be promoted to a worshipful ontology, while the wordless artist, a mute fabricator of consistent artefacts, was forbidden to set foot on theoretical and critical ground.[1]

To discuss the artist's market performance seemed to me to miss the point. But what my friend's remark made clear was that Morris was an object of commercial exchange in the same way as any other artist. That I needed reminding of this had to do with, firstly, the fact that Morris's career had increasingly resembled an academic one, with his connections to *Critical Inquiry* and *October*; and secondly, that the field of inquiry into Morris has generally excluded investigation into the economic, political or social conditions of his production. The borders of the discursive field have been effectively policed by the artist, and the resulting scenario is a game of (artistic) transgression followed by (critical) recuperation, in which the artist always wins. The situation, elegantly parodied by Morris in a 1994 essay,[2] resembles the comic strip *Krazy Kat*, in which a cat (Krazy) enjoys an unrequited love affair with a mouse (Ignatz), who responds to its affection by hurling bricks, leading to the mouse's frequent incarceration. In the article, Ignatz is symbolically Morris, the target of his bricks is the market, and their exchange results in his periodic recuperation: but Morris, like Ignatz, always gets out of jail.

The article in question is 'Robert Morris Replies to Roger Denson, Or Is That A Mouse in My *Paragone*?', the fourteenth and final essay in the collection *Continuous Project Altered Daily*. The only new essay in the collection, it ironically surveys the artist's career at the time of a major retrospective exhibition. In it Morris responds to an interviewer anxious to unify the different aspects of the artist's career, and to establish external referents for the work. However, the text is not a direct response to Denson's pedantic questions, but a monologue spoken in the character of Krazy Kat, the audience for which is Ignatz. The performance takes place:

> in an asylum-like scene: incomprehensible structures are under way; all kinds of materials are strewn about – plywood, steel, heaps of earth, and enormous blobs of grease – mirrors lean precariously, and half-visible body parts dangling in the shadows give a grotesque atmosphere to the chaos. A muffled cacophony of arguing voices, tool noises and construction sounds pervade the space which is also occasionally pierced by a shriek or the clatter of a thrown object. Shadowy figures carrying objects or fighting flit here and there into the lights.[3]

The 'incomprehensible structures' in fact refer to different works, and the nine characters who populate the scene are manifestations of the different identities the artist has assumed during his career. 'Body Bob' is therefore the performer of the early 1960s

dance pieces, mostly realized with the Judson Dance Theater; 'Major Minimax' is the Minimalist; 'Lil Dahlink Felt' is the author of the so-called 'Anti Form' pieces in industrial felt; 'Dirt Macher' is the maker of *Earthwork*, a 1968 amalgam of dirt, wire and grease – and so on. The narrative itself, where it is intelligible, has Krazy Kat and Ignatz as customs officers, attempting to put the chaos in order by punching the 'thirteen tickets' of a 'metaphysical manifest',[4] each one representative of a different aspect of Morris's career.

As a parody of *Krazy Kat*, the piece is not an unqualified success (it would be better had it used one of George Herriman's original stories as a basis), but it performs most interestingly as an index of Morris's career, most importantly illustrating the multiple, co-existing identities of the 'shattered' subject. The failure of Krazy and Ignatz to re-establish the subject's unity points up the hopelessness of the task. That Morris could not be tied to any one area of practice, or type of behaviour puzzled critics from the beginning of his career – a *Time* magazine review of 1968 wondered if there were not one but several Robert Morrises. At the same time, a disjunction was clearly visible between the pedantic, intellectual Morris of the essays he published for *Artforum*, and the drole, 'Buster Keaton-faced Kansas Citian' who emerged in interviews and general articles.[4] The artist's assumption of multiple and shifting identities has also been manifest in his disruption of documentary forms, the interview in particular. 'Robert Morris Replies To Roger Denson' is a somewhat extreme example: the artist not only refuses to answer the questions directly, but uses a cartoon character as the speaking voice (the interview form is subverted further by listing the – now redundant – questions at the left-hand side of the main text.

Since the publication of this piece in 1994, all published interviews with Morris have involved a comparable manipulation of the interview form. Indeed, the artist now appears to decline all face-to-face interviews, and requires the exchange to take place via a much-used fax machine.[6] As a result, his responses have become more literary at the point of production and have sometimes self-consciously changed voice during the interview, moving from an expository mode, to anecdote and back. Pepe Karmel's 1995 interview is a good example.[7] Anxious to recuperate the artist's biography as part of a 'humanist' project, Karmel asks questions about Morris's early life, and the associative values of certain materials. Morris appears to regard this as a challenge; his responses are highly elaborate anecdotes, becoming increasingly fantastic as the interview proceeds. In the manipulation of the documentary form so that truth becomes legible as fiction, the result suggests the 1971 essay 'The Art of Existence: Three Extra-Visual Artists', also published in *Continuous Project Altered Daily*, in which Morris describes the work of three non-existent artists, who identities become progressively more extravagant. The final artist Morris encounters, 'Robert Dayton',

> is a fairly unnerving personality. He keeps his head shaved which seems to accentuate the deep scars on his face and neck. He also wears a monocle around his neck which he occasionally peers through if he needs to see a detail or read a gauge. He seems to enjoy playing with a certain sinister ambience that surrounds the work. When I was with him he frequently squinted at me through the thick glass of the monocle and leeringly compared the venting systems of Buchenwald and Belsen.[8]

One target of Morris's irony is the artist himself, a fact made clear by including the essay in the collected writings. All the previously published essays, the four 'Notes on Sculpture' and 'Anti-Form', worked towards defining an area of practice by using examples of little-known artists' work, just as 'The Art of Existence' pretends to do. Its irony inevitably

© Association of Art Historians 1997

infects these earlier writings, and the reader is left doubting their veracity. The 'Robert Morris' that emerges in the essay, and in general, is constructed to resist recuperation by the market. When one is not presented with multiple, co-existing Morrises, the single subject is destabilized by irony. It is this strategy of resistance that the collected writings emphasizes.

However, as Morris notes in the introduction to *Continuous Project Altered Daily*, 'what is alive in any given mode of art making is necessarily brief:[9] it is, in other words, only a matter of time before what is 'alive' (or 'resistant') is recuperated. Faced with the disunity of Morris as a subject, the commercial imperative is to make whole again, to re-establish, as it were, the Morris brand. Neither of the recent catalogues shrink from the task, but there are, nevertheless, parts of the catalogues which usefully preserve something of the discontinuity of Morris's work. Rosalind Krauss's essay for the Guggenheim catalogue (which also provides its title), 'The Mind/Body Problem: Robert Morris in Series',[10] is perhaps the most sophisticated attempt. Krauss describes Morris's career as an alphabetical series of notes, an ostensibly logical structure. But there are absences: there is, for example no entry under 'N', nor under 'X', 'Y', and 'Z'. Furthermore, the entries are in no sense equivalent. 'A.J. Ayer' is followed by 'Bat, What Is It Like To Be A', followed by 'Card File', referring to a 1962 work, and other entries include 'Fluids, Body', 'Pollock' and 'Kubler, George'. The form of the essay functions as an analogue of Morris's production, superficially logical, but fundamentally discontinuous. It is also, we could say, specifically analogous to the serial forms of the minimalist works of the 1960s, which Morris regarded as irrational[11] (although they were often read by critics as the reverse). A further advantage of Krauss's essay is that it permits discussion across conceptual boundaries. An important argument relates Robert Smithson's ironic travelogue 'The Monuments of Passaic'[12] to Morris's essay 'Anti-Form',[13] speculation which would be difficult in a more conventional framework, as the writings do not suggest comparison: Smithson's piece is a narrative which makes no clear reference to sculpture, while Morris's is expository, and refers only to sculpture. In these ways, Krauss maintains a sense of the disunity of Morris's project, and usefully resists the resolution of the 'Problem' identified by the title.

It is, however, only a partial success, as Krauss's entries are structured thematically around Samuel Beckett's novel *Watt*[14] in which the main character perceives the world accurately in terms of form and movement, but is unable to make sense of it. Some of the references to the novel make explicit connections between it and aspects of Morris's work: for example, the dance *Waterman Switch* – in which Morris and Yvonne Rainer were seen naked, locked in a loveless embrace, inching along a track – is described as an 'unmistakeable homage to *Watt*'.[15] Later, in the entry 'Fluids, Body', Krauss argues at some length that Morris is better understood in terms of Beckett, not Duchamp as has been repeatedly argued. There is a reference to *Watt* in a 1975 essay,[16] it is true, and Krauss has a better-than-average grasp of Morris's reading habits. But it is questionable whether this argument is any more than a sophisticated form of the biographical recuperation seen elsewhere: explaining Morris by means of Beckett substitutes Beckett for any number of other terms, all of them reductive if deployed in this way. The discontinuousness of Morris's work would seem to me to provoke more complex, and more political questions.

The Guggenheim catalogue provides a more critical analysis in David Antin's 'Have Mind Will Travel'.[17] It takes as its starting point Roberta Smith's *New York Times* review of Morris's 1991 retrospective at the Corcoran Gallery of Art, Washington, in which Smith described Morris as an 'artistic kleptomaniac' and hence 'a bit of a fake'.[18] The subject has a long history: in 1969 *Artforum* published the first American interview with Joseph Beuys, in which the artist recounted to Willoughby Sharp how Morris and Yvonne

Rainer had visited his Düsseldorf studio in 1964 and seen 'everything'.[19] There was no doubt that Beuys wanted to imply that Morris had stolen the idea for the felt pieces from him, although the tone of the exchange is mischievous, not malicious. In the United States artists such as Richard Serra, Alan Saret and Stephen Kaltenbach have made similar accusations of Morris,[20] and not always in the same good humour. Morris remains, for many of Leo Castelli's rivals in the New York avant-garde art market, a thief of other artists' ideas, if only anecdotally.[21]

Antin cites 'The Art of Existence' as an example of Morris's own intervention in this terrain, identifying irony as a major factor in the artist's production. But, as he remarks, 'irony is a difficult figure to control, perhaps impossible',[22] once identified, it tends to destabilize all existing and future production (it has already been shown how, for example, 'The Art of Existence' threatens the earlier essays). It can also affect the perception of ostensibly peripheral documents. In a fascinating aside, Antin quotes from a letter from a 'Mark N. Edwards' of Madison, Connecticut, attacking 'The Art of Existence' on the grounds that it attempts to revive his own career by associating himself with three talented, but unknown artists. It is, in other words, an attack on exactly the behaviour Morris was ironizing, and Antin wonders whether it is in fact a production of the artist under an assumed name. Such critical interrogation does not feature elsewhere in the catalogues, which is a pity, as much of the documentation of Morris's career is highly unstable. A good case, which neither of the catalogues resolves, is the exhibition *Nine at Leo Castelli*, curated by Morris at Castelli's West 108 St. warehouse in December 1968. Although little visited, the exhibition was a major critical event, receiving extensive treatment in the American journals. Yet documentary accounts of it are notably inaccurate: the Paris catalogue, to give one example, describes it as *9 in a Warehouse*, gives its dates as February to April 1969, and states the inclusion of Claes Oldenburg (who did not participate), while omitting to mention Giovanni Anselmo and Gilberto Zorio (who did).[23] More curious is the absence of any documentation of the exhibition either in Castelli's archive, or the Morris archive at the Guggenheim Museum. When I questioned Morris about this, he replied, somewhat enigmatically, 'now only gossip and legend remain.'[24] Antin gives an inaccurate account of *Nine at Leo Castelli* too, but unlike the other writers, he admits that such instability is widespread, and in doing so allows that a work's meaning is not only produced by the artist, but by its readers too. His metacritical approach compensates for a recuperative conclusion, in which Morris is given a fixed identity: he is a 'restless, ironic and intellectual artist', a 'nomad' rather than a 'homeowner'.[25]

If Kraus and Antin preserve – respectively – a sense of the work's discontinuity and instability, the remaining catalogue material is more conventionally recuperative. Where Anti succeeds in destabilizing Morris as subject, in the same publication Maurice Berger sets out to fix the identities resulting from such destabilization. Berger establishes the Morris 'I' as explicitly performative, and he presents the artist's career as a series of performed identities. His conclusion describes

> the political activist who campaigned against the Vietnam war and the institutional
> hierarchies of the museum ... the workman who invited the public into the
> Whitney Museum of American Art in 1970 as he installed a monumental landscape
> of concrete, timbers, and steel; the explorer who negotiated the complexities of
> vision and perception as he walked mirror, in hand though a snowy landscape in
> his film *Mirror*; the blind man lost in self-imposed darkness who closed his eyes
> drew on paper with graphite and plate oil, and later scrawled a record of his
> actions at the bottom of the drawing; the dominator who posed half-naked in a
> helmet and S&M drag in a poster for his 1974 exhibition at Leo Castelli; the son

172

© Association of Art Historians 1997

who stands next to his father in a recent painting; the autobiographer who, in a series of recent essays recalls episodes from his own life.[26]

Three remarks might be made about his passage: firstly, Berger fixes Morris's 'shattered' identities much more securely than the artist has done. 'Robert Morris replies to Roger Denson' describes nine Morrises, but gives them enigmatic pseudonyms, and describes them in Krazy Kat's absurd voice; they can only be identified with difficulty, and even then some of the edges are blurred. Berger classifies Morris's identities, and hence stabilizes them. Secondly, such an approach arguably succeeds in re-establishing the unified subject: Morris becomes explicable as an actor with a repertoire of character roles, yet implicitly also has a hidden identity of his own. Thirdly, Berger's tone seems to move towards mythification of Morris. The performative roles he describes – 'political activist', 'explorer', 'dominator' – have Morris emerge in each case as an heroic figure. Often this exaggerates the performed identity: 'explorer' is an amusing inflation of the artist's role in the film *Mirror*. The problem here is a conflation of Morris's assumption of heroic roles with the idea of Morris actually being a hero (by being a great performer), and the problem is confirmed later on the same page, when the artist is dramatized as not only 'entering the labyrinth of the self' but 'reshaping the role of the artist (as well as the spectator) in an age of significant aesthetic and social reconstruction'. Readers of Morris Berger's earlier book *Labyrinths: Robert Morris, Minimalism and the 1960s*[27] might find these remarks familiar. There, Berger first set out the argument about Morris's performed identities, but describes the artists's project as an explicitly political one, therefore privileging one identity – the 'political activist' – over the others. A key image of the book shows Morris, on the steps of the Metropolitan Museum, New York, addressing a crowd of anti-Vietnam protestors, every inch the counter-cultural hero. It is a hugely seductive image: unfortunately, it is the only occasion in Morris's career when he can be aligned with a specific political position. By comparison with the New York avant garde of the 1970s, Morris's work describes near-total withdrawal from political engagement, and the artist's current opinion of politics appears to be one of misanthropic disgust. In spite of these criticisms, it must be said that Berger's work on dance, both here and in *Labyrinths*, is extensive and provocative, while the book itself remains the only monograph so far on Morris.

Elsewhere in the Guggenheim catalogue, the urge to unify Morris's oeuvre is much in evidence. Annette Michelson in 'Frameworks' finds precedents for the recent use of the frame in many earlier minimalist pieces,[28] while Jean-Pierre Criqui's 'On Robert Morris and the Issue of Writing: A Note Full of Holes' argues for the equivalence of the artist's published writings and his text-based art.[29] If anything the Paris catalogue exaggerates this tendency; it republishes Criqui's essay, along with a translation of a Barbara Rose piece from 1991, which describes Morris's career as an 'Odyssey', a metaphor that implies continuity, whatever the evidence to the contrary.[30] One of two new essays commissioned for the Paris catalogue, by Catherine Grenier, accounts for difference of the work by giving it a central theme of melancholy, and the writer concludes by comparing Morris explicitly with Goya.[31]

I missed a critical perspective in these catalogue essays. The urges to recuperate Morris, and to make him whole, which motivate both the catalogues have not helped produce an historical assessment of the artist. The dance pieces, which Berger makes central to the oeuvre, were produced under different conditions to the objects, and were subject to different rules of exchange. One could not buy a dance, whereas one could – and did – buy a Morris sculpture (the evidence in the artist's archive indicates that a reasonable market in Morrises was developing by the mid-1960s). Likewise, Criqui posits an equivalence between the publications and some of the work intended for exhibition.

But in what sense are these equivalent? Is an article for *Artforum*, with a circulation of 15,000, consumed in the same way as the *Memory Drawings*, text-based objects made in a single edition? Or speaking more generally, how was it that a market for such difficult work emerged? To this writer, it still seems extraordinary that in March 1969 Morris could be paid by one of New York's most prestigious galleries to hump dirt, grease, and rusty metal around a warehouse, in a three-week performance that hardly anyone saw.[32] With few exceptions, the catalogue authors seem to be caught up in the *Krazy Kat* spectacle Morris has recently described, the artist's well-directed bricks becoming targets for critical recuperation. Ironically, it seems that Morris will show the way ahead: a forthcoming essay for *Critical Inquiry* discusses the increasing professionalization of the art world, noting how the availability of well-paid casual labour in the 1950s and 1960s enabled experimentation to take place. Perhaps publication of this essay will open up a wider field of inquiry.[33]

Notes

1 Morris, R., *Continuous Project Altered Daily, The Writings of Robert Morris*, MIT Press, Cambridge, 1994, p. (ix).
2 'Robert Morris Replies to Roger Denson (Or Is That a Mouse in My *Paragone*?)', Morris, 1994, pp. 287–315.
3 Morris, 1994, p. 287.
4 Morris, 1994, p. 289.
5 'Sculpture', *Time*, 17 May 1968, p. 60.
6 In recent interviews, both Pepe Karmel and W.J.T. Mitchell describe Morris as withdrawing from a face-to-face interview at a late stage. My own requests for a meeting have also been turned down in favour of correspondence by fax.
7 See, in particular, Pepe Karmel, 'Robert Morris: Formal Disclosures', *Art in America*, vol. 83, June 1995, pp. 88–119.
8 'The Art of Existence: Three Extra-Visual Artists', Morris, 1994, p. 113.
9 Morris, 1994, p. (ix).
10 'The Mind/Body Problem: Robert Morris in Series', Solomon R. Guggenheim Museum, 1994, pp. 2–16.
11 Solomon R. Guggenheim Museum, 1994, p. 11.
12 Robert Smithson, 'The Monuments of Passaic', *Artforum*, vol. 6, no. 4, December 1967.
13 Robert Morris, 'Anti Form', *Artforum*, vol. 6, no. 8, April 1968, pp. 33–5.
14 Samuel Beckett, *Watt*, Paris: Olympia Press, 1953.
15 Solomon R. Guggenheim Museum, 1994, p. 3.
16 See Morris, 1994, pp. 154–6.
17 Solomon R. Guggenheim Museum, 1994, pp. 34–49.
18 Roberta Smith, 'A Hypersensitive Nose for the Next New Thing', *New York Times*, 20 January 1991, pp. H33–4.
19 Willoughby Sharp, 'An Interview With Joseph Beuys', *Artforum*, vol. 8, no. 4, December 1969, pp. 40–7.
20 For example, Serra accuses Morris of plagiarism in 'Interview by Peter Eisenman', *Richard Serra: Writings, Interviews*, Chicago: University of Chicago Press, 1994, p. 153.
21 John Gibson (dealer), and James Monte (artist, critic and former curator at the Whitney Museum of American Art) are among those who have produced this view, unprovoked. Interviews with the author, New York City, May 1996.
22 Solomon R. Guggenheim Museum, 1994, p. 40.
23 Centre Georges Pompidou, 1995, p. 235.
24 Robert Morris, letter to the author, June 1996.
25 Solomon R. Guggenheim Museum, 1994, p. 49.
26 Solomon R. Guggenheim Museum, 1994, p. 30.
27 Maurice Berger, *Labyrinths: Robert Morris, Minimalism and the 1960s*, New York: Harper and Row, 1989.
28 Solomon R. Guggenheim Museum, 1994, pp. 50–61.
29 Solomon R. Guggenheim Museum, 1994, pp. 80–8.
30 Centre Georges Pompidou, 1995, pp. 165–78.
31 Centre Georges Pompidou, 1995, pp. 11–30.
32 *Continuous Project Altered Daily*, Leo Castelli Warehouse, 1–22 March 1969.
33 Robert Morris, 'Professional Rules', *Critical Inquiry*, (forthcoming). Morris kindly let me have a final draft of this.

© Association of Art Historians 1997

Art History ISSN 0141-6790 Vol. 20 No. 1 March 1997 pp. 175–180

SHORTER REVIEWS

Gold, Silver and Bronze: Metal Sculpture of the Roman Baroque by *Jennifer Montagu*, New Haven and London: Yale University Press, 1996, 262 pp., 12 col. plates, 267 b. & w. illus., £40.00

Roman Baroque sculpture is so readily associated with monumental commissions which overwhelm the spectator that it is often forgotten that artists in this milieu were also employed on much smaller pieces, such as tabernacles, incense boats and medals. The premise of this study is that these diminutive objects can be as complex, rewarding and telling as larger, more easily visible works. They are firmly categorized here as sculpture, and so in a healthy manner the often uncomfortable division between the so-called fine and decorative arts, which is invariably imposed because of criteria of scale, is undermined.

Rather than being a comprehensive history of seicento metal sculpture, the book takes the form of a series of chronologically arranged case studies, based on Jennifer Montagu's Andrew Mellon lectures, which were delivered in Washington in 1991. Its themes complement her earlier books: *Bronzes* (1963), *Alessandro Algardi* (1985) and *Roman Baroque Sculpture. The Industry of Art* (1989). Developing further the preoccupations of *The Industry of Art* in particular, she illustrates the rich and varied relationships between patrons, designers, sculptors and specialists who cast and polish, so that her chosen exemplars emerge as marvels of collaboration and control. As befits the scrutiny of such small works, the appeal of minutiae is carried over to details of archival discoveries and connoisseurship.

The first theme discussed is the variety of small-scale Roman sculpture produced around the year 1600. In the almost complete absence of independent statuettes, of the sort which had been widely produced in the sixteenth century, this involves looking at works such the tabernacles of Sta Maria Maggiore and S. Luigi dei Francesi. The four extraordinary gilt-bronze prophets, which originally formed part of the latter, Montagu convincingly attributes to Jacob Cobaert, completely altering, in one stroke, our perception of a sculptor who is usually only accorded a footnote in the story of Caravaggio's career (as it was the rejection of his marble St Matthew for the Contarelli chapel that paved the way for the painter's commission).

There follows a more extensive study of other tabernacles, such as Bernini's for St Peter's. In this case the author eloquently draws attention to the energized statuettes of Christ and the saints which crown it; as she points out, they have been completely ignored in the vast literature on the artist. Such revelations are followed by an analysis of papal medals executed by the German Hamerani family; silverware recorded in plaster casts that was given by the Pallavicini to the grand dukes of Tuscany; and from the eighteenth century a study of the Giardini and Giardoni families of metal-workers. Finally, we are shown the spectacular Italian altar furniture commissioned for the Portuguese King John V, which is in the Museu de Sao Roque, Lisbon. In five appendices documentation relating to the key sculptures in the preceding chapters is transcribed.

© Association of Art Historians 1997. Published by Blackwell Publishers, 108 Cowley Road, Oxford OX4 1JF, UK and 350 Main Street, Malden, MA 02148, USA.

The photography is of very high quality throughout, and a large number of either obscure or completely unknown works are illustrated. Frustratingly, however, no dimensions are given for any of the pieces considered. The whole book, which is witty and ingenious, will not simply be of use to those interested in Rome. It should remain a rich resource for many with wider concerns, ranging from the variety of secular and sacred patronage in the seventeenth and eighteenth centuries, to workshop practice, and the crucial question invariably posed by sculpture about the nature of the link between designer and executant. What was once either simply not looked at all, or unjustly seen as Baroque marginalia, has now been brilliantly brought centre stage.

Christopher Baker
London

Albion's Classicism: The Visual Arts in Britain 1550–1660, Studies in British Art 2, edited by *Lucy Gent* New Haven and London: Yale University Press for The Paul Mellon Centre for Studies in British Art and the Yale Center for British Art, 1995, 470 pp., 200 b. & w. illus., £48.25

For too long, the study of the visual culture of Tudor and Stuart Britain has been organized by a specific narrative: the story of its growth 'from benighted ignorance towards continental adulthood' (p. 2) as it slowly absorbed the lessons of the Italian Renaissance. *Albion's Classicism*, originating in a conference held at the Warburg Institute in 1993, presents a direct challenge to the hegemony of this Italianate paradigm. In its place it offers a richly particularized re-reading of Britain's encounter with classicism, attending to the specific processes through which one culture assimilated, adapted, and in some cases resisted, the practices of another, and in so doing inflected them with different meanings and values.

The sixteen essays, framed by the editor's introduction and an afterword by Catherine Belsey, range across painting, sculpture, architecture, literature, material culture and religion and the interdisciplinarity of the cast of contributors is also sustained within the individual essays. Lisa Jardine, for example, examines the culture of gift-giving between northern humanists, interpreting the textual and visual artefacts of this exchange for vital clues to the processes of intellectual exchange. A sequence of essays on architectural topics problematizes 'the assumption ... that the triumph of classicism was inevitable'. (p. 31) Maurice Howard examines the constraints of function, economics and decorum that shaped the building of English town halls and Paula Henderson surveys the shifting dimensions of the fashion for that most Italianate form: the loggia. Deborah Howard reveals the hierarchies of decorum informing Scottish architecture of the period, reminding us of its distinctive cultural frame, and her essay is complemented by Michael Bath's analysis of the humanist emblematics of the painted ceiling at Pinkie Castle (1613), commissioned by the crypto-catholic Alexander Seton.

British Protestantism's uneasy relationship with imagery in general and classical-pagan imagery in particular is addressed in essays by Margaret Aston (analysing the dangerous paradoxes that attend the making of portraits of religious reformers) and by Nigel Llewellyn – on tomb sculpture. Keith Thomas maps the range of significances that the use (or avoidance) of the orders could hold for different religious groupings, stressing the absence of any unified meaning for 'British classicism'.

Alice Friedman offers another way of looking at the making of visual choices through

© Association of Art Historians 1997

her analysis of the very specific desires implied in one woman's programme of self-representation. In 'Constructing an Identity in Prose, Plaster and Paint: Lady Anne Clifford as Writer and Patron of the Arts' she argues that the apparently 'conservative' idiom favoured in her commissions needs to be understood rather in terms of a deliberate rejection of the italianizing fashions which had been current in her husbands' circles. In the Great Picture at Appleby (*c.* 1646) and in her rebuilding of the Clifford family castles, she appears as self-consciously celebrating tradition, dynasty and, specifically, matrilineal inheritance.

One of the most innovative features of the book is the recurrent concern for historicizing visual experience, a project exemplified in Lucy Gent's 'The Rash Gazer: Economies of Vision in Britain 1550–1660' and Christy Anderson's 'Learning to Read Architecture in the English Renaissance'. Gent, through a reading of the constructions of vision implicit in Hilliard's *Arte of Limning* and Marvell's *Upon Appleton House*, reveals the persistance of 'a version of sight more materialized than the rational sight constructed by fixed-point perspective' (p. 390). Anderson explores the tensions being played out in the assimilation of classicism between an architecture based on textual authority and what she calls 'the Albion tradition': native patterns of reading buildings which valued visual responses of wonder and amazement in the decoding of significant ornament. This tradition is exemplified in the buildings of Sir Thomas Tresham where 'like overlapping panes of glass, sliding one beside the other, Latin inscription, heraldry and the orders can all take place at once.' (p. 261) Anderson's stress on the importance of heraldry and its quasi-magical significance is echoed in many papers, notably in Ellen Chirelstein's reading of Queecborne's portrait of Sir William Drury (1578) as *impresa*, and in Thomas Greene's 'Shakespeare's Richard II: The Sign in Bullingbroke's Window'.

At a time when the pretensions of the survey text are no longer sustainable this multi-voiced volume provides a more useful model for mapping the representational practices of early modern Britain. *Albion's Classicism* will become a central text for cultural historians of this period.

M.L. Durning
Oxford Brookes University

Salvator Rosa: His Life and Times by *Jonathan Scott*, New Haven and London: Yale University Press, 1995, 259 pp., 75 col. plates, 165 b & w illus., £40.00.

In the introduction to this book the author states his intention to produce 'an old-fashioned Life and Times of Salvator Rosa (1615–73) that will interest readers in taking another look at his paintings, drawings and prints.' This is exactly what he has done. Since the seventeenth century the painter and satirist Salvator Rosa has fascinated audiences as a character whose life and art seem to exemplify the temperamental, melancholic and independent artist as 'unfettered' genius. Noted in his own time for his cynical wit and choice of unusual subjects, Rosa became better known later for his wild, natural landscapes and his 'proto-Romantic' views. In many ways this book is a twentieth-century version of Lady Sidney Morgan's *Life and Times of Salvator Rosa* (1824), without the more fanciful tales of Rosa's life among the *banditti* and his participation in the revolt of Masaniello in Naples, and with the benefit of the extensive scholarship on Rosa published during the past sixty years.

© Association of Art Historians 1997

The book is arranged chronologically in chapters that cover subjects from Rosa's early life and training, to his troubles with the Church and jealous rivals, his friends and patrons, his contemporary reputation and continuing influence. Scott recreates the landscape of Rosa's life through descriptions of overcrowded Naples, the Medici court in Florence, the streets of Rome, and the country villas visited by Rosa. The story of Rosa's life unfolds along the lines laid down by his earliest biographers, supplemented by the painter–poet's own vivid words from the numerous surviving letters and verse satires. Scott contributes original translations of Rosa's writing which capture the spirit and flavour of the artist's lively style and biting humour. There is a selected bibliography, endnotes and illustrations of most of Rosa's major works, although the quality of the colour plates is inconsistent. Several recently rediscovered paintings are reproduced, most notably the dramatic *Self-Portrait as Pascariello*, Rosa's favourite *commedia dell'arte* character.

In the end, Scott's Salvator Rosa is a rather diminished character, and the book has little new to add to our understanding of this painter or the artistic milieu of seventeenth-century Italy. Scott seems ambivalent towards his hero and somewhat disappointed, describing several of his paintings as 'clumsy', 'awkward', 'dull', or 'feeble', and accusing the artist of Neapolitan laziness (p. 196). Rosa is criticized for relying on standard source books such as Ripa's *Iconologia*, his borrowings from other artists, and his poor Latin. Rosa's assumed pose as a moral philosopher is dismissed, while the role of his personal sorrows and indignation are cited as the inspiration for his most complex allegories. Scott draws attention to the lack of consistency of any 'moral programme' in Rosa's work (p. 215), as if this were a failure, and stresses Rosa's reliance on his friend, the scholar Giovanni Battista Ricciardi, who often supplied him with ideas, as if the transition from concept to completed painting did not constitute an original effort. The author supports his view of Rosa's dependency on the younger Ricciardi through the re-identification of Rosa's self-portrait in the Metropolitan Museum of Art as a portrait of his friend, despite its strong resemblance to Rosa's own features in known self-portraits. This view of Rosa's lack of intellect – 'savage Rosa' in contrast to 'learned Poussin' in the words of James Thompson quoted by Scott (p. 225) – seems to reinforce the accusations of his enemies that this painter could not possibly have written his own satires. He does give Rosa credit for the clever self-marketing of his talents and brings fresh insight to the reception of Rosa's satires as essentially performance pieces. Although his discussion of artistic theory and production in Rome is overly simplistic, Scott does evoke the atmosphere of competition and creative energy that characterized the period. In spite of its shortcomings, the book succeeds in fulfilling its intended purpose. It is a very readable and generally informative introduction to Rosa and his world which should stimulate renewed interest in this extraordinary artist.

<div align="right">
Wendy Wassyng Roworth

University of Rhode Island
</div>

The Age of Caricature. Satirical Prints in the Reign of George III by *Diana Donald*. London and New Haven: Yale University Press, 1996, 248 pp., 27 col. plates, 183 b. & w. illus., £45.00.

As Diana Donald points out in the introduction to this major new study, scholarly examination has rarely done justice to the cultural significance and visual complexity of

 © Association of Art Historians 1997

Georgian graphic satire. Dorothy George's seminal catalogue of the British Museum collection, together with her related monographs on social and political caricature, set the tone in treating satirical prints as relatively unproblematic evidence of 'popular opinion', illustrating the ebb and flow of public life in Hanoverian England. Despite important contributions by scholars such as Atherton, Paulson and Jouve, analysis of graphic satire has been dogged by the partiality of attempts to relate the verbal-visual structures of the medium to an appraisal of its cultural meaning and political effectivity. In a series of inter-related essays, Donald allies a shrewd close reading of individual prints with far-reaching historical research, achieving a synthetic overview which challenges old assumptions and opens up important new perspectives.

At first glance, many of Donald's themes might appear disappointingly familiar: topics such as the representation of the crowd in caricature, responses to the French Revolution, and the satirists' treatment of contemporary fashion and high life have all attracted detailed study in recent years. Yet, in virtually every instance, Donald not only draws on revealing and unfamiliar sources, both verbal and visual, but questions many of the assumptions which have sustained previous investigation. Perhaps most contentiously, she challenges historians such as Herbert Atherton and John Brewer, who have interpreted the satirists' portrayal of the mob and popular politics as displaying a repudiation of the demotic force of 'opinion without doors'. For Donald, images of plebeian indiscipline constitute a self-congratulatory affirmation of the vitality of English liberty symptomatic of the populist anti-elitism of the prints themselves. Such a reading bolsters her broader contention that Georgian graphic satire addresses socially and geographically diverse publics, rather than a restricted, essentially metropolitan élite. Though Donald's view is consistent with most previous studies of the medium, paucity of evidence renders identification of the satirists' audience notoriously difficult and, as Eirwen Nicholson has recently argued, has fostered unrealistic assessments of caricature's social penetration.[1]

In defending the populist line, Donald draws particular attention to the widespread use of emblem in prints during the 1760s, arguing that such a visual language would have held out little appeal for a polite public increasingly impatient with convoluted pictorial allegories. Yet, in the same way as condescending representations of popular politics receive scant attention in her discussion of the 'mob', so complex emblematic prints, presupposing a high level of political awareness and wide range of cultural reference, figure less prominently in Donald's account than the more earthy and technically rudimentary ideographic satires of the anti-Bute campaign of the mid-1760s. Though her account of loyalist attempts to forestall popular unrest through the use of visual propaganda in the 1790s convincingly demonstrates how prints could inflect 'opinion without doors', material and intellectual constraints probably played a larger role in limiting the active audience for the satirist's art than is acknowledged here. In particular, satirists' preoccupation with often abstruse parliamentary affairs – an aspect rather underplayed within Donald's selection of themes – probably failed to engage a significant section of the unenfranchised population. In the end, perhaps, it might be most productive to regard the audience for prints as variable and fragmented, with much output appealing to the predilections (and pockets) of a privileged few, while particular topics and campaigns engaged a more socially inclusive public.

It is a token of the seriousness and imagination with which Donald treats her material that such substantive issues merge in a field which in the past has rarely risen above the banalities of illustrated social history. Donald avoids the dry descriptions so typical of writings on caricature to treat a broad spectrum of imagery with an attention and sophistication normally reserved for the likes of Hogarth, Gillray and Rowlandson. In doing so, she has done much to revitalize the study of graphic satire and bring it from the

© Association of Art Historians 1997

margins to the very heart of the ongoing reassessment of eighteenth-century British visual culture.

Neil McWilliam
University of East Anglia

Notes

1 Eirwen E.C. Nicholson, 'Consumers and Spectators: The Public of the Political Print in Eighteenth-Century England', *History*, vol. 81, January 1996, pp. 5–21.

Problem Pictures: Women and Men in Victorian Painting by *Pamela Gerrish Nunn*, Aldershot: Scolar press, 1995, 172 pp., 50 b. & w. illus., £35.00

In the second half of the nineteenth century a new category of pictures emerged within British art and criticism. 'Problem pictures' described a particular kind of open-ended narrative painting which frequently dealt with themes of social and moral significance, drawn from contemporary life. The paintings which were placed within this category wove definitions of gender and class into their pictorial and narrative structures and audiences derived a new, keen pleasure in reading the images and speculating about their outcomes. 'Problem pictures' were a specific type of art production which belonged to a particular moment in British social and cultural history.

But, in spite of its title, Pamela Gerrish Nun's most recent book does not address this genre of nineteenth-century British art. In fact, Nunn's definition of the term 'problem pictures' is promiscuously broad, embracing: 'any Victorian picture that involved women and men in its making or its content' (p. 2). To this end, the book might more properly have been called 'Problematic pictures'. In effect, this is a useful collection of essays, by one of the leading scholars in the field of Victorian art, on a range of subjects relating to the visual representation of gender.

The chapters/essays can be divided broadly into two groups: those which examine aspects of the institutions of Victorian art, and those which discuss specific themes and subjects in the painting of the period. Within the first group, there are essays on artistic identity and the position of women artists; on the 'gendering' of flower painting in the period; the domestication of history painting; and there is an interesting examination of women artists and the female nude. In the second category, there are chapters on the 'sensation' paintings which were produced in response to the Matrimonial Causes Act of 1857; the depictions of femininity which emerged in response to the Indian Mutiny; and a careful and effective study of images of emigration, through a case study of Marshall Caxton's *An Emigrant's Thoughts of Home* (1859).

The essays included in this collection address only some of the problematic or disturbing issues which confronted Victorian culture. Indeed, it is hard to know which paintings produced in this period (or, in any other period) would not fall into the category of 'problem pictures', as defined by the author. So, although this book is a welcome addition, there still remains a gap in the literature of art history, for a book on 'Problem pictures', which examines fully the structural relationships between gender and genre, and which assesses the neglected academic paintings of the last decades of the nineteenth century.

Lynda Nead
Birkbeck College, University of London

© Association of Art Historians 1997

Art History ISSN 0141-6790 Vol. 20 No. 1 March 1997 pp. 181–183

ABSTRACTS

The Authority of Art: Cultural criticism and the idea of the Royal Academy in mid-Victorian Britain

Colin Trodd

In mid-Victorian Britain the Royal Academy was subject to detailed investigation and valuation by a number of cultural, social and governmental forces. Focusing on the relationship between professional status and cultural power, many of these examinations were concerned with the role played by the Royal Academy in the public exhibition of art and the national education of artists.

The purpose of this article is to survey and analyse the rhetorics which organized debates concerning the function and identity of the Royal Academy in the period between 1850 and 1880. Engaging with a range of primary sources – Select Committee Reports, exhibition reviews, critical essays and public speeches – this work addresses the following questions: How was the term 'professional' used in definitions of the Royal Academy? To what extent was its privileged position within the social, ceremonial and symbolic landscapes of Victorian culture dependent upon its exploitation of commercial markets? How could the Academy reject the claim that, in establishing the social status of its own membership, it had contrived to return art to the level of trade? Where was the Academy positioned in relation to the discourses of national culture which circulated within Victorian culture?

The Body and Difference: Anatomy training at the Ecole des Beaux-Arts in Paris in the later nineteenth century

Anthea Callen

This article has two aims. Firstly, to augment the published information currently available on the teaching and learning of anatomy at the Ecole des Beaux-Arts in Paris including an Appendix of the curriculum *c.* 1880 under Dr Mathias-Marie Duval (1844–1907) and, secondly, to analyse some of the artistic anatomy's roles and meanings in pictorial representations of the human body. The main foci for visual analysis are a Salon medal-winning oil painting of 1888 by François Sallé (1839–99), *The Anatomy Class at the Ecole des Beaux-Arts* (Sydney, Art Gallery of New South Wales), depicting Duval's class, and the photographs of human morphology by Dr Paul Richer (1849–1933); Duval and Richer professed anatomy at the Ecole during the period 1873 to 1933. Positing a dynamic interaction between the professions of art, medicine and anthropology in the production of anatomy teaching and anatomy's visual canons, analysis concentrates on decoding the constitution of historically specific social relationships of class and gender, as inscribed across representations of the anatomical body.

© Association of Art Historians 1997. Published by Blackwell Publishers, 108 Cowley Road, Oxford OX4 1JF, UK and 350 Main Street, Malden, MA 02148, USA.

The Student Years of the 'Brücke' and Their Teachers

Peter Lasko

The student years 1901 to 1906 of the four founder members of the Brücke association of artists are analysed – Fritz Bleyl, Ernst Ludwig Kirchner, Erich Heckel and Karl Schmidt-Rottluff – based on the unpublished 'study' files that survive in Dresden Technical University. Although they studied architecture, their education offered a wide range of courses, including architectural and interior design, freehand drawing and sketching, perspective drawing, the History of Art and Architecture, as well as the historical and practical aspects of the Applied Arts, which casts doubt on the often stated claim that the Brücke artists were entirely self-taught. The courses they studied in Dresden are discussed, as well as Kirchner's Winter Semester of 1903–04, which he spent at the progressive Debschitz and Obrist Art School in Munich. The writings of Hermann Obrist and the two best known of their Dresden professors, Cornelius Gurlitt and Fritz Schumacher, are examined, in an attempt to analyse what influence the ideas and theoretical positions of their teachers might have had on them. Appendices list all the surviving documents (A), the courses taken (B), courses taught by their teachers (C) and their addresses in Dresden (D).

Defining *Hispanidad*: Allegories, genealogies and cultural politics in the Madrid Academy's competition of 1893

Oscar E. Vázquez

This essay examines the 1893 competition held by Madrid's San Fernando Academy for the best representation of 'Spanish Culture symbolized by the grouping of the great men' throughout the ages. Few late nineteenth-century academies attempted such a grandiose definition of culture by depicting *all* great native historical personalities from *all* major disciplines in a *single* canvas. More importantly, academicians repeatedly accused contestants of portraying foreign influences in their entries, of corrupting the truly Spanish, even while they, contrarily, pointed to non-Iberian sources of Spanish culture. Ancient and Renaissance Italy were but two mythologized sites of origins for academicians who debated cultural genealogies and definitions of '*Hispanidad*'. The contest coincided with the fourth centenary of 1492, and the winning panels were intended for Madrid's National Library; hence, the Academy debates are inseparable from the discourses of Spain's imperialist ambitions, or that of rising regional militancy. Yet, there was something more immediate at stake for academicians: the Academy's demise as economic centre of the arts and site of cultural authority. The debates disclose the controversial roles envisioned for this beleaguered institution at the turn of the century. The debates, therefore, like the competition panels themselves, were allegories of contemporary cultural politics.

The Flight from South Kensington: British artists at the Antwerp Academy 1877–85

Jeanne Sheehy

From the 1870s onwards the majority of painters in the British Isles had some training in the Schools of Art in the government system, administered from South Kensington,

© Association of Art Historians 1997

London. However, these schools provided only elementary training; more specialized ones like the Royal Academy and the Slade in London had limited places; and there was a general feeling that any serious artistic training had to be completed abroad. Although Paris was the favourite destination, a surprisingly large number went to the Royal Academy of Fine Arts at Antwerp (British and American students, their origin, age and date of registration are listed), mostly to attend the antique and life classes. At Antwerp time limits in the drawing classes, and an introduction to the Flemish colourist tradition, freed many of them from the excessively high finish insisted upon in the British schools. Unlike the École des Beaux-Arts in Paris, still fixed in the neo-classical tradition, the Antwerp Academy also had clothed models, for the benefit of genre painters, and there was also a course in landscape and animal painting. The Academy, combining elements of French, German and Flemish schools, introduced British artists to the broader currents in European painting.

© Association of Art Historians 1997

CAMBRIDGE

The Urban Image of Augustan Rome

Diane Favro

Examines the idea and experience of the ancient city at a critical moment, when Rome became an Imperial capital. This book explores for the first time the motives for urban intervention, methods for implementation and broader design issues such as formal urban strategies and definitions of urban imagery.

£45.00 HB 0 521 45083 7 368 pp.

..

Byzantine Art and Architecture

Now in Paperback

An Introduction

Lyn Rodley

Offers a systematic introduction to the rich material culture of the Byzantine empire, from the fourth to the fourteenth centuries, for the student or any other interested reader. The text is copiously illustrated by well over 400 halftones, plans and maps.

'... a most comprehensive and exemplary book.'
The Greek Gazette

£22.95 PB 0 521 35724 1 394 pp.

..

Picturing the Passion in Late Medieval Italy

Narrative Painting, Franciscan Ideologies, and the Levant

Anne Derbes

An examination of the narrative paintings of the Passion of Christ created in Italy during the thirteenth century. Demonstrating the radical changes that occurred in the depiction of the Passion cycle during the Duecento, Anne Derbes analyses the relationship between these new images and similar renderings found in Byzantine sources.

£45.00 HB 0 521 47481 7 288 pp.

The Art of Giovanni Antonio da Pordenone

Between Dialect and Language

Charles E. Cohen

A stunning, two volume study of a key figure of the Golden Age of Venetian and Veneto art, which includes a catalogue of all his accepted and collaborative works and an examination of the social, cultural and historical context of his career. Containing nearly 800 halftones and over 30 colour plates.

£195.00 HB 0 521 30630 2 920 pp.
Cambridge Studies in the History of Art

..

The Western Scientific Gaze and Popular Imagery in Later Edo Japan

The Lens within the Heart

Timon Screech

The first study to consider the introduction of Western technology in the eighteenth century. Demonstrates that the introduction of Western visual devices had a profound impact on Japanese notions regarding sight.

£50.00 HB 0 521 46106 5 324 pp.
Cambridge Studies in New Art History and Criticism

..

Monumentality in Early Chinese Art and Architecture

Stanford from CAMBRIDGE

Wu Hung

This pioneering work reinterprets the history of early Chinese art and architecture, from prehistory to the early sixth century.

£55.00 HB 0 8047 2428 8 398 pp.

Stanford University Press books are distributed outside North America
by Cambridge University Press

CAMBRIDGE
UNIVERSITY PRESS

The Edinburgh Building, Cambridge CB2 2RU

CAMBRIDGE

Art and Spirituality in Counter-Reformation Rome
The Sistine and Pauline Chapels in S. Maria Maggiore
Steven F. Ostrow

Offers an interdisciplinary study of the Sistine and Pauline chapels, providing an interpretive reading of their artistic programmes as an expression of their patrons' personal spirituality and of the larger institutional concerns of the papacy.

£60.00 HB 0 521 47031 5 411 pp.
Monuments of Papal Rome

..

Nicolas Poussin's Landscape Allegories
Sheila McTighe

Nicolas Poussin's Landscape Allegories offers new interpretations for several of the artist's most beautiful and enigmatic paintings of his late career. Sheila McTighe argues that, despite their outward limpidity, they are in fact deliberately obscure, their meaning recognisable only to an intellectual milieu.

£40.00 HB 0 521 48214 3 232 pp.

..

Art into Ideas
Essays on Conceptual Art
Robert C. Morgan

Provides an overview of one of the most important and influential developments in American and European art over the past thirty years. Focusing on works by a range of international artists, including Joseph Kosuth, Sherrie Levine, and Joseph Beuys, Robert Morgan defines and elucidates the premises of conceptual art.

£35.00 HB 0 521 47367 5 228 pp.
£12.95 PB 0 521 47922 3
Contemporary Artists and their Critics

Art and the Victorian Middle Class
Money and the Making of Cultural Identity
Dianne Sachko Macleod

Looks at the class, motivations and patterns of consumption among middle-class patrons in Victorian Britain. Supplemented by an indispensable appendix of collectors, this an essential work of reference for scholars, collectors and students of nineteenth-century art and culture.

£65.00 HB 0 521 55090 4 558 pp.

Early Impressionism and the French State
Jane Mayo Roos

Explores the reception of modernist painting in the years that preceded the Impressionist exhibition of 1874. The study considers the Salon's experiences of Courbet, Manet, and the group that became knows as the Impressionists.

£45.00 HB 0 521 55244 3 320 pp.

..

Unity Temple
Frank Lloyd Wright and Architecture for Liberal Religion
Joseph M. Siry

The first in-depth study of one of the seminal works of America's most renowned twentieth-century architect. Unity Temple is treated as a work of art that embodies both Wright's theory of architecture and his liberal religious ideals.

£50.00 HB 0 521 49542 3 377 pp.

CAMBRIDGE
UNIVERSITY PRESS
The Edinburgh Building, Cambridge CB2 2RU

'Their brief is to enlighten and stimulate, not merely to inform. They need to have the depth of knowledge and sophistication of thought to entertain the more informed of our clients as well as the speaking skills, lightness of touch and the ability to distil the essentials to please those with less familiarity with the subject.'

Does this describe you? Martin Randall Travel, the leading specialist in art history tours around the world, are constantly recruiting lecturers for occasional work leading small groups of discerning laypeople. The daily fee is usually £120 to £180, plus all expenses. Write with CV to:

MARTIN RANDALL TRAVEL LTD
10 Barley Mow Passage, London W4 4PH, UK. Tel. 0171–742 3355.

Subscribe to

CIRCA

Ireland's Journal of Contemporary Visual Culture

17A Ormeau Avenue	58 Fitzwilliam Square
Belfast BT2 8HD	Dublin 2
Tel:01232 230375	Tel/Fax:+ 353 I 6765035
Fax: 434135	email: circa@iol.ie

For all that's happening in the Arts in Ireland, all year round. Including features, news, reviews and interviews, and reflecting the exciting and changing cultural environment, from both sides of the border. Also: the Circa Index, referencing 1981–1991, ten years of Art in Ireland, price £8. A limited number of full sets of back issues (1 – 77), including the Index, and CD to accompany issue 69 are available, price £295.

Subscription Rates
(4 Issues)

INDIVIDUAL	INSTITUTIONS
UK/Eire £15.75	UK/Eire £29
Europe £20.00	Europe £35.00
Overseas £30.00	Overseas £45.00

you can pay by cheque, postal order or credit card

Advertising Enquiries to Anne Kennedy at:
ArtServices,
17A Ormeau Avenue, Belfast BT2 8HD
Tel/Fax. (01232) 237717

ARLIS/UK & Ireland Annual Conference
University of Kent at Canterbury, 3 - 6 July 1997

Art Libraries in the Cyber-Age

This conference will address the latest developments in electronic information resources for the visual arts. Topics will include aspects of electronic publishing snd electronic journals, new navigational tools, and digital imaging and delivery.

The conference will include the following sessions:

- **The Internet: navigational tools & developing projects**
- **The art historian's use of the Internet**
- **The Internet & public libraries: access for all**
- **Funding & digitisation initiatives**
- **Electronic publishing of primary & secondary sources**
- **Issues of preservation & standardisation**

The Electronic Libraries Programme's specific projects related to art and design will be highlighted, including **ADAM** (the Art, Design, Architecture & Media Gateway) and **DIAD** (Digitisation in Art & Design). Demonstrations and opportunities for hands-on experience will be a major feature of the conference.

From navigating the Net the conference will move to navigating the narrow lanes of Kent in an afternoon of planned visits to some of the county's historic villages, renowned for their houses, gardens and castles.

For further information please contact one of the following:

Gaye Smith
The Manchester Metropolitan University Library
All Saints
Manchester
M15 6BH

Tel :0161 247 6116
Fax:0161 247 6349
email: g.smith@mmu.ac.uk

Sonia French
Administrator
ARLIS/UK & Ireland
18 College Road
Bromsgrove
Worcs.
B60 2NE
Tel & Fax: 01527 579298
email:
sfrench@arlis.demon.co.uk

Artistic Reflections

Max Beckmann, German, 1884-1950, Self Portrait, 1937. ©The Art Institute of Chicago

Self-Portrait in Words

COLLECTED WRITINGS AND STATEMENTS, 1903-1950

Max Beckmann
Edited and annotated by Barbara Copeland Buenger

This revealing collection reverberates with Beckmann's experience of life from the time he moved from the first years of his career in Paris and Berlin to the final years in the United States.
Cloth £27.95 496 pages 10 halftones, 8 maps

Machine in the Studio

CONSTRUCTING THE POSTWAR AMERICAN ARTIST

Caroline A. Jones

"Accessible, undogmatic, yet brimming with an exhilarating richness of insight."
—Peter Halley
Cloth £39.95 536 pages 9 color plates, 111 halftones, 3 line drawings, 2 tables

*Cloth edition available

The Sexuality of Christ in Renaissance Art and in Modern Oblivion

SECOND EDITION, REVISED AND EXPANDED

Leo Steinberg

The second edition of *The Sexuality of Christ in Renaissance Art and in Modern Oblivion*, doubled in size by the addition of a "Retrospect," expands the now classic original text in three directions. It brings in a host of confirming images; deepens the theological argument; and answers skeptical or scandalized critics who decried the book at its first publication.
***Paper £23.95 440 pages 300 halftones**

Giovanni Bellini, Madonna and Child, c. 1470 Bergamo, Accademia Carrara

The Double Screen

MEDIUM AND REPRESENTATION IN CHINESE PAINTING

Wu Hung

In the first exploration of Chinese paintings as both material products and pictorial representations, *The Double Screen* shows how the collaboration and tension between material form and image gives life to a painting.
***Paper £19.95 256 pages 16 color plates, 155 halftones**

Courtesy of Artothek

NOW IN PAPER

The Moment of Self-Portraiture in German Renaissance Art

Joseph Leo Koerner

"[Koerner's] elegantly written book deals with the fateful period in the history of German art when it reached its highest point."
—Willibald Säuerlander, *New York Review of Books*
Paper £27.95 564 pages 1 color plate, 223 halftones

In the UK and Europe, available at your bookseller or directly from our distributor in the UK:
voice 01243 779777, fax 01243 820250, email customer@wiley.co.uk

THE UNIVERSITY OF CHICAGO PRESS

5801 South Ellis Avenue, Chicago, Illinois 60637 Visit us at http://www.press.uchicago.edu

APOLLO

THE INTERNATIONAL MAGAZINE OF THE ARTS
ESTABLISHED 1925

Save 25% off the cover price
with a year's subscription to Apollo

Annual subscription (12 issues): UK £70.00; Overseas £75.00;
USA (air speeded) $125.00; single copies including postage £10.00
(All major credit cards accepted)

1 - 2 CASTLE LANE, LONDON SW1E 6DR
TEL: 0171-233 8906 FAX: 0171-233 7159

The *Oxford Art Journal* has an international reputation for publishing innovative critical work in art history, and has played a major role in recent rethinking of the discipline. It is committed to the political analysis of visual art and material culture and to a critical engagement with problems of representation, in the belief that a radical re-examination of the visual has a broad cultural significance.

OXFORD ART JOURNAL

ARTICLES IN VOLUME 20 ISSUE INCLUDE

MARGARET HEALY Bronzino's *Allegory* and the Art of Syphilis

HELEN MILLS The Road not Taken

JON BIRD *Infvitabile Fatum*: Leon Golub's History Painting

ROBERT BURSTOW The Limits of Modernist Art as a 'Weapon of the Cold War': Reassessing the Unknown Patron of the Monument to the Unknown Political Prisoner

JOSEPH MONTEYNE Absolute Faith, or France Bringing Representation to the Subjects of New France

LAURA MOROWITZ Anti-Semitism, Medievalism and the Art of the Fin-de-Siècle

visit our website at
http://www.oup.co.uk/oxartj

Image: John Best
'Meleager' (c.1710)
Courtauld Institute of Art

1997 Order Form Volume 20 (2 issues)

■ Institutions £49/US$87 ■ Individuals £26/US$50 ■ New Subscribers £20/US$38

☐ Please send me a free sample copy.
☐ Please enter my 1997 subscription to Oxford Art Journal
☐ I enclose a cheque payable to Oxford University Press.
☐ Please debit my Mastercard/Visa/American Express/Diners/JCB Card.

Card Number: ☐☐☐☐☐☐☐☐☐☐☐☐☐☐☐☐

PLEASE PRINT DETAILS

Expiry Date: ☐☐☐☐

Name _____

Signature _____

Address _____

Please note: £ Sterling rates apply in UK and Europe, US$ rates elsewhere. Customers in the EU and Canada are subject to their own local sales tax.

City/County _____

Postcode _____

Oxford University Press Journals Marketing (X97) Great Clarendon Street, Oxford, OX2 6DP UK.
Tel: +44 (0)1865 297907 Fax: +44 (0)1865 267485 email: jnlorders@oup.co.uk

THE ART BOOK

Now published by Blackwell Publishers and the Association of Art Historians

Executive Editor: Sue Ward
Honorary Editor: Howard Hollands
US Books Editor: Jean Martin

The Art Book has become firmly established world-wide as essential reading for anyone who needs to keep abreast of newly published books in the world of decorative, fine and applied art, art history, photography, architecture and design.

Subscribe to *The Art Book* **for:**

- Accessible, prompt and critical reviews
- Broad coverage, including reviews of books *on* artists, books *by* artists, art magazines and CD ROM and computer databases
- In-depth interviews with leading personalities in the art world
- Entertaining and informative 'Diary Notes' from correspondents around the world
- Bestseller lists from London and New York
- Listings and reviews of major exhibitions and their catalogues
- Overviews of the work of key artists, art movements and debates and theories
- Special schools section, written by practising teachers and education officers at major museums and galleries, providing help for both students and teachers of art and art history in schools and FE

Re-launching in 1997 in an exciting new format!

Volume 4, 1997, 4 issues, ISSN 1352-0733
Corporate/Institutional Rates: £45.00 (Europe), £55.00 (RoW), $87.00 (N. America)
Personal rates: £20.00 (Europe and RoW), $32.00 (N. America*)

For more information please contact our customer services department,
Blackwell Publishers Journals, PO Box 805, 108 Cowley Road, Oxford OX4 1FH, UK,
tel: +44 (0)1865 244083, fax: +44 (0)1865 381381,
e-mail: jnlinfo@blackwellpublishers.co.uk

Ref: C0592

For full details, or to order a free sample copy,
find us on the internet ~ URL: http://www.blackwellpublishers.co.uk

Association of Art Historians

22nd Annual Conference
4-6 April 1997
at the Courtauld Institute of Art, London

Structures and Practices

The conference will address issues raised by artistic structures and practices and the relationships between them. The idea of structures is treated in the broadest terms. It will explore art institutions and the more conceptual frameworks within which art and architecture have been made and interpreted, including questions of language and gender.

The Conference will include the following academic sessions:

- Performance and the Performative
- Landscape, Space and Gender
- Patronage in German Art 1870-1945
- The Making of the Illuminated Manuscript Book
- Producing the Past: Aspects of Antiquarian Culture and Practice 1600-1850
- Plan/Non-Plan in 20th century Architecture
- Spanish Art and its Regulators
- Ars Longa? The Trouble with Public Art
- The Museum and its Metaphors
- Feminising the Framework
- Architecture and Language
- British Portraiture: structures and practices
- Patronage at the European Courts c.1500-1800
- The Renaissance Fork: European Decorative Arts c. 1300-1600 and their Display
- Words for Images: The Vocabulary of British Art Criticism c. 1550-1850
- The Legacy of Surrealism
- Academics of Art and the Transmission of Artistic Knowledge

Conference convenors: *Susie Nash and John House*

Reduced conference fees for members of the Association of Art Historians

FREE ENTRY FOR ALL TO THE ART HISTORY BOOK FAIR

In addition to the academic sessions, there will be a plenary lecture by the architect Daniel Libeskind, and parties in the National Portrait Gallery, the Banqueting House in Whitehall, and the Courtauld Gallery.

Conference and Book Fair Administration:
Susie Nash and Lyn Baber, Courtauld Institute of Art,
Somerset House, Strand, London WC2 0RN

Tel: 0171-873-2408 Fax: 0171-873-2781

ART HISTORY

Polity

History of Italian Art

Edited by PETER BURKE

Translated by Ellen Bianchini and
Clare Dorey

*'These well-chosen essays
provide a comprehensive overview of Italian art.'*
The Art Book Review

❖ Written by a distinguished group of cultural historians

The essays in this volume provide a comprehensive account of Italian "art" in the wider sense: as well as painting and sculpture, they examine photography and iconography, restorations and fakes, landscapes and writing. They focus not only on individual artists and epochs, but on the conditions under which Italian art was and is created: its principles, intentions and effects.

Volume One
Includes contributions from:

❖ *Peter Burke* on the history of the Italian artist from the twelfth to the twentieth century

❖ *Enrico Castelnuovo* and *Carlo Ginzburg* on regional art outside the traditional centres

❖ *Nicole Dacos* on antique art

❖ *Francis Haskell* on the "dispersal" and conservation of artistic works

❖ *Anna Maria Mura* on the public reception of art

Volume Two
Includes contributions from:

❖ *Giovanni Previtalion* on the periodization of Italian art history

❖ *Giovanni Romero* on art and everyday life in the Renaissance court

❖ *Salvadore Settis* on iconography in the Middle Ages

❖ *Bruno Toscano* on art and the church in the seventeenth century

❖ *Federico Zeri* on the concept of the Renaissance and the conflict between historical and art-historical periods

SPECIAL PURCHASE PRICE - save £5.00
on paperback two-volume set

0-7456-1819-7 paperback £25.00 August 1996

Volume 1: 338 pages
0-7456-0694-6 hardback £35.00 1994
0-7456-1754-9 paperback £14.95 August 1996
Volume 2: 500 pages
0-7456-0695-4 hardback £35.00 1994
0-7456-1755-7 paperback £14.95 July 1996

**For a free copy of our new History catalogue,
telephone Angela Hollingsworth on
01865 791100 or email
aholling@blackwellpublishers.co.uk**

For further information, please contact Polity Marketing,
108 Cowley Road, Oxford, OX4 1JF or telephone
01865 791100.